MODERN
ART
IN
BRITAIN
1910–1914

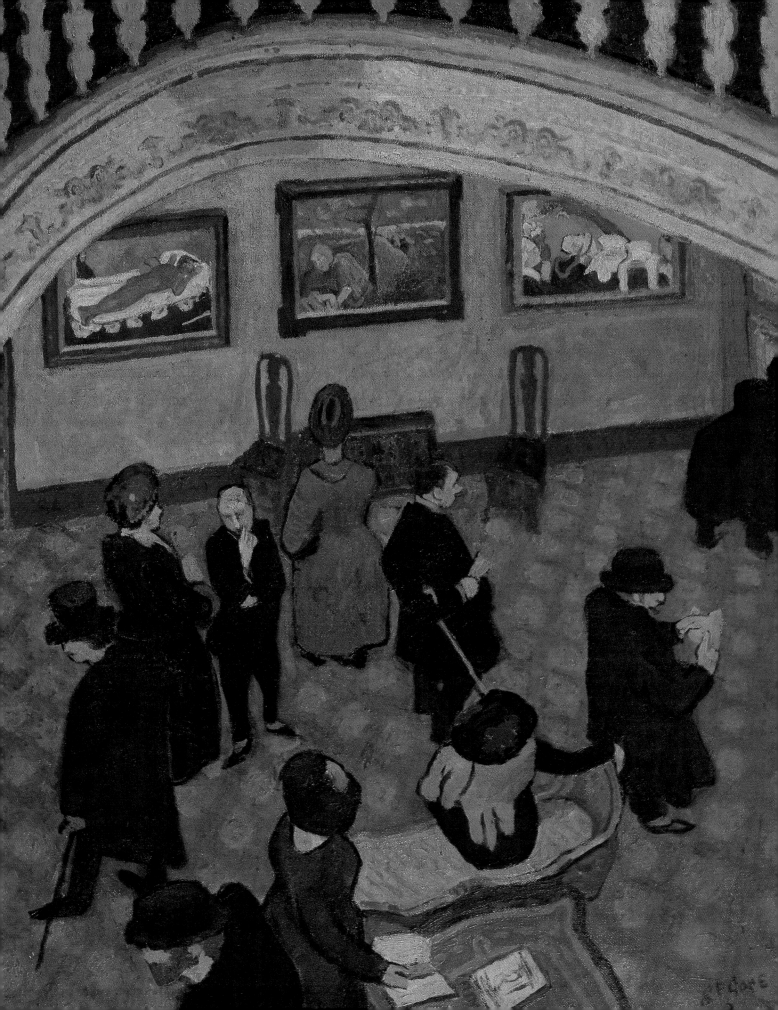

MODERN ART IN BRITAIN 1910–1914

ANNA GRUETZNER ROBINS

MERRELL HOLBERTON
PUBLISHERS LONDON

in association with

BARBICAN ART GALLERY

FOREWORD

THIS year the Barbican Centre celebrates fifteen years of non-stop artistic presentations since its opening in March 1982. As its first exhibition, Barbican Art Gallery showed *Aftermath: France 1945–1954*, a powerful appraisal of the country's cultural activity as it emerged from the trauma of occupation. Now, fifteen years on, we display *Modern Art in Britain 1910–1914*, a snapshot of the short period of frenetic artistic output in this country before Europe and a generation of men sank into the quagmire of the First World War.

In the years between these two major exhibitions, Barbican Art Gallery has established a reputation for enquiring into art history and art practice, especially in Britain, by re-evaluating overlooked areas of activity and reassessing the contributions of particular artists by focussed treatments of their work.

Modern Art in Britain 1910–1914 is one of the most ambitious projects that Barbican Art Gallery has realised to date. It stems from Dr Anna Gruetzner Robins's on-going research into the group of influential exhibitions that took place in this country during the pre-war period when modern European art was introduced to an unsuspecting British public and caused such a stir. Dr Robins's thesis is that the selection of these exhibitions established the canons of modern art as we know them today, and it is only through her painstaking work that we have been able to amass such a wealth of information about the works exhibited and the response to them.

Loans to our display bring together some of the major works by European artists that were originally shown in the exhibitions held in Britain between 1910 and 1914. They are placed beside works by those British artists that responded positively to this introduction of modern European art.

For the first time, Cézanne is placed beside Fry and Gore; Gauguin beside Gertler and Kramer; Van Gogh beside Gilman and Ginner; Derain and Matisse beside Bell, Fergusson, Innes, John and Peploe; Picasso beside Gaudier-Brzeska, Lamb and Lewis; Boccioni and Severini beside Bomberg, Cursiter, Dismorr, Nevinson and Saunders, and more thereafter. The array of works is fascinating and the insight that this study provides reveals the wide extent of the cultural interchange between Britain and Europe before the outbreak of conflict.

Barbican Art Gallery is indebted to the many lenders that have made this exhibition possible. Our selection has been drawn from public and private collections in Europe, Russia and North America as well as this country, reflecting the international spread of work within an exhibition that places British artists in their international context. The success of the exhibition is marked by the willingness of our national and international lenders, without whose support this display could not have been achieved. The Museums and Galleries Commission has been invaluable in providing cover under the Government Indemnity Scheme.

JOHN HOOLE
Curator, Barbican Art Gallery

FRONT COVER Paul Gauguin, *Tahitian women bathing* (detail), 1892, cat. 59

BACK COVER Attributed to Roger Fry, *The Matisse room at the Second Post-Impressionist Exhibition*, 1912, cat. 46

FRONTISPIECE Spencer Gore, *Gauguins and connoisseurs at the Stafford Gallery*, 1911, cat. 89

Barbican Centre

CONTENTS

INTRODUCTION 7

MANET AND THE POST-IMPRESSIONISTS 15

PROVENÇAL STUDIES AND OTHER WORKS BY AUGUSTUS JOHN 46

CÉZANNE AND GAUGUIN 52

THE FUTURIST EXHIBITION 56

THE SECOND POST-IMPRESSIONIST EXHIBITION 64

EXHIBITION OF PICTURES BY J.D. FERGUSSON, A.E. RICE AND OTHERS

(THE RHYTHM GROUP) 108

POST-IMPRESSIONISTS AND FUTURISTS 116

TWENTIETH-CENTURY ART:

A REVIEW OF MODERN MOVEMENTS 139

POSTSCRIPT:

MATISSE AND MAILLOL AT THE LEICESTER GALLERIES, 1919 159

CATALOGUE 164

CHRONOLOGY 181

APPENDIX 186

SELECT BIBLIOGRAPHY 193

NOTES 197

ACKNOWLEDGEMENTS 205

LIST OF LENDERS 206

INDEX 207

INTRODUCTION

THE theme of *Modern Art in Britain* is the series of celebrated exhibitions held between 1910 and 1914 which displayed and offered for sale virtually the entire canon of modern art. It examines the contents of nine major exhibitions, including the two Post-Impressionist exhibitions organized by Roger Fry, and reproduces many of the works they included. The aim is to contribute to an understanding of the ideas and excitements that shaped the formation of taste and the development of modernism in Britain.

The European works of art included in the 1997 exhibition at Barbican Art Gallery and illustrated and discussed in this book were selected, whenever it was possible, on the basis that they were shown in one of these exhibitions of modern art held in London between 1910 and 1914.[1] These exhibitions were: Fry's *Manet and the Post-Impressionists* (1910), *An Exhibition of Pictures by Paul Cézanne and Paul Gauguin* (1911), *Paintings by the Italian Futurist Artists* (1912), the *Second Post-Impressionist Exhibition* (1912), *Post-Impressionists and Futurists* (1913), and the showings of modern European art including Kandinsky and Brancusi at the Allied Artists Association between 1909 and 1914. In addition, several significant showings of British art in the same years have been examined. Augustus John was the first British artist to be labelled a Post-Impressionist; J.D. Fergusson and Anne Estelle Rice and the Rhythm group caused a stir in British art circles; and exhibition *Twentieth-Century Art: A Review of Modern Movements*, held at the Whitechapel Art Gallery in 1914, which largely consisted of British artists, encapsulated the issues raised in the earlier showings of modern European art. If all the works shown in all these exhibitions were re-assembled, they would form the most superb collection of modern art in the world.

The series of essays about these exhibitions that follows is arranged chronologically, and will hopefully help evoke the complexion of each original exhibition by discussing key works which were the focus of critical debate. That debate, and the general reception in the British press and public at large, provide the broader focus of the essays. As well as to the pictures, reference is made to documentary material of the time, including catalogues, photographs, periodicals and posters.

We have come to expect that an exhibition arranges an artist's work in a carefully presented chronological

LEFT Robert Delaunay, *The Cardiff Football Team*, 1913, exhibited in London in 1914, cat. 25

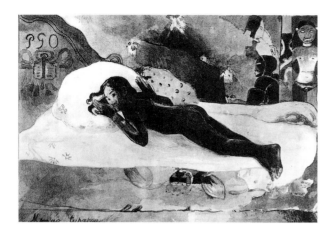

Paul Gauguin, *Manao tupapau*, 1894, cat. 56

sequence. This was certainly the premiss behind the selection of work by Matisse and Picasso in the *Second Post-Impressionist Exhibition*. But the introduction of the work of other European modern artists to Britain was not so neatly packaged. For example, British audiences first saw two of the spectacular, vividly coloured Fauve studies of the Thames at London, including Derain's *Charing Cross Bridge* (Paris, Musée d'Orsay) and another work similar to cat. 27 (repr. p.11) when they were exhibited in *Modern French Art*, an exhibition organized by Robert Dell for the Brighton Art Gallery in summer 1910.[2] The critic Frank Rutter, who had witnessed the outraged reaction of British visitors to Kandinsky's paintings at the Allied Artists Association earlier that summer, used the example of exhibits by Derain, Matisse and Valtat in Brighton to point out that "Kandinsky is no isolated phenomenon, and this may give them [the critics] pause in leveling charges of insincerity and wilful eccentricity".[3] Rutter's knowledge of modern art was acquired in Paris, where he frequently went to review exhibitions. His review of the Brighton show makes clear that he recognized its implicit radical nature. On the other hand, it would be fair to say that Fry's idea of modern art, at least in 1910, was determined by Julius Meier-Graefe's explanation in *Modern Art* (1908), which hagiographized Manet, Gauguin and the French 'giants'. This book influenced Fry's selection for *Manet and the Post-Impressionists* and this exhibition largely determined the idea of modern art as it was first formulated in the English-speaking world.

The first essay looks at the exhibition *Manet and the Post-Impressionists* (1910), when works by Cézanne, Gauguin and Van Gogh dominated and were the major topics of discussion. Each artist was represented by a large selection of key works which, together, must have been an unparallelled visual delight. Some of these pictures have become icons of modernism, including Van Gogh's *Crows over wheatfields* [fig. 1], and Gauguin's *Manao tupapau* or *The spirit of the dead watching* [fig. 15; see also the lithograph, cat. 56, repr. this page]. There were many other pictures of equal importance but lacking the same iconic status. Identifying the range of exhibits for the first time has helped to disclose some of the myths of modernism that originated with *Manet and the Post-Impressionists* – in particular, the patriarchal rôles in the development of modern art assigned to Manet and Cézanne.

The responses of the critics to these artists created the stereotypes that were to have a lasting impact. Van Gogh's supposed madness dominated the critical discussion of his pictures in 1910 much as it would continue to do for the rest of the century. When, at the time of the Cézanne show at the Tate Gallery in 1996, *The Guardian* published the results of a survey asking "Is Cézanne the father of modern art?", it was probably unaware that it was parroting the wisdom of Roger Fry in 1910.[4] Pictures by Gauguin depicting women of colour elicited a barely disguised racist response from many critics, who chose to ignore other Gauguin pictures and helped to perpetuate the stereotype of Gauguin as the artist "gone native". Sometimes the artist himself was implicated in this process. The story about Matisse wanting to paint in the manner of a child was one that the artist himself was keen to encourage.

In the second essay an analysis of the comments made about Augustus John's *Provençal Studies* at the Chenil Gallery – where David Bomberg was to have his first show in 1914 – highlights John's major rôle among British artists and reveals the controversy that surrounded these oil panels.

Cézanne and Gauguin was a small exhibition held at the Stafford Gallery in 1911. Spencer Gore's *Gauguins and connoisseurs at the Stafford Gallery* [cat. 89, frontispiece] records the critical and popular interest in Gauguin. The Stafford Gallery show was sponsored by Sir Michael Sadler, a keen collector of Gauguin and an early enthusiast of Kandinsky. This essay highlights his rôle as a collector and that of his son Michael Sadler

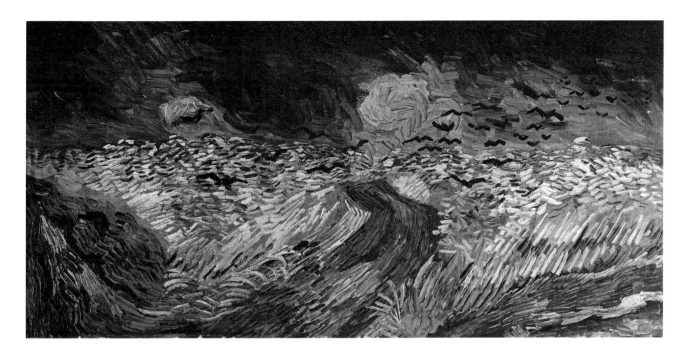

FIG. 1 Vincent van Gogh, *Crows over wheatfield*, 1890, Van Gogh Museum (Vincent van Gogh Foundation), Amsterdam

(who later changed his name to Sadleir, and so he will be known henceforth in this book) as a writer on art. Many works once in Sadler's collection are in the Barbican Art Gallery show, including cats. 88 (Gore; repr. p. 102), 166 (Picasso; repr. p. 128), 162 (Nolde; repr. p. 130) and many others. The Gauguin pictures that Sadler once owned have become some of the artist's best known works. Sadly Gauguin's *Vision after the sermon* (Edinburgh, National Gallery of Scotland; fig. 16) and a watercolour, *Tahitian landscape* (Whitworth Art Gallery), are the only paintings by Gauguin once in Sadler's collection that remain in Britain.

The widespread response to *Manet and the Post-Impressionists* must have influenced Marinetti's decision to make the Sackville Gallery, London, the first port of call after Paris for *The Futurist Exhibition* he masterminded in 1912. British critics were ambivalent about Futurism but it was a powerful stimulus for British artists and important examples from this show are discussed. Several of the Futurist works in the Sackville show, including Severini's *The boulevard* [cat. 181 repr. p. 59] and Carra's *Leaving the theatre*, have been in Britain since the time of their exhibition in 1912 and are now in the collection of the Eric and Salome Estorick Foundation, London.

In spite of their popularity few works by Van Gogh and Gauguin were included in subsequent exhibitions. Fry's unwillingness to include them in the *Second Post-Impressionist Exhibition* in 1912 does not reflect any slackening of public interest. Rather it shows Fry's determination to ensure that Cézanne received the critical attention he felt that he deserved. The equally large number of Cézannesque works by Derain, Friesz, Vlaminck and others that were selected for the 1912 show is proof that Fry wished to draw attention to Cézanne's 'followers' in France, and thus ensure that Cézanne succeeded Manet as 'father of modern art'. This essay discusses works by Cézanne, 'Cézannesque' pictures by other French artists, and examples by the many British artists who painted 'Cézannesque' pictures, including Gore, Grant and Fry.

There were a few works by Matisse and Picasso in *Manet and the Post-Impressionists*. Many critics felt that there should have been more, including examples of Picasso's more recent work. As a result both artists were well represented in 1912, and now that the exhibits have been identified it is clear, because they were explained in this way in the press, that the works were chosen to reflect the evolutionary development of Matisse's and Picasso's most recent styles.

Augustus John, *Dorelia wearing a yellow and red scarf, ca.* 1910–12, cat. 124

In addition to paintings, there were a large number of Matisse sculptures, drawings and lithographs and Picasso drawings and prints on show in the *Second Post-Impressionist Exhibition*. The magnificence of the original selection can be envisaged from the works of art that can be identified and from the painting of the exhibition which traditionally has been attributed to Roger Fry [cat. 46, repr. p. 78], also to Vanessa Bell. Vanessa Bell helped Fry to hang the *Second Post-Impressionist Exhibition*, and her response to Matisse's vivid colour can be seen almost immediately in her painting.

Many critics thought that J.D. Fergusson and Anne Estelle Rice and their group should have been included in the *Second Post-Impressionist Exhibition*. The group exhibition of these American, British and Scottish Fauves in the Stafford Gallery in 1912 highlights another aspect of British modernism.

Frank Rutter, the founder of the Allied Artists Association, the art critic of *The Sunday Times* and *Art News*

and curator of Leeds City Art Gallery, was an influential figure whose rôle has been largely overlooked. His different version of modernism from that of Roger Fry was revealed in the exhibition *Post-Impressionists and Futurists*, held in 1913. The title does not do justice to the full range of work displayed, including Camille Pissarro – who Rutter thought was a far more influential figure than Fry had allowed – a large group of Neo-Impressionist artists whom Rutter supported in *Art News*, Vuillard and Bonnard, Matisse and the Fauves, Cézanne, Gauguin, Van Gogh, Picasso, Severini and several German Expressionists. The show was a protest against what Rutter considered to be the narrowness of Fry's interests.

Rutter was one of a triumvirate of critics to be blessed by Wyndham Lewis in his journal *Blast No. 1*. The others were C. Lewis Hind, who wrote for *The Daily Chronicle*, and Paul G. Konody, who wrote for *The Observer* and *The Daily Mail*. Hind met Matisse in 1910

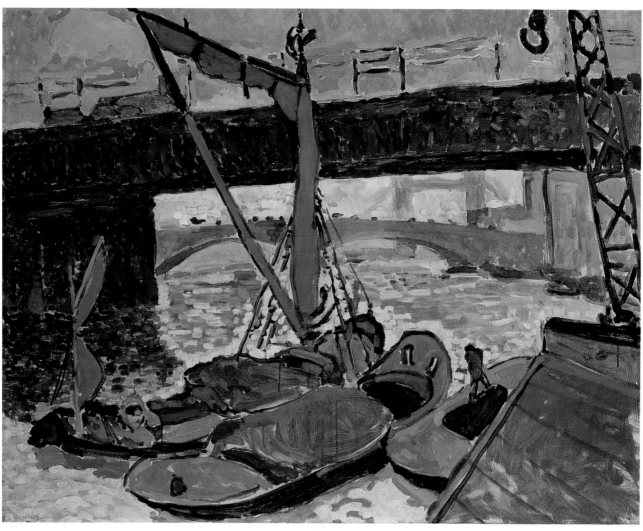

André Derain, *Barges on the Thames*, 1906, cat. 27

and published a sympathetic book, *The Post-Impressionists* (1911), which was illustrated largely with works from *Manet and the Post-Impressionists*. Hind subsequently emigrated to America where he wrote for *The Christian Science Monitor*. Konody, who published a translation of Camille Mauclair's *The French Impressionists* in 1903 and at the end of his life travelled to Paris to see a Francis Picabia exhibition, was not as sympathetic to modern art as Rutter and Hind. But his remarks were astute and his detailed observations about works he had seen are invaluable.

A more shadowy figure was Percy Moore Turner, who later owned the Independent Gallery and advised Samuel Courtauld about purchases; Michael Sadler also acquired many works from him. His gallery artists first became known between 1910 and 1914 – for example, Henri Edmond Cross's *Mediterranean landscape* [cat. 23] was purchased from the Independent Gallery. Moore Turner often sold pictures (for example *Manao tupapau*) which were first exhibited in one of Fry's exhibitions. Although Fry was a highly influential figure in shaping ideas about modern art in Britain, there were several others whose names are barely remembered today.

Michael Sadleir was the first British collector to acquire a work by Kandinsky when he bought six *Klänge* woodcuts from the Allied Artists Association in 1911. Sadleir formed a close relationship with Kandinsky, while his father, who had greater funds at his disposal, amassed an important early collection of his works. Well before Fry wrote about Kandinsky in eulogistic terms in 1913,

Rutter was corresponding with Kandinsky in August 1911 about the meaning of *Klänge*, as a postcard in the Tate Gallery Archive reveals.

The penultimate essay focusses on two shows held in 1914, *Twentieth-Century Art: A Review of Modern Movements*, at the Whitechapel Gallery, and *English Post-Impressionists, Cubists and Others*, at Brighton Art Gallery. It looks at the group divisions that were rife amongst the British artists who are better known as the Camden Town painters, the Bloomsbury Group or the Vorticists. Part of the purpose of the essay has been to question whether all the petty disagreements and squabbles reflected serious differences of artistic preoccupations, or whether there are closer links between the British modernists than has hitherto been suggested.

No single exhibition marked a conclusive end to this rich period in British art. Many important exhibitions were held between 1914 and 1919 (see Chronology). There was, however, a change in the complexion of these exhibitions of modern art, which is typified by the exhibition *French Art 1914–1919* at Heal's Mansard Gallery, as Andrew Stephenson has suggested.[5] The reason for ending with a discussion of the showing of recent works by Matisse at the Leicester Galleries in 1919 is simply that many of the paintings shown there were bought by British collectors and are now in public collections in Britain. This is a bittersweet contrast to the situation in 1912, at the time of the *Second Post-Impressionist Exhibition*, when many of Matisse's best known paintings were for sale. Not one of these paintings has remained in Britain.

FIG. 2 *The Sketch*, 16 November 1910,
Supplement

GIVING AMUSEMENT TO ALL LONDON: PAINTINGS BY POST-IMPRESSIONISTS.

WORKS OF "A GROUP OF ARTISTS WHO CANNOT BE DEFINED BY ANY SINGLE TERM," EXHIBITED AT THE GRAFTON GALLERIES.

1. "L'APPEL," BY PAUL GAUGUIN.
4. "LE GARAGE," BY MAURICE DE VLAMINCK.
7. "EGLISE DE CARRIÈRES," BY ANDRÉ DERAIN.
9. "LE BOULEVARD D'ARLES," BY VINCENT VAN GOGH.
2. "JEUNE FILLE AU BLUET," BY VINCENT VAN GOGH.
5. "LA FEMME AUX YEUX VERTS," BY HENRI MATISSE.
10. "VUE SUR LA MARTINIQUE," BY PAUL GAUGUIN.
3. "GRANDES BAIGNEUSES," BY PAUL GAUGUIN.
6. "CHRIST AU JARDIN DES OLIVIERS," BY PAUL GAUGUIN.
8. "LA DANSE DES VENDANGES," BY JULES FLANDRIN.
11. "COUP DE VENT D'EST," BY HENRI EDMOND CROSS.

In the introduction to the catalogue of the Exhibition of Works by Manet and the Post-Impressionists at the Grafton Galleries, it is written: "The pictures collected together in the present exhibition are the work of a group of artists who cannot be defined by any single term. The term 'Synthesists,' which has been applied to them by learned criticism, does indeed express a quality underlying their diversity; and it is the principal business of this introduction to expand the meaning of that word, which sounds too like the bray of an angry gander to be a happy appellation. As a definition it has the drawback that this quality, common to all, is not always the one most impressive in each artist. In no school does individual temperament count for more. In fact, it is the boast of those who believe in this school that its methods enable the individuality of the artist to find completer self-expression in his work than is possible to those who have committed themselves to representing objects more literally. This, indeed, is the first source of their quarrel with the Impressionists: the Post-Impressionists consider the Impressionists too naturalistic. . . . In the work of Matisse, especially . . . search for an abstract harmony of line, for rhythm, has been carried to lengths which often deprive the figure of all appearance of nature. The general effect of his pictures is that of a return to primitive, even perhaps of a return to barbaric, art. This is inevitably disconcerting." All London is going to the Exhibition, and is deriving much amusement from it. Be sure not to miss it

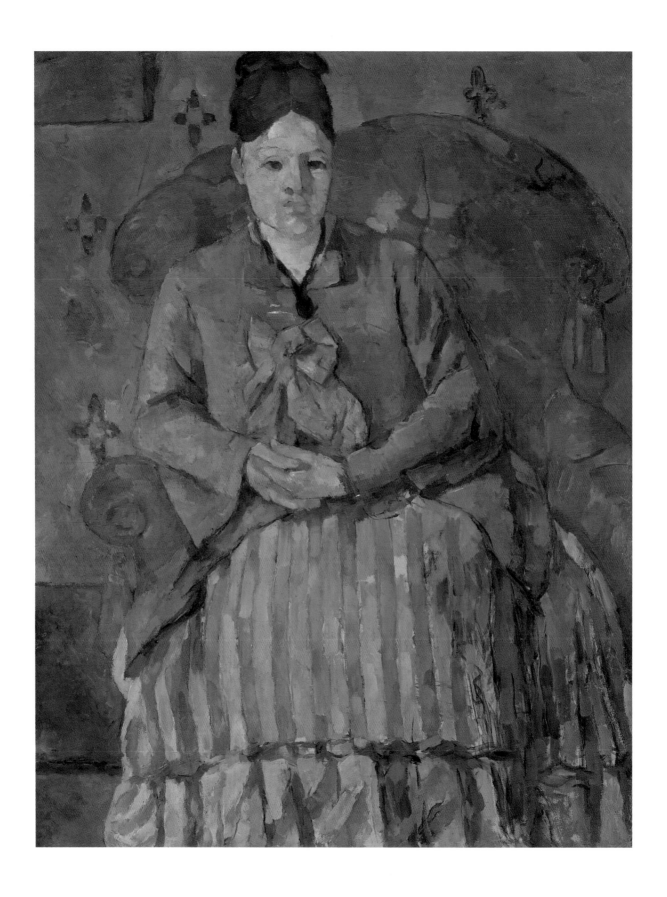

MANET AND THE POST-IMPRESSIONISTS

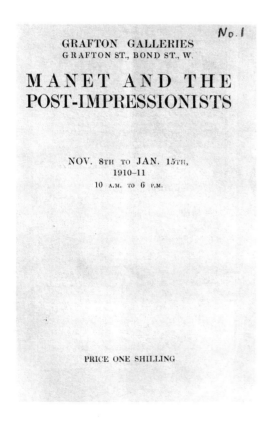

FIG. 4 Catalogue of the *Manet and the Post-Impressionists* exhibition

LEFT FIG. 3 Paul Cézanne, *Mme Cézanne in a striped skirt*, 1877, Museum of Fine Arts, Boston

IT started with what the journalist and critic Desmond MacCarthy called "the Art Quake of 1910".[1] The directors of the Grafton Galleries, in Grafton Street off Bond Street, in the heart of the most prestigious gallery district in London, discovered that they had a gap in their programme. Roger Fry convinced them they should have a show of modern foreign artists. At the time Roger Fry was best known in the art world as a connoisseur of Old Master paintings, and while attentive readers of the scholarly *Burlington Magazine* would have noticed that Fry was developing an interest in contemporary art, the directors of the Grafton Galleries would have had no reason to assume that the name of Roger Fry would become so closely associated with the advent of the modern art movement in England.

An exhibition that was both 'contemporary' and 'foreign' was bound to be seen as a challenge to conventional tastes and values, and indeed from the first Fry was determined that the exhibition should shock. He tested out the effect of the pictures on his friend Desmond MacCarthy, as MacCarthy related to his wife Molly: "At these interviews with dealers I used to pose as M. le Publique, and on one point my verdict was final: Was there, or was there not, anything in some nude which might create an outcry in London?"[2] He also told her: "I enjoyed choosing the pictures (which by the bye give you the most tremendous shocks). We got about 50."[3]

The private view, to which the press were invited, of the exhibition officially entitled *Manet and the Post-Impressionists* was held on Saturday, 5 November 1910. Following what Fry subsequently described as "a wild hurricane of newspaper abuse from all quarters",[4] it opened to the public three days later, on Tuesday 8 November. During the two months until its closure on 15 January 1911, it elicited an outraged response from among the 25,000 people who paid a shilling as an entrance fee (which included a catalogue with an introduction by MacCarthy), and a variety of reactions, from hostility and ridicule to whole-hearted enthusiasm, from the scores of critics who reviewed it in professional journals, magazines and newspapers.[5] Each social class, gender and generation responds differently to the cultural manifestations of their time. Fry's 'Retrospect' in *Vision and Design* discusses the reaction of the cultured classes to the exhibition,[6] who, he said, were more

vehement than any in their condemnation. He says that he was accused of anarchism. MacCarthy also noted that it was those who presided over what Vera Brittain would call an "unparallelled age of rich materialism and tranquil comfort",[7] and who aspired to high culture, social status and aristocratic values, who objected most to the exhibition.

The Duchess of Rutland, for example, an amateur artist whom Fry had asked to be on the Honorary Exhibition Committee, which numbered twenty-two, wrote to Desmond MacCarthy as Exhibition Secretary lamenting that she had allowed her name to appear on the Committee without seeing any of the pictures.[8] "I am so *horrified* at having my name associated with such an *awful* exhibition of horrors I am very very much upset by it", she wrote, begging him "to keep my name out of the next issue of catalogues", which it duly was.[9]

Elderly upholders of a moral code which elevated inhibition to the status of a virtue and contained the yearnings of Eros in the rituals of the Church Social and the Coming-Out Ball were frightened by some of the pictures which depicted the human body. Oliver Brown, later director of the Leicester Galleries, remembered entering the exhibition and being addressed by an old academician: "Don't go in, young man, it will do you harm. The pictures are evil."[10] MacCarthy claimed that he overheard remarks such as "pure pornography" and "admirably indecent" but he said that there was not a word of truth in this because he had been careful to exclude "physiological nudes" and "kept two pictures back at the last minute".[11]

For some the peculiar effect of these unfamiliar pictures may have threatened to undermine Victorian values. But at the same time a new younger generation of art lovers was cultivating its own preferences. They were not satisfied to ape the tastes of their elders, and indeed to an extent formed their preferences in opposition to them. Clive Bell, critic, husband to Vanessa and friend to Fry, said of the effect of the exhibition: "Rich collectors, directors and their trustees may well have been frightened … but the younger members of the art-loving public were for the most part wildly enthusiastic … already at the first and second Post-Impressionist exhibitions almost all the cheaper pictures found buyers."[12] Sales from the exhibition confirm this: £4600 worth of paintings were sold. When Van Gogh's sister-in-law, Johanna van Gogh Bonger or Gosschalk-

Bonger, as she was known at the time of the exhibition, wrote to say that she wished to buy a Redon picture, MacCarthy informed her that sadly it had been sold.[13] Unfortunately the Gauguins, the Van Goghs and the Cézannes – or so Bell claimed – were far too expensive for the ordinary pocket.

Despite the deep division of opinion over the show, no overtly political connections were made: "There were no explicit statements from either side that linked the Post-Impressionists with any perceived social turbulence".[14] Nevertheless, the strength of popular and critical response does indicate that, without ever remotely gaining a revolutionary edge, the exhibition at the Grafton Galleries became both a radical cultural arena and a free marketplace – an institutionalized space and time of apparent freedom from the insidious forms of Victorian convention and control where dramatic and compelling artefacts of modernity, perceived by some as indicators of both aesthetic and social change, were exhibited in great numbers and variety before an English audience.

Certainly the extent of official blindness and hostility cannot be underestimated. Conservatives such as the critic of *The Times*, C.J. Weld-Blundell, denounced the exhibition as "degenerate", "like anarchism in politics … the rejection of all that civilisation has done".[15] It was in this climate that the critic Hugh Blaker, who advised the Davies sisters on their renowned collection of Impressionist paintings now in the National Museum of Wales, made a passionate plea to the National Gallery, in one of several letters he wrote to the press, to consider pictures from the exhibition for its collection: "We, who form our ideas from a study of the past, and to whom these modern masters have long been familiar, earnestly hope that their semi-official welcome will result in the purchase for the National Gallery of at least, examples of Manet and Cézanne. Dare we also hope for one of the beautiful pastorals of Gauguin? Flandrin, Denis and Van Gogh will not percolate into official craniums until about the year 2000 when the help of the National Art Collections Fund may be invoked to prevent the few remaining examples from leaving the country."[16] Blaker's plea fell on deaf ears.

THE EXHIBITS

The list of artists that were represented in *Manet and the Post-Impressionists* makes wondrous reading: Cézanne, Cross, Denis, Derain, Flandrin, Friesz, Gauguin, Girieud, Herbin, Laprade, Maillol, Manet, Manguin, Marquet, Picasso, Puy, Redon, Rouault, Seurat, Signac, Van Gogh, Vallotton, Valtat and Vlaminck. Previously, little has been known about the more than two hundred and fifty individual works that were shown. Now that most of them have been identified (see Appendix), it is clear that some very well known works of art, indeed some of the great icons of modernism, were on show and available for sale in London in 1910.

Fry had a little over two months to select *Manet and the Post-Impressionists*. Desmond MacCarthy, a member of the Apostles, the élite Cambridge group to which many of the male members of Fry's circle had belonged, agreed to act as secretary and they set off for Paris. In early September 1910, they made the rounds of the dealers' galleries accompanied by Robert Dell, the Paris correspondent of *The Burlington Magazine* who ran the Barbazanges Gallery in Paris in association with its owner, Percy Moore Turner. In October Fry returned to Paris where he met Lady Ottoline Morrell, a member of the Executive Committee which included Fry, Lionel Cust, C.J. Holmes, Lord Henry Bentinck, R. Meyer Riefstahl and Robert Dell. Earlier in 1910 Dell had organized *Modern French Art* for the Brighton Art Gallery, an exhibition which in some ways set a precedent for Fry's show. Dell had complained about the difficulty of getting collectors to lend work, and he may have persuaded Fry to try the Paris dealers. These included the prestigious Bernheim-Jeune and Durand-Ruel galleries, which formed a consortium with the German dealer Paul Cassirer to lend the Manet pictures which they had recently acquired from the Auguste Pellerin collection. The Bernheim-Jeune gallery also lent pictures by Seurat, Signac, Cross and others from their stock. The Druet Gallery and Ambroise Vollard, who had been the first to support Cézanne, and who Fry already knew, were also generous lenders. Clovis Sagot, who had been one of the first dealers in Paris to support Picasso, and Daniel Kahnweiler, who was making a meteoric rise to fame as the dealer of Cubism, also lent pictures.

Without the support of the celebrated American expatriates Leo and Gertrude Stein, who had purchased an impressive collection which included Cézanne, Matisse and a formidable number of works by Picasso, it is unlikely that Fry would have gone to Sagot and Kahnweiler. Fry first met the Steins, and their brother Michael and his wife Sarah, who had a collection of Matisse that was unequalled in Paris, in 1908. Both Stein collections were open to interested parties from 1908. In fact, Leo Stein lent two works to Fry's show, a Matisse and a Picasso.

Other private collectors who supported the show included Gustav Fayet, who had an important collection of Gauguin; the Frenchman Alphonse Kann, a rather obscure dealer who had a collection of modern art, who in the 1930s fled to England; and Mrs Emily Chadbourne, the wife of a Chicago industrialist who had been sculpted by Epstein, who took Ottoline Morrell to meet Picasso and Matisse.

After Paris, MacCarthy went on alone to Munich where he met the German historian and critic R. Meyer Riefstahl, who was anxious "to meet the wishes of the directors of the G[rafton] G[alleries]" and who facilitated more loans. In November 1910, *The Burlington Magazine* published a long article by Meyer Riefstahl on Van Gogh.[17] It was probably Meyer Riefstahl who persuaded Paul von Mendelssohn-Batholdy, the Berlin collector, to lend Van Gogh's *The sunflowers*, and Hugo von Tschudi, Director of the Munich Neue Staatsgalerie, who had a private collection of Van Gogh pictures, to lend three of the uncatalogued pictures, *Rain effect* [fig. 10], *Self-portrait* (Cambridge MA, Fogg Art Museum) and *The roadmenders*. But the majority of the Van Gogh exhibits were lent by Johanna van Gogh Bonger. In his capacity as manager of the Bernheim-Jeune gallery the critic Félix Fénéon, who had supported Seurat and the Neo-Impressionists, persuaded her to lend. A letter to her from Fénéon casts interesting light on Fry's plans. It was to be "une exposition de 200 tableaux dont 120 par van Gogh, Cézanne, Renoir [crossed out, probably written in error], Seurat et Gauguin. Ces quatre maîtres constituent donc la partie essentielle de l'exposition." Fénéon asked Mrs Van Gogh Bonger to consider lending a dozen works by Van Gogh. The exhibition, Fénéon told her, was "la plus importante qui ait jamais été faite en Angleterre dans cet ordre d'idée".[18] Johanna van Gogh Bonger had been lending Van Gogh pictures to German exhibitions for some time but *Manet and the Post-Impressionists* was her

Roger Fry, *The Black Sea coast*, 1911, cat. 44

first British venture.

Cézanne, Gauguin and Van Gogh were the best represented and their work received most critical attention. These three artists, all of them deceased by the time of the exhibition, had not shown together in group exhibitions within their lifetimes, as the Impressionists had done. *Manet and the Post-Impressionists* created a posthumous group identity for them, and cemented their reputations as the giants of Post-Impressionism. Fénéon's letter suggests that Fry originally planned that Seurat, too, should be well represented as one of the four Post-Impressionist masters. But in the end Seurat was not well represented, a fact that Fry subsequently

regretted, and his work was hardly noticed in the press. The exhibition also canonized the term 'Post-Impressionism', the name that Fry casually chose when thinking up what to call it.

Given the central contributions of Cézanne, Gauguin and Van Gogh, why was Manet accorded such prominence in the title of the exhibition? A simple answer would be that Fry was persuaded to take Manet pictures by Bernheim-Jeune, who had shown the Pellerin Manet collection earlier in 1910. But it should also be remembered that before 1910 Manet was regarded in England as the quintessential French modern artist – an elegant, well connected figure who eschewed the

FIG. 5 Paul Cézanne, *The Bay of L'Estaque*, 1879-83, Philadelphia Museum of Art

mythical and classical subjects so beloved of the offi-cial art of his day in favour of figures and motifs from the new age – railway stations, crowded cafés, the bar at the Folies-Bergère. His name could be deployed in the exhibition's title as a signifier to an English audi-ence of the 'modern' project which turned its eyes upon the present, prepared to depict all manner of figures and objects without reticence or priority, even though some subjects might be deemed 'ugly' or degrading by clas-sically trained 'Art for Art's Sake' critics.

Fry's earliest exposure to such a representation of Manet's pivotal rôle was within the New English Art

Club circle in which he moved in the early 1890s. Though their ideas undoubtedly had a formative effect, the process is not well documented. The New English circle included the artist Sickert and the critics George Moore and D.S. MacColl; they were enthusiastic admir-ers of some recent French art, and Manet was held in especially high regard by MacColl and by Moore, who had known him personally and who had been painted by him. In the art criticism he wrote for *The Speaker* in the 1890s, Moore eulogized Manet, according him a god-like status. At the same time, however, other aspects of late nineteenth-century French art were regarded with

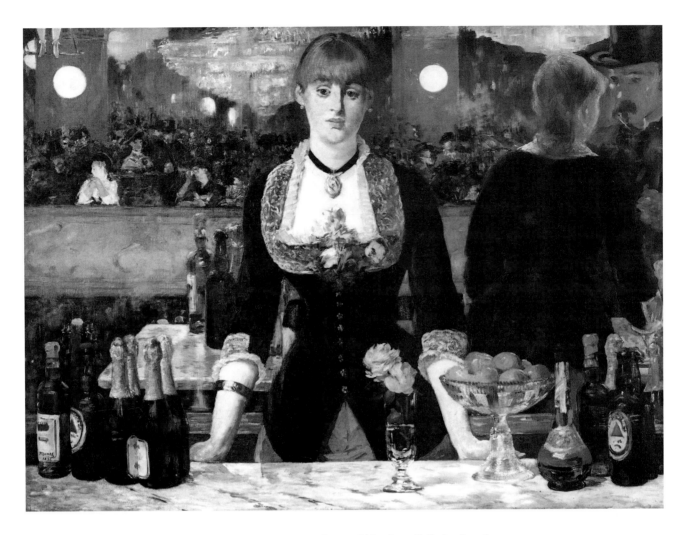

FIG. 6 Edouard Manet, *A bar at the Folies-Bergère*, 1881–82, Courtauld Institute Galleries, London

deep mistrust. Neither Moore nor MacColl liked Monet's late paintings, which they dismissed as the product of a dry, 'scientific' approach, as if they were tainted by naturalism and its claims to scientific objectivity in the depiction of social conditions. Such an approach lacked – to their minds – the crucial quality of instinctual, original creative endeavour. This charge was also was made about Seurat's Neo-Impressionist paintings. Fry broadly adhered to this position. He, too, tended to dismiss art about which he was ambivalent as being too scientific. (Moore's heated attack against Seurat in his book *Modern Painting* probably explains Fry's reluctance to represent Seurat or the other Neo-Impressionists, Cross and Signac, in *Manet and the Post-Impressionists*.)

The arrangement of the exhibits, however, shows that to some extent Fry used Manet as a whipping post against which striking comparisons could be made with other artists, especially Cézanne, who was less familiar to English audiences. In hanging the exhibition Fry "was entirely absorbed in deciding which picture would look best next to another".[19] The overall visual impact was described by May Morris in a letter to John Quinn: "The general effect in the exhibition rooms was far more striking and decorative than the effect of a collection of what one may call same pictures would be, with their silver tones, their blacks and greys, and general discretion and propriety".[20]

On entering the exhibition, the first pictures the visitor saw were a group of Manets and Cézannes. Manet's

FIG. 7 Paul Cézanne, *Still life with basket of apples*,
Art Institute, Chicago, as reproduced in C. Lewis Hind,
Post-Impressionism, London 1911

Bar at the Folies-Bergère [fig. 6] was in the first room of
the gallery, and close by were a Cézanne still life of a
bowl of fruit (probably *Still life with a basket of apples*,
Art Institute of Chicago [fig. 7]) and Cézanne's *Mme
Cézanne in a striped skirt* [fig. 3]. The fullest indication
of what Fry intended by this arrangement is contained
in a lecture which he gave at the time of the exhibition,
in which he asserted that Post-Impressionist artists did
not necessarily aim to give illusive likeness. To show this
he compared Manet's *Bar*, the still life by Cézanne and
Mme Cézanne in a striped skirt. Manet's picture, which
followed the rules of perspective, Fry said, was "mar-
vellous in the completeness and directness of its illusive
power" and although the Cézanne did not follow estab-
lished rules – as seen in the top of the dish of apples
which was "a parallelogram with rounded corners"
rather than an ellipse – it still had a more vivid sense of
reality. Fry also compared the face of the barmaid in
Manet's picture to that of Cézanne's wife, a compari-
son easily misconstrued by an untutored audience.[21]
"The ordinary visitor collapsed with laughter at the sight
of the Cézannes; one elderly man … went into such con-
vulsions of laughter on catching sight of Madame
Cézanne that his companion had to take him out and
walk him up and down in the fresh air."[22]

In Fry's mind Cézanne was superior to Manet. He
admitted that Manet was more realistic, but, he said,
the Cézanne portrait "arouses in my imagination the
idea of reality, of solidity, mass and resistance … which
is altogether wanting in Manet's picture".

The centrepiece of the Manet exhibits, the great *Bar
at the Folies-Bergère*, was the most magnificent picture
in a group which consisted of late portraits of some of
Manet's favourite models. *A bar at the Folies-Bergère*
must have been the most expensive picture in the exhi-
bition. It was reportedly insured for £10,000. By com-
parison, Cézanne's *Viaduct at L'Estaque* [cat. 20, repr.
p. 22] was bought by the Antell Ateneum, Helsinki, for
£800.

The critical response to the Manets serves as a
reminder that, beyond enlightened circles such as the
New English, the British art establishment was either
openly hostile or at best indifferent to French Impres-
sionist painting. Even as late as 1905 Frank Rutter had
failed to get the National Gallery to accept a painting
by Monet after raising the money for its purchase by
public subscription. There is little indication in the press
coverage of 1910 that *A bar at the Folies-Bergère* was des-
tined to remain in Britain, or that it was a modern mas-
terpiece which would become the object of endless
critical interpretation. Although many critics would have
remembered its recent appearance at the large Impres-
sionist exhibition organized by Durand-Ruel in London
in 1905, few bothered to mention it. Oscar Wilde's
friend Robert Ross complained about the very quality
that makes it compelling, saying that it belonged too
much to its own time and that it lacked universality:
"What a distressing possession, how unpleasing, how
'fashionable'".[23] The painter Spencer Gore suggested
that it appeared "'faked' in the studio by a virtuoso of
great skill".[24]

RESPONSE TO CÉZANNE

There were twenty-one Cézannes in the exhibition, rep-
resenting a wide range of his career. Fry remarked that
the opportunity to look at these pictures daily was an
instructive experience and that his respect for Cézanne,
whom he pronounced "the great genius of the whole
movement", increased during the course of the exhi-
bition. Fry's appointment of Cézanne as "father of
modern art" was hardly unique. But it did have a par-
ticular hold, as we shall see, on the British imagination.

Fry's discovery of Cézanne has acquired a legen-
dary significance, the facts of which are as follows. He

Paul Cézanne, *The viaduct at L'Estaque*, ca. 1883, cat. 20

apparently first noticed Cézanne when he saw two still-life paintings at the New Gallery in 1906. He sang his praises in an unsigned article for *The Burlington Magazine* in 1908, and he translated and published Maurice Denis's 'Cézanne' in *The Burlington Magazine* in 1910. Fry was by no means the only member of the London art world to know about Cézanne. George Moore first mentioned Cézanne in the 1880s, and caricatured his oddity in *Reminiscences of the Impressionist Painters* (1905). Both Walter Sickert and Philip Wilson Steer attended the large Cézanne retrospective at the

Salon d'Automne in 1907, where they both admired Cézanne's *The black clock* (private collection). All three placed Cézanne within the Impressionist movement. When Sickert reviewed *Manet and the Post-Impressionists* he pointed out correctly that the Impressionist landscapists including Cézanne "spoke one language". "Pissarro and Cézanne mutually influenced each other", he said, and "Gauguin learned from Pissarro, Cézanne and Degas."[25] Oddly, Sickert did not mention the one painting in the exhibition which made Gauguin's debt to Cézanne absolutely clear – *Portrait of a*

Roger Fry, *Quarry, Bo Peep Farm, Sussex*, 1918, cat. 50

woman, with still life by Cézanne (Chicago, Art Institute). The portrait of an unidentified woman (the picture was entitled *Portrait of Mme X* in *Manet and the Post-Impressionists* and *L'Arlesienne* in the press notices) pays specific homage to Cézanne. Behind the woman we see *Fruit bowl, glass and apples*, a still life by Cézanne which Gauguin owned and which he represented using brushwork that emulates Cézanne's technique. The pose of the model echoes one used in several portraits by Cézanne of his wife, a conceit that undoubtedly would have pleased Fry.

Fry developed a keen interest in Cézanne's legacy. But remarkably he set about constructing Cézanne as a modern artist who had no connections with Impressionism, stressing instead his close links with Old Mas-

ter painting, comparing for example Cézanne's *Mme Cézanne in a striped skirt* to Piero della Francesca and saying that his still life surpassed that of Chardin. Cézanne was "the great classic of our time". His approach has an interesting parallel with that of Leo Stein, who used the same method when he talked to visitors about Cézanne. Part of Fry's reasoning may have been strategic, to do with the negative response to French Impressionist painting in Britain. Fry would have known that there would have been no point in acknowledging Cézanne's links with Impressionism and that he would have to play a different card when representing Cézanne as a Post-Impressionist to a British audience in 1910.

Nevertheless the question remains, what exactly did

Fry 'see' in Cézanne? How did Fry process that particular aesthetic logic contained in a Cézanne landscape? What each person sees in a picture, and more particularly in a Cézanne landscape, is a complex and vexing issue. Clearly Fry 'saw' something quite different from what Sickert saw in Cézanne's *The Bay of L'Estaque* [fig. 5]. Both Sickert and Fry wrote in eulogistic tones about this picture. It is a view of the sunlit bay and picturesque rocky coastline at L'Estaque on the Mediterranean coast just to the west of Marseilles. Cézanne had chosen a viewpoint, Sickert said, which emphasized the structure of the rocky coastline and the curving line of the bay, "compelling us to accept the time and the rhythm he chooses to impose". He also pointed out that Cézanne had created a shimmering atmospheric effect "which was a marvel of tones in mother of pearl". Sickert understood that it was the "delicate but abrupt transitions" of colour, the blues and greens played against warm reds and ochres, that created the atmospheric effects in *The Bay of L'Estaque*.[26] In other words, it was a 'colourist style' which originated in the theory and practice of Impressionist landscape painting.

In Fry's mind the "shimmering atmosphere" – as he described it – was not soft but hard "as though it were cut in some incredibly precious crystalline substance, each of its facets different, yet each dependent on the rest".[27] This is the essential difference of perception.

It is to Fry's credit that he recognized that to refer to Cézanne's visual effects required a new critical vocabulary, but why insist on 'geometric hardness'? Fry undoubtedly was thinking of a remark that Emile Bernard attributed to Cézanne, "Everything in nature models itself on the cone, the cylinder and the sphere". There is good evidence that Fry repeated this 'wisdom', and used it as a basis for his own painting (cf. cat 50). Certainly a number of British critics called on it by way of explanation. It has been long-lived, in spite of its inaccuracy. But the hardness that Fry said he saw also gave Cézanne's paintings an authority that was prerequisite for pictures by an artist who Fry was determined should be acknowledged as the father of modern art. Fry was keen to break with the past and his earlier exposure to the Impressionist painting he regarded as 'soft'.

Fry's view of Cézanne was exceptional and his rôle as Cézanne's advocate in Britain should not be underestimated. His study of the "great genius" stretched and enhanced his critical vocabulary as is evident in his description of *The viaduct at L'Estaque* which he and the Finnish art historian Tancred Borenius, who was in London at the time of the exhibition, advised the Antell Ateneum to purchase from the exhibition. In contrast to the idyllic viewpoint in *The Bay of L'Estaque*, *The viaduct at L'Estaque* depicts a modern aspect of the Provençal landscape – the railway track which connected Paris and Marseilles. As Fry pointed out, "the short strip of road crossing a small gully and turning the edge of a hill by some houses" was "without any picturesque interest ..." but "this was the material out of which Cézanne's magic art distils for us this strange and haunting vision. The composition, apparently accidental and unarranged, is in reality the closest, most vividly apprehended unity." To the attentive observer "new relations, unsuspected harmonies continually reveal themselves", both in "the subtle, pure, crystalline colour" and the "linear construction of the pattern". Cézanne, Fry concluded, "has produced many landscapes of more striking and obvious beauty than this but few which reveal more truly the intensity and the spontaneity of his imaginative reaction to nature".[28]

In comparison to Roger Fry, there is a noticeable and revealing failure of language in the other critics' descriptions of Cézanne. This applies whether or not they admired the pictures. The normally eloquent A.J. Finberg, the Turner scholar, was reduced to describing *The Bay of L'Estaque* as a picture of "rocks and water", which is hardly edifying.[29] *The Daily Telegraph* critic, who was probably Claude Phillips, admired the picture but resorted to nineteenth-century, picturesque landscape terminology when he described it as "the silvery transcript of a fair, quiet page of Nature".[30] Nowhere is D.H. Lawrence's assertion that the "English delight in landscape is a delight in escape" better evidenced than in such flowery, otherworldly outpourings. As we shall see, a Neo-Romantic critical vocabulary is ill suited to responding to the landscapes of Van Gogh and Cézanne, which "make a more violent assault on the emotions", and which, as Lawrence suggested, may have repelled some people for that reason.[31]

Of the portraits, *The old woman with a rosary* (London, National Gallery) was the only Cézanne that was illustrated in the press, but the critics were virtually silent about it. Several critics commented on *Portrait d'homme à cravate blue* (*sic*), which was probably the early portrait *Uncle Dominic the lawyer* (Paris, Musée d' Orsay).[32]

Paul Cézanne, *The large bathers*, lithograph, 1897–98, cat. 22

Much of the debate about Post-Impressionism took place in letters to the press. The most vehement letters were published in *The Morning Post*, which, according to MacCarthy, suppressed the more supportive letters. Fry allowed most of these letters to pass over in silence, but on a few occasions he was prompted to reply. One Henry Holiday wrote to *The Nation* and complained that *The bathers* (Geneva, Jean Prevost Foundation; see cat. 22, repr. this page) by Cézanne "were as nearly as form-less as possible – feeble and flabby, painted with patchy colour, expressing nothing. The man on the right has a black eye and a great blobby nose, suggesting that he has just come out second-best at a prize fight … I have some-times seen bathers, but not being a Post-Impressionist, I failed to see thick, black lines around their limbs."[33] Fry

rose to Cézanne's defence: "He forgets that Art uses the representation of nature as a means to expression, but that representation is not its end, and cannot be made a canon of criticism." He also replied to Charles Holmes's claim in *Notes on the Post-Impressionists* (1910) that the male figures of the bathers were "clumsy". "I see no evi-dence of clumsiness," wrote Fry, "given the particular feeling for form which is personal to him … the quality of his pigment seems to me singularly beautiful."[34]

Finally Hugh Blaker took Fry's view and in a fami-liar critical manœuvre attempted to outflank the carpers by emphasizing the classicism of *The bathers* in a letter to the *The Saturday Review*: "Those bathers of Cézanne! You can trace their genesis through the centuries to El Greco – almost to Masaccio."[35]

Maurice Denis, *Ulysses and Calypso*, 1905, cat. 26

THE RÔLE OF MAURICE DENIS

It was this aspect of tradition in a modern context that Fry valued the most in the work of Maurice Denis. Denis had been a member of the Nabis, who dominated the Paris art world in the 1890s. Some of the original group, whose first allegiance had been to Gauguin, were included in *Manet and the Post-Impressionists*. After 1900 Denis played a central rôle in the development of the new classicism, disseminating its ideas in his writings and his work. Denis's influential article 'Cézanne', stressing Cézanne's classicism, which Fry translated and published in *The Burlington Magazine*, was one of a number of articles Denis published in *L'Occident* during the 1900s on Post-Impressionism (though not yet so called).[36] These articles in *L'Occident*, which Denis described as "a review which has placed arts and letters

once again in the atmosphere of a tradition" were highly influential.[37]

Fry had defended Denis in the *Burlington* in 1908, when he admitted that he had been keeping his eye on Denis's work for the past five years, an interest which reflects the high regard with which his work was received in the Paris exhibitions.[38] Fry reviewed the Salon d'Automne in 1910, singling out Maillol, a central figure in the new classicism, and comparing Matisse's *Dance* and *Music*, the two great murals commissioned by Schukine, with Denis's *Florentine evening*, a group of eight mural paintings commissioned by Charles Stern for his Paris residence.[39] The two mural schemes were the talking point of the exhibition, as Apollinaire observed: "Crowds gathered in front of Maurice Denis's mural decorations … the paintings of

Vanessa Bell, *The bathers, Studland Beach*, 1911, cat. 3

Matisse created a scandal, as ever."[40] Fry found fault with both schemes. He complained about the "extremely crude chord" of the "bright red ... full green ... and heavy opaque blue" in the Matisse murals and the lack of virility in the Denis, which "seems to have compromised a little too much with the demand for eighteenth-century elegance". They lacked the usual "vividness" of Denis's work which was its appeal.[41] But Fry had no such reservations about Denis's *Ulysses and Calypso* [cat. 26, repr. p. 26], which he and Tancred Borenius advised the Antell Ateneum to buy. It was "among the best recent creations of this sympathetic and scholarly artist". Denis was "the most learned of modern artists". *Ulysses and Calypso* reflected the temper of the "great classic tradition of France" which "no movement in France, however revolutionary ... ever loses sight of for long".[42]

Calypso was a nymph and daughter of Atlas who lived on the remote island of Ogygia, where she kept Ulysses for seven years until she was ordered by Jupiter to send him home to Ithaca. The mythical reference, the languorous, rhythmically arranged bathing figures who commune with nature in an idyllic setting by the sea, and the mood of ease and serenity in *Ulysses and Calypso* is characteristic of a group of pictures which depict mythical themes in an Arcadian setting that Denis executed in the 1900s, including *The shepherds* (Moscow, Pushkin Museum) and *Orpheus*, which were also exhibited in *Manet and the Post-Impressionists*.

THE CRITICISM OF GAUGUIN

There were some complaints that Gauguin, who had the largest number of works in the exhibition, was over-represented. Others thought that all the Gauguins should have been hung together, instead of being used to "salt the exhibition". In fact there were two concentrated groups of pictures. One group of mostly Tahitian pictures hung in the Large Gallery. *Manao tupapau* or *Spirit of the dead watching* [fig. 15] hung in the centre of the wall devoted to Gauguin. The others included *Portrait of a woman with still life by Cézanne*, *Marquesan man in a red cape*, *The sister of Charity*, *Tahitian women bathing* [cat. 59, repr. p. 31], *Parau na te varua ino* or *Words of the devil*, *Women at the seaside* and *Reverie*. Other pictures by Gauguin including *The black pigs* [cat. 57, repr. p. 34] and *Adam and Eve* also hung in this room. The second group, which consisted of

paintings done in Brittany, including the controversial *Christ in the Garden of Olives*, and some early paintings that showed the influence of Pissarro, as Sickert and others pointed out, hung in the Centre Gallery. Smaller groups including *Joseph and Potiphar's Wife*, a favourite with the more conservative critics, *Three Tahitians* [cat. 60, repr. p. 30] and *Tahitian fishermen* hung in other parts of the exhibition and there were a large number of drawings and watercolours in the drawing section.

The critical responses to Gauguin were dominated by references to his life history, and his alleged rejection of western values in favour of a primitive and wild existence among the natives of the tropical South Sea island of Tahiti. Such references often became overheated and conflated with romantic notions of instinctual artistic genius.

The critics positioned Gauguin within a founding modernist triumvirate which included Van Gogh and Cézanne. "Some of these extremists, by their very extravagances, would have killed the movement; but in the background were the pioneers, dead yet speaking, very serious, very insistent – the austere reserved Cézanne; that fiery furnace, Van Gogh, burning with a passion for self-expression, who painted some of his finest pictures when he was an inmate of the madhouse at Arles, and who died by his own hand, unable to endure longer the agony of his life; and Gauguin, the 'great barbarian', who fled from Europe and civilization, painted the walls of mudhuts in Tahiti, and died on one of the islands."[43]

In the vivid iconography of modern art as constructed by the press, Van Gogh and Gauguin were depicted as the elemental forces that drove the movement – the fiery spirit of revolt.

These popular constructions of the notion of "artistic genius" caught hold of the British imagination in 1910, and the lives of the artists quickly acquired a significance which was deemed as potent and as worthy of study as their art. Gauguin left Paris to live in Tahiti in 1891, returned to Paris in 1893 and left Europe for good in 1895, living in Tahiti until 1901 when he moved to the remote island of Hivaoa in the Marquesas, where he died in 1903. Gauguin's tale of his adventures in Tahiti, *Noa Noa*, which was published in book form in 1901, the mythologizing by his critics of his quest for the primitive, and the romantic picture of Gauguin that Meier-Graefe painted in *Modern Art* (1908), all ensured

that there was widespread familiarity with the tale of his odyssey from Paris to a more 'primitive' life. British critics used his biography to explain his art and speculated about life in the tropics.

For example, Haldane MacFall wrote: "He tried to forget all he had learnt … of civilization … and deliberately chose to go back to savage utterance in order to give forth the primal emotions and sense of a barbaric people …. Gauguin's primitivism is one of the purest of arts in its intention and craftsmanship, for it sought to utter the life of a savage people. It is to Gauguin's immortal fame that, as European turned savage, he revealed to Europe the savage genius." Indeed, it was widely accepted that Gauguin had "gone native".[44] Only Fry, who admitted he found Gauguin difficult, saying that one needed to make concessions and excuses when looking at his art, questioned the validity of the myth of Gauguin the savage primitive, and said that it was impossible to "forget that he was a Parisian".[45]

In his supposed quest for exotic experience in a far-flung land, Gauguin was a figure of envy to many. But life in straw huts did not quite have the pleasurable associations it acquired later in the century. *The black pigs* [cat. 57, repr. p. 34] encapsulated the fantasy of the simple, primitive, fecund life of the savage that the British middle classes, with their preference for perfectly thatched country cottages, imagined Gauguin had led. "Whether he went to a South Sea island in order to become a real primitive, he certainly succeeded."[46] The complex visual borrowings in *The black pigs* were not lost on Robert Ross, who compared the silhouette forms of the pigs to naturalistic fresco paintings in ancient Egyptian tombs. But the view of straw-covered huts and palm trees under a clear blue sky with "jolly little black pigs" left him uneasy. Ross was left comparing Gauguin's depiction of life in Tahiti to an exhibit at the 1908 Franco-British Exhibition in London where Londoners could view a tableau depicting Africans living in straw huts.[47]

In the critical discussion of these pictures, bizarre images of the primitive life abound. Indeed the word 'primitive' abounds. But the term is used to evoke. It is never clearly defined. 'Primitive' aspects of Gauguin's life and the 'primitive' style he evolved in response to 'primitive' subjects are interchangeable. Gauguin was a "brooding barbarian" who painted "terrifying studies of nude Malays" in a "sinister, exotic and bizarre"

manner and who had "a gift for strange and sullen colour" and "simplified form" that has "hints of primitive grandeur".[48]

Sometimes what might be termed a racial imagination, never far from the surface in much of the writing of the period, 'takes over' the reviewer. In the racial imagination non-white, non-European peoples are depicted as dark, unknowable bodies, their culture a repository of unnameable horrors.[49] For example, *Two Tahitian women* (New York, Metropolitan Museum of Art) was used as an example by the *The Graphic*, which labelled it *Girls of Tahiti* to show that "strong savage pigment" was necessary when depicting these "natives of Tahiti" and that Gauguin got "inside their skins, and … rendered in terms of paint their expression, their feeling, even their superstition".[50] Such lurid accounts aimed both to repel and to titillate. Consider the effect on the genteel, lower middle-class reader of *The Daily Express* – whose aspirations to interact with nature were in the main confined to tea on a manicured lawn amid herbaceous borders – of the picture described as "hideous brown women, with purple hair and vitriolic faces" who "squat in the midst of a nightmare landscape of drunken palm trees, crude green grass, vermilion rocks and numerous glaring coloured excrescences" (probably *Tahitian fisherwomen*).[51]

Even those who thought that Gauguin's method of picture-making was visually pleasing recoiled before his depiction of Tahitian women. For example, Wilfred Scawen Blunt's response to *Women at the seaside* (private collection) was ambivalent: "There is one picture signed Gauguin which at a distance had a pleasing effect of colour. Examined closer I found it to represent three figures of brown people … one of them a woman suckling a child, all repulsively ugly, but of good general dark colouring."[52]

This is not to suggest that the critics disliked these subjects. On the contrary, a large number of them actively admired Gauguin's pictures – including Rutter, Sickert, Konody and MacCarthy. As Spencer Gore reported, Gauguin's work was the least disliked in the exhibition. They particularly liked the magnificent display of Tahitian pictures that hung on the right side of the Large Gallery, admired their sombre and rich colour, their expressive line and general decorative effect. The magnificent figure of the monumental bather, the dramatic effect of the decorative patterning

ABOVE Paul Gauguin, *Three Tahitians*, 1899, cat. 60

RIGHT Paul Gauguin, *Tahitian women bathing*, 1892, cat. 59

of the *pareus* (the sarong-like dress worn by Tahitian women) and the swirling water, and the vivid contrast of brilliant green, red and yellow against black and white in *Tahitian women bathing* [cat. 59, repr. p. 31] made it a particular favourite. The massive physicality of the bathers had specific associations with primitivism. "See how he rejoices in ... large robustness in his big massive *Bathers* [as it was entitled in the exhibition], in the rich volumes of life, in their brilliant skin and black, soft curling hair, with the dim blue reflections." Rutter asked, "Do you admire old stained glass and can you find in this painting no beauty of colour? Are you an admirer of Japanese colour prints, and can you find in this painting no beauty of design? Above all if you are a purist, detesting redundancy and hyperbole in literature and oratory, can you not see in the very conception and execution of this work a striving for simplicity that is the very essence of the highest art?"[53] MacCarthy also defended its stunning visual effect: "It has the barbaric quality which, as Baudelaire pointed out, is often visible at a completed stage of art, whether Egyptian or Assyrian."[54]

The luscious yellow, violet and green undulating patterning, the rhythmic arrangement of the group of figures and the delicately modelled features of the women's faces make *Three Tahitians* [cat. 60, repr. p. 30] a startling image. In a reinterpretation of the *Three Graces* a man stands with his back turned between two women who hold fruit and flowers. The picture may reflect Gauguin's known interest in androgynous and homosexual males who were openly tolerated in Tahitian society. It has a classical aspect which reflects the European ideal. These figures are closer to the European stereotype of 'unspoiled barbarians' and 'noble savages' who share the close physicality and lack of sexual inhibition which the idea of a return to nature epitomizes. Hence *The Literary Digest*, which reproduced the picture with the caption "Are we ready for 'A Tahitian School'?", joked that its critic was "ready to return to nature".[55] Others agreed it was a compelling image, including the novelist Arnold Bennett who obtained a photograph of it from the exhibition which, he said, he regarded "with acute pleasure every morning".[56]

One of the most controversial and best liked pictures by Gauguin was *Manao tupapau* or *The spirit of the dead watching* [fig. 15, p. 54], which British commentators knew as *L'Esprit veille*. According to Gauguin, who

explained its meaning many times in letters and in *Noa Noa*, the painting was based on his memory of a real event. Coming home one evening, he found his young Tahitian girl companion Tehura lying in terror imagining she saw "one of those legendary demons or spectres, the Tupapaus, that filled the sleepless nights of her people". Some details of this literary 'tale' were known to Fry, who noted "its sympathy with primitive instincts of supernatural fear",[57] and to Desmond MacCarthy, who pointed out the "savage's constant fear of the other world".[58] The image of a young naked girl "lying full length upon her 'little Mary'", as one critic crudely put it, whose vulnerability was compared to a "gammage golliwog", gave them enough to think about without knowing Gauguin's account in *Noa Noa*. Moreover, there were many who admired its pictorial qualities, as MacCarthy explained: "It is a composition of horizontal and undulating lines, of harmonies of orange and blues, united by derivative violets and yellows, a superb piece of decorative painting."[59]

Sickert, who recorded in his review that he had advised Gauguin not to take up painting as a career when they met in Dieppe in 1885, was full of admiration for the "strange grandeur [that] has crept into Gauguin's figures". Referring to *The Sister of Charity* (San Antonio, Texas, (McNay Art Museum), which depicts a Catholic nun seated on a small European chair surrounded by Marquesan natives, he instructed his readers to "look at the pose of the figure holding a dish behind the little nun". But he reserved his highest praise for *Manao tupapau*. "Has paint ever expressed perfect form more surely and with more fullness?" It would be a crime, Sickert said, if *Manao tupapau* (and also Gauguin's *Les Laveuses*) were not acquired for the nation. "Here is National Gallery quality at its highest level."[60]

Unfortunately the National Gallery did not take Sickert's advice. However, *Manao tupapau* was one of five Gauguin pictures Michael Sadler bought in September 1911. They were the centrepiece of *Cézanne and Gauguin*, an exhibition at the Stafford Gallery in 1911 (see p. 52).

FIG. 8. *The Illustrated London News*, 26 November 1910, p. 824

BY MEN WHO THINK THE IMPRESSIONISTS TOO NATURALISTIC:

THE MANET AND THE POST-IMPRESSIONISTS EXHIBITION, AT THE GRAFTON GALLERIES.

1. "JEUNE FILLE AU BLEUET," BY VINCENT VAN GOGH. (1853 - 1890)

2. "MADONE AU JARDIN FLEURI," BY MAURICE DENIS.

3. "LA BERCEUSE," BY VINCENT VAN GOGH.

4. "ORPHÉE," BY MAURICE DENIS.

5. "VUE SUR LA MARTINIQUE," BY PAUL GAUGUIN.

6. "LA FEMME AUX YEUX VERTS," BY HENRI MATISSE.

7. "L'APPEL," BY PAUL GAUGUIN.

It is no exaggeration to say that the exhibition of pictures by Manet and the Post-Impressionists is drawing all fashionable London to the Grafton Galleries: not only the Society that is artistic, but that which is merely curious. As is pointed out in the catalogue: "The movement in art represented in this exhibition is widely spread. Although, with the exception of the Dutchman Van Gogh, all the artists exhibited are Frenchmen, the school has ceased to be specifically a French one. It has found disciples in Germany, Belgium, Russia, Holland, Sweden. There are Americans, Englishmen, and Scots in Paris who are working and experimenting along the same lines; but the works of the Post-Impressionists are hardly known in England, although so much discussed upon the Continent."—[PHOTOGRAPHS BY DRUET.]

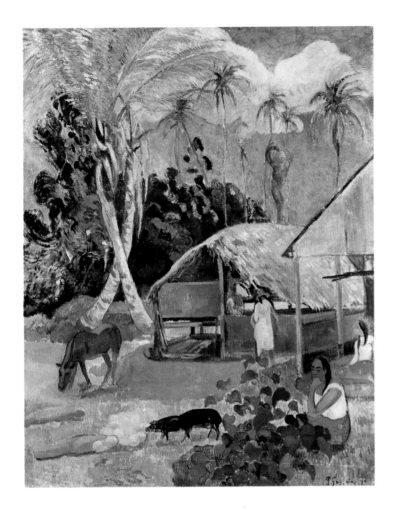

Paul Gauguin, *The black pigs*, 1891, cat. 57

Paul Gauguin, *Tahitians, ca.* 1891, cat. 58

VAN GOGH

"There is a postman [by Van Gogh] which I expect will send people to the turnstile clamouring for their money back. He is so wonderfully hideous, alive, and has so disconcerting a face put suddenly three inches from one's own."[61] "The longer I live with these pictures the more certain I become that van Gogh is the great man of the movement. I admire him so much. He moves me. He gives me faith in the beauty I want most to realize in the world & in human beings."[62] Desmond Mac-Carthy's changing sentiments about the memorable display of over twenty-four paintings and drawings by Van Gogh in *Manet and the Post-Impressionists* are evidence that great pictures do change our perception of the world.

This was the first time that a large group of works by Van Gogh was shown in Britain. Two of the pictures by Van Gogh which recently reached record prices, *Sunflowers*, which sold for $36.3 million in 1987, and *Dr Gachet*, which sold for twice that amount in 1990, were exhibited in London in 1910. Indeed some of Van Gogh's best known works, including *The Postman Roulin* and *La Berceuse*, were displayed and offered for sale. The only work by Van Gogh known to have sold, however, was *Les Usines* (Cleveland Museum of Art), which Fry described as "the soul of modern industrialism seen in the hard splendour of the mid-day sun upon the devouring monsters of a manufacturing suburb".[63] It was bought by Gustav Robinow, a resident of Richmond Hill, Surrey.[64] British audiences saw *Crows over the wheatfield* [fig. 1], soon to be a very famous painting, the *Resurrection of Lazarus* (Amsterdam, Van Gogh Museum), *The Pietà* [cat. 79, repr. p. 39], the beautiful *Irises* [fig. 11], a favourite painting of the British critics, two *Sunflowers* and a large number of landscapes including three or four uncatalogued ones. A month after the exhibition opened, Mrs Van Gogh Bonger sent four drawings and *Self-portrait in front of an easel* [fig. 9]. *Manet and the Post-Impressionists* was the only significant showing of Van Gogh in Britain until the Leicester Galleries' Van Gogh exhibition in 1923. In contrast to Britain, between 1901 and 1914 there were thirty exhibitions of works by Van Gogh in Germany, where he acquired an enthusiastic following.[65] Indeed, this provoked a xenophobic reaction from Konody: "It is not likely that English collectors will follow the lead of Germany and rush blindly

into filling their houses with pictures that are highly interesting on the walls of an exhibition, and that may even contain a hint of the direction the normal evolution of art may take in the near future". He added, "Germany is welcome to them".[66]

The hanging of the exhibition made no reference to the artistic and biographical links between Van Gogh and Gauguin which would later dominate Post-Impressionist scholarship. The Van Gogh pictures were grouped in the apse of the Large Gallery. Works by Cézanne and the Neo-Impressionists Seurat, Signac and Cross hung on an adjacent wall. At least one critic saw a stylistic connection between Van Gogh's expressive, calligraphic technique and the broadly handled, mosaic-like strokes that typified the later work of Signac and Cross, while another suggested that Van Gogh's *View of Arles with irises in the foreground* (Amsterdam, Van Gogh Museum) "best exhibits the adherence to the architectural principles of Cézanne".[67]

Manet and the Post-Impressionists was the first occasion when Van Gogh was written about extensively in the English language.[68] The earliest writings about Van Gogh laid the foundation for the myth that had taken firm shape by 1910, and which had an enormous influence on British critics. They had heard about Van Gogh's supposed madness, the time he spent in an asylum (amongst the uncatalogued works in the exhibition was one which depicted "the oblong of the asylum among the pine trees", possibly *Pine trees in the asylum garden* [private collection]) and his suicide, and some even knew about the ear incident. In Hind's mind, Van Gogh's instability had made him a martyr to his art – "burning with a passion for self-expression, who painted some of his finest pictures when he was an inmate of the madhouse at Arles, and who died by his own hand, unable to endure longer the agony of his life".[69] Their version of these events which was composed of garbled accounts, wild speculation and their unashamed prejudice about madness added to the previously established myth of Van Gogh and coloured his reputation for a long time to come.[70]

It is now known that Van Gogh suffered from a form of epilepsy, but British critics for the most part sensationalized his illness and described him as a raving lunatic. As Rutter said, "The vultures of criticism have seized on van Gogh's intervals of insanity and used them as a pretext for dismissing his art as the raving of

FIG. 9 Vincent van Gogh, *Self-portrait in front of an easel*, 1888, Van Gogh Museum (Vincent van Gogh Foundation), Amsterdam

a madman".[71] In an attempt to quell their spurious speculations, Johanna van Gogh Bonger wrote to Mac-Carthy explaining the nature of Van Gogh's illness, and MacCarthy read the passage from her letter at a lecture. He later commiserated with her: "It is lamentable the way in which all the lesser critics harp upon van Gogh's illness. It is just the vulgar love of sensationalism."[72]

Fry also refused to accept the commonly held view that Van Gogh's alleged mental instability had influenced his art. In answer to Michael Sadler, who asked whether Van Gogh could be compared to Cimabue, he wrote: "Is Van Gogh's passion as pure and intense as Cimabue's – the question becomes one of great delicacy and scarcely to be answered off-hand. I should be inclined to say that it was as intense, but much less simple, much less serene, more troubled by the conflicts and ironies of modern life, more tortured and less healthy. This admission may even make me go further

and say that, in an age of vulgar commercialism in art, so passionate a spirit as van Gogh's did arrive at beautiful expression." [73]

Van Gogh's supposed madness was frequently a touchstone for the critics, but they had few guidelines to follow when looking for evidence of it in his art. What one took as a sign of sanity another might see as the product of a deranged mind. This can be seen in two very different reactions to the *Pietà* [cat. 79, repr. p. 39]. The *Pietà* was painted from a copy of a lithograph after Delacroix that Van Gogh owned and there is a close compositional similarity between the lithograph and Van Gogh's picture. The *Pietà* is a brilliant example of Van Gogh's late style, where the traditional distinction between line and colour disappears, and the calligraphic, linear strokes of intense blues and yellows follow the shapes of the figures and the forms of the landscape.

Konody thought that the *Pietà* was "an astonishingly personal interpretation of another artist's painting" and that looking at it "one could understand the cult of which Van Gogh has been made an idol". But he added, "Unfortunately there are other pictures with his signature that were obviously painted during his detention in a lunatic asylum, and that are clearly the expression of an unhinged mind".[74] Konody was not to know that Van Gogh painted the *Pietà* while a patient in the asylum at Saint-Rémy after his breakdown at Arles. Nor was this information available to *The Athenaeum*, which took the opposite view to Konody: the heavy impasto and expressive brushwork were "the twitch of a paralytic" and the faces were the product of "barbarous vision".[75] *The Athenaeum* liked *Rain effect behind the hospital* [fig. 10], with its soft colour harmonies of blue, green and purple, which was also a favourite of Sickert's. But others saw evidence of madness in the late landscapes painted at Arles, Saint-Rémy and Auvers. Some critics recognized that the landscapes "cannot be submitted to the ordinary canons of criticism" and that they were "experiments in a new method of expression" which "make even the silent talk". Before Van Gogh's *View of Arles with irises in the foreground*, "one friend said 'Beautiful' and another 'Hideous'".[76] But faced with landscapes which did not fall under the "ordinary canons of criticism" most of the British critics decided that their expressive handling was a reflection of madness. The landscapes illustrated "the poverty of the system" which forced "the painter into wild and wilder

eccentricities of brushwork which express nothing so much as the mental derangement which the unfortunate man was approaching". It was "bewildering, frenzied exaggeration". They were "sinister and weird impressions of landscape" and "the visualised ravings of an adult maniac".[77] *Crows over wheatfield* had not acquired its legendary significance within the modernist canon as the final testament of the artist. Therefore, no one associated it with Van Gogh's imminent suicide. Some made jokes: "I said it was a prairie fire. My companion insisted that it was a sandstorm. Someone beside us entered into the fray by deciding that it was the Great Fire of London while yet another stranger came up and called it a ham omelette smoking."[78]

The display of Van Gogh landscapes – *Rain effect behind the hospital, The plain at Auvers, Landscape with carriage and train in the background,* a panoramic view of the 'real country', as Van Gogh called it, which the drawing *The Oise at Auvers* [cat. 81, repr. p. 38] also depicts made a magnificent display. *The Oise at Auvers* and *A corner of the garden of St Paul's Hospital* [cat. 80, repr. this page] were once owned by the British collector Frank Stoop, who acquired his first work by Van Gogh, *Farms near Auvers* (London, Tate Gallery) in 1910. It is hard to conceive why the skill and discipline of Van Gogh's 'expressive' technique and the delineated strokes of colour which articulate the textures and form of the landscape did not attract the British public with its well known love of landscape painting. When Johanna van Gogh Bonger belatedly decided to send four Van Gogh drawings, including two landscapes, and Van Gogh's *Self-portrait* [fig. 9] to the exhibition she hoped that they would encourage the British public to look more closely at the paintings. Apparently the plan worked because MacCarthy reported back to her: "The drawings look splendid. They have done a good deal to make people look at the pictures."[79]

The figure studies and portraits by Van Gogh were more abused than his landscapes and taken as even greater evidence of his madness. Desmond Mac-Carthy's initial response, as we have seen, to *The Postman Roulin* (Philadelpia, Barnes Foundation) was one of revulsion. The close-up view of the face with its touches of green and slashes of orange red, and the green and blue beard, were "wonderfully hideous". In spite of his professed admiration for Van Gogh's portraits, MacCarthy had prejudices. Referring to *La*

Vincent van Gogh, *A corner of the garden of St. Paul's Hospital at Saint-Rémy*, 1889, cat. 80

Berceuse – a complex figure study for which Mme Roulin, the postman's wife, posed – MacCarthy said that it did not fit the middle class ideal of maternity but it would suit "a sailor's cabaret in Marseilles".[80] This was a reference to Van Gogh's intention that *La Berceuse* should serve as a modern-day icon, which shows that MacCarthy was familiar with Van Gogh's historiography. By suggesting that it was most suited to a working-class environment, MacCarthy was echoing the sentiments of the British middle class, who would have posed for portraits dressed in their best in comfortable, opulent interiors and who would not have seen portraits which revealed the character of ordinary people. For instance, MacCarthy remembered the outraged response of Wilfred Blunt and his daughter and son-in-law, the painter Neville Lytton, when they saw *Young man with cornflower.* They teased him by saying it would serve him right if his wife's forthcoming baby were born with a similar face. Rutter was one of the few critics who

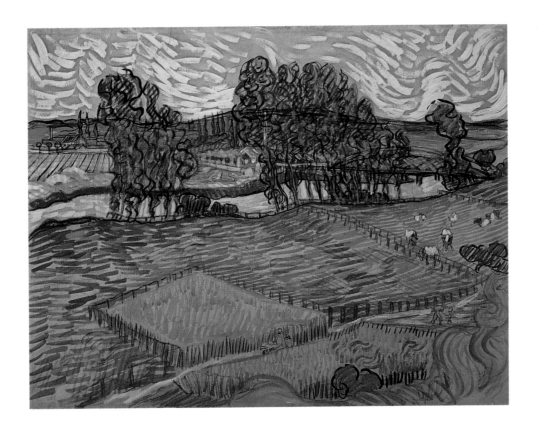

Vincent van Gogh, *The Oise at Auvers*, 1890, cat. 81

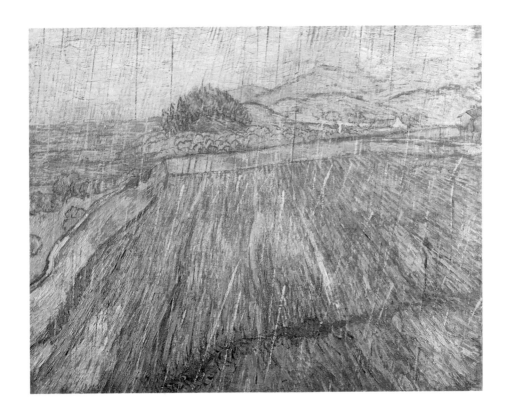

FIG. 10 Vincent van Gogh, *Rain effect behind the hospital*, 1889, Philadelphia Museum of Art

RIGHT Vincent van Gogh, *Pietà* (after Delacroix), 1889, cat. 79

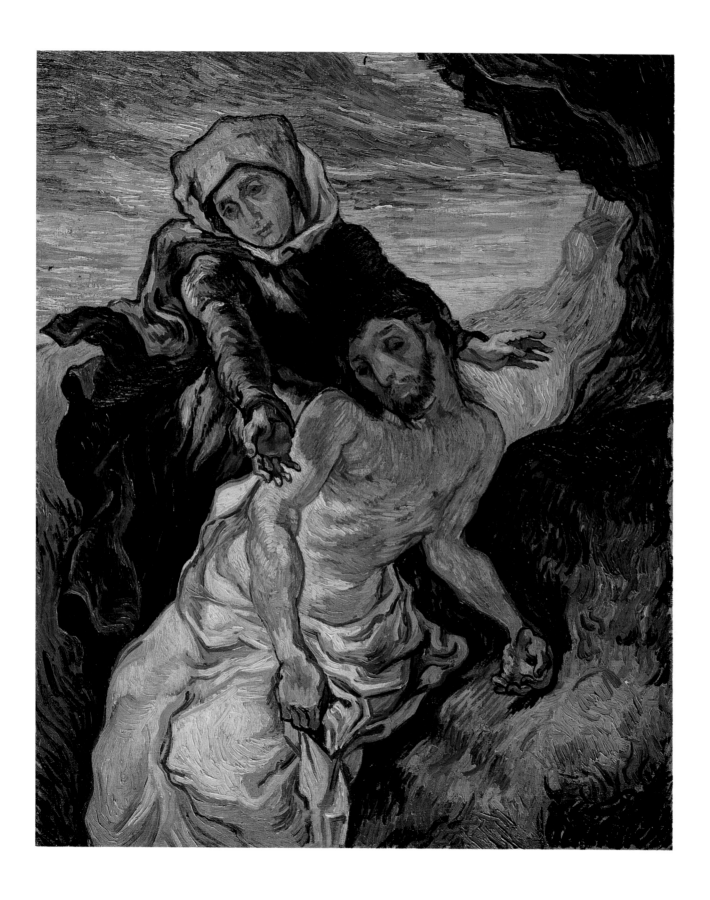

appreciated the formal innovations in *La Berceuse* and admired its "wonderful arabesque background, with its carelessness of actuality and forcible co-ordination of essential conventions for decorative effect".[81]

But few quarrelled about Van Gogh's flower paintings. The sunflower paintings have been so deeply imprinted into the modern imagination, have been so widely and frequently reproduced that it is difficult to comprehend that the British critics and public were seeing them for the first time at *Manet and the Post-Impressionists*. The large-scale *Sunflowers* and the *Irises* [fig. 11] with their strong complementary colours made a powerful impact in the Large Gallery. "Of exceeding beauty as a decoration is the *Iris*; a group of these lovely, deep-hued amaranthine blooms, relieved upon a ground of pale amber, glowing in colour, shooting forth rays of many-coloured gold, appears in the centre of one of the walls, a bouquet of great sunflowers."[82] They were "the very summit of achievement … reached by Van Gogh", wrote Konody.[83]

THE IMPACT OF MATISSE

In common currency, Post-Impressionism is usually associated with Cézanne, Gauguin, Seurat and Van Gogh, who were all dead by 1910. However, *Manet and the Post-Impressionists* had its fair share of living artists. Two of them – Matisse and Picasso – attracted as much critical attention as Cézanne, Gauguin and Van Gogh. Thanks to Michael and Sarah Stein, Matisse had a small following in Britain before the exhibition. Their collection of nearly fifty works, including oil paintings, works on paper and sculpture, was renowned. Fry, Bell, Hind and Rutter were amongst the British guests at the weekly Saturday evening gatherings held in their Paris apartment.[84] Hind, who first met the Steins in spring 1910, claimed to have spent many hours in their spacious white apartment: "That vast studio was crowded with visitors. One heard the usual giggles and protests, the usual disdain and disgust. Here and there were some who were half-convinced, and a few who were wholly convinced. My first sensation was one of dismay, almost of horror. That group of nudes in flat, house-painter's colour, one green, one pink, one yellow! that abortion of the female form so grotesquely naked! those vivid streaks of paint pretending to represent a figure emerging from foliage into sunlight! that head with the blatant smear of green shadow under the chin! that abominable bronze!"[85]

Hind was soon a convert to Matisse's art and professed that he "would walk a mile to see a new Matisse". But he claimed that he did not fully understand Matisse, who "troubles me … with his ache for expression, his sympathy with primitive artists and Oriental decorators … his plastic power and abstract colours, his elongation or attenuation of the figure to suit his architectural or decorative designs".[86]

Sally Stein was a rich source of information about Matisse and she probably persuaded Hind to publish an extract of Matisse's *Notes of a Painter* which appeared in a long article, 'The New Impressionism', in December 1910.[87] According to Hind he "never theorises before or during painting. Theorising may follow when the work is done. He will never paint if he is troubled or annoyed; it is his wish to begin every new picture virginally with an unanxious pure soul." *Notes of a Painter*, which has been described as one of the most significant books to have been written by an artist in the twentieth century, was first published in 1908 and translated into Russian and German in 1909. This partial English translation has been overlooked.

Apparently Hind was with Matisse at the Steins when someone criticized a Matisse picture, saying that his little boy might have done it. Matisse explained, "It is my aim to see as my little boy sees."[88] Hind also described Sally Stein, who was a well-known proselytizer, but he refused to accept her assertion that Matisse's art produced a feeling of tranquillity. Hind felt "a sense of excitement and stimulation". Hind provided a third way of understanding Matisse in *The Post-Impressionists* (1911). Of Matisse's *Self-portrait* (Copenhagen, Rump Collection) in the Stein collection, he wrote: "That head of himself – bearded, brooding, tense, fiercely elemental in colour – seemed … the serious Matisse, almost a recluse, indifferent to opinion, whose aim is to approach a fresh canvas, as if there were no past in art, as if he is the first artist who has ever painted."[89]

Fry did not borrow works by Matisse from the Michael and Sarah Stein collection, nor did he borrow work from Matisse's dealer, the Bernheim-Jeune gallery.[90] Instead, he relied on a number of private collectors and on Matisse himself, who lent a number of drawings and sculptures. Fry's early mentor, the American art historian, critic and connoisseur, Bernard Berenson, who in reply to a critical review of 1908 had sprung to Matisse's defence with a letter to *The Nation*,

lent a modest early landscape. Alphonse Kann lent a drawing (*Marguerite*, 1906)[91] and a still life, and Leo Stein lent *View of the sea, Collioure* (Philadelphia, Barnes Foundation). Emily Chadbourne, who had taken Ottoline Morrell to Matisse's studio in 1909, lent three drawings, which are probably those she later donated to the Art Institute of Chicago. *The girl with green eyes* [fig. 12] was the only recent oil-painting by Matisse in the exhibition. It is possible that Matisse had persuaded Harriet Levy, a friend of the Steins, to lend it. Certainly it was returned to Matisse, for, as Jack Flam has pointed out, we see it on its return from London, propped up still in its packing case, in Matisse's *The pink studio* (Moscow, Pushkin Museum) of early 1911.[92]

Fry did not become a totally committed 'Matisse-ite' until spring 1911. Seeing *The girl with green eyes* from day to day increased his admiration. It was "singularly perfect in design, and ... original and completely successful in the novelty, frankness, and bravery of its colour harmony".[93] The plaster cast, the decorative pottery and the red and green areas of the background of *The girl with green eyes*, the lack of distinction between the bold outline of the pottery and the woman's face, and the expressive brushwork which describes the pattern of the Chinese gown and also makes an abstract pattern behind her, suggest Matisse was making an explicit statement about picture-making.[94]

The girl with green eyes was frequently illustrated in the reviews of *Manet and the Post-Impressionists*. It took most of the British critics by surprise. Hind's declaration, "I will be 'Right O!' Give me *The Woman with Green Eyes* even at the risk of being confined in a lunatic asylum", was penned in response to the outcry it provoked.[95] What Matisse had told Hind early in 1910 – "it is my aim to see as my little boy sees" – was the popular notion of Matisse in the British press. Konody said that *The girl with green eyes* had the "imbecility of an intentionally childish daub". He mocked the idea that Matisse was serious: "To say that his 'woman with the green eyes' is exactly the sort of thing that would be expected by a child of six, if it were placed in the possession of a full palette and asked to paint a head and bust of a woman, is only stating the obvious. Assuming that Henri Matisse is really serious ... one can only explain his perversity in this way: in carrying the striving for supreme simplicity and synthetic summing up beyond reasonable limits he has come to the conclusion

that it must be safe to rely upon the naive visualising of a child that has not yet been taught to see nature in a certain manner." [96]

The most damning condemnation came from the Director of the National Portrait Gallery, Charles Holmes: "If *Girl with Green Eyes* were regarded as an experiment in simplification", he wrote, then it was acceptable because "every artist who recognises the need for simplicity in expression will understand that the efforts to attain it ... may lead ... to very odd results." But, he continued, "to spend all one's life in solemnly manufacturing these oddities is to prove oneself a dunce". If Matisse added "refinement to technical methods which are now crude" and "the rich insight of educated men to the primitive elements of vision" then he might become a "powerful artist", but if not, then he could not be considered an original artist.[97]

Little was said about Matisse's sculpture. Even Hind, who, as we have seen, was one of Matisse's most sympathetic British critics in 1910, described them as "bulky, distorted figures, as if a dumb man were trying frantically to utter his surging thoughts – see them, and praise or curse", [98] which suggests that he found them far more difficult to comprehend than Matisse's paintings. Hugh Blaker, firing off one his many letters to the press, pointed out, "The impressionistic bronze ... is astounding in its anatomical knowlege, especially from the back view" (he may have been referring to *Reclining nude no. 1* [cat. 152, repr. p. 82])." Blaker continued: "The critics have completely ignored this masterpiece, which is worthy of a place in our national collections. I commend it to the notice of the Contemporary Art Society. Its purchase would precipitate a veritable newspaper typhoon; but then the majority of our newspaper critics are like the racing tipsters – they don't know."[99] Blaker's suggestion met with no response.

The deliberate distortions in the drawings were equally suspect. Sickert, who took pride in his own draughtsmanship, was suspicious: "If you will look at Matisse's drawings, you will see he has acquired the most fluent school facility, just the kind of school facility that you do not find in good drawing or great drawings ... these distortions arrest if they do not please, and the consciously or unconsciously desired end is attained in the bronzes as in the drawings. In the paintings, unrelated colours tell us no more than the empty drawings do." [100]

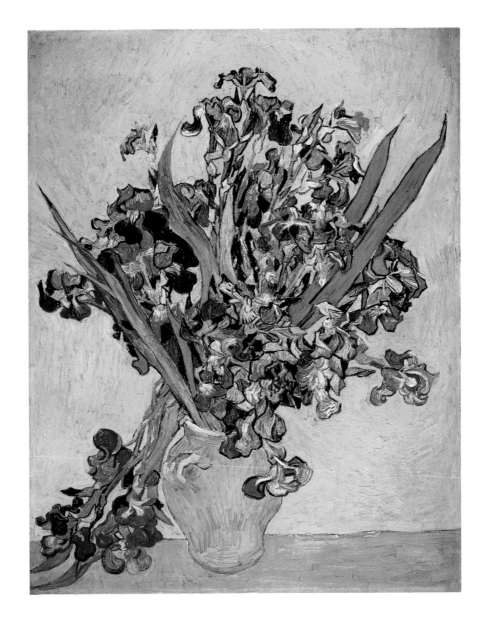

FIG. 11 Vincent van Gogh, *Vase with irises*, 1890, Van Gogh Museum (Vincent van Gogh Foundation), Amsterdam

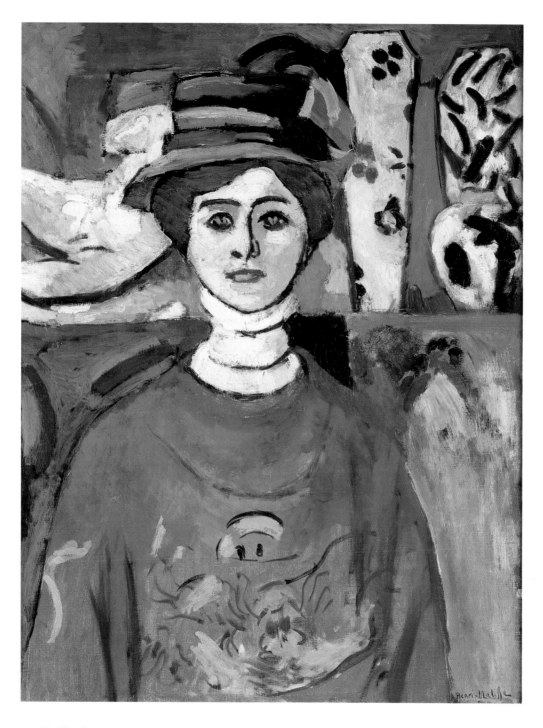

FIG. 12 Henri Matisse, *The girl with green eyes*, 1908, San Francisco Museum of Modern Art

KAHNWEILER'S ARTISTS

The gallery of the twenty-six-year-old dealer Daniel Kahnweiler at no. 28, rue Vignon, Paris, which opened in 1907, was reportedly only known to a handful of the élite. In 1909 Kahnweiler decided to concentrate on a small stable of artists including Braque, Derain, Picasso and Vlaminck, whose work he had first noticed in the public Salon exhibitions. Although he did not offer Braque, Picasso and Derain formal contracts until 1912, he effectively bought all the work his gallery artists produced. His policy was to show their work to interested parties, but he did not hold exhibitions in his gallery. Instead he devised a careful strategy of sending their work to exhibitions abroad.

Kahnweiler knew something about the innate conservatism of the London art market. He had been introduced to Asher Wertheimer, a dealer in Old Master pictures and Sargent's patron, while staying with his uncles in London in 1906. He may have been wary of sending work by Braque and Picasso to London. Or it may be that Fry was simply not ready to accept their Cubist pictures. In the event Kahnweiler lent three works by Derain and six by Vlaminck. Although Derain and Vlaminck are best known as Fauve artists, both were represented by more recent Cézannesque work, which provided the British public with a good introduction to Cubism.

Derain's *Vue de Martigues* (Kunsthaus Zurich) was one of the landscapes that exemplified Derain's Cubism for Apollinaire and were greatly admired by Braque and Picasso. His *L'Eglise à Carrières* and *Parc à Carrières* [cat. 28], which Fry bought from the exhibition, have strong Cézannesque elements – the trees which act as a framing device and the concentration on a single motif. Equally, the strong architectural element and the motif of the bridge in Vlaminck's *Le Pont*, which Clive Bell bought from the exhibition, are Cézannesque. This last compares to Vanessa Bell's *A bridge, Paris*, 1911 [cat. 2, repr. this page], which has elements that reflect Fry's ideas about Cézanne's classicism.

The British critics, however, hardly noticed the exhibits of Derain or Vlaminck. Picasso was the artist they were watching. Although he was represented by only two oil paintings, *Nude girl with a basket of flowers*, autumn 1905 (similar in style to *Poverty* [cat. 165, repr. p. 70]), which Fry borrowed from Leo Stein, and *Portrait of Clovis Sagot* [fig. 13], which he borrowed from

Vanessa Bell, *A bridge, Paris*, 1911, cat. 2

Sagot, Picasso captured much of the critical attention.

Leo Stein, who was brother to Michael, and his sister Gertrude were early collectors of Picasso, and by 1910 they owned over sixty works by him. Both the Steins and Sagot belonged to the close circle of poets, collectors and dealers who surrounded Picasso in 1910. Leo and Gertrude Stein acquired *Nude girl with a basket of flowers* from Clovis Sagot shortly after Leo met Picasso in 1906. It was one of the first Picassos in their collection, and the picture had special significance for both of them. Initially Leo had liked it and Gertrude had hated it, saying it would spoil her dinner when Leo brought it back to the apartment they shared. But "some years later, when we were offered an absurd sum for the picture and I wanted to sell it – since for that money one could get much better things – Gertrude would not agree to sell".[101] *Nude girl with a basket of flowers*, too, had played a seminal rôle in their conversion to Picasso's art. That may be why this early work was chosen to launch Picasso in England, rather than one of the many more recent pictures in their collection. But in some respects the plan backfired. British critics were used to seeing Whistler's thinly painted tonal pictures in a close key of colour, and liked *Nude girl with a basket of flowers*, but were left unmoved. According to Sickert, its Whistlerian characteristics were proof that Picasso was a "quite accomplished sort of minor international painter".[102]

The *Portrait of Clovis Sagot* was the first of four portraits of his dealers – three others of Vollard, Uhde and Kahnweiler were painted in 1909 and 1910. Sagot had been one of Picasso's most supportive dealers during

his early years in Paris. William Uhde held a small loan show of Picassos in May 1910, and Vollard showed work by Picasso in December 1910. Sagot could not compete with the bigger dealers who vied for Picasso's custom before he signed his contract with Kahnweiler, but by loaning his portrait by Picasso he was able to advertise his ties with the artist. Six of the seven drawings by Picasso were lent by Sagot, all of them for sale.

The contrast between the two oil paintings by Picasso did not go unnoticed. "Two pictures by Picasso illustrates [sic] the influence of a theory. In the Large Gallery there is his *Nude girl with a basket of flowers*, a fine thing, almost an exquisite thing, in which there is expressed a spirit of something approaching classic detachment; in the next gallery there is his portrait of 'M. saget' [sic], worked out in some geometrical theory."[103] What clearly fascinated Fry was the "remarkable change" in Picasso's style. The early work, including the etching *Salome*, 1905, which was exhibited ex-catalogue, showed that Picasso had a "technical mastery beyond cavil", proof that any subsequent changes in Picasso's style had a sound artistic basis. Fry's description of Picasso's Cubism as "the strangest passion for geometrical abstraction" suggests that he had not grasped its complexities.

Hind, for one, suggested that Fry had been far too timid in his selection of Picasso (and Matisse). *Portrait of Clovis Sagot* has a strong representational element and it did not illustrate the most recent phase of Picasso's rapidly evolving Cubism, as Frank Rutter pointed out. Rutter was in the habit of visiting both Kahnweiler's gallery and those of the other dealers, Sagot and Vollard – as his review of the Salon d'Automne in October 1911 makes clear.[104]

In November 1910, Rutter published *Revolution in Art*, a little known book which deserves to be taken more seriously. Picasso has passed through many manners, Rutter said, and his drawings alone showed "his extraordinary mastery of form and his elasticity of vision and treatment" but, as was evident in his Cubist pictures, Picasso had "more recently evolved a new vision of form, building up his paintings with a series of cubes, greyish to yellow green in colour, about three inches square as a rule, cubes some square to the spectator, others at angles, and all ingeniously fitted together to express his feeling for form".[105] Of any British critic, Rutter probably had the greatest understanding of

FIG. 13 Pablo Picasso, *Portrait of Clovis Sagot*, 1909, Kunsthalle, Hamburg

Cubism in 1910, and he was keen to see more Cubist works by Picasso. Writing at the time of the *Picasso Drawings* show at the Stafford Gallery, an exhibition of drawings from *ca.* 1903 to 1907 including probably *Poverty* [cat. 165, repr. p. 70], he lamented, "In London we have to take our foreign art as we can get it, not necessarily in the chronological order of its appearance."[106] Others, such as Konody, who wrote, "This artist has evolved a system of constructing the surfaces in his recent pictures out of cubes, so that his recent work has the appearance of Byzantine mosaics", were struggling with a very description of Cubism.[107]

This lack of understanding is hardly surprising. When Matisse and Picasso were presented as the two competing giants of early modernism in the *Second Post-Impressionist Exhibition,* the critical faculties of the British critics would be put further to the test.

PROVENÇAL STUDIES AND OTHER WORKS BY AUGUSTUS JOHN

RIGHT ABOVE Augustus John, *Olive trees by the Etang de Berre, Martigues,* 1910, cat. 120

RIGHT BELOW Augustus John, *Blue lake, Martigues, ca.* 1910–12, cat. 123

BELOW FIG. 14 Catalogue of the exhibition *Provençal Studies and Other Works by Aug. E. John*

THE CHENIL GALLERY, CHELSEA, S.W.

PROVENÇAL STUDIES

and

OTHER WORKS

by

AUG. E. JOHN.

NOV.—DEC., 1910.

WHILE the debate about *Manet and the Post-Impressionists* was raging, Augustus John's exhibition of recent works opened in November at the Chenil Gallery, no. 183a, Kings Road, Chelsea.[1] "Somebody has ironically asked why Mr. Augustus John was not included among the Post Impressionists," quoted the Daily Graphic.[2] Indeed Rutter said, "John is the most strongly individual artist we possess at the moment – one of the few artists in England capable of being a law unto himself."[3] Hind also pinned his hopes on John in *The Post-Impressionists*, his book about *Manet and the Post-Impressionists*: "Let me whisper something. John is the chief of the English representatives of the new movement in art." He lavished praise on his recent panels: "All the world is his hunting ground in these Provençal-studies. Each is entirely his own, each is vital."[4]

Forty-eight oil panels by John and one or two "monstrous" sculptures by Epstein were displayed in the two downstairs rooms of the Chenil Gallery. "Abnormal as Mr. John's paintings are, they are not so fantastic as Mr. Epstein's things."[5] Upstairs were drawings by John, Epstein, William Orpen, David Muirhead and William Nicholson. Earlier in 1910, John had travelled in Provence visiting Arles, Avignon, Les Baux and Marseilles before going on to Italy. John would have been aware of the rich associations that the South of France had for Post-Impressionist painters – Van Gogh whom John first heard about in 1908 from Henry Lamb at Arles; Cézanne at Aix where John made a pilgrimage with Ottoline Morrell – and he probably knew that the South had been a favoured place of the Fauves. Jessica Dismorr also painted at the sites John visited in 1910; Provence had particular associations for the British community in Paris. In April John settled his family in the Villa Ste-Anne at Martigues. The light and landscape of Provence were an inspiration for John just as they were for the French artists who worked there.

John's Provençal pictures have not been systematically dated, but it is evident that from the beginning he was using bright, clear colours applied in a free and expressive manner. Traditionally oil panels were used for landscape studies, but they would not have been exhibited as works of art in their own right. Whistler was the first artist to exhibit large groups of panels painted in a highly experimental manner, and John almost certainly would have been aware of this

precedent. The panels in John's 1910 show have not been conclusively identified. *Olive trees by the Etang de Berre* [cat. 120, repr. p. 47] could be either *"L'Etang de la Berre"* or *"Oliviers"*, landscapes without figures described as exquisite colour harmonies. *"The Children in the Garden"*, which had "beautiful tones of grey green to enhance the subdued tints in the clothes of the sculpturesque group of children" may be *Two children in the garden* [cat. 121, repr. p. 51].[6] The colour, applied flatly in two or three pure hues in other panels (cf. cat. 122, repr. p. 50), have a "contrasting note of brillant colour in juxtaposition with soft dreamy greens, blues and greys", while the later works, painted and exhibited after 1910, were sometimes more densely worked (cf. cat. 123, repr. p. 47).[7] One series consisted of various studies of "one statuesque woman, usually with a yellow head-dress" in various stages of finish, including *"The Yellow Handkerchief"*, which depicted her seated with a vivid red and yellow handkerchief around her head (cf. cat. 124, repr. p. 10), and *"Yellow Head-dress"*, "a front view of the face, head and shoulders" which "shows masterfully how finely Mr. John can model a head and paint flesh".[8] Traditionalists thought that his "trick of making a drawing on his canvas and blocking out the colours, leaving a white line around his figures … is a mere mannerism".[9]

While the critics who approved of *Manet and the Post-Impressionists* also supported John, the show at the Chenil Gallery was not well received by the traditionalists. Early in his career, while still a student at the Slade, John was typecast as an exquisite classicist and a perfect modern. It was to prove impossible to fulfil such a rôle, because it was assumed that his work would reflect the ideals of the past and yet still have originality. A.J. Finberg, who said that the 'Provençal Studies' were not pictures or sketches, referred to the depiction of light in past art by Masaccio, Piero della Francesca and the more recent nineteenth-century artist Puvis de Chavannes in his discussion of these "studies of open air lighting", but he dismissed John's efforts to "throw back like the men at the Grafton gallery, to the primitive art of children, savages and lunatics". He concluded: "John does do what the feeble and incapable blunderers among the Post-Impressionists … were striving to accomplish. The childlike … vision which we are told men like Gauguin and Cézanne were trying to find seems to have come naturally to Mr. John."[10]

Rutter thought that John needed the human figure "to fully express himself" but this was not a commonly held opinion. At first glance John's depictions of women and children would appear to have little in common with Gauguin. But for the traditionalists, his treatment of the figure was as unsettling as Gauguin's. They were "abnormal". The poses were "unnatural". "We see neither nature nor art in many of these strangely-formed heads, these long too rapidly tapering necks and these blobs of heavy paint that sometimes do duty for eyes", wrote *The Times*.[11] It was all the more vexing because John's drawings were a reminder that he could be "alive to tradition". "At his worst he can outdo Gauguin … the colour of Van Gogh (Van Gogh when he was sane as a colourist); and at his best, when he remembers that he is an artist, he rises to heights the Post-Impressionists have never reached."[12] These vitriolic comments were a reaction as much to the images of women and children that John represented in these panels – to their Bohemian manner of dress, their headscarves, loose smocks, bare legs and feet – as to the manner in which they were painted. Their 'natural', relaxed poses had more in common with those of the 'primitive' people in Gauguin's Tahitian pictures than they did with Edwardian England.

The critical response to John's exhibition explains why Clive Bell invited John to exhibit in the *Second Post-Impressionist Exhibition*. John intially accepted the offer and then later changed his mind. His own view of *Manet and the Post-Impressionists* was ambivalent.[13] He first thought that *Manet and the Post-Impressionists* was "a bloody show". But he did not dismiss modern art out of hand. For example, he made a quick trip to Paris in January 1911 to see "a show of paintings by Picasso which struck me as wonderfully fine" at Vollard's gallery. No catalogue exists for the exhibition at Vollard's, but John was most likely referring to works from the period 1905–06, which, he said, were "full of secret beauty of sentiment". He admitted he had admired them for a long time. It may be that the prospect of seeing Picasso's *Nude girl with a basket of flowers* drew him back to *Manet and the Post-Impressionists* for a second visit. Seeing the show again made him change his mind. He decided that Van Gogh was "a great artist" and especially liked the drawings and the self-portrait, admired a Gauguin Tahitian picture, and said Cézanne "was a splendid fellow, one of the greatest". He did not

Augustus John, *Aran Isles*, 1916, cat. 126

change his opinion of Matisse, who he thought was "a charlatan, but an ingenious one".[14] Whatever John's reason for not participating in the *Second Post-Impressionist Exhibition* it was not because he was not sympathetic to modern art.

The landscape panels painted by John in subsequent years reflect his continuing interest in painterly experiment (cf. cat. 126, repr. this page). They are technically far more adventurous than the large figure compositions which made his reputation in the years before the First World War.

ABOVE Augustus John, *Dorelia standing in a landscape, ca.* 1912, cat. 125

RIGHT ABOVE Augustus John, *Children paddling*, 1910, cat. 122

RIGHT BELOW Augustus John, *Two children in the garden, Martigues*, 1910, cat. 121

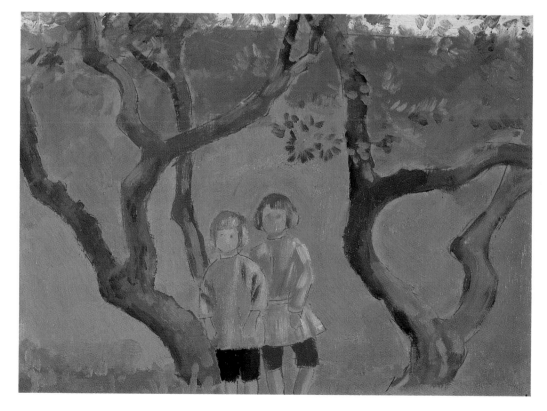

CÉZANNE
AND
GAUGUIN

ON 23 November 1911, an *Exhibition of Pictures by Paul Cézanne and Paul Gauguin* opened at the Stafford Gallery, no. 1, Duke Street, St James's, in the heart of London's Mayfair. The Stafford Gallery had moved from Bond Street the previous year to "attractive new showrooms" that recalled those "of several well-known Parisian establishments". It opened under the new management of John Neville. The inaugural show, organized by the Druet Gallery, was *Jules Flandrin*. Robert Dell, who had recently helped Fry select work for *Manet and the Post-Impressionists*, wrote the catalogue preface.[1] Little is known about John Neville, but the exhibitions of Camille Pissarro, *Picasso Drawings* and Fergusson held at the Stafford Gallery during its short existence reflect the interests of someone *au courant* with the contemporary art world.

Michael Sadler, later Sir Michael, educationalist and Vice-Chancellor of Leeds University, was relatively new to collecting when he approached Neville in September 1911. He had started to buy works of art in 1909 with the advice of E.J. van Wisselingh, who had given Sickert an exhibition at his London gallery in 1895, and D.S. MacColl. Sadler's first acquisitions reflect the taste of the New English circle. In spring 1910, after seeing the Caillebotte bequest of Impressionist pictures in Paris, he began collecting Barbizon pictures. *Manet and the Post-Impressionists* was a revelation to him and he quickly rose to the defence of the Post-Impressionists. He acquired a number of works that he first saw in *Manet and the Post-Impressionists*, but it is not known whether any were bought at the time of the show. The autumn of 1911 was a period of frantic buying. Sadler's son Michael T.H. Sadleir had the initial idea of holding a Cézanne and Gauguin exhibition. Sadler promised to guarantee any losses up to £50. As father and son walked around their Surrey garden, they decided that Neville should go to Paris to negotiate the price of *Manao tupapau* [fig. 15], which they hoped to get for slightly less than what Druet was asking at *Manet and the Post-Impressionists*. They instructed Neville that they would pay the top price of £1400 if they could not get it cheaper. Neville also arranged to have Vollard send over Gauguin's *Christ in the Garden of Olives* for inspection and some Cézanne landscapes. They also discussed investing in young unknown artists. While Sadler was initially sceptical, by the following year he was

advising the young Mark Gertler to see Neville about his work.[2] The negotiations with the Paris dealers went on for several weeks. Sadler was still negotiating with Druet about different Gauguin pictures at the end of October. He had set his eye on various pictures but none of them was available. It may be that Druet suggested *Vision after the sermon* [fig. 16], as an alternative.[3] During October Sadler purchased *Manao tupapau*, *Christ in the Garden of Olives*, *The vision after the sermon* and an unidentified pastel by Gauguin, and also Cézanne's *La maison abandonée*, 1892-94 (USA, private collection). Sadler's new Gauguin acquisitions were the centrepiece of the *Cézanne and Gauguin* exhibition.[4]

Spencer Gore's *Gauguins and connoisseurs at the Stafford Gallery* [cat. 89, repr. p. 55], which Sadler once owned, celebrates Sadler's new Gauguin acquisitions and their showing at the Stafford Gallery. From right to left we see *Vision after the sermon*, *Christ in the Garden of Olives* and *Manao tupapau*, three pictures which are now considered to mark Gauguin's pictorial development as he moved from naturalistic representation to picture-making that was a complex synthesis of myth and memory, rhythmic pattern and colour. Gore had a witty visual sense and his homage to Gauguin may be slightly tongue-in-cheek, since *Gauguins and connoisseurs* reiterates the composition of *Vision after the sermon*. The red ground becomes red carpet, the praying Breton women have been turned into spectators, and the arm of the tree is turned into the overhanging arch of the gallery. Some of the gallery spectators can be identified: the bearded Augustus John appears in the left foreground; the diminutive John Neville stands pensive in conversation with a large woman, and Wilson Steer, who twenty years earlier had been one of the most enthusiastic supporters of French Impressionism in England, stares at the wall on the right.

Vision after the sermon marks a turning point in Gauguin's approach as he abandoned painting from nature and began to paint from his imagination. Its red antinaturalistic colour, its sources in Japanese prints and the depiction of a mystical experience based on religious belief and a biblical event have been the subject of long debate.

When *Christ in the Garden of Olives*, in which Gauguin represented himself as the betrayed and misunderstood figure of Christ, was exhibited at *Manet and the Post-Impressionists* it always had a crowd in front of it: "It was so strange, so unlike any contemporary or past rendering of the Agony in the garden."[5] *Manao tupapau*, which had hung in the middle of the long wall of Gauguin paintings at the Grafton Galleries, also "attracted a good deal of attention, more perhaps of conjecture as to its subject," wrote Michael Sadleir, "than of admiration of its intrinsic beauty".[6] Michael Sadleir had considerable influence on his father's collecting patterns. He wrote perceptive, well informed articles and reviews on modern art for *Art News* and for *Rhythm*, the periodical he helped to found in summer 1911 (see further p. 108). During his frequent trips to Paris, Sadleir became well acquainted with the Paris art world, and when Oliver Brown of the Leicester Galleries decided to hold exhibitions of modern art after the First World War, it was Sadleir who suggested ideas, including the Matisse show, and arranged to have work sent from Paris (see p. 159).

Sadleir's eulogy to *Manao tupapau*, or *L'esprit veille*, the title by which it was known at the Stafford Gallery (and in Fry's show), was published in *Rhythm* in 1911, shortly after his father had acquired the picture. Sadleir realized that the picture's success depended upon a fusion of word and image and argued that its literary meaning and its use of pattern and colour were equally important. "The colour of the picture is a wonderful harmony of rich red purple, golden bronze and blue, with a bold frieze pattern of vivid yellow flowers along the flounce of the couch." Sadleir quoted from Gauguin's *Noa Noa*, which had "word colours ... as rich and definite as the purples of his pictures". The "blend of poetry and common place" in *Noa Noa*, "the same burning reverence which appears in his religious pictures, which makes agony in the garden as intense as any primitive Italian masterpiece", convinced Sadleir that "religion is the mainspring of Gauguin's genius". Gauguin was "a genuine primitive" and "Tahiti and savagery cured him".[7]

There were fourteen Gauguins in the Stafford Gallery exhibition, but most of the critical discussion centred on the Sadler pictures. The feelings of shock and revulsion that were expressed when the critics first saw works by Gauguin in *Manet and the Post-Impressionists* virtually disappeared and Gauguin was hailed as a recognized master. J.B. Manson praised his "genius for decoration" and his "unusually strong and sensitive gift for drawing". Turning his attention to *Manao*

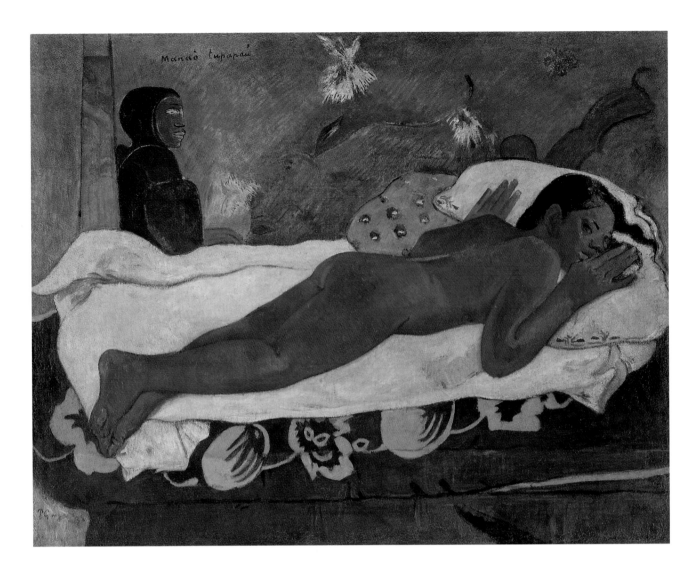

tupapau, he praised the drawing of the "young girl's figure" and "the repletion and variety of the colour"; he commended the arabesque arrangement of the composition in *Vision after the sermon*, the "synthetic use of colour" in *Christ in the Garden of Olives* and the decorative qualities of *Schuffnecker in his studio* (Paris, Musée d'Orsay).[8] This process of aestheticization, which turned pictures that initially had been considered to be revolting into masterpieces, was essential if Gauguin was to be canonized as one of the "most interesting personalities in modern art". Manson had no doubt that Cézanne, who was represented by eight works including *La Maison abandonée*, which Sadler owned, should share the critical acclaim with Gauguin. He was "a finer painter" with "a fine feeling for structural composition"

and "finely developed sense of colour" but essentially Manson was as lost for words to describe the Cézanne exhibits as the majority of critics had been the previous year.[9] This failure of critical language persisted in the criticism of the Stafford show so that much of it consisted of little more than superlatives. Cézanne's "fruit-piece" was "superb" and *The bridge* was "the finest and most completely realised work from his brush" that Konody had seen.[10]

While most British critics were happy to see Gauguin as a great inventor of "intensely decorative silhouettes", Sadleir was interested in Gauguin's identification with 'primitive' art and his legacy for contemporary artists. He explained in 'After Gauguin', another article published in *Rhythm*, that there were two types of Gauguin

LEFT FIG. 15 Paul
Gauguin, *Manao
tupapau* or *The spirit of
the dead watching*, 1892,
Albright-Knox Art
Gallery, Buffalo NY

RIGHT FIG. 16 Paul
Gauguin, *The vision
after the sermon: the
struggle of Jacob and the
Angel*, 1888, National
Gallery of Scotland,
Edinburgh

BELOW Spencer
Gore, *Gauguins and
connoisseurs at the
Stafford Gallery*, 1911,
cat. 89

follower: the first type was Sérusier (his father had purchased Sérusier's *Le café* [cat. 180] in September 1911) and other pupils who had worked in Britanny with him; the second the 'Neo-primitives', who Sadleir identified as Derain and Kandinsky, and who used a technique "reminiscent of primitive and savage art".[11] Derain's recent woodcut illustrations for *L'Enchanteur pourrissant*, one of which was reproduced in *Rhythm*, had "the primitive force of Gauguin's Tahitian pictures freed from the limitations of time and place".[12] Then, referring to Kandinsky's *Concerning the Spiritual in Art*, Sadleir explained Kandinsky's view that "primitive art is a more direct expression of the soul of externals" and that "the new art inclines at present to primitive technique" but "the art of the future ... can develop fresh methods of its own, unhampered by tradition."[13] The works by Gauguin that Sadler acquired introduced Sadleir to modern art but he was more than willing to develop his interest in non-representational contemporary art (see p. 132).

THE FUTURIST EXHIBITION

FILIPPO Tommaso Marinetti, the rich poet and self-styled director and publicist of the Futurists, had his eye on London early on. After publishing the founding manifesto of Futurism in August 1909, he appeared at the Lyceum Theatre in March 1910 to lecture on his newly formed movement. It was the first of many lectures he gave in London between 1910 and 1914.

Parts of the 'Futurist Venice' manifesto and the 'Initial Manifesto of Futurism' were published in *The Tramp* in August 1910.[1] It was another part of the complicated strategy engineered by Marinetti to launch Futurism as an independent modern movement with its own identity. In August 1911, Rutter published the 'Manifesto of the Futurist Painters' in *Art News*, the official newspaper of the Allied Artists Association (AAA) founded in 1908.[2] Although Rutter was not entirely sympathetic to Futurism, he did wish to make the AAA as representative as possible of the different aspects of modern art. He may have hoped to woo the Futurists to join his new organization, which had an annual non-juried exhibition at the Albert Hall. But Marinetti, who was remarkably astute about the politics of modern art exhibitions, launched a more ambitious plan.

When Marinetti wrote the first Futurist manifesto in 1909, no Futurist works existed. By 1911 he had assembled an identifiable group of Futurist artists, all of whom were producing a prodigious number of works. These included five manifesto pictures: Umberto Boccioni's *The city rises* (New York, Museum of Modern Art), Luigi Russolo's *Revolt* (The Hague, Gemeentemuseum), Enrico Carra's *Funeral of the anarchist Galli* (New York, Museum of Modern Art) and Gino Severini's *The Pan Pan dance at the Monico* (destroyed). In March 1912, an exhibition of thirty-five works – ten by Boccioni, eleven by Carra, six by Russolo, and eight by Severini – was assembled in the three tiny rooms of the Sackville Gallery at no. 28, Sackville Street in the West End of London. All the artists on show and Balla, who did not exhibit, attended the riotous opening with Marinetti.[3] Like all Futurist acts, the plan for the exhibition, the catalogue and the manifestos had emanated from a central office in Milan financed by Marinetti. The Sackville Gallery exhibition was the second stop in a whirlwind tour that had started at the Bernheim-Jeune Gallery in February and within two years had visited between twelve and fifteen European galleries.[4]

FIG. 17 Catalogue of the *Exhibition of Works by the Italian Futurist Painters*

THE SACKVILLE GALLERY, LTD.,
28, Sackville Street, Piccadilly.

EXHIBITION
of Works by the
ITALIAN FUTURIST
PAINTERS

MARCH, 1912.

Price - SIXPENCE.

The subject of the majority of Futurist works at the Sackville Gallery was the most modern and urban aspect of contemporary life. An extensively illustrated thirty-six-page catalogue contained three Futurist documents translated into English: the 'Initial Manifesto of Futurism' (20 February 1909), the 'Technical Manifesto of Futurist Painters' (11 April 1910) and an introduction written by the exhibitors proclaiming that they wanted to replace the "tumbling and leperous palaces of Venice" with "the rigid geometry of large metallic bridges and manufactories with a waving hair of smoke".[5] The explanations in English under each picture title in the catalogue were written by R.R. Meyer-See, the director of the Sackville Gallery, who moved to the Marlborough Gallery the following year where he gave Severini a one-man exhibition. Meyer-See particularly liked Severini's pictures. He bought *Yellow dancers* [cat. 182, repr. p. 62] and *The boulevard* [cat. 181, repr. p. 58] from the exhibition. His captions certainly did not improve the humour of the British critics, who had to wade through nineteen pages of text before they reached the list of works and Meyer-See's accompanying notes. Meyer-See's explanation that "forms are destroyed by electric light and movement" in *Yellow dancers* is no more illuminating than his description of *The boulevard*: "light and shadow cut up the bustle of the boulevard into geometrical shapes". His comment about Boccioni's *A modern idol* [cat. 15, repr. p. 59], "light effects upon the face of Woman", is inane.

The show had almost as much impact on the public as *Manet and the Post-Impressionists*. The gallery was "thronged daily" with curiosity seekers, a fact which did not surprise Rutter, who remarked, "London is full of people who will gladly pay a shilling to see a 'sensation'".[6] However, in terms of the reception from the critics, Marinetti's plan to establish the Futurists backfired. The inner circle of British critics who had mostly welcomed Fry's idea that art had its own visual language were suspicious of the seemingly literary basis of Futurism, far too reminiscent of much of nineteenth-century British art's dependence on literary explanations. Fry, Konody, Rutter (who complained that there was more explanatory text in the catalogue than there were exhibits), Hind and Sickert (who thought that "painting, like speaking, is a form of expression") all had reservations.

Fry, having voiced his objections, judged the works in his own terms. He praised Severini, the Futurist who stood out because "he has a genuine and personal feeling for colours and pattern, and the quality of paint is that of an unmistakable artist". He liked Severini's "charming" *Yellow dancers* who shimmer and move in the electric light isolated from the crowd of spectators at the Café Monico. He dismissed Meyer-See's explanation as "aesthetically quite irrelevant" and decided that "the picture is good enough to appeal on its own merits".[7] While Fry was not prepared to take the ideas of the Futurists too seriously, Konody found them disturbing. They particularly grated on the British sensibility, with its long-standing suspicion of representations of modern urban forms. Only after Konody had interviewed Marinetti and Boccioni – "the leaders of the movement" – did he feel more reassured about their revolutionary claims. He had set out with trepidation wondering whether "it would be advisable to protect myself by chain-armour", but after talking to them for two hours he decided that "Marinetti's flowery and fiery eloquence is as misleading as Carra's absurd portrait". Marinetti "turns the hard facts of modern industrial and mechanical progress into poetry of passionate violence". Futurism, he advised, is "the splendid awakening of a new national consciousness".[8]

Previously Konody had claimed that he found Futurist art incomprehensible and had ridiculed the innovatory visual aspects of Futurism, suggesting, for example, that Boccioni's trilogy *Leavetaking* was composed of "a tangle of things that looked like curled wood-shavings".[9] Though reassured after his meeting with Marinetti, he failed to recognize the use of new stylistic means to depict the vitality, violence and chaos of modern urban industrial society.

Rutter, on the other hand, recognized the use of "the extreme wing of the Salon d'Automne and Galerie Kahnweiler as their model points". He readily praised individual pictures – for example, Carra's *Leaving the theatre* (London, Eric and Salome Estorick Foundation), but he decided that they would do better to observe movement in nature rather than "play at visualising abstract metaphysics which their master M. Bergson can express far more lucidly and intelligently".[10]

Characteristically, Hind jokingly advised gallery visitors to take their spectacles with them "to read the 36 pages of excited print that composes the catalogue … and an italicised description of each work". He decided

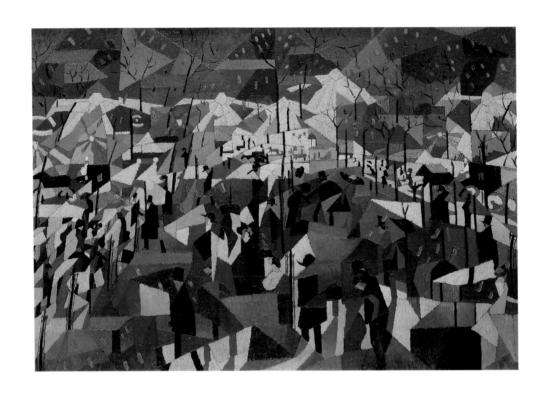

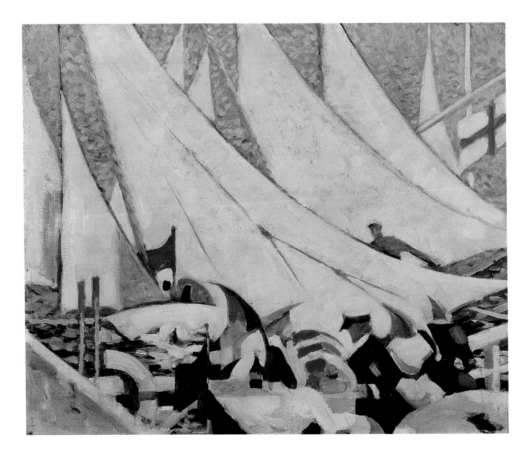

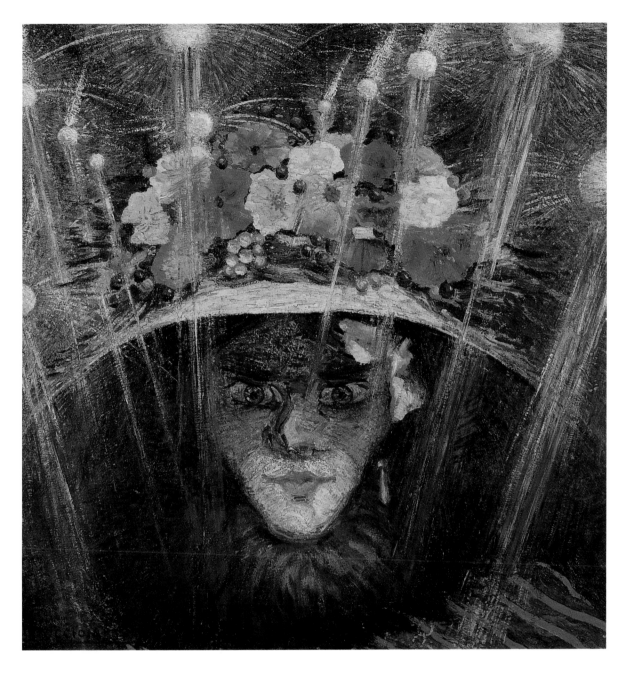

ABOVE Umberto Boccioni, *A modern idol*, 1911, cat. 15

LEFT ABOVE Gino Severini, *The boulevard*, 1910–11, cat. 181

LEFT BELOW Stanley Cursiter, *The regatta*, 1913, cat. 24

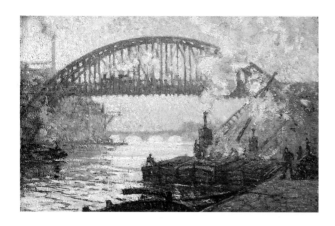

Christopher Nevinson, *The railway bridge, Charenton*, 1911–12, cat. 161

that Futurism had swallowed itself: "For when art must depend upon literature to explain itself it ceases to be art." In the tiny Sackville Gallery, it was impossible to see Severini's big canvas *The Pan Pan dance at the Monico*, which depicted "the bustle and hub bub created by the Tsiganes, the champagne-sodden crowd, the perverse dance of the professionals, the clashing of colours and laughter".[11] Sickert refused to judge it until "it can be seen in a room from a distance at least three times its whole width from it".[12] All accounts suggest that it was the most topical picture in the show, but among the critics there is little evidence of whole-hearted understanding. Rutter failed to recognize that the effect, "the spasmodic, artificial oscillation of a cinematograph", was an appropriate means of conveying the frenetic, repetitive movement of modern dance.[13] Fry was more sympathetic. It was a brilliant piece of design and its "curious methods" did to some extent convey "the mental exasperation" that a scene in a modern dance hall provoked.[14]

The lukewarm critical reception contrasts with the reaction among artists. Having previously painted in a style like that of cat. 161, repr. this page, Nevinson exhibited at the AAA in 1913 (now lost), the first British Futurist painting (now lost, cf. also fig. 20, p. 76). Russolo's *The train at full speed* and Severini's *The Pan Pan dance at the Monico* had an immediate effect on Lewis.

Bomberg's *Vision of Ezekiel* (London, Tate Gallery) is executed in a manner that shows an intelligent awareness of Severini. Severini's *The boulevard* inspired the Scottish artist Stanley Cursiter (cf. cat. 24, repr. p. 58), who was a Futurist for a brief period. Gaudier-Brzeska's *Bird swallowing a fish* [cat. 55, repr. this page] draws on the dynamic principles of Futurism. Futurism was an international cultural phenomenon in which British artists played a part.

Surprisingly Sickert was one of the few critics to appreciate fully that Futurism had its own powerful political and social agenda. His oddly titled essay 'The Futurist "Devil-among-the-Tailors"' – a reference to the fact that the Sackville Gallery was next door to Whistler's tailor – displays an erudite knowledge of Futurist writing and poetry. It was essentially a "movement of Italian patriotism" which was "austere, bracing, patriotic, nationalist, positive, anti-archaistic, anti-sentimental, anti-feminist". He indicated that British artists had much to learn from this stance. But he warned that "to be an avowed and militant Futurist is in itself no guarantee of pictorial ability".[15] Giovanni Cianci has fully documented the importance of Futurism for Wyndham Lewis.[16]

Henri Gaudier-Brzeska, *Bird swallowing a fish*, 1914, cat. 55

RIGHT FIG. 18 *The Sketch*, Supplement, 6 March 1912, p. 4

WHAT DO YOU THINK OF IT—SERIOUSLY? FUTURIST WORKS.

1. "IDOLE MODERNE." BY BOCCIONI. 2. "LA RÉVOLTE." BY RUSSOLO. 3. "TRAIN EN VITESSE." BY RUSSOLO.

4. "LA RUE ENTRE DANS LA MAISON." BY BOCCIONI. 5. "SOUVENIRS D'UNE NUIT." BY RUSSOLO.

It was arranged that an exhibition of works of the Futurist School of Painters should open at the Sackville Gallery, 28, Sackville Street, on March 1. In reproducing these examples of pictures by Futurists, we cannot do better than reprint the note given under the other Futurist pictures presented in our issue of Feb. 14. "Their (the Futurists) 'intoxicating aim' is to depict states of mind, to compel the spectator to live in the picture, which must be the synthesis of what we see and what we remember. For instance, they argue, when the right shoulder or the right ear of an individual is shown, it is useless to represent also the left shoulder or the left ear of that figure. Further, they do not illustrate sounds, but the vibrating intervals between sounds.——

Photographs by Delius. [*Continued opposite.*]

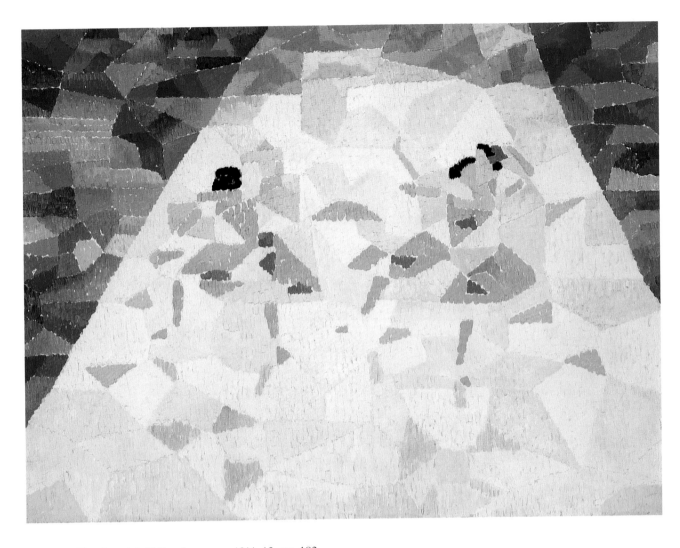

ABOVE Gino Severini, *Yellow dancers, ca.* 1911–12, cat. 182

RIGHT Gino Severini, *Dancer no. 5,* 1916, cat. 183

THE SECOND POST-IMPRESSIONIST EXHIBITION

Duncan Grant, Poster for the *Second Post-Impressionist Exhibition*, 1912, cat. 105

THE *Second Post-Impressionist Exhibition* opened at the Grafton Galleries on 5 October 1912 and ran initially until the end of that year. The exhibition was then extended, with some alterations, until the end of January 1913. During this time it has been estimated that in the region of 50,000 people attended the show.

The *Second Post-Impressionist Exhibition* was an international show.[1] A total of around 257 works were divided into three sections: French, English and Russian. The Bloomsbury critic Clive Bell chose the English section, Boris Anrep, a Russian artist and associate of the Bloomsbury circle, selected the Russian section, and the French section was put together by Roger Fry. Each wrote a short essay in the catalogue by way of introduction to their section.[2]

A large poster [cat. 105, repr. this page], the product of the collective efforts of Vanessa Bell, Roger Fry, Duncan Grant and Frederick Etchells, advertised the exhibition. Bell and Fry conceived the initial design, Grant made the drawing of the head of a woman with an upraised arm (who is probably Vanessa Bell), and Etchells added the lettering. The poster was printed in black and white and in a collectors' edition of either green or orange.[3] The poster has a stark modernity which reflects the focus of the exhibition: up-to-date modern art. In this respect the show's title, the *Second Post-Impressionist Exhibition*, was misleading. It might have been assumed that it consisted largely of late nineteenth-century art, whereas recent works by Matisse and Picasso, both living and practising, dominated the exhibition.

The art criticism that Fry wrote in 1911 and 1912 shows his growing interest in modern art and the international art exhibition scene, and this is reflected in his selection for the *Second Post-Impressionist Exhibition*. A review of the Sonderbund exhibition in Cologne, held in spring–summer 1912, which in some respects was modelled on *Manet and the Post-Impressionists* with "a room for Cézanne, another for Gauguin, and whole galleries full of Vincent Van Gogh", shows that his opinion of the original triumvirate had changed.[4] Not surprisingly, he liked Gauguin's *Poèmes barbares* (1896; Cambridge MA, Fogg Art Gallery), which he had used for the poster of *Manet and the Post-Impressionists*, and which Michael Sadler acquired for his collection shortly after seeing it in the Cologne show.[5] However,

Fry expressed reservations about Van Gogh. In 1911, he had prophesied: "We in England shall probably wait twenty years and then complain that there are no more Van Goghs to be had except at the price of a Rembrandt."[6]

In 1912, after seeing the Van Gogh pictures at the Sonderbund exhibition, he decided that Van Gogh was a less advanced artist than Cézanne. His use of colour, he said, was "just a little monotonous" compared to Cézanne's "sombre discretion".

"The astonishing thing is not that there should be unassimilated, imperfectly fused, merely factual elements in Van Gogh's art – elements which, to our heightened sense of expressive form, are no longer tolerable – but that Cézanne, the begetter of the whole movement, should still remain supreme and unsurpassed."[7]

Matisse and Derain were also represented at Cologne. Tellingly Fry conceded that, while they may not have reached Cézanne's standards, they still were more advanced than Van Gogh. He compared a portrait by Van Gogh to Matisse's *Portrait of Marguerite* (Paris, Musée Picasso). Van Gogh's portrait retained unnecessary factual and descriptive elements which detracted from its expressive design and made it lack the "complete fusion and transmutation of a rhythmic idea".[8] Fry's evolutionary model to explain the complex developments of modern art had strengthened since 1910.

Increasingly Fry put his faith in living artists. Neither Gauguin nor Van Gogh were represented in the initial hang, although the publisher T. Fisher Unwin did lend a Van Gogh still life (which, according to Frances Spalding, usually hung outside his flat at the Albany), to the extended show.[9] Instead, photographs were displayed illustrating the chronological development of their art. The only artist in the *Second Post-Impressionist Exhibition* who was represented posthumously was Cézanne. To Fry, Cézanne's timeless, universal quality represented the critical yardstick by which the evolution of modern art could be measured. His achievement, according to Fry, represented a crucial historical rupture.

CÉZANNE AND CÉZANNISM

Initially Cézanne was represented by six landscapes and a few watercolours. They hung on their own in the small Octagon room at the entrance to the main galleries. This arrangement effectively introduced Cézanne as the spearhead of an impressive group of living artists in the modern movement. As Hind wrote, Cézanne was "the spiritual father of these moderns, who, whether they like it or not, are grouped together under the title of Post-Impressionists. The meshes of the net are wide, but these revolutionaries must be called something."[10]

In fact the popular view of Cézanne had changed dramatically. The general consensus in the press was that "Cézanne's battle ... is already won". He was "a mighty precursor".[11] As *The Glasgow Herald* pointed out, "pictures by him are now treasured in several public galleries abroad, and in this country the time is ripe generously to welcome sensitive limpid landscapes such as the *Le Dauphin* [sic], interpretations of nature's fairness like *Les Moissonneurs*".[12] *The Times* opined that the landscapes by Cézanne, who was the "spiritual father of the moderns" were "beautiful".[13]

It is no wonder that Fry was to reflect a month after the exhibition opened: "Two years ago Cézanne's works drew down the most violent denunciation. He was 'a butcher who had mistaken his vocation', a bungler who could never finish a picture, an imposter, he was everything that heated feelings and a rich vocabulary could devise. This year Cézanne is always excepted from abuse."[14]

In January 1912, the complexion of the *Second Post-Impressionist Exhibition* changed when a number of the Matisse and Picasso exhibits were sent to New York for the Armory Show. More than thirty works by Cézanne were hung in their place, including many watercolours (cf. cat. 19). After seeing them even Cézanne's most hard-bitten opponents were convinced of his greatness. They were familiar with the long tradition of English watercolour sketches done directly in front of nature, and Cézanne's watercolours convinced them that he was still in touch with nature. Konody said that they showed that Cézanne made "daily excursions to record impressions of Nature's vastness as well as her details" and that they explained why he was "revered by French artists".[15] *The Times* also praised the addition of Cézanne watercolours. It thought that the watercolours

LEFT Jean Marchand, *Still life*, 1911, cat. 144

BELOW Maurice de Vlaminck, *Buzenval*, 1911–12, cat. 188

RIGHT André Derain, *Window at Vers*, 1912, cat. 29

best illustrated the essential differences between Cézanne and the Impressionists. While Cézanne shared the Impressionists' interest in reality, he tried "to discover in it designs of abstract grandeur". Cézanne "found music in masses, and he has ... given a new start to European painting."[16]

Fry's achievement in re-educating the British about Cézanne was considerable. One only has to compare the sentiments of two popularizers, the Irish writer and critic George Moore who moved on the fringes of the Impressionist society in the 1880s, and Clive Bell, who flirted with the next generation of French artists. The first appears in Moore's *Reminiscences of the Impressionist Painters* (1906): "His work may be described as the anarchy of painting, as art in delirium. It is impossible to deny to this strange being a certain uncouth individuality; uncouth though it be there is life in his pictures, otherwise no one would remember them."[17] The second appears in Bell's *Art* (1914), where Bell wrote his fatuous remark that Cézanne was "the Christopher Columbus of Modern Art".[18]

Why was Fry determined to establish Cézanne as the father of modern art? Did he assign an authoritative, paternalistic rôle to Cézanne, and suggest that his work had its own recognizable stylistic autonomy, in order to create an interpretative baseline from which he could view the discrepancies, discontinuities and changes that confronted him when he looked at modern art? As a dead artist Cézanne could not offer any further surprises.

Most of the French artists in the *Second Post-Impressionist Exhibition* were Cézannists at some stage or other. Cézanne's *Three bathers* (Paris, Musée du Petit Palais), which he bought in 1899, taught Matisse how to be a modern artist. After the great Cézanne retrospective exhibition at the Salon d' Automne in 1907, Derain's work underwent significant changes, as William Rubin has pointed out. In the words of Kahnweiler, Derain was the painter who "more than any other communicated to his colleagues, through his paintings and in his words, the lessons of Cézanne".[19] Cézanne was first detectable in Picasso's work of 1905–06, and again in 1908–09 (cf. *Two trees*, cat. 167, repr. p. 74).

Cézanne's appeal was never simply stylistic. His popularity grew during an intense period of nationalism and neoclassicism. Braque saw Cézanne as a conservative deeply attached to tradition. Friesz also thought of Cézanne as the latest representative of the classical tradition.[20] Many of the French works in the exhibition had a strong Cézannesque element. Friesz's *Paresse* [fig. 19] belongs to a group of figure compositions begun in 1907 which mark his sudden rejection of the bright colour of the La Ciotat pictures (cf. cat. 41), which were frequently illustrated in *Rhythm*, for a sombre classicism that had clear links with Cézanne. Friesz owned a large number of Cézanne reproductions. His greatest admiration was for Cézanne's *Bathers*, as is evident in the large classically inspired figures in *Paresse*. The classically ordered, lyrically conceived landscape and the motif of the mountain are Cézannesque features which appeared in later landscapes (cf. cat. 42, repr. p. 168).

Window at Vers, 1912 [cat. 29, repr. p. 67], which is one of thirty-seven still-life paintings that Derain sent to Kahnweiler in 1912, is rich with allusions. The contrast of the sombre, ordered still-life elements on the table with the more frivolous arrangement of the flowers on the window ledge and the geometric shapes of the window and table viewed at an odd angle can be related to Cézanne, but combines several conventions. The calm, ordered landscape (which surely must have impressed the young Paul Nash), framed by overhanging branches and foliage, and then again by the window framed by the curtain, owes as much to Poussin as it does to Cézanne. It reflects Derain's increasing commitment to studying the Old Masters and his interest in the subtle differences between genres as a way of renewing his own art.[21]

Not surprisingly, *Window at Vers* appealed to the more traditional critics – to Konody, who, recognizing its debt to tradition, said it was painted in "a pleasantly archaistic imitation of a Pier dei Franchesi [*sic*] background".[22] *The Times* thought *Window at Vers* was a "picture in the great classical tradition" which, it said, "looks Post-Impressionist mainly because the artist has simplified all his forms further than any artist of the seventeenth century and because he has tried to keep his masses of paint alive rather than smooth". Derain was "an accomplished artist by modern standards".[23]

FIG. 19 Othon Friesz, *La Paresse*, 1909, whereabouts unknown, as reproduced in the catalogue of the *Second Post-Impressionist Exhibition*

CUBISM AND THE CRITICS

Many British critics confused Cézannesque painting and Cubist painting. The distinction in terminology is clear-cut in the case of Braque and Picasso who had abandoned a traditional system of representation. But in the case of Marchand (cf. cat. 144, repr. p. 66), who maintained a traditional system of representation while introducing facetted geometric simplification, the differences are not so obvious. This was also the case with Vlaminck who fell under the influence of Braque and Picasso yet never abandoned traditional form and space. This element and the strong geometric simplification of *Buzenval* [cat. 188, repr. p. 66] caused one critic to remark that it was "cubism at its most plausible".

Roger Fry's knowledge of Cubism was sketchy in 1910, but his review of the Salon d'Automne of 1911, which, he said, was "an exhibition of cubism without the most successful cubists" because "neither Picasso, Herbin, nor Derain" were represented, reflects his determination to keep abreast of recent developments. Nevertheless, his understanding of Cubism remained limited. Geometrical simplification and classification of natural form was an ancient idea, Fry said. The difference was that the Cubists used it as a means of

ABOVE André Lhote, *Port de Bordeaux*, 1912, cat. 143

LEFT Pablo Picasso, *Poverty (Les Misérables)*, 1903, cat. 165

Jean Marchand, *Place de Ceret*, ca. 1912, cat. 145

Fry also suggested in his review that the "most successful cubists", in comparison to the Cubists who, unlike Picasso and Braque, exhibited in the Salon, had created "a strangely expressive language of almost musical abstraction".[26] This definition would be his launch-pad when he came to explain Picasso's Cubist works in London in 1912.

The arrangement of pears and apples which make a curving line around the flower-pot, the odd angles and disjointed viewpoints, and the feathered patches of colour in Marchand's *Still life* [cat. 144, repr. p. 66] are Cézannesque characteristics that had a strong appeal for Fry. He acquired a similar work, *Still life with bananas and apples* (Lewes, The Charleston Trust), which also was exhibited in the *Second Post-Impressionist Exhibition*, for his own collection, while Clive Bell acquired an urban scene.[27] This geometrically conceived picture explains why Marchand was included in the Section d'Or exhibition of Salon Cubists shown in October 1912. His obvious links with Cézanne (cf. cat. 145, repr. this page) and his seemingly avantgarde status appealed to both Bell and Fry.

Kees van Dongen, the Dutch artist whom Kahnweiler had supported for a while, became another favourite after Fry saw Van Dongen's show at Bernheim's in 1911. He was represented in the *Second Post-Impressionist Exhibition* by several portaits including *Portrait of Mme van Dongen* (Rotterdam, Boymans van Beuningen Museum). Van Dongen's predilection for corruption and vice was excused on the grounds that it was a national characteristic: "he is, after all, of the race of Rembrandt". His art was "turbid and imperfect". Oddly it was Van Dongen's ability to realize "the humanity of his models beneath the corrupt artificiality of their condition" that Fry liked.[28] Most observers would agree that Van Gogh's portraits have a far greater humanity than Van Dongen's. Fry's remarks show the extent of his willingness to place living artists at the top of his priorities.

The "most successful cubists" were represented in the *Second Post-Impressionist Exhibition* because Kahnweiler – Picasso and Braque's dealer – decided to support the show. Whereas the Bernheim-Jeune Gallery staged several high-profile one-man exhibitions of Matisse after he signed a contract with the gallery in 1909, Kahnweiler held no exhibitions of Picasso at the Kahnweiler Gallery in the pre-War years. He did, how-

expression in its own right. The Cubist room at the Salon d'Automne showed that some artists used Cubism for sensational effect, "mixing a quite photographic realism of certain parts, with a chaotic jumble of cubes and pyramids elsewhere".[24] But he thought others, including Fresnaye and Lhote, were more successful. His description of Lhote's *Port of Bordeaux* [cat. 143, repr. p. 71] explains why he included two pictures depicting the port in the *Second Post-Impressionist Exhibition*. Fry liked what he thought was "very like a child's drawing with its odd composition and elementary shapes … it gives one a sense of the wonderful and unexpected quality of a harbour with its incongruous collection of many disparate things, big boats, little boats, steamers, cranes, wharves, all brought together for some inscrutable purpose by the busy little ant-like men who scramble over and around their machines, and yet for all the discontinuity which is part of the naive attitude, it is held together in design just by that insistence throughout on a single geometric measure of all the forms."[25]

ever, stockpile works by Picasso even before Picasso signed a formal contract with him in 1912. Picasso was one of a small stable of artists, including Braque, Derain, Van Dongen and Vlaminck, whom Kahnweiler decided to support. By 1910 he had acquired over sixty works by Picasso, some of which he could easily have lent to *Manet and the Post-Impressionists*. He was willing to lend works by Derain and Vlaminck, as we have seen, in 1910; his failure to send works by Picasso and Braque was part of his carefully worked-out strategy. Certainly he allowed them to be represented in other avantgarde exhibitions abroad while withholding from organizing shows of their work in Paris. Secrecy fuelled mystique. Kahnweiler lent their work to one exhibition abroad in 1910, and to three exhibitions in 1911. In 1912 his interest in the international market took a rapid upturn and he lent nearly two hundred works to a total of eight international exhibitions and dealers' shows outside France, including the *Second Post-Impressionist Exhibition*.

Visitors to Kahnweiler's gallery from London included, as we have seen, Frank Rutter and Clive Bell, who remembered standing "in Kahnweiler's shop" with an intelligent official from South Kensington who admitted that the Picassos still puzzled him but he was a thorough convert to Derain.[29] In October 1911, Clive and Vanessa Bell bought Picasso's *Jars with lemon* (summer 1907) from the Kahnweiler gallery for £4 while visiting Paris, and Fry made several purchases there, including Picasso's *Head of a man*, 1913 (New York, Richard S. Zeisler; see further p. 153). The large consignment of four works by Braque, seven works by Derain, nine works by Vlaminck and thirteen works by Picasso which Kahnweiler sent to the *Second Post-Impressionist Exhibition* suggests that Fry and Bell persuaded him that the London art market had changed. His decision to support the London exhibition also reflects an increasingly ambitious scheme to capture the international art market.

Kahnweiler later said that the *Second Post-Impressionist Exhibition* had been a group show "of my painters for the most part, although there were other modern painters of the time" and that he collaborated with Fry and Bell when selecting works by his gallery artists.[30] Thirteen of the fifteen works by Picasso came from Kahnweiler's stock (see Appendix for their identification and present location). The other two were *Composition: The peasants*, which was lent by Vollard, and *Green bowl and black bottle*, which was lent by Leo Stein. The earliest was *Portrait of Suzanne Bloch*, autumn 1904, the latest *Head of a man with a moustache*, painted in the early months of 1912. Fry compared these early and late portraits, showing that the earlier picture demonstrated that Picasso was capable of painting a likeness, while he aimed at extreme abstraction in the Cubist portrait.[31] The majority of works, including two still lifes, *Still life with bananas* and *Green bowl and black bottle*, a landscape, *Landscape with two trees*, two 1909 drawings of heads, an important transitional picture, *Woman and mustard pot* [cat. 169, repr. p. 75], three 1911 pictures, viz. *Bottle and books*, which Vanessa Bell persuaded H.T.J. Norton to buy, *Buffalo Bill* and *Le Bouillon Kub* (The stock cube) and the 1912 *Head of a man with a moustache* plotted the development of Cubism in careful stages. Kahnweiler took a keen interest in how his artists developed over time. By 1912 he had photographic albums of the work of each gallery artist arranged in chronological order, which he willingly showed visitors to the gallery.[32]

Kahnweiler's gallery in the rue Vignon was small. He could reportedly show only six works at a time. He kept the best work out of sight, reserving it for his most important customers. Whether he allowed them the full run of his stock is not known. Did Fry and Bell choose *Man with a moustache* from Kahnweiler's collection of recent Picassos, or did Kahnweiler decide for them? Kahnweiler, who was far more used to lending to German shows, gave more support to the *Second Post-Impressionist Exhibition* than he did to the Armory Show in New York in 1913, when he lent four works by Picasso.[33]

The exhibition of a group of Braque and Picasso Cubist pictures at the *Second Post-Impressionist Exhibition* was an exceptional event in the early history of Cubism. The range of works by Picasso was clearly intended to show how Cubism had developed. Picasso was introduced to Britain as the leader of the Cubists. By comparison there was little discussion of Braque, who was represented by a single Cubist work and three others. Mark Roskill suggests that Picasso's rôle as the dominant artist in the partnership with Braque was explicit for the first time in the *Second Post-Impressionist Exhibition*. Kahnweiler had an influential rôle in the promotion of Picasso because the number of Cubist

ABOVE Pablo Picasso, *Two trees*, 1907, cat. 167

RIGHT Pablo Picasso, *Woman and mustard pot*, 1909–10, cat. 169

FIG. 20 Christopher Nevinson, *The arrival of the train de luxe*, 1913, as reproduced in *The Graphic*, 25 October 1913, p. 748

works by Picasso far outweighed the number by Braque.[34] Moreover, the only Cubist work by Braque, *Violin: Mozart/Kubelick* (early spring 1912), made a cerebral reference to Cubism. The letters KUBELICK were a reference to the great Czech violinist Jan Kubelik, father of the celebrated conductor Rafael Kubelik, which was an example of Braque's version of Symbolist synaesthesia in the convergence of art and music and at the same time a pun on 'Cubism' which he found irresistible.[35] The Braque hung in the same room as the most recent Cubist work by Picasso, *Head of a man with a moustache*. Konody was one critic who assumed that the letters KOU which appear in the top right corner of the Picasso portrait were an advertisement for Cubism. He made the same assumption about *Le Bouillon Kub* (early spring 1912; now lost), which hung in another room of the exhibition. But he was the only critic who struggled to explain the recently executed Cubist works – *Le Bouillon Kub*, Braque's *Violin: Mozart/Kubelick*, and Picasso's *Head of a man with a*

moustache. Like the Braque, *Le Bouillon Kub* incorporates a reciprocal phonetic wordplay on Cubism. The letters KUB painted on Picasso's *Le Bouillon Kub* was a *double entendre* that makes a jokey reference to the brand name of a stock cube and Picasso's own highly serious Cubism. "Note the significant connection between these CUBist masterpieces with the lettering 'KUB', 'KUBelick,' and 'KOU.' Can it be that Kubelik was chosen as a subject merely because his name begins with these three letters? ... And does not *Le Bouillon Kub* suggest that Picasso is merely laughing at his admirers, telling them 'These are the ingredients with which I stew my cubist bouillon'?"[36] Can we assume that these three works were selected simply because they served to announce the arrival of cubism in Britain in a light-hearted manner? Certainly the joke was not lost on Nevinson who incorporated KUB into the now lost *Arrival of the train de luxe* (cf. fig. 20). Three years later Wyndham Lewis would 'Blast' *Le Bouillon Kub* for being a bad pun (see p. 158).

What emerges clearly from the reviews of the *Second Post-Impressionist Exhibition* is that Picasso was seen to be the leader of the Cubists because it was thought his work had far greater originality. For example, Claude Phillips wrote in *The Daily Telegraph*: "M. Picasso, who was in his earlier development a 'fantaisiste' ... reappears here as the pontiff of the 'Cubistes', the head of this peculiar movement."[37] Without a significant number of works by Braque to which they could refer this was a natural assumption to make about Picasso.

It was Fry's view that the appeal of Picasso's work lay in the changes which occurred "with kaleidoscopic rapidity" so that "new conceptions" were constantly emerging. Picasso, Fry said, was "the most gifted, the most incredibly facile of modern artists" who was "continual[ly] experimenting". Fry saw this as Picasso's way of coping with a natural talent which could easily become academic, a tendency he "deliberately countered ... by adopting some more abstract and unrepresentative idea of form".[38]

In 1912, Fry admired Picasso's diverse experimentation more than he admired the individual works by him in the exhibition. The 1907 *Still life with bananas* and the 1908 *Green bowl and black bottle* appealed to Fry because they showed "the power of building up out of the simplest objects designs of compelling unity and precision" and because, more than in his other work,

they showed a "concentrated passion". But Fry admitted that he was taking the later Cubist works partly on trust. While understanding the basis of their construction, he could only apprehend their "purely abstract form", "dispassionately and intellectually".[39] In his analysis of Picasso Fry provided the quintessential model of the modern artist – his painting evolving in pursuit of new forms of abstraction. Moreover, his interpretation of Picasso's Cubist paintings as being essentially abstract established a prototype for subsequent formalist analyses of Cubism.[40]

Fry's view that Picasso's Cubist work was complex and challenging was one shared by Frank Rutter, who wrote: "It is highly logical, but to me it appears very complicated, but I confess for its proper elucidation at the moment je ne suis pas à la hauteur."[41] Their remarks suggest that they discussed Cubism with Kahnweiler, well known for discussing his pictures with selected customers, to whom he explained that Cubism was a philosophical system.

The gouache drawings *Head and shoulders of a man* (Basle, Galerie Beyeler) and *Head* (New York, Museum of Modern Art) with their highly simplified, strongly facetted, forms illustrated the first stage of Picasso's Cubist portraiture in the *Second Post-Impressionist Exhibition*. Few of the British critics commented on them. *Woman and mustard pot* of 1909–10 [cat. 169, repr. p. 75] took the brunt of their hostility. *Woman and mustard pot* is an example of the rapid development that took place after Picasso's stay at Horta in 1909, when he invented a distinctive facture which he "inserted into a pre-existing set of representational conventions".[42] It is far less obscure than the later Cubist portraits *Buffalo Bill* and *Man with a moustache*. The face is the most densely painted area of *Woman and mustard pot*. The simplified features are built up into a mass of facetted layers of green and ochre, and the head and torso supported by the right hand collapses with the weight into the right side of the painting so that the denser handling, in a sense, has a physical relationship to the posture of the figure. The pose and anatomy of *Woman and mustard pot* still allude to classical conventions for representation but they are simultaneously changed by cubist facets which transform the pictorial surface and deny reference to a classically modelled figure set within illusionistic space.

Woman and mustard pot is listed as *La Femme au pot de moutarde* in the *Second Post-Impressionist* catalogue. At least one critic translated the title too literally and described the woman as a deformity who "appeared to have the mustard smeared all over her",[43] while Konody, referring to the enlarged mass of the woman's face, said that it was evidence of "the clearly stated fact that the woman has just swallowed the contents of the pot".[44]

The jokes about *Woman and mustard pot* reflect the critics' underlying struggle to cope with the denial of conventional representation in the portrait, but, at least, as *The Times* said, "a human form was obscurely discernable". The critics were even less equipped to discuss Picasso's latest Cubist portraits. His analytic Cubist portrait *Buffalo Bill*, in which the broad-brimmed cowboy hat, long hair, moustache, beard and knotted neckscarf of this popular hero of the American West is transposed into a series of hieroglyphic yet representational signs, was described as a "kaleidoscopic conundrum".[45] Few made a distinction between any of Picasso's Cubist works. "Picasso states science, and when science swallows art, good-bye art ... I find Picasso's cubist portraits as unsympathetic as they are unintelligible."[46] Konody thought that "to profess that these jig-saw puzzles produce any emotion except hilarity could only be hypocrisy. The incoherent ravings of a lunatic may be caused by profound emotion, but they are as far removed from real poetry as Picasso's cubic pictures are from real pictorial art. Far be it from me to accuse this highly intellectual painter of insanity. In his work everything is deliberate and calculated; but, I repeat, these experiments have not the remotest connection with art. They are not even decorative as patterns. The best that can be said for them is that they are inoffensive in colour."[47] Even the sympathetic 'E.S.G.', writing in *The Daily Graphic*, struggled to describe the revolutionary nature of Picasso's Cubism: "Not one person in ten thousand who looks at Picasso's work knows as much about form and colour as he. If he chooses to arrange a head or a body in the form of cubes or triangles it is not because he imagines that to ordinary inspection a head or body looks like that, but because he is trying to resolve complex forms harmoniously into simpler ones."[48]

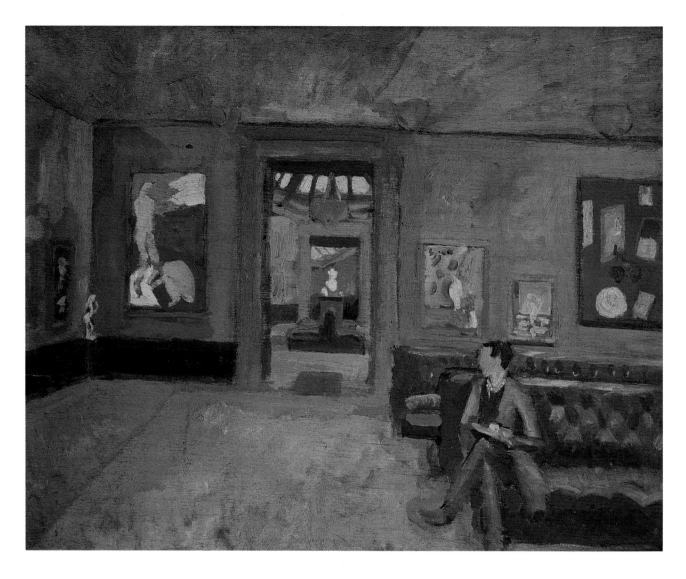

Attributed to Roger Fry, *The Matissse room at the Second Post-Impressionist Exhibition, at the Grafton Galleries, London*, 1912, cat. 46

MATISSE

Any lingering doubts that Fry may have had about Matisse had been dispelled by May 1911 when he confessed in a letter to Matisse's old friend Simon Bussy: "I am now become completely Matissite. I was very suspicious at the beginning of our exhibition, but after studying all his paintings I am quite convinced of his genius."[49] Whether Fry meant by "all his paintings" Michael and Sally Stein's collection is not clear, but it is certainly true that this was the most comprehensive display of Matisse's work available to him.[50]

Fry was taking Matisse more seriously by 1912.

Meanwhile Matisse needed a success in London. He did not sell a single work from a show in New York at the beginning of 1912 and he was poorly represented at the Sonderbund exhibition in Cologne in May with only five works. Moreover, as Picasso's reputation grew, Matisse's status within the Parisian avantgarde was being seriously undermined. As Fry admitted in his introduction to the catalogue, "The influence of Picasso on the younger men is more evident than that of Matisse". But it was Fry's view that both Matisse and Picasso stood out "at the present moment as leaders", and that "no sharper contrast can be imagined than

FIG. 21 Henri Matisse, *The red studio*, 1911, Museum of Modern Art, New York

FIG. 22 Henri Matisse, *Carmelina*, 1903, Museum of Fine Arts, Boston

exists between these men".[51] As Jack Flam points out, Matisse's new contract with Bernheim-Jeune which allowed no increase in prices suggests that the gallery viewed his work as difficult to sell.[52] Certainly Bernheim-Jeune decided to test the London market for Matisse. They lent six of his works to the *Second Post-Impressionist Exhibition*. Matisse also gave the show his full support by lending paintings still in his possession, some of which had not been previously exhibited. These included: *The young sailor II* (1906), *Luxe II* (1907), *Dance I* (1909), *Nude by the sea* (1909), *Still life with lemons*, *Marguerite with a black cat* (1910), which was reproduced in colour as the frontispiece of the illustrated catalogue, *Purple cyclamen* (1911), *The red studio* [fig. 21] (1911), *Goldfish and sculpture* [fig. 23] (1912). Two other recent works were exhibited for the first time in London, *Nasturtiums with Dance II* (1912) and *Conversation* (begun in 1909, completed in summer 1912),

which Matisse sold to Shchukin, who lent them to Fry's show. In total, Matisse was represented at *Second Post-Impressionist Exhibition* by nineteen paintings, eight sculptures, eleven "figure and landscape studies in pencil and pen and ink",[53] two watercolours, one woodcut [cat. 149] and some lithographs. (For the present location of these works, see Appendix.)

The rest of the exhibits ranged from *Carmelina* [fig. 22] (1903), which was probably the earliest, and included *La Coiffeure* (1907) and *The red Madras hat* (1907) which had caused a scandal at the Salon d'Automne in 1907. These exhibits represented significant moments in Matisse's exhibiting career, and formed a chronological survey of his development as a modernist. The idea of a survey had a strong appeal for Fry as he developed his own ideas about progressive modernism, but it was also integral to Matisse's own exhibiting practice. Matisse was particularly sensitive to the ways in which the selection of his work could show the development and evolution of his most recent painting. His first one-man show at Vollard's in 1904 of forty-five paintings and one drawing from 1897 to 1903 had set a precedent. His subsequent exhibition strategy followed this pattern, both in his one-man shows and at the Salon d'Automne in 1908, when he showed works done at various times "to prove the logic of his experiments and of his evolution", as Louis Vauxcelles pointed out.[54]

Fry hoped that Matisse would come to London for the opening of the exhibition. *The Matisse room at the Second Post-Impressionist Exhibition* [cat. 46, repr. p. 78] pays specific homage to Matisse, and especially to Matisse's *The red studio*, a painting about past, present and future developments in Matisse's art. The painting is attributed to Fry; however, Richard Shone states that it is by Vanessa Bell.[55]

Fry had praised *The pink studio* (Moscow, Pushkin Museum) at the Salon des Indépendants in 1911: "The perspective is by no means correct, but the artist has managed by a subtle adjustment of these rectangular forms in a strikingly coherent and indestructible unity to arouse in the spectator a sense of the amplitude of his ideal space ... the colour washed on with almost crude simplicity of handling is as satisfying as it is new and strange. The picture has that rarest of qualities, glamour, in that it gives to commonplace things a significance quite beyond what their ordinary associations imply."[56]

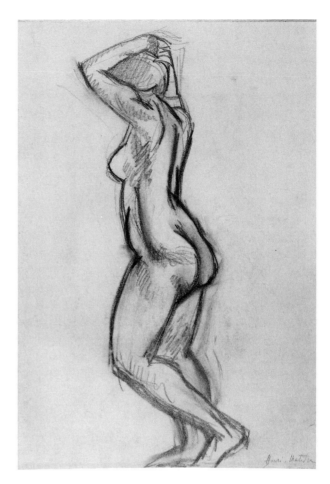

Henri Matisse, *Nude squatting in an armchair*, 1906, cat. 148

Henri Matisse, *Nude*, 1907, cat. 150

Oddly Fry described the objects depicted in *The pink studio* – the screens, furniture and the rug – but he did not mention any of the works of art that are visible, including *The girl with green eyes* which he had just sent back to Matisse from its showing in London. The hanging of the Matisse rooms which Fry undertook with Vanessa Bell suggests that they were fully aware of the significance of the works of art that we see in *The red studio* and that they recognized that they represented significant moments in Matisse's development.

Some of the works which Matisse lent to the *Second Post-Impressionist Exhibition* appear in *The red studio*. They are *Young sailor II*, *Purple cyclamen* and *Le Luxe II* which cluster to the right of the clock above two of

the sculptures that were exhibited – *La Serpentine* (the plaster cast was exhibited in London) and the plaster cast of *Jeannette III*. In the painting of the Matisse rooms we see *The red studio* hanging to the right of the doorway, and two other works painted in 1911, *Still life with aubergines* and *Wild daffodils*. Just glimpsed on the left wall is *The red Madras hat*. So what we see in *Rooms at the Second Post Impressionist Exhibition* is a chronological hang with a range of work made between 1907 and 1911. The exhibition space is not a studio space, as Fry would have realized. He could not begin to create a picture within a picture with *The red studio* as a starting point. But by grouping the works as he did, he was showing that Matisse's "whole development has

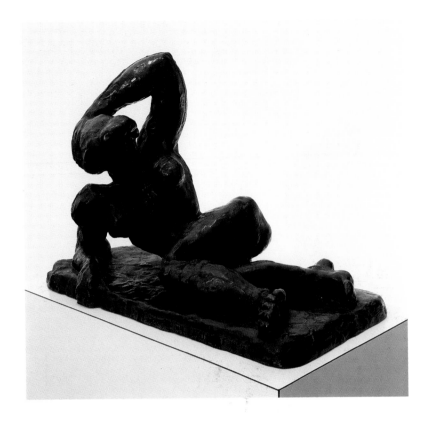

proceeded by ... clear and logically related steps".[57] Matisse's career as a modern artist was a process of discovery and imitation that became increasingly self-referential. This had an untold effect on the development of Bloomsbury painting.

Fry fully appreciated Matisse's achievements as a colourist. The examples chosen of Matisse's art illustrate his evolution from traditional modelling in light and shade, as seen in *Carmelina*, to translating "contrasts of shade into contrasts of pure colour", as seen in *The red Madras hat*. Finally Matisse learned "to dispense even with ... perceptible colour contrasts", so that in "his latest achievements with colour, the same identical colour may be used to express a number of distinct planes and different objects". Fry added, "This use of pure flat masses of colour ... enables him to give to colour a purity and force which has scarcely ever been equalled in European art."[58]

Yet Fry's liking for Matisse was not based entirely on formal concerns. There were many rude criticisms of *Conversation*, which explains why Fry chose it as an example of Matisse's recent work, pointing out that the depiction of the intimacy of a "commonplace event" (it represents Matisse and his wife in nightclothes) had a placid, monumental, epic quality that could be compared to Assyrian sculpture.[59] The Matisse rooms at the *Second Post-Impressionist Exhibition* would have staggered today's exhibition audience. Some of his most famous paintings were exhibited in London in 1912. Some of them were for sale. Sadly none of them have remained in Britain.

The consensus among the critics was that Matisse was a wonderful colourist. Most of them professed their admiration for Matisse's delectable colours – the luscious pink, blue and green of *Dance I*, the vibrant, deep red ground of *The red studio* which denies all illusion of naturalistic space, the intense blue of *Conversation* with its eerie stillness, and the extraordinary effect of the blue, green, orange and yellow in *Goldfish and sculpture* [fig. 23], about which *The Times* wrote: "The picture as a whole strikes the eye as a very novel and brilliant piece of colour ... this colour gets its ... vividness from the intensity of the artist's interest in what he represents ... it is colour expressing just what he has to say about

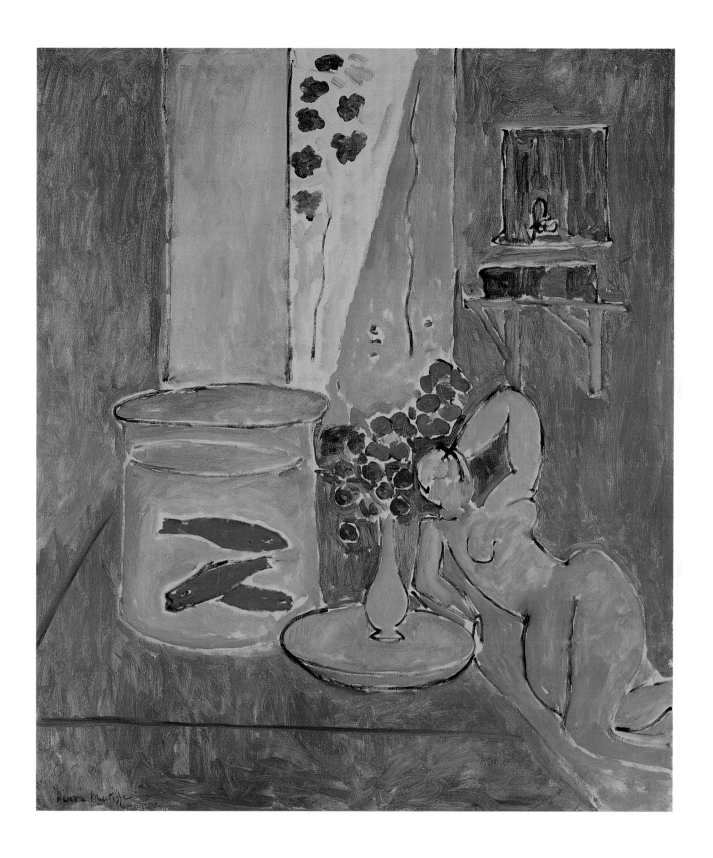

everything … the vase holding the nasturtiums seems a perfectly flat shape; and its colour has the value and force that can only be given by flatness … the enclosing line makes it swim in light and has an abstract beauty of its own. Indeed the quality of the paint in this picture is beautiful throughout; and … [is] beautiful in many other pictures." Even the sceptical Konody was forced to admit that Matisse's "inventions of rare schemes of boldly, yet subtly, contrasted colours are almost without exception pure delight to the eye".[60]

Yet this sensual appreciation of Matisse's colour elicited an underlying puritanical judgement about Matisse's stature as an artist, and doubts were raised about whether he was a great artist. As Claude Phillips said, Matisse expressed "the rhythm of life" which he thought that "another, more greatly gifted than he, may lift into mid-air on the wings of inspiration".[61]

Matisse, of course had other British admirers, including Hind, who praised him for "liberating our eyes to a new kind of beauty which … will sweep from his designs like music, and which rests the heavy-laden like music". Hind was a populist. His insistence that Matisse had an "inhuman personality" who used "women, gold fish, and flowers as if they were fabrics", who painted "as if there were nothing in the world but himself", reflects another consensus.[62] British critics thought Matisse's art lacked humanity. "He is an artist whose vision is not controlled at all by the ordinary human interests or by the ordinary human notions of the visible world", wrote *The Times*. It said *The red Madras hat* was "a woman is painted as if she were an animal. The artist does not seem to express any human relation of his whatever with her. He has simplified her face and her form just as ruthlessly as if she were a piece of still life."[63]

This hesitation about Matisse's way of representing the human figure can be seen in the different reactions to *Dance I* (cf. fig. 26). Several critics, including Fry and Rutter, had reviewed *Dance II* when they saw it at the Salon d'Automne in 1910. Fry saw *Dance I* in Matisse's studio in 1909, and *Dance II* in June 1910, but at the time he had strong reservations about Matisse. His review of the Salon d'Automne in 1910 where he saw *Dance II* again shows that he had hardly changed his opinion. He complained about the "extremely crude chord" of the colour which he said had "no elusiveness, no play, no hint of infinity". However, he did admire

the "original linear rhythm, which comes out finely in the ring of dancing figures".[64] The fact that two years later Matisse had a prominent position in the *Second Post-Impressionist Exhibition* shows how elastic Fry's thinking about modern art was in these years. Rutter also reviewed the Salon d'Automne in 1910. He warned his readers that it was pointless to say "you do not like the raw blue and green against which the red figures … are dancing" because "those same figures are tremendously expressive of life and movement" and, he added, "to deny its emotional force or the mastery of its execution is to confess a lack of sensibility."[65] *The Times* thought "the peculiar inhumanity of Matisse" was "most obvious" in *Dance I*. "He is not interested in his dancers as women. He is interested in the rhythm which they make together", and, although he was "an artist of great powers", he was "wilfully perverse" because he showed "complete detachment from all human interests".[66] "Was it necessary for the realisation of this rhythmic effect to deny the beauty of the human form?" asked *The Spectator*.[67]

Konody also had strong views about the figures in *Dance I*, which he thought were "repulsively contortionate caricatures of nature and humanity". He was willing to admit that Matisse's "inventions of … contrasted colours are almost without exception pure delight" but, he said, there was "throughout his work what appears to be research for the repulsive in form and movement".[68]

So keenly did *The Times* assume that Matisse treated the human figure in an inhuman manner that it failed to recognize that the nude in *Goldfish and sculpture* was in fact the sculpture *Reclining nude no. I* [cat. 152, repr. p. 82] and complained that the "nude is merely still life … he is much more interested in the goldfish in the bowl and the nasturtiums in the green vase".[69]

The works by Matisse that were most soundly abused were the four versions of *Head of Jeannette*. "The Frenchman is in the act of mutilating beauty. We see his baneful progress in the several stages of the *Buste de Femme*, and finally in the disgusting *Femme Accroupie*." Plaster casts of *Jeannette I, II* [cat. 153, repr. p. 88] and *III* were "dotted about" in the Centre Gallery and a bronze cast of *Jeannette IV* (cf. fig. 24) was placed in the last room of the exhibition. An installation photograph [fig. 26] shows *Jeannette IV* flanking *Dance I* while on the other side is *Seated nude (Olga)*, 1910. Eric Gill's

RIGHT FIG. 24 *Head of Jeannette IV* and *Reclining nude no. 1*
by Matisse as displayed in the *Second Post-Impressionist
Exhibition*

BELOW FIG. 25 *Heads of Jeannette I, II, III,* by Matisse as
displayed in the *Second Post-Impressionist Exhibition*

LEFT FIG. 26 *Dance I*
and the sculptures
Seated nude (Olga) and
Head of Jeannette IV by
Matisse and *Garden
Statue* by Gill as
displayed in the *Second
Post-Impressionist
Exhibition*

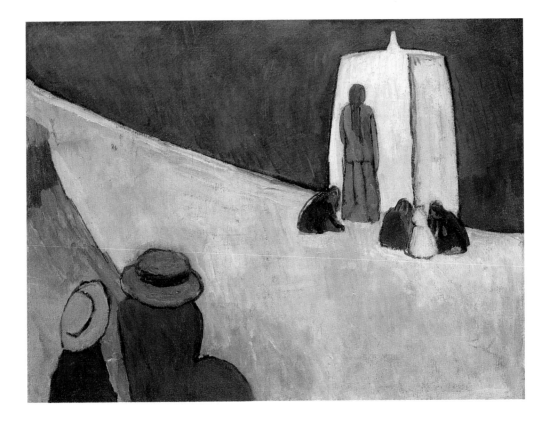

LEFT ABOVE Vanessa
Bell, *Nursery tea*, 1912,
cat. 5

LEFT BELOW Vanessa
Bell, *Studland Beach*,
ca. 1912, cat. 4

ABOVE Duncan Grant,
*The Post-Impressionist
ball*, 1912, cat. 106

RIGHT Duncan Grant,
*Ladies in Friar's Walk,
Lewes, ca.* 1912, cat. 104

Henri Matisse, *Jeannette II*, 1910, cat. 153

Garden statue is positioned in front of *Dance I*.

In the first two versions, the modelling is naturalistic, although there is a greater degree of simplification in *Jeannette II* which is made more apparent by the geometric base seen in the photograph taken in 1912 [fig. 25]. It contrasts with the original, slightly rounded triangular shape of the base for *Jeannette I* and complements the softness of her features and wavy hair. In *Jeannette II* the features are simplified and the hair becomes a block-like mass which the two blocks of the base accentuate. In *Jeannette III* and *Jeannette IV*, descriptive naturalism is no longer a priority. Having accentuated the blockiness of the head in *Jeannette II*, Matisse used the rounded forms of *Jeannette I* as a starting point for experiment with more rounded, bulbous shapes so that the hair and features of *Jeannette III* and *Jeannette IV* appear to be implanted with organic

matter that makes them swell and protrude.

What seemed to be an audacious transformation from a recognizable portrait head to one that in the later versions is deliberately deformed outraged many British critics, including Konody, who was unrelenting in his condemnation. The sculpture was "unredeemed, deliberate" – clearly deliberate as Matisse "himself proves by showing a *Buste de Femme* in four consecutive stages of completion, in which the approximate resemblance to a human being of the first stage is gradually eliminated until the final head in bronze assumes an aspect of inexpressible loathsomeness, such as could not be even distantly approached by the most debased and depraved type of humanity". It is hardly surprising that when Fry defended Matisse (and Picasso) in 'An Apologia' published in *The Nation* a month after the exhibition opened, he took the criticisms of the *Jeannette* series – that they were ugly and repulsive – as a point for retaliation. Although, oddly, Fry did not group them together in the exhibition, what he admired was their successive evolution from a head which had been sculpted "more or less naturalistically" to the final result, *Jeannette IV*. (In fact, Matisse was to sculpt one more version.) As a likeness, *Jeannette IV* was "monstrous and repellent" but "judged as pure form … has an intensity … which gives it the same kind of reality as life itself".[70]

In 1912 Vanessa Bell, Duncan Grant and Roger Fry were Matisse's warmest supporters in Britain. No other British critic matched Fry in his elucidating comments about Matisse. When Grant saw the Matisses hanging at the Grafton Galleries just before the exhibition opened in 1912, he described them simply as being "radiantly beautiful".[71] Neither Fry nor Bell nor Grant formed a close friendship with Matisse in the way that they did with Derain, for example. But they did visit him in his studio: Fry for the first time in May 1909; Grant for the first time in April 1911; Bell with Fry in 1914 and Fry again in 1916 are amongst the recorded visits. Evidence would suggest that they kept fairly close track of Matisse's most recent works in the years before the First World War. For example, Grant saw Matisse's Morocco pictures at the Bernheim-Jeune Galleries in Paris in April 1913. When Vanessa Bell saw two examples of Matisse's latest work in his studio in 1914, she confided to Grant that they "didn't seem to me as good as his earlier work."[72] There are many examples

Roger Fry, *Summer in the garden*, 1911, cat. 45

Vanessa Bell, *Virginia Woolf*, 1912, cat. 6

of works by Bell, Fry and Grant which borrow from Matisse. The nearly featureless, mask-like faces of the figures in *Dance I*, in *Conversation* and in the portrait *Joaquina* (Prague, National Gallery) are undoubtedly the source for Fry's *Summer in the garden* of 1911 [cat. 45, repr. this page], which depicts Vanessa Bell convalescing. (It was painted before the *Second Post-Impressionist Exhibition* but after Fry had started to study seriously the works of Matisse.) As Simon Watney has pointed out, Matisse's *Le Luxe II* undoubtedly inspired Vanessa Bell's *The tub* (London, Tate Gallery). And whatever the psychological implications and gender politics of Vanessa Bell's portrait *Virginia Woolf* [cat. 6, repr. this page] Matisse again is a source for her treatment of the face, both here and in the two different paintings entitled *Conversation* (Univerity of Hull and London, Courtauld Institute Galleries).

The all-over red background of Matisse's *The red studio* is an obvious source for the vibrant red in the two portraits of *Iris Tree* [cats. 10 and 111, repr. p. 154] painted on the same occasion by Vanessa Bell and Grant. (They also would have known Gauguin's *Vision after the sermon* [fig. 16], which has an anti-naturalistic red background.) Indeed *The red studio* may account for the noticeable preference for red seen in paintings by Bomberg and Lewis (see further below, p. 152). Further, the example of Matisse had a profound effect on the way that Vanessa Bell and Duncan Grant regarded themselves as artists.

THE ENGLISH GROUP

By comparison very little was said about 'the English Group' in the *Second Post-Impressionist Exhibition*. Only a few critics bothered to comment on Clive Bell's final selection of Vanessa Bell, Frederick Etchells, Jessie Etchells, Roger Fry, Eric Gill, Spencer Gore, Duncan Grant, Henry Lamb, Wyndham Lewis and Stanley Spencer. (Bell had hoped that Augustus John would also show with 'the English Group' but, as we have seen, John declined the invitation.) When the show was extended and rehung in January 1913, Wadsworth was added to the English group and the selection of work by some of the others was increased.

Bell claimed in the catalogue that the debt of the English group "to the French is enormous", and that "each owes something, directly or indirectly, to Cézanne". But he added that the point was not to play the detective

Duncan Grant, *Bathing*, 1911, cat. 101

RIGHT Duncan Grant, *Football*, 1911, cat. 102

BELOW Duncan Grant, *The kitchen*, 1914
(reworked 1916–17), cat. 110

and identify their debt. What he was looking for in his selection was "simplification and plastic design". What all Post-Impressionist artists had in common was that they concentrated on "the significance of form" (Bell used this phrase for the first time here).[73] Oddly the selection of works in the English section did not always match the radicalness of Bell's sentiments. This may explain why very few of the critics bothered to mention them.

Roger Fry was represented by five works: *The cascade*, *Newington House*, *Angles sur Langlin* ("a charming French riverside scene" but "rather impressionist than post-impressionist"), *The terrace* (private collection) and *Siena*. Of these, Fry's favourite was probably *The terrace*, which he reproduced in the catalogue. Clearly Fry wanted to signal his strong interest in Cézanne's painting. He introduced Cézannesque elements into his own work in 1911, as evident in *Summer in the garden*. Cézanne's influence was noted in the work that Fry showed at the Alpine Club Gallery in January 1912, which included *Chauvigny* [cat. 43, repr. p. 169]. The simplification and distortion of seemingly solid shapes, and the treatment of the sky in *The terrace*, are a good indication of how Fry "saw" Cézanne by 1912. *The terrace* shows how Fry turned the most fluid and atmospheric aspects of Cézanne's landscapes into something rigid. There is no doubt that Fry's interpretation of Cézanne had a pervasive effect on English painting.

In September 1912, two weeks before the exhibition opened, Duncan Grant had not completed the pictures intended for the Grafton show: I am "trying to finish some dozen of pictures for this blessed Grafton Show. I almost believe Uncle Trevor was right and that I shall end my days in the Royal Bethlem Hospital surrounded by hundreds of unfinished works."[74]

In the event Grant was represented by six pictures: *Pamela* (New Haven, Yale Center for British Art), *The dancers* [cat. 103, repr. p. 174], *The Queen of Sheba* (London, Tate Gallery), *The countess*, *Seated woman* (London, Courtauld Institute Galleries) and a portrait of the artist Henri Doucet – recent works which reflected his experiments in stylistic diversity. Essentially these works reflect Grant's response to *Manet and the Post-Impressionists*, which he visited frequently. Richard Shone observes that Grant's season ticket to 'Manet and the Post-Impressionists' "is battered from use, as well

as drawn on".[75] The exhibition turned him into a modern artist.

Early modernism was self-referential. Artists who engaged in the project of early modernism imitated each other, as Grant quickly recognized. As Richard Shiff has pointed out, "Such imitation of attitudes, practices and customary actions in no way amounts to copying, but involves free expression."[76] In April 1911, as Frances Spalding has discovered, he made his first trip to Matisse's studio, where, according to Grant's account, Matisse was beginning work on *Nasturtiums with Dance I*.[77] Much to Grant's amazement Matisse grew the nasturtiums which appear in the picture in his greenhouse.[78] Grant also probably saw *Dance I*. It gave him a new-found confidence in depicting the human figure – the male bathers and footballers who play with abandon in the murals Grant, among others (see fig. 27), made for the Borough Polytechnic [cats. 101 and 102, repr. pp. 90 and 91] in summer 1911, the leaping figures in the Brunswick Square murals (destroyed).

The date of Grant's first visit to Leo and Gertrude Stein's collection is unrecorded. By 1913 he had begun to incorporate aspects of pictures he saw there into his own work, including Picasso's *Nude with drapery* (St Petersburg, The Hermitage), which he said made him weep the first time he saw it. During this period of induction Grant consciously imitated a number of modern styles. No single work epitomizes his first modernist style. This process of imitation involved different methods of mark-making: the Cézannesque handling in *The dancers*, the pointillist technique known as his 'leopard technique' (as in *Ladies in Friar's Walk, Lewes*, [cat. 104, repr. p. 87]), which, as Simon Watney has suggested, probably derives from seeing works by Matisse which adapted Signac and Cross's pointillism, and the diagonal hatching in *Artist's camp* [cat. 107], which derives from Picasso's *Nude with drapery*. Grant's exhibits in the *Second Post-Impressionist Exhibition* were noticeably eclectic: *Pamela* was compared to Vuillard; the *Queen of Sheba* was a charming piece of decoration; *The countess* showed Grant "merely emulat[ing] Matisse at his silliest"; *The dancers* "wrestle[d] unsuccessfully with a problem triumphantly solved by Matisse". As Rupert Brooke observed, "He is roaming at present between different styles and methods."[79]

By comparison, Etchells combined different techniques with free abandon in *The dead mole* [cat. 36, repr.

1. "PADDLING IN THE PARK." BY ALBERT ROTHENSTEIN. 2. "HAMPSTEAD HEATH." BY F. ETCHELLS. 3. "FOOTBALL." BY DUNCAN GRANT.
4. "PUNCH AND JUDY." BY MAX GILL. 5. "SAILING BOATS, ROUND POND." BY B. ADENEY. 6. "THE ZOO." BY ROGER FRY.

The pictures here reproduced are mural decorations set up at the Borough Polytechnic towards the end of last year. They are by Mr. Roger Fry and a band of other artists who, in inaugurating this new movement in art, believe themselves to be producing the first examples of the art of the future. Their aim is to convey idea or scene in the simplest possible manner—to eliminate as much detail as they can, so that their work will appeal to the emotions rather than to the ordinary senses. The paintings in question have been the cause of considerable controversy and some ridicule, but a number of eminent men of science and letters have given them their approval. Mr. Roger Fry is the editor of the "Burlington Magazine," and the well-known art critic. The photographs of the pictures were supplied by Messrs. Hanfstaengel, of 16, Pall Mall East.

FIG. 27 *The Sketch*, Supplement, 6 March 1912, pp. 6–7

p. 98]. The subject of *The dead mole* appears to be the flirtation between an older man and a young boy. The undulating arabesque forms of the landscape and the flat areas of colour are Gauguinesque, the broken colour technique derives from pointillism, the arbitrary use of colour originates in Fauve painting. Its awkwardness reflects a lack of familiarity with these techniques. On the other hand, Grant's mixed Post-Impressionist technique of *ca.* 1913–14 has a confidence that reflects his far greater understanding of the painting process. *The kitchen* [cat. 110, repr. p. 91] is a brilliant example of Grant's mixed Post-Impressionist style. It combines a number of French painting techniques and uses them with complete originality. The odd angle of the room divided by a panel (which was copied from two

Italian fairground columns, brought back from Venice in 1913), the table which veers at a right angle and the intimate subject-matter – three women in a kitchen – derive from Vuillard. Vuillard used these odd angles to represent stifling proper bourgeois domesticity, but this is not the case with *The kitchen* which has a strong auto-biographical element. The naked man who glances coyly over his shoulder at the woman cuddling a child rather than the more sexual woman with her breasts exposed is a self-portrait. It probably alludes to Grant's homosexuality and his known delight in the maternal comfort and domestic security that Vanessa Bell provided. The ochre colour is applied in a distinctive Cézannesque feathered patch. The all-over application of ochre and the arbitrary grey-green and reddish-

LEFT Henri Gaudier-Brzeska, *Self-portrait*, 1913, cat. 54

RIGHT Harold Gilman, *Portrait of Sylvia Gosse*, 1912–14, cat. 67

RIGHT Henri Gaudier-Brzeska, *Sophie*, 1913, cat. 53

orange colour of the two female figures who face us, which derives from the painted column, relates to Matisse. The curving blue line around the back of the chair which is repeated twice in the sleeve of the dress and the light green outline of the bodice repeated on her jawline is highly sophisticated. The mask-like features of the figure on the left derive from Picasso's great *Demoiselles d'Avignon* project for which Leo and Gertrude Stein owned many of the sketches. Clive Bell's definition of 'significant form' was an argument against representation. It was a wholly inadequate term for Grant's painterly experiments in colour.

Like Grant, Wyndham Lewis recognized that imitation was a key characteristic of modernist art. The work executed between 1910 and *ca.* 1913 borrows heavily from modern European art, much of which Lewis saw in London, but these sources are more discreet than they are in Grant's work. The most controversial of Lewis's exhibits in the *Second Post-Impressionist Exhibition* was the lost *Mother and child*, a reproduction of which Lisa Tickner has recently discovered in *The Sketch* [fig. 28].[80] Several critics saw a connection between *Mother and child* and Picasso's Cubism. Konody who, as we have noted, did not have an enlightened understanding of Cubism, suggested that Lewis had "simplified and standardised Picasso's cubism".[81] Rupert Brooke said he was "more or less alone in resembling Picasso".[82] The geometric simplification which, Konody quipped, had been determined with "compasses and T-squares" of the figure of the mother and child is readily apparent in reproduction, but there is no evidence that it had the sophisticated spatial configuration of the mature Cubist works by Picasso and Braque in the *Second Post-Impressionist Exhibition*. The geometric treatment in *Mother and child* owes as much to the Futurist works Lewis saw at the Sackville Gallery, which in turn 'borrowed' from Cubism. It was also far closer to the work of the 'Salon Cubists' such as Lhote. Cubist terminology had a loose meaning amongst British critics. *The Sketch* reproduced alongside *Mother and child* Picasso's pre-Cubist drawing *Head of a man*, further evidence of a confused understanding of Cubism.

Many of Lewis's works do not survive from this period, which makes it difficult to determine his development. Some works by Picasso were an important stimulus but it is not known which ones Lewis had seen

or was able to see, given the low public profile of these works in France. *Sunset among the Michelangelos* [fig. 38, p. 148] was probably executed after he saw Picasso's *Woman with a mustard pot* and Matisse's *The red studio*. The angular geometric simplification of the magnificent *Smiling woman ascending a stair* (1911–12 [cat. 133, repr. p. 99]) owes more to the large-scale figure compositions of Metzinger and Gleizes. Referring to *Smiling woman ascending a stair* Lewis said, "that picture is a laugh though rather a staid and traditional explosion. The body is a pedestal for a laugh."[83] His interest in using the figure to express laughter and other emotions can be compared to Matisse's use of expressive figures, as, for example, in *Dance I*. The simplified, flat outlined figure in *Le Penseur* [cat. 135] also compares to *Dance I*. Lewis's subsequent abusive attack on Picasso and Matisse was the cry of a man who protests too much. The evidence of the work suggests that it does not reflect his attitude in this crucial early period.

There has been some speculation about why Lewis chose to depict a traditional mother and child image with its obvious religious connotations in an experimental modernist style.[84] Lewis's so called *Russian madonna (Mother and child)* [cat. 134], which depicts a non-European Madonna for which Gauguin's Tahitian female figures are the most likely source, is another example. The most likely source for these modern versions of a traditional theme was Epstein's *Maternity* [fig. 35]. Lewis would have been fully aware of the uproar it caused at the AAA (see further p. 134).

It is not difficult to understand why Eric Gill, the favourite sculptor of the Contemporary Art Society, was the only sculptor in Bell's 'English Group'. His exhibits included *The Golden Calf* [cat. 63, repr. p. 100], the sculpture that was originally intended for Mme Strindberg's cabaret-theatre club, *The Cave of the Golden Calf*, together with paintings by Charles Ginner and Spencer Gore [cats. 76 and 97, repr. p. 101] and by Lewis (see further p. 137).

By no means did Clive Bell's selection for 'The English Group' necessarily bring together the most radical example of works. According to Keith Clements, Bell misunderstood his instructions and borrowed the wrong work by Henry Lamb from Lady Ottoline Morrell's collection for the exhibition, much to Lamb's fury.[85] Lamb (cf. cat. 132) was represented by two works, *Composition*, the offending wrong picture owned

THE PICTURE OR THE BABY? WOULD YOU SAVE ONE OF THESE?

1. "THE QUEEN OF SHEBA." BY DUNCAN GRANT.
3. "HEAD OF A WOMAN." BY PABLO PICASSO.

2. "PORTRAIT OF MME. VAL DONGEN." BY VAL DONGEN.
4. "MADONNA AND CHILD." BY WYNDHAM LEWIS.

Our readers will recall that when the first Post-Impressionist Exhibition was held in this country we gave illustrations of a number of the pictures, including some reproduced with the aid of natural-colour photography. The second Post-Impressionist Exhibition is now being held at the Grafton Galleries. Of the pictures there shown we reproduce four typical examples. Sir George Birdwood has been taken severely to task for suggesting that, in case of fire, it would be better to allow a live baby to burn than a Dresden Madonna. His actual words, in a letter to the "Times" on vandalism at Philæ, were: "I would try to save both, but if the direful choice were forced upon me, I should certainly save the Dresden Madonna first. One can get another baby any day." Would any of our readers take the same view regarding the above works?—[Photographs by Topical and C.N.]

FIG. 28 *The Sketch*, Supplement, 9 October 1912, p. 9

ABOVE Frederick Etchells, *The dead mole*, 1912, cat. 36

RIGHT Wyndham Lewis, *Smiling woman ascending a stair*, 1911–12, cat. 133

Eric Gill, *The Golden Calf*, 1912, cat. 63

by Ottoline Morrell, and a portrait of Lytton Strachey. Clive Bell could be accused of timidity or of prejudice when it came to choosing Vanessa Bell's work. Vanessa Bell described them as "four things at the Grafton which are quite ordinary and no one's ideas but my own, at least so I think!"[86] These "quite ordinary" works were a still life, *The nosegay*, which Roger Fry lent, *Asheham* (private collection), which was said to belong "to the inlaid linoleum type of Post-Impressionist landscape", *The mantlepiece* and *The Spanish model* (Leicester Museum and Art Gallery). *Asheham* and *The nosegay*

have some simplication of form, and the clear pinks and red of *The Spanish model* suggest her later simplified colour schemes, but the figure of the woman is still naturalistic. These works give little hint that *Manet and the Post-Impressionists* had made an impact on Vanessa Bell. Yet as Bell later admitted, "Here was a sudden pointing to a possible path, a sudden liberation and encouragement to feel for oneself which were absolutely overwhelming."[87] *The Bathers, Studland Beach* of 1911 [cat. 3, repr. p. 27] and *Studland Beach* of 1912 [cat. 4, repr. p. 86] are far more radical examples of

Charles Ginner, *Design for tiger-hunting mural in the Cave of the Golden Calf*, 1912, cat. 76

Spencer Gore, *Design for deer-hunting mural in the Cave of the Golden Calf*, 1912, cat. 97

Vanessa Bell's Post-Impressionism. The combination of naked male and female bathers, women in modern-day dress and young children in *The bathers* would have certainly shocked an Edwardian audience, especially when they realised that it had been painted by a married woman (Vanessa Bell was listed as Mrs Bell in the catalogue). This was reason enough not to consider it for the *Second Post-Impressionist Exhibition*. The subject of bathers by the seaside and the classical treatment of the figures relate to pictures by Denis, in particular *Ulysses and Calypso* [cat. 26, repr. p. 26], but also more modern-day versions such as the one Fry described in

Lucien Pissarro, *Wells Farm Bridge*, 1907, cat. 170

Spencer Gore, *Nearing Euston Station*, 1911, cat. 88

Spencer Gore, *Letchworth Station*,
1912, cat. 94

Spencer Gore, *The cinder path*,
1912, cat. 93

his 1911 review of the Paris Salons: this had a sky that was a "flat mass of gold", a sea of "pure delicate green with rose-coloured surf", a violet shore and "girls at play".[88] Vanessa Bell's *The bathers* has a confidence of handling and execution that reflects her increasing sense of liberation.

The theme of women and children at the seaside is treated in a far more sombre fashion in *Studland Beach*, but it is a far more radical work in treatment. The most obvious source for the stark, flat forms of the bathers, their beach hut and the shore and sand outlined in a blackish colour is the Picasso still life *Jars with lemon* (Liechtenstein, private collection), which Clive and Vanessa Bell bought in October 1911. *Studland Beach* shares its simplification, its palette of beige, brown, blue, grey and yellowish ochre and the forms have the same heavy outline. Vanessa Bell recognized the outstanding aspects of French art and was able to translate these qualities into something of her own. There has been some speculation about the source for the standing figure with a heavy mane of hair falling down her back in a simple block shape. The bather in Gauguin's *Tahitian women bathing* [cat. 59, repr. p. 31] must be the source. Matisse also recognized the potency of this image. The Gauguin has been suggested as a source for his sculpture *Back IV*, but it is equally true, as Frances Spalding has pointed out, that Fry showed Matisse photographs of British paintings while he was working on the sculpture.[89]

Clive Bell had singled out Spencer Gore in his review of the AAA of 1912, writing that it was "a joy to watch the progress of this good artist", and so it is hardly surprising that Gore was the only artist from Sickert's immediate circle whom Bell included.[90] A noticeable change in Gore's painting style occurred after *Manet and the Post-Impressionists*. His review of that exhibition shows that it was the pictures by Derain, Friesz, Herbin and especially Marquet (see further p. 150) – of whom Gore wrote that "he would like to see more" – that held the most interest for him.[91] The representation of the modern landscape of leisure and industry, town and suburb that characterized Fauve landscape had a strong appeal for Gore. The Impressionists were the first artists to record the changing modern world and its effect on landscape, and Gore's friendship with Lucien Pissarro undoubtedly accounts for his intial interest in depicting the industrial landscape. *Nearing Euston Station* [cat. 88, repr. p. 102], which is one of several works by Gore which depicts the grimy rail yards around Euston Station near where he lived in North London, compares to Pissarro's *Wells Farm Bridge* [cat. 170, repr. p. 102] but the vividly coloured advertising hoardings in *Nearing Euston Station* give it a more blatant modernity. The pictures that Gore painted at Letchworth Garden City are the best examples of his keen interest in modern landscape and it is not surprising that Bell chose two works from this extraordinary group for the *Second Post-Impressionist Exhibition*.

Letchworth was the first garden-city development, part of Ebenezer Howard's utopian plan to solve overcrowding and unhealthy conditions in densely populated urban areas. In 1903 the shareholders of Letchworth Garden City Ltd purchased nearly 4,000 acres of agricultural land near Baldock in Hertfordshire. In what would prove to be a classic case of rural re-development, the tenant farmers, smallholders and allotment gardeners were given notice to quit before the building scheme for the new town began. Letchworth Garden City was quite literally superimposed on the older rural landscape. Gore stayed and painted in Letchworth between August and November 1912 while staying in Harold Gilman's newly built house (1908). But Gore did not simply celebrate the new suburban development in his Letchworth pictures. *The cinder path* [cat. 93, repr. p. 103] depicts the footpath which connected Letchworth to the older established town of Baldock, whose inhabitants apparently felt bitter about the new development. It makes an ugly dark mark through the brightly coloured terrain of the tilled fields, which has been depicted in simplified organic shapes of luscious red, yellow and green, and leads us to the distinctive red-roofed white stucco houses designed by the architects Parker and Unwin which dominate the landscape beyond.

Letchworth was designed to be economically self-sufficient but lack of employment and leisure facilities in the town meant that many of the inhabitants commuted to London. The commuters who have just arrived by train and march single file appear to be robot-like in contrast to the more relaxed group who wait on the opposite platform in *Letchworth Station* [cat. 94, repr. p. 103]. Gore's treatment of the figures may be compared to Marquet's depictions of the modern crowd (cf. cat. 146, repr. p. 150). The view of the newly built

FIG. 29 Mikalojus Konstantinas Čiurlionis, *Rex*, 1909, M.K. Čiurlionis State Museum of Art, Kaunas

FIG. 30 Mikalojus Konstantinas Čiurlionis, *Prelude of the knight*, 1909, M.K. Čiurlionis State Museum of Art, Kaunas

station and railway line of this suburban development which cuts through and encroaches on the existing countryside is not sympathetic. As Konody observed, it suggested "the silent protest of a lover of the green countryside against the intrusion of unbending iron and black smoke. An almost cruel stress is laid on all that is hard and stiff and graceless, dingy and unpleasant in and around a railway station".[92]

THE RUSSIAN GROUP

Many of the works that Boris Anrep selected for the Russian section did not arrive and some of them arrived late. Consequently there was very little discussion of them in the press. "Can it be that the works of this group are only included because to our eyes they are strange and unaccustomed?"[93] Others asked whether the Russian artists could be considered to be Post-Impressionists, noting for example the connection between Kouzma Petrov-Vodkine's classical treatment of figures riding oxen in a field of corn in *Les Bœufs* and that of Augustus John.[94] Charles Marriott, who published *Modern Movements in Painting* in 1920, was one of the few critics who wrote favourably about the Russian pictures. He especially liked *Rex* by Čiurlionis [fig. 29], who had died prematurely the previous year, although he confessed he did not understand its mixture of fantasy and landscape. Again, "I do not know what *Gifts* the men are bearing to the city of brass in Roerich's picture", he added, "but I know that city in dreams".[95] Anrep's introduction makes it clear that he was keen to introduce those Russian artists who were most committed to creating a distinctly Russian art. The best known of this group were Natalia Gontcharova whose *Apostles* [cats. 83–86, repr. pp. 106–07] was illustrated in the catalogue, and Mikhail Larionov. Both artists were represented by neo-primitivist examples of their work which characteristically drew upon examples of Russian folk craft, children's art, *lubok*, hand-coloured popular cartoons, and especially Russian icons. A revival of interest in indigenous Russian folk art had started in the late nineteenth century. But the neo-primitivists must have been also stimulated by the interest in 'primitive' art amongst the Parisian avant-garde.[96] Roerich's exhibits also showed these neo-primitivist tendencies. Anrep pointed out that he did not simply borrow the style of Russian icons but interpreted their religious spirit in his own manner.

Natalia Gontcharova, *Evangelist (in blue)*, 1910, cat. 83

Natalia Gontcharova, *Evangelist (in red)*, 1910, cat. 84

Natalia Gontcharova, *Evangelist (in grey)*, 1910, cat. 85

Natalia Gontcharova, *Evangelist (in green)*, 1910, cat. 86

EXHIBITION OF PICTURES BY J.D. FERGUSSON, A.E. RICE AND OTHERS (THE RHYTHM GROUP)

"WHY was this branch of British Post-Impressionism ignored by the directors of the Grafton Gallery – this branch that is so fresh and alive?" asked Hind about the Stafford Gallery group show of American, English and Scottish Fauves which opened on 3 October 1912 and ran concurrently with the *Second Post-Impressionist Exhibition*.[1] Fry had little sympathy with their work, which he thought was "turgid and over-strained".[2] As late as 1925, Sickert, referring to an exhibition of Fergusson and Peploe and others at the Leicester Galleries, would write: "While Post-Impressionist painters in France have been not inconveniently divided into Fauves and Faux-Fauves, the corresponding division in England may be said to have been practically established as between Post-Impressionists licensed by Mr. Fry, and those unlicensed by Mr. Fry."[3] Michael Sadleir had close connections with these Anglo-American Fauves. He was co-editor with John Middleton Murry, an Oxford friend, of the British journal *Rhythm* (1911–13), which had been founded by Murry and J.D. Fergusson, (who was its art editor until November 1912) to advance the Anglo-American Fauve group.[4] It is highly probable that Sadleir persuaded the director of the gallery, John Neville, to plan the exhibition to coincide with Fry's show. Earlier in the year, in February, Peploe had an exhibition of drawings at the Stafford Gallery which sold well, and Fergusson exhibited there in March 1912. So Neville would have been inclined to support the group with which they were associated.

Hind was not the only critic to ask why the Stafford Gallery artists had been excluded from the *Second Post-Impressionist Exhibition*. Konody thought that the English group at the *Second Post-Impressionist Exhibition* were "dull and colourless" compared to the Stafford Gallery Fauves "who apply the new principles as passionately and fearlessly as their French fellow workers". "It is difficult to understand why no place should have been found in Grafton-street for their interesting work", he added.[5] He congratulated the management, "always on the alert for what is best and most alive in modern art All these artists express modernity; each of them belongs to to-day."[6]

Of the group of ten Anglo-American exhibitors at the Stafford Gallery, those considered the most talented were Jessica Dismorr, Fergusson, S.J. Peploe, Anne

Estelle Rice and Ethel Wright. At the time of the exhibition Fergusson and Rice, the group's leaders, were based in Paris. All the other exhibitors had lived in Paris, where they met at the Café d'Harcourt. As Mark Antliff reports, their literary allies included Huntly Carter, Francis Carco, Tristam Dereme and, as we have noted, Middleton Murry and Sadleir.[7] Before the Stafford Gallery exhibition *Rhythm* was their launchpad in Britain. Under Fergusson's direction *Rhythm* published illustrations by Dismorr and Rice and others and reproductions of their work. *Rhythm* also published a highly interesting range of photographs, some of which were supplied by Kahnweiler, of drawings and paintings by Picasso, Derain, Friesz and other French Fauves, Kandinsky, Gontcharova and Dunoyer de Segonzac, who was an ally, amongst others. Sadleir, who wrote eloquently about Rice, published art criticism in *Rhythm*.

Rutter, who was a friend of Fergusson, was another early supporter and published an article on Fergusson's portraits in *The Studio* in December 1911.[8] In 1909 Rutter commissioned Fergusson to write a review of the Salon d'Automne for *Art News*, the mouthpiece of Rutter's newly established Allied Artists Association. Rutter was already taking a strong interest in the activities of the 'Matisseites', as Fergusson called the international group of Fauves who had gathered in Paris. In his reviews of the 1910 Salon d'Automne, Rutter singled out Rice and Fergusson. He praised the "decorative design ... expressed in strong personal colour that has the intensity and luminosity of old stained glass" of Rice's *Deux danseuses égyptiennes*, which represented stylized dancers "in bright colours" on a flat red background, hung in the place of honour, and which caused an uproar in the French and British press; one critic apparently spat at it. Rutter congratulated Fergusson on his new Fauve style and praised "the colour harmony and design" of "his two decorative portraits", *Dame aux oranges* and *Hortensia*. "Great strength of mind is needed to mingle to the full with the torrent of post-impressionism, steering one's course the while, but thanks to a hard-headed ancestry J.D. Fergusson may be trusted to emerge from the present anarchy a law-giver, if not an actual despot." This is probably the first time the term Post-Impressionism was used by a critic. Rutter saw himself in competition with Fry as the British critic who was the most up-to-date with current developments. It was Rutter's opinion that "Paris has done

wonders for Mr. Fergusson".[9]

Anne Estelle Rice was an American who lived in Paris from 1906 until she came to live in England in 1913. Rice and her close associate Fergusson, a Scotsman who lived in Paris between 1907 and 1914, were the best known of the group. Both artists exhibited at the Salon d'Automne to which they had been elected *sociétaires*. Their work was frequently noticed in the British press.

Fergusson is usually considered to be the leader of the group, though this was not the view at the time. Anne Estelle Rice's first one-person show at the Baillie Gallery in London in 1911 took place three years before Fergusson's first one-person London show at the Doré Gallery, for which Rutter wrote the introduction. Referring to her exhibition at the Baillie Gallery and the strong impact she had in Paris, Michael Sadleir pointed out that "Miss Rice like every other leader of the fauvist movement, is too individual to allow her being classed wholly with anyone else". The Fauves, Sadleir explained, were "united by their desire for rhythm, strong, flowing line, strong massed colour, decentralised design" and there was "no better example ... than that of Anne Estelle Rice's work".[10]

The sensuous curving forms of Fergusson's goddess 'Rhythm' in the work entitled *Rhythm* [cat. 39, repr. p. 111], posing against a highly decorative background of fruit and flowers, reflects Bergsonian ideas, as Mark Antliff has argued, about gender and the dichotomy between cultural activities dominated by men which were thought to represent an *élan vital* and procreation, the sphere of women, who represented nature's fecundity. The woman in *Rhythm* "takes the form of a benign earth goddess". Fergusson has associated her female form with nature's fecundity, expressed in the thick, curving lines of vivid colour.[11] A drawing of this iconic nude was used for the cover of *Rhythm* [fig. 31], and the painting was chosen by Rutter for his exhibition *Post-Impressionists and Futurists*. The Stafford Gallery catalogue lists four works by Fergusson but he was represented by at least six exhibits. Fergusson's ideas dominated the group and their persuasive effect on its female members should not be underestimated. For example, Rice and Dismorr (cf. fig. 32) represented the theme of naked females dancing. "Through intuition artists are producing inspired pieces of music, putting together new pictorial material, composing lyrics in colour, lyrics in line, lyrics in light to the new deity,

John Duncan Fergusson, *The blue hat, Closerie des Lilas*, 1909, cat. 38

John Duncan Fergusson, *Portrait of Anne Estelle Rice*, 1908, cat. 37

RIGHT John Duncan Fergusson, *Rhythm*, 1911, cat. 39

ABOVE FIG. 32 Jessica Dismorr, *Rhythm*, 1911–12
Private collection

BELOW Anne Estelle Rice, *Staffordshire figures*, *ca.* 1912,
cat. 173

rhythm", noted an editorial in the first issue of *Rhythm*.[12]

There is little evidence of gender bias in the writings of Michael Sadleir or Frank Rutter. It would be fair to say that Rice and Fergusson shared the critical admiration of their supporters. Rutter, for example, in his 1911 review of the Salon d'Automne,[13] favoured Fergusson's "group of full-coloured decorative paintings", including *Rhythm*, which he said were "practically the only conspicuous British exhibit". But the following year he singled out Anne Estelle Rice, who was represented by eight works including *Afternoon tea, Château Madrid, Paris* (cf. cat. 171), in his review of the Stafford Gallery show: "She is the most interesting painter of the group She interprets life in a series of intimate decorations so personal and so revealing of a distinct individuality that the merely decorative quality seems almost accidental." *Springtime, Jardin de Luxembourg*, he continued, was "a vivid rendering of actual facts presented to us in a convention of bright spaces of colour outlined by ample firm lines ... we have a decoration of the gardens gay with flowers, but decoration for itself has not been the end aimed at. The picture is a symbol of an emotion which fundamentally has nothing to do with the paint at all."[14]

Her contemporaries' esteem shows the important rôle that Rice played within the group and it probably accounts for the strong presence of women exhibitors (four out of the ten were women) at the Stafford Gallery. (None of the original French Fauves had been women.) Jessie or Jessica Dismorr, as she was later known, had been a pupil at the Académie de la Palette, the atelier where Jacques–Emile Blanche offered classes in English and where Fergusson and also Dunoyer de Segonzac taught. Blanche had little sympathy with any aspect of Post–Impressionist painting, as a letter written at the time of *Manet and the Post-Impressionists* makes clear, and most of the students there were not interested in contemporary painting. But many artists in the Rice-Fergusson circle came together by way of La Palette. Dismorr had only been a pupil at La Palette for a short time when she joined their circle. In summer 1911 she contributed to the first issue of *Rhythm*.

The American-British Fauves followed in the footsteps of the original French Fauves, and worked at out-of-the-way spots in France. Fergusson was at Montgeron in 1908. Dismorr was painting in Provence in 1910 with Margaret Thompson, and again in 1911

Jessica Dismorr, *Landscape with figures, ca.* 1912, cat. 30

John Duncan Fergusson, *Cassis from the west*, 1913, cat. 40

with Thompson and Thompson's future husband William Zorach. Fergusson, Rice and Peploe were in Royan in 1910, and Fergusson and Peploe went again the following year. In 1913 Fergusson, Peploe and Rice painted at Cassis. Dismorr and Rice also painted in Italy.

Rutter thought that the panels by Dismorr, *Night scene, Martigues* and *Sunlight, Martigues*, at the Stafford Gallery were "among the pleasantest things in the gallery", and "genuine and true".[15] 'Pleasant' does not fully describe the intensity of the landscape panels Dismorr painted between 1911 and 1913 (cf. fig. 33). They share the distinctive heavy outline and flat colour that characterizes the work of Fergusson and Peploe, but the colours of Dismorr's landscapes are brighter and more expressive. Peploe did succumb to Fergusson's influence. The landscapes they painted in France share a Cézannesque handling and they favoured the same motifs. Hind pointed out that Peploe had "entirely changed his aims … he has become an ardent practitioner of what may be called the Peploe–Fergusson branch of Post-Impressionism".[16]

Samuel John Peploe, *Ile de Bréhat*, 1911, cat. 163

Samuel John Peploe, *Still life*, 1913, cat. 164

FIG. 33 Jessica Dismorr, *Martigues, Marketplace*, 1912 Private collection

POST-IMPRESSIONISTS AND FUTURISTS

Catalogue of the *Post-Impressionist and Futurist Exhibition*, cat. 197

1913 No.5

Post-Impressionist and Futurist Exhibition

With an Introduction by—
FRANK RUTTER, B.A.
(Curator of the Leeds City Art Gallery.)

THE DORÉ GALLERIES
35, NEW BOND STREET, LONDON, W.

FRANK Vane Rutter was art critic of *The Sunday Times*, editor of *Art News* (1909–12), the founder of the Allied Artists Association (1908), curator of the Leeds City Art Gallery and a keen collector of modern art. (By 1926 he owned around eighty works.) His interest in modern art pre-dates Fry's introductions to the British public. When Rutter founded the AAA in 1908 he took as his model the non-juried annual Salon des Indépendants exhibitions which he was in the habit of viewing. There he would have seen work by Braque, Derain, Kandinsky, Signac and Vlaminck amongst others. Rutter hoped for an international exhibition in London that would attract these avantgarde artists.

As we have seen (see p. 45), Rutter knew about Cubism early on (1910). By 1911 he was on speaking terms with Derain, with whom he claimed to have discussed African art outside Kahnweiler's gallery, and he advised his readers to visit that gallery to see the best Cubist works. His ideas about modern art are set out in *Revolution in Art* (1910), a little known publication that shows his keen interest in contemporary French artists. "Men like Picasso, Matisse, Derain and others are smashing the fallacy that imitation … is art", he said, declaring that these artists had reached a stage "practically unknown in Britain".[1]

Despite his socialist sympathies, Rutter believed that revolution in art had nothing to do with social upheaval. He saw the history of art as a "series of advancements" but observed that avantgarde artists were rarely interested in changing society.

POST-IMPRESSIONISM: AN ALTERNATIVE VIEW

Rutter appears to have been the first critic to have used the word 'post-impressionist' in print.[2] Yet he was sceptical about its precise meaning, declaring in his review of the *Second Post-Impressionist Exhibition* that the term 'post-impressionist' covered "half-a-dozen distinct and separate art movements" including Neo-Impressionism, Fauvism, Cubism and Futurism.[3] He was more interested than Fry in the chronological sequence of recent developments in France, and he outlined his plans for "an historical exhibition" which would explain these developments to the British public. The first room would show the older Impressionists, the second the Neo-Impressionists, the third Cézanne, Van Gogh and

Gauguin, with a note in the catalogue explaining their connection with the older Impressionists. A fourth room would be for the Fauves, there would be a small room for Picasso and two more rooms for the other Cubists and the Futurists.

In 1913 Rutter realised his proposal in two separate shows: *Post-Impressionist Pictures and Drawings* at the Leeds Arts Club, and the *Post-Impressionist and Futurist Exhibition* at the Doré Galleries in London.[4] The Leeds show was a prototype for the larger London show and, while neither quite fulfilled Rutter's ambitious plans, they brought together a more diverse group of artists than either of Fry's shows, as Rutter subsequently willingly admitted.[5]

As an unidentified critic, who was undoubtedly prompted by Rutter, wrote in *The Sunday Times*: "It is possible now, for the first time, to follow the development of modern painting ... from the impressionism of Camille Pissarro through Cézanne, Van Gogh and Ganguin [*sic*] to Piccasso [*sic*] and Severini By the inclusion of artists new to London such as Van Rysselberghe, Delaunay, and the German post-impressionists, the exhibition establishes its claim to be considered the most comprehensive display of its kind ever held in England."[6]

With the assistance of Michael Sadler, the collector and mayor of Scarborough A.M. Daniel and others, Rutter organized the little known *Post-Impressionist Pictures and Drawings* which opened in Leeds in June 1913. Although half of the works were for sale, ostensibly it was a loan exhibition of work owned by collectors based in the North of England. Sadler lent Gauguin's *Poèmes barbares* (see p. 64) and two Kandinsky watercolours. The Manchester businessman Herbert Kullmann lent Cézanne's *Le village derrière les arbres* (1898; Bremen, Kunsthalle) and Van Gogh's *The Auvers stairs with five figures* (1890; St Louis City Art Museum).[7] It is not widely known that Kullmann had a large collection of modern art, part of which, including work by Cézanne, Van Gogh and Matisse, was sold at auction in 1913. When Sadler visited Kullmann – or Coleman as he was known by then – at his home in West Didsbury, a suburb of Manchester, in 1922, he saw two Cézannes, a Courbet, two Renoirs, a Van Gogh and Gauguin's *Nevermore* (now London, Courtauld Institute Galleries) dispersed amongst a collection of 'primitive' objects.[8]

The Leeds show probably prompted the directors of the Doré Galleries to invite Rutter to organize a similar exhibition in London. In a letter to Lucien Pissarro, whom he approached for the loan of work by his father Camille, Rutter explained: "The aim of the exhibition is to illustrate the development of modern painting from 'Impressionism' (now classic) to the vagaries of the present day." He declared that he would devote "very little space to the extremists". The bulk of the exhibition would show "what has been built firmly on the foundations laid by your Father, Manet, Cézanne, etc."[9]

Rutter's view that Pissarro's true worth had not been appreciated and that critics had missed his historical importance as a link figure between the School of 1830, the Impressionists and Gauguin, Van Gogh and Seurat was generally shared by the Camden Town group. Sickert was one of the first to acknowledge Pissarro's importance for Cézanne and Gauguin. This was the main thrust of his preface for the Pissarro show held at the Stafford Gallery in October 1911. "It is one of the entertaining ironies of fashion," he wrote, "that Cézanne, ninety per cent of whose work consists of monstrous and tragic failures, should have been deified by speculation in Paris, Berlin and New York while Pissarro's brilliant and sane efficiency awaits full justice".[10]

Rutter's own review of the Pissarro exhibition stresses the importance of Impressionist landscape painting and its use of a palette based on chromatic contrast for "the various schools of painting which have made some noise in the world during the last quarter of a century".[11] The only Impressionist landscapist in Rutter's show was Camille Pissarro. A group of seven pictures, the majority of which were painted in the last two decades of Pissarro's life (he died in 1903), including *The little country maid* (London, Tate Gallery), was hung at the beginning of the exhibition. (Rutter had asked Lucien to help him hang the exhibition and it was probably Lucien who decided that they were best suited hanging as a single group.) Effectively Rutter challenged Fry's definition of Post-Impressionism when he appointed Pissarro as the unrecognized father of Post-Impressionism. Pissarro was "the master of Gauguin and van Gogh [and] he unconsciously brought into being the painters, who, with Cézanne, were to be the parents of most that is known as 'post impressionism'".[12]

"Since 'post' is the Latin for 'after', where are Vuillard and Bonnard?" Sickert had asked when he reviewed *Manet and the Post-Impressionists*.[13] Both of

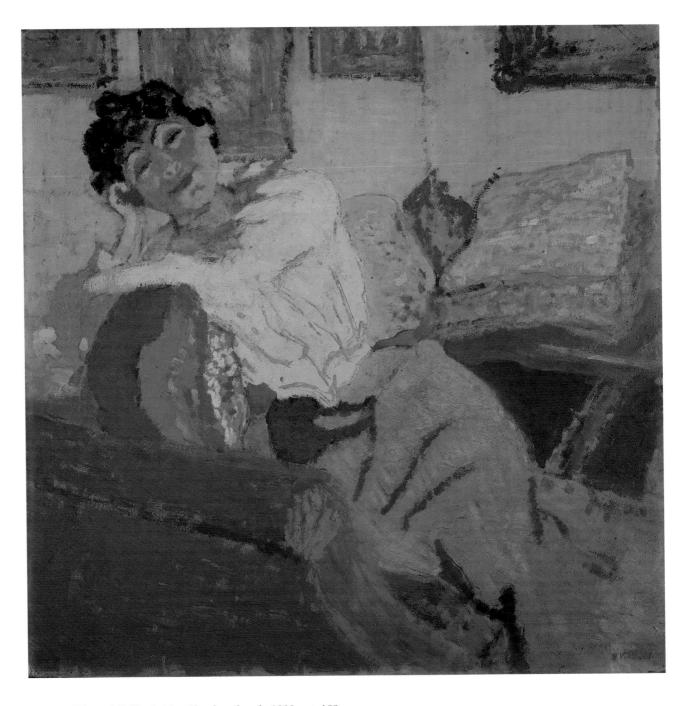

ABOVE Edouard Vuillard, *Mme Hessel on the sofa*, 1900, cat. 189

RIGHT Walter Sickert, *Oeuillade, ca.* 1911, cat. 184

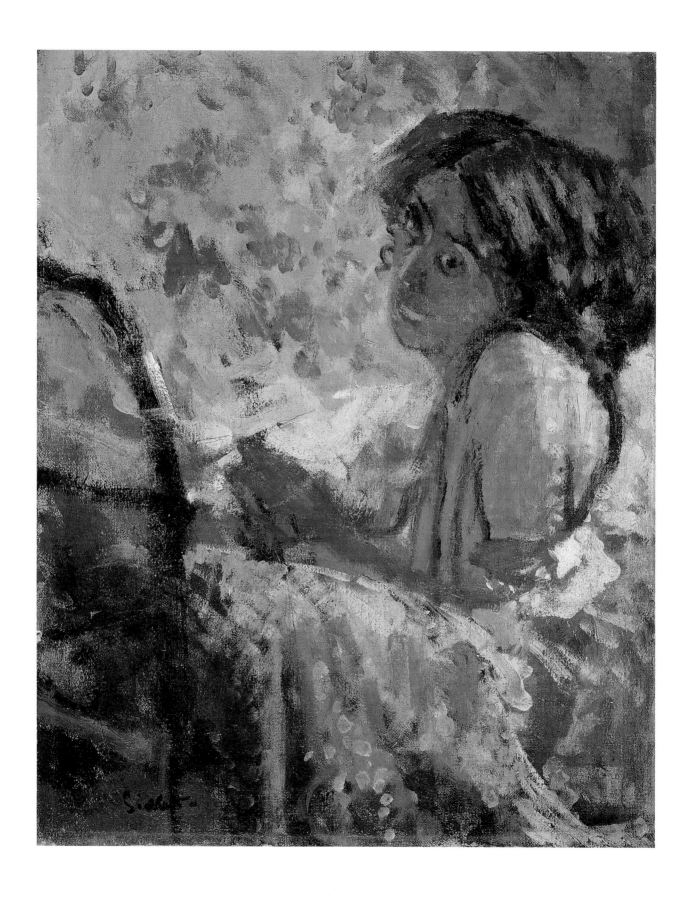

these artists maintained a high profile in the contemporary French art world. Fry did include two works by Bonnard in the *Second Post-Impressionist Exhibition*. Vuillard still was unrepresented. As Belinda Thomson points out, Vuillard had fairly regular contact with British collectors, artists and exhibiting societies, and both he and Bonnard were frequent contributors to the International Society exhibitions.[14] Fry was so determined to challenge all aspects of recent British taste in art that he may have thought that Vuillard's established reputation in Britain was a good enough reason not to regard him as a Post-Impressionist. Rutter explained he was correcting Fry's oversight by including Bonnard and Vuillard, "the accepted masters of Intimist painting". He correctly pointed out their connection with Sickert, who frequently praised Vuillard. Sickert admitted at times to be shocked by Vuillard's "scrawled splashes of distemper". He decided that this slapdash technique had a self-conscious "rudimentary quality" which had "an almost purposed negligence".[15]

The painter Jacques-Emile Blanche had first pointed out Sickert's close links with Vuillard and Bonnard, and the three artists would appear to have regarded each other's work with mutual self-respect. Sickert reported that they offered critiques of each other's pictures while he was living in France. For example, there are close connections between their compositional arrangements (cf. Vuillard's *Mme Hessel on the sofa* [cat. 189, repr. p. 118] and Sickert's *Oeuillade* [cat. 184, repr. p. 119]), their palette and their choice of subject-matter.

These intimist compositions were highly consequential for Gore, Gilman, Ginner and other artists in Sickert's circle, and Rutter pointed out that they "might with least confusion be regarded as 'intimists' of England."[16] Connections between Vuillard and Bonnard's treatment of the nude and the paintings of nudes in interiors by these English artists (cf. cat. 66, repr. p. 123) hardly need pointing out. Vuillard's treatment of single figures set in deeply recessed space, like the sumptuous *Mme Hessel and her dog* (Bristol City Art Gallery), compares in treatment, though not in kind, to Gilman's depiction of the humble living quarters of *Interior with Mrs Mounter* [cat. 73, repr. p. 127].

Rutter admitted that "classification at best is but a clumsy and inexact contrivance", and pointed out that Cézanne, Gauguin and Van Gogh were difficult to categorize. Cézanne held "a unique position … between the older and younger schools" and was "commonly regarded as the Father of Post-Impressionism". Rutter questioned whether Cézanne was the sole originator of the modern movement. He did admit that he had had "an immense influence on modern painting", and by way of illustration drew attention to a group of watercolours by Picart le Doux and Maurice Asselin which were presumably similar to Asselin's *Parc de Versailles* of 1911 [cat. 1, repr. p. 121] with its strong Cézannesque element.[17]

Cézanne was represented by a painting entitled *The lake* (which may have been *The lake at Annecy* now in the Courtauld Institute Galleries) in the first printing of the catalogue, and two lithographs, *The large bathers* (1896–98; cat. 22, repr. p. 25) and *Small bathers* (1896–97; cat. 21). A version of one of them was lent by Michael Sadler, which he bought in Germany in 1912. Sadler had hoped to acquire an oil painting of *Bathers* by Cézanne (probably the Barnes Foundation version) from a Munich dealer in 1912, but he had to cancel the sale because his funds would not allow it. The lithograph, one of three Cézanne lithographs he owned, was one of several prints and watercolours that he lent to Rutter's show.

With such a display of modern art, few critics bothered to mention Cézanne. But Clive Bell leapt at the opportunity to make more extravagant claims for Cézanne's greatness, saying that "Cézanne set modern art on the right road" and that "*The Lake* … was the most important aesthetic document in the exhibition, besides being the best picture".[18]

Rutter's show did not have the support of the major dealers. He was dependent upon private collectors for the loan of many of the works by major European artists. The Gauguin lithograph *Mahne no varn* (*sic*; properly *Mahna no varua ino*), one other lithograph, and an unidentified self-portrait (probably *Self-portrait with idol*, now San Antonio, Texas, McNay Art Museum) were lent by Sir Michael Sadler.[19] Two or three oil paintings by Van Gogh were borrowed from private collectors. These included *Interior of a café restaurant*, which had been bought by the playwright Alfred Sutro and his wife Esther, a painter, from Vollard's gallery in 1896. The Sutros were friendly with Vuillard. According to Alfred, Vuillard "took us to see a picture of van Gogh that had for some quite considerable time been on show at Vollard's, the dealer. My wife – a

painter herself – loved it at first sight, and we bought it for the three hundred francs that M. Vollard was asking."[20] The Sutros had lent the Van Gogh to the International Society exhibition in 1908, which was the first time a Van Gogh was shown in Britain. T. Fisher Unwin, the publisher and Sickert's former brother-in-law, lent an unidentified small still life of 'spikey flowers' which he had previously lent to the extended version of the *Second Post-Impressionist Exhibition*. Rutter described the third oil-painting, *Boats at anchor*, as a "comparatively early river scene" painted in the Neo-Impressionist manner. In addition, there were nine 'colortypes' after works by Van Gogh in the show.[21] These reproductions and the photographs of paintings by Picasso highlight the importance of reproductions for British modernists. They bought photographs of paintings that were on sale in the exhibitions, postcards and the early publications like *Van Gogh: Mappe*, Munich 1912, which had fifteen reproductions of Van Gogh's paintings. After seeing the big Van Gogh exhibitions in Paris in 1901 and 1903, numerous artists including Matisse, Vlaminck and Derain had used him as a model for their own experiments. Rutter would also have been thinking of Gilman, Ginner and Gore when he pointed out that Van Gogh "had an influence on modern art hardly inferior to that of Cézanne".[22] Sickert recalled this trio of British modernists grouped around Van Gogh's *Zouave* (F424) "without flinching".[23] This occasion and Rutter's show were rare opportunities to see work by Van Gogh in Britain after 1910.

The room at the Bernheim-Jeune Gallery, "entirely decorated with works of Van Gogh, a sight unsurpassed in beauty and intensity", that Gilman and Ginner saw when they accompanied Rutter to Paris in early autumn is usually seen as a great moment in their development as modernists.[24] Rutter recalled that Ginner's "object of greatest devotion was Van Gogh", as Drummond's portrait of Ginner [cat. 31], which is modelled on a Van Gogh self-portrait, makes clear, and Gilman shared this passion.[25] Yet each artist responded differently. There are notable differences between the way Gilman and Ginner each 'saw' Van Gogh, and their art differs in its turn from that of the other artists who admired him.

Some works by Gilman have a close compositional dependency to a particular painting by Van Gogh, and Gilman was not adverse to pointing this out. On one

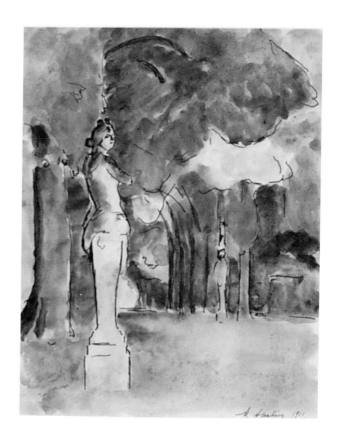

Maurice Asselin, *Parc de Versailles*, 1911, cat. 1

occasion he drew attention to the relationship between his painting *The canal bridge, Flekkefjord* (1913; London, Tate Gallery) and a painting of a bridge by Van Gogh which presumably was *The bridge at Asnières* of 1887 (Zurich, E.G. Buhrle Foundation), which Gilman would have seen at *Manet and the Post-Impressionists*. Notably Gilman's *The eating house* [cat. 69, repr. p. 127] borrows its composition and subject-matter from Van Gogh's *Interior of the Restaurant Carrell at Arles* (Private collection; F549). Gilman kept postcards of Van Gogh paintings pinned up on his studio wall and he also owned *Van Gogh: Mappe* and an early edition of Van Gogh's letters, *The Letters of a Post-Impressionist* (1912).[26] The debt to Van Gogh's well known *Bedroom at Arles* (Amsterdam, Van Gogh Museum) in Gilman's drawing *The farmhouse bedroom* [cat. 72] hardly needs pointing out. It is one of many late reed-pen drawings by Gilman where the incredible variety of the mark-making signifies an intense admiration for Van Gogh's drawings (cf. cat. 74, repr. p. 124).

ABOVE Harold Gilman, *A nude in an interior*, 1911, cat. 66

LEFT Edouard Vuillard, *Interior with a screen, ca.* 1909–10, cat. 190

The close, direct confrontation between artist and sitter in Gilman's paintings and drawings of *Mrs Mounter* can be compared to Van Gogh's *Postman Roulin*, and in a less direct way to *La Berceuse*. Like *La Berceuse*, a modern-day madonna which was intended by Van Gogh to evoke associations with maternal security, the homely figure of Mrs Mounter seated behind a teapot and cups of tea – the ubiquitous British domestic comfort – is another modern-day soothing image (cf. cat. 71, repr. this page). Gilman undoubtedly would have been aware of the meaning that Van Gogh gave *La Berceuse*. The bleakness that some have 'read' into *Mrs Mounter* has more to do with stereotypes about landladies and lodgers and a class prejudice similar to the one expressed by Desmond MacCarthy when he suggested that *La Berceuse* was not suitable for hanging in a middle-class home (see p. 37).

In his self-portraits and his letters, Van Gogh cultivated the image of a simple man of the people devoted to his art, with strong humanitarian ideas. *Self-portrait in front of an easel* [fig. 9] which arrived late at *Manet and the Post-Impressionists*, in which he depicts himself dressed in a workman's blue coat, standing resolute, palette and brushes in hand, was a startling image to present to a British audience used to artists who preferred to ape the manners and lifestyle of English aristocrats. Sickert, of course, was issuing frequent warnings in his art criticism about the danger of such practices and found his own solutions for upsetting the *status quo* in the British art world. But the life of Van Gogh, and the romantic accounts in the British press of how he dis-

Harold Gilman, *Mrs Mounter*, ca. 1916, cat. 71

Harold Gilman, *Seascape: breaking waves*, 1917, cat. 74

associated himself from his middle-class background, provided a compelling model for Gilman.

The rhythmic, arabesque patterning of the trees in Ginner's *Neuville Lane* [cat. 75, repr. p. 125] and the companion picture *Victoria Embankment Gardens* (London, Tate Gallery) explicitly acknowledge a debt to Van Gogh's Arles garden pictures. The contrast between the flower-strewn hillside in the foreground and the quiet seaside town and the electricity poles and wires which encroach down the road in *Rottingdean* [cat. 78, repr. p. 126] show that Ginner fully appreciated the contrast between the older rural elements and the modern industrial aspects in Van Gogh's *Landscape with carriage and train in the background* and *Les Usines*.[27]

Rutter's brief was to arrange a show containing as many different aspects of contemporary European art

Charles Ginner, *Neuville Lane*, 1911, cat. 75

as possible. Artists and movements were represented by major works and by prints, colour reproductions and even photographs, but his grasp of these movements was sometimes hazy. He rightly mentioned Gauguin's importance for the Fauves, a point that Michael Sadleir had also made in a recent article in *Rhythm* (see p. 53). But his introduction reveals that he had only a rudimentary grasp of the history of Fauvism, although he did admit that Matisse had "good claims to be regarded the leader of the 'fauviste' movement". Matisse was represented by five lithographs (cf. cat. 148, repr. p. 81) which Rutter admired as much as Fry. (Fry owned at least one lithograph; Rutter owned at least two, a portrait and a nude study.) Matisse's *Place des Lices, St Tropey* (*sic*) was also shown, as well as *Joaquina* (now Prague, National Gallery), which Bell complained he

had seen three times in eighteen months; first at the Salon d'Automne in 1911 and then at the *Second Post-Impressionist Exhibition*.[28] Without the competition of larger works, this stunning portrait with its vivid pink and orange colour was far more noticed in Rutter's show, in spite of the fact that it was "timidly skied".

RUTTER AND PICASSO

While he was arranging the Leeds show Rutter travelled to Paris where for the first time he met Picasso, possibly in the company of Michael Sadleir, in his studio.[29] They discussed the nature of Cubism. It is well known that Picasso gave few interviews during his Cubist period and that he was reluctant to talk about Cubism, so Rutter's account of his meeting with Picasso when the artist "explained to me in his own studio that he was aiming at a new realism" is especially interesting.[30] Some of this conversation is recounted in Rutter's preface to the *Post-Impressionists and Futurists* catalogue. The preface, however, does not make clear that Rutter is recalling his first-hand conversation with Picasso in Paris in spring 1913. This becomes apparent only in his subsequent *Evolution in Modern Art* (1926).

In the catalogue preface, Rutter explained that Picasso "accomplished in early youth a series of masterly drawings and etchings in orthodox styles" and that "later he developed the angular style seen in his *Lady with a Fan*". Rutter continued, "The transition from this to *Head of a Lady with a Mantilla* (No. 74) is easy to follow, and here we have the beginnings of cubism. But after this comes the *Portrait of Kahnweiler*."[31] All three of these works by Picasso were illustrated by photographs which, presumably, Picasso gave to Rutter. Rutter, who did not include Braque in the exhibition, had no doubts about the leading rôle of Picasso, "the father of cubism". But, he said, "M. Picasso disclaims being a cubist himself, he calls himself a realist. According to the artist, his latest works show 'things as they are and not as they appear'; that is to say they do not show 'one' aspect but a number of sectional aspects seen from different standpoints and arbitrarily grouped together in one composition."[32]

When he referred to this meeting in *Evolution in Modern Art* Rutter used the example of Egyptian art, which was presumably suggested to him by Picasso, to illustrate what he meant by the "new realism". "The

Charles Ginner, *Rottingdean*, 1914, cat. 78

Vincent van Gogh, *Hayricks*, 1890, cat. 82

Harold Gilman, *Eating house*, ca. 1914, cat. 69

Harold Gilman, *Interior with Mrs Mounter*, ca. 1916–17, cat. 73

Pablo Picasso, *Le Repas frugal*, 1904, cat. 166

human figure in Egyptian bas-reliefs and wall-paintings is never realised in its entirety. Each limb and member is given separately in the aspect most easily remembered … these memorised fragments are then put together to suggest the entire form of man. Picasso developed this principle, only he made the result far more difficult to understand by his simultaneous presentation of various aspects of fragments of the same object." Rutter continued, "When I first met him at Paris in 1913 Picasso said not a word of abstraction but claimed to be a realist … he maintained that he was a realist – 'plus royaliste que le roi' – indeed, the only true realist in paint. It was not realism, he argued, to show merely one aspect of an object from one point of view: the reality included all possible aspects from all possible points of view. The business of the 'real realist' painter was to combine a selection of these aspects in his painting."[33]

Picasso's claim that he was a realist was reassuring for Rutter, who had decided that Cubism was a necessary antidote to the "soft, 'fuzzy' mess of paint into which the baser sort of Impressionism tended to degenerate". He did not accept Fry's explanation that Cubism

merely had formalist aims, or that it was, as Patricia Leighton has recently explained it, "a game of line, colour, and form, devoid of social critique and programmatic animus towards the past".[34]

Two early etchings by Picasso were also included in the *Post-Impressionist and Futurist* show: *Salome* and *Le Repas frugal* [cat. 166, repr. this page]; also *Composition of a death's head*, which *The New Freewoman* described as an "exquisite little study … a splendid pattern of planes in gay colour".[35] This suggests that it was *Study for composition with skull*, spring–summer 1908, (Moscow, Pushkin Museum).

ORPHISM AND FUTURISM

One of the most startling inclusions in Rutter's show was Delaunay's large-scale oil *L'Equipe de Cardiff* (*Cardiff Football Team*) of 1912–13 [cat. 25, repr. p. 6], a version of an even larger painting which had been a talking point at the Salon des Indépendants in the spring of 1913, when it was appraised by the poet Apollinaire. Both the painting and the oil-sketch combine planes of pure colour – described by Apollinaire as "the first great example of colour construction applied to a large area" – and stridently modern figurative elements: the Eiffel Tower, the Great Wheel, the aeroplane, the vividly coloured poster and the energetic footballers. Rutter had a keen interest in the topical pictures of the Paris shows and would have been eager to introduce an artist "new to London".

In October 1912, Apollinaire had identified Delaunay, Fernand Léger, Francis Picabia and Marcel Duchamp as Orphists, a term he later changed to 'Orphic Cubism' in *Les Peintres Cubistes* (1913). By February 1913, Apollinaire had expanded the scope of Orphic Cubism to include the Blaue Reiter and Futurist groups, and redefined his original terminology to suggest it be called Simultanism. Rutter's claim that the Italian Futurists had been "more or less influenced" by Picasso's Cubism and that "a similar development in Paris has been given the name of 'Orfeism' [*sic*], and of this movement M. Delaunay is the protagonist",[36] shows that he was attempting to keep abreast of the finer points of what has been described as "the most elusive movement in the history of twentieth-century painting".[37]

British male critics could hardly fail to respond to the mix of sport, masculinity and modernity in *The Cardiff Football Team*. Gore's *Flying at Hendon* [cat. 95] also

represents this up-to-date modern theme. Dunoyer de Segonzac's *The boxers*, a large oil (destroyed) which was exhibited in Rutter's show, also represented a popular male sport. A drawing by Segonzac, *The boxers* (cf. cat. 179, repr. this page) was reproduced in *Rhythm*. Wrestling was the subject of Bomberg's *Ju Jitsu*, [cat. 16, repr. p. 138], the first of his paintings to reveal a squared-up grid. Gaudier-Brzeska also explored the theme in *The wrestlers* [cat. 51, repr. this page] as did Eric Gill. Wrestling and boxing were two favourite pastimes in the gymnasiums of the East End where Bomberg lived, but his interest in them was not simply biographical. The subject of sport and masculinity had a wider appeal within European modernism, as Bomberg would have known from the examples in Rutter's show.

Claude Phillips in *The Daily Telegraph* described the Delaunay as "a huge poster-like design" and thought "this sort of semi-cubism, so noisy, and self-assertive, suits the subject very well".[38] 'J.B.' in *The Manchester Guardian* praised Delaunay for venturing into the football field in search of "vital and primitive expressions of life", but criticized its sloppy effect.[39] "What will Footballers say?" asked the *Daily Sketch*. "It is a cheery monstrosity, suggesting that a colour-blind bill sticker who was sent out on a half-acre job with posters advertising Blackpool for health, an assorted selection of brands of cocoa, and a flying race at Hendon, had got the sections mixed up in his bag and then put them on in the dark. A nice picture, but you probably couldn't get a single housemaid who would be left alone in the house with it."[40]

The importance of *The Cardiff Football Team* for Nevinson's *The arrival* (London, Tate Gallery) has not been fully appreciated. In a less direct way its vibrant planes of colour were equally important for Grant's abstract collages (cf. cats. 112 & 113, repr. p. 155 & 154).

Severini was represented in Rutter's show by two works, *Dance* and *Polka*. Marinetti had hoped that the Futurists would show together as a group; Severini, however, had broken this rule the previous April. His exhibition *The Futurist Severini Exhibits his Latest Works*, at the Marlborough Gallery, had received widespread press coverage. Severini was interviewed many times in the British press. He "met Roger Fry, one of the most highly esteemed critics and writers on modern art and one of the most enlightened, who was very interested

André Dunoyer de Segonzac, *The boxers, ca.* 1911, cat. 179

Henri Gaudier-Brzeska, *The wrestler*, 1912, cat. 51

Emil Nolde, *Freihafen, Hamburg*, 1910, cat. 162

in my show"; also Epstein, Wadsworth, Clive Bell and his family, and Nevinson, with whom he spent two weeks in London.[41] The show was well attended but sales were poor and the reviews mixed.

Severini's show may have been a critical and financial failure, but he did gain an important convert in Nevinson. The interview with Severini in *The Daily Express* casts interesting light on his attitude to London and shows how important his ideas were for Nevinson.[42]

Severini described a journey through the "hideous prettiness of the panorama" of the English countryside but it was only when he reached London that his pulse quickened. "We seek for subjects in landscapes that are thick with black factory chimneys, in streets that are thick with moving throngs, in cafés that are thick with the cosmopolitan crowd … we understand the lyricism of electric light, of motor-cars, of locomotives, and of aeroplanes." He praised the modern aspects of London: "London is a city where movement and order reign … Motor-omnibuses passing and re-passing rapidly in the crowded streets, covered with letters – red, green, white – are far more beautiful than the canvases of Leonardo or Titian, and closer to Nature."[43] Marinetti, too, considered London with its underground railway system to be an ideal Futurist city.

Severini's spectacular *Dancer* pictures (similar to *Dancer no. 5* [cat. 183, repr. p. 63]) some of them embellished with collage and three-dimensional mod-

elling, did catch the imagination of some of the critics who reviewed his one man show. There was admiration for the effect of movement in *A dancer at Pigal's* (Baltimore Museum of Art), where "the darkness spins away in lumps from the sword-like rays of electric light", and "the shattered reflections, with fixed points of suggestion in the shape of notice-boards" in *The motor-bus* and *The Nord–Sud Railway* (both Milan, private collection).[44] All of these works were illustrated in the catalogue with a preface and introduction by Severini. But many critics remained deeply suspicious of an art that was seemingly cloaked in literary explanation. Konody thought that Severini was "utterly incapable of communicating either emotions or ideas" and that he wrote "sheer gibberish under the cloak of pseudo-scientific language". But he concluded that Severini was not a charlatan: "He is honestly convinced that he is on the right path, and that before many years have gone by we shall see nothing abnormal in Futurist painting, and we shall be able, without great mental effort, to read life, movement, and the whole essence of the visible world into his 'plastic rhythms'".[45]

Hind, who was his usual jokey self, satirized the political aims of the Futurists, comparing them to the "angry, untidy, gesticulating" suffragettes that he saw on his way to the gallery on Duke Street in the heart of Mayfair: "Inside was Gino Severini and bombs in the symbols of paintings." Severini was amiable and pleasant but Hind was not convinced. "I realised that Futurism is really a mental, not an emotional movement. It is not art; it is a kind of frenzied psychology, amply expressing itself in print, failing absolutely in paint."[46]

GERMAN EXPRESSIONISM; KANDINSKY

The German Expressionists, whom Fry effectively had ignored, were represented by works on paper from Michael Sadler's collection: Emil Nolde's *Freihafen, Hamburg* [cat. 162, repr. this page] and twelve others by Emile Bernard, Max Pechstein, Gabriel Munter, Franz Marc and W. Helbig.

The glaring omission from Rutter's show, however, was Kandinsky, who had been a regular exhibitor at the London Salon of the AAA since 1909. Initially his paintings were beyond the comprehension of most British critics. As Gore pointed out in 1910, when Kandinsky sent three works including *Improvisation 6* and *Composition 1*, "The design is almost entirely one of colour,

FIG. 34 Vassily Kandinsky, *Improvisation 29*, 1912, Philadelphia Museum of Art

Vassily Kandinsky, *Improvisation 19*, 1911, cat. 128

Vassily Kandinsky, *Composition II*, 1911, cat. 129

the forms scarcely explaining themselves, and the colour is so gay and bright, pitched in so high a key, as to appear positively indecent to the orderly mind of the Briton".[47] Perhaps Gore was thinking of Wilfrid Myers's comments: "Kandinsky offends from malice aforethought. Shapeless patches of garish colours, strung together in meaningless juxtaposition by bold, black lines, are dignified by the names of 'Composition No. 1', 'Improvisation No. 6' and save the mark 'Landscape'. These atrocities are really only suitable for the badge of a Wagner Society."[48]

Kandinsky had his first commercial success at the AAA in 1911, when Michael Sadleir paid a pound for six woodcuts and an album with text. They were *Composition II* (1911; cat. 129, repr. this page), *Reiterweg* (1911; cat. 127), *Improvisation 7* (1911; cat. 128), *Improvisation 19* (1911; cat. 128, repr. this page), *Motif for improvisation* (1911) and one more woodcut, all proofs for *Klange*, an illustrated book of prose poems by Kandinsky which chronicled his work from the figurative to the abstract. (It was illustrated with twelve colour and forty-four black-and-white woodcuts when it was published in 1913.) Sadleir lent these woodcuts to Rutter's Leeds show, and in the catalogue notes he drew attention to the recently published *Klange* (*ca.* 1912) calling it a "sumptuous volume" and "a miracle of book production".[49]

After purchasing the Kandinsky woodcuts, Sadleir quickly became an informed critic of Kandinsky. A postcard from Kandinsky to Rutter written in August 1911 gave a fuller explanation of *Klange*, which suggests that Rutter wrote to Kandinsky about Sadleir's recently purchased woodcuts at Sadleir's bidding.[50] In March 1912, Sadleir reviewed Kandinsky's *Concerning the Spiritual in Art*, which, he said, was "an attempt to bring artist and public into sympathy with each other". He was to translate and publish it two years later. Sadleir explained that Kandinsky was "one of the leaders of the new art movement in Munich which includes painters, poets, dramatists, critics all working to the same end – the expression of the soul of nature and humanity, or, as Kandinsky terms it, the 'inneres Klang'. The abstracted art of Kandinsky does not cease to be real because it is not material." Sadleir wrote, "To divorce art from life is fatal, and, as he wisely says, the result of such an act is either pure pattern-making or the barren creation of impossible dream-conditions."

Concerning the Spiritual in Art "throws clearly into relief some of the chief ideas which fill the minds of modern artists".[51]

In August 1912 Michael Sadleir accompanied his father on a tour of Germany. They travelled to Düsseldorf, where they saw the Marczell von Nemes collection which included Cézanne and Van Gogh and which Sir Michael Sadler had seen before in Budapest in 1911. They went on to Cologne (10 August) to see the Sonderbund exhibition, then to Frankfurt before travelling to Murnau to meet Kandinsky. They went to Munich where they met Hugo von Tschudi and finally they went to Dresden. Sadler acquired works by Cézanne, Gauguin and probably Nolde and Pechstein.[52] His meeting with Kandinsky and his son's strong interest inspired him to form a collection of works by Kandinsky; he purchased *Aquarelle no. 10* (whereabouts unknown; Barnett 304) from the Second Blaue Reiter exhibition and also acquired from Kandinsky *Study for Improvisation 28* (1912; New York, Guggenheim Museum, Hilla von Rebay collection; Barnett 316), both of which he lent to Rutter's Leeds show. In addition, Sadler owned at least three more watercolours by Kandinsky, one etching and one oil, *Fragment 2 for Composition VII (Centre and corners)* (1913; Buffalo NY, Albright-Knox Gallery), which Kandinsky gave him in 1913. The extent of Sadler's collection of works by Kandinsky, however, has not been ascertained. During the First World War, Sadler told Kandinsky that his collection of paintings and drawings by him was being appreciated in Britain more and more (Mark Gertler was a new convert in August 1915). Although he was in relatively straightened circumstances during the War, Sadler acquired from Kandinsky, while the artist was living in Stockholm, an etching, some drawings for which he paid £25 and at least one watercolour entitled *Moscow* for which he paid £10. 10s.

At the beginning of 1913 Kandinsky had hoped to hold a Blaue Reiter exhibition in London, but his initial plan to hold it at the Goupil Gallery came to nothing. Sadler suggested the Alpine Club Gallery instead, because it was not under the directorship of a dealer. The proposed Blaue Reiter exhibition in London did not materialize for reasons of cost.

In March 1913, however, Kandinsky was represented in Fry's 'Grafton Group' show at the Alpine Club Gallery. Sadler lent two watercolours. Fry had been staying with him recently in Leeds, a mecca for critics, collectors and artists. Sadler told Kandinsky that Fry had been "deeply interested in your drawings".[53] Sadler was a generous collector and after Fry's Grafton show, as we have noted, he lent the two watercolours to the Leeds *Post-Impressionist Paintings* show in June. He may not have wished to send them back to London in October.

By 1913, Michael Sadleir was well versed in Kandinsky's ideas about the interrelating abstract function of music and painting. He explained in the catalogue for the Leeds Post-Impressionist show: "Kandinsky paints pieces of colour and line music, based on the varied appeals which are made, singly and in combination, by different tones and forms." The two watercolours lent by his father were definitely non-representative, he said, and advised: "It is as idle to look for natural objects in them as to listen for galloping horses, or laughing men in a Bach fugue. Kandinsky's colour and line music is the antithesis to that of modern music … it is very pure music, appealing solely to the inner emotions."[54]

Roger Fry clearly was thunderstruck by the three works by Kandinsky he saw at the AAA in 1913. Fry pointed out that this non-juried exhibition reflected "the incredible jumble of conflicting ideals and aspirations of the modern world. Side by side with Kandinsky, pushing forward his fascinating experiments into a new world of expressive form, he will find some dear old friends of his childhood … Side by side with Brancuzi's and Epstein's audacious simplifications he will find the last gasps of enthusiasm for Roman *pastiches* of Greek art."[55]

Fry thought that the three works by Kandinsky – including *Landscape with two poplars* (Chicago, Art Institute), *Improvisation 29* [fig. 34] and one other unidentified *Improvisation* – were the best pictures in the exhibition. His review makes it clear that he was ready to be persuaded of the expressive power of non-representational art. Characteristically Fry used the more representational picture, *Landscape with two poplars*, as the starting point in his argument for abstraction. It "strikes one most at first because the forms have the same sort of relations as the forms of nature whereas in the two others there is no reminiscence of the general structure of the visible world". Fry admitted that continuous looking at a work of art had a persuasive effect on his judgement: "After a time the improvisations become more definite, more logical, and closely knit in structure, more

surprisingly beautiful in their colour oppositions, more exact in their equilibrium." The improvisations were "pure visual music". Finally Fry concluded: "I cannot any longer doubt the possibility of emotional expression by such abstract visual signs."[56]

Whatever Rutter's reason for not including Kandinsky in *Post-Impressionists and Futurists*, he firmly believed that his abstractions, which, he said, were "more subtle than cubism", had an "internal harmony" and that Kandinsky had written "the most lucid and best reasoned account of the aims of abstract painting that has yet been written". When Kandinsky's paintings were shown in London for the first time, Rutter recalled, "they probably excited more laughter than any paintings have ever caused. Now there are earnest young painters who call him the greatest living artist."[57]

MODERN SCULPTURE

Rutter claimed that a feature of the AAA show in 1913, which he thought was the most successful of the organization's annual exhibitions, was the strong presence of modern sculpture by Brancusi (who was showing for the first time in Britain), Zadkine (who sent three heads), Epstein and Gaudier-Brzeska. For this reason he included sculpture by Brancusi, Zadkine and Epstein in *Post-Impressionists and Futurists*.

Epstein had been a welcome newcomer to the AAA in 1910 when his exhibits were praised by Gore in *Art News*. Epstein's massive unfinished *Maternity* [fig. 35] dominated the press coverage of the AAA in 1912. Various sources have been cited for this extraordinary fecund figure, including Hindu erotic carvings and possibly African art. Gauguin's *Tahitian women bathing* [cat. 59, repr. p. 30] with its monumental figure, a rope of hair down her back, suggests an interesting connection with Epstein's *Maternity*. Indeed Epstein's sculpture suggests many links with painting. For example, the incised lines on *Birth* [cat. 35, repr. p. 135] compare to Matisse's lithographs (cf. cat. 148, repr. p. 81).

The press reaction to *Maternity* was mixed. Fry thought that *Maternity* lacked "vitality": "It is terrible that such a talent and such force of character and intellect as Mr. Epstein has remained ineffectual."[58] But many were in favour, including Clive Bell, who thought it would "secure for its author pre-eminence among British sculptors".[59] J.B. Manson said it was "a dignified statement of a fine simple fact of Nature" and

FIG. 35 Jacob Epstein, *Maternity* (detail), 1910, Leeds Museums and Galleries (City Art Gallery)

thought that Epstein had treated the Hoptonwood stone with "regard to the character, possibilities, and limitations of the material".[60] Konody perceptively recognized that Epstein's method of direct carving made it "impressive, mysterious, archaic like the sculpture of primitive Egypt", but he decided it was "repulsive in the accentuation of the animal and suppression of the spiritual elements".[61] *Tatler* was ambivalent about this "ugly but powerful" sculpture: "It repels you both as a thing of beauty and as an idealised figure of motherhood. It makes no appeal to you even as a work of art … yet … it impresses itself upon you, it makes you feel … it is a vital, ugly, yet strangely fascinating thing."[62] *Maternity* was "the most conspicuous exhibit" at the AAA in 1912. Most would have agreed with Konody, who thought its vast exhibition space was one of the best places to show sculpture in London.

Epstein visited Brancusi in his studio in summer 1912, and again in May or June 1913 when he was accompanied by David Bomberg. He may have taken

Jacob Epstein, *Birth*, 1913, cat. 35

Jacob Epstein, *Doves* (first version), 1913,
cat. 34

a photograph of *Maternity* to show Brancusi. He almost certainly persuaded Brancusi to join the AAA and send work the following year. Brancusi had been exhibiting at the Salon des Indépendants since 1910. He depended on these open exhibitions because he did not have a Paris dealer or a committed following of French collectors. His first real success came in February 1913 when he shared the critics' attention with Duchamp and Matisse at the Armory Show. He sold three works. His success there may be another reason why he decided to try another international exhibition in July. The AAA catalogue lists *Sleeping Muse I* (Art Institute of Chicago), for which Brancusi asked £48 as opposed to the £150 that Epstein asked for *Carving in flenite* (London, Tate Gallery). Of the two other sculptures, which were ex-catalogue, one was probably *Mademoiselle Pogany*, a "highly polished gilt bronze globe with a sharp triangle for a nose and slightly incised eyes", which Fry acquired possibly from the exhibition for his own collection.[63] The other was probably the black cement version of *Prometheus* (University of Cambridge, Kettle's Yard), which was described as a "petrified ostrich egg, with a few crude markings on the shell".[64] In the event, the AAA venture was a financial success because Brancusi sold two of the three heads he exhibited. These sales may have prompted Brancusi to visit London in 1913, when he met Gaudier-Brzeska.

Fry thought that "the three heads were the most remarkable works of sculpture at the Albert Hall". They had "a technical skill which is almost disquieting, a skill which might lead him, in default of any overpowering purpose, to become a brilliant pasticheur. But it seems to me that there was evidence of passionate conviction; that the simplification of forms into which he presses his heads give a vivid presentment of character; they are not empty abstractions, but filled with a content which has been clearly and passionately apprehended."[65] By comparison Konody thought the three heads Brancusi exhibited showed "farcical affectation and downright imbecility",[66] and Hind's only contribution was to pass on a comment from one of the crowd: "I like that crazy bronze thing."[67]

Konody thought that the sculpture by Epstein was just as disagreeable, and so did Fry. He complained that *Carving in flenite* was a "monstrosity designed to make the flesh creep".[68] He did not comment on the copulating forms of the *Doves* [cat. 34, repr. p. 135]. He also

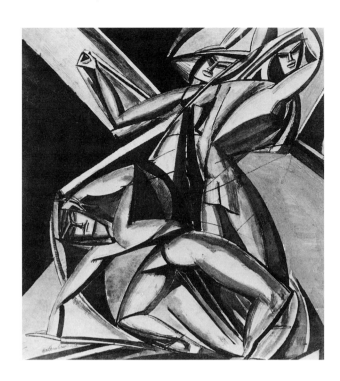

FIG. 36 Wyndham Lewis, *The dancers*, 1912, Manchester City Art Galleries

mocked Gaudier-Brzeska's busts of *Horace Brodsky* [cat. 52], and *Alfred Wolmark*, which he said were executed in "a kind of frenzied cubism that is certainly calculated to attract attention, but fails as much in conveying a sense of the sitter's character and appearance."[69]

Brancusi's *Sculpture en pierre* (unidentified, possibly *Prometheus*), the three Zadkines from the 1913 AAA show, another version of Epstein's *Doves* (Jerusalem, Israel Museum) and *Head of a baby* (1907) were exhibited in *Post-Impressionists and Futurists. The Manchester Guardian* thought the carving in Epstein's *Doves* better expressed "the harmonio [*sic*] of art expression after which M. Picasso is so elaborately striving in paint."[70] *The Daily Sketch* treated Epstein with derision. It concluded that the best thing about Epsteins's *Doves* was that "he hasn't messed the marble up so much, so that it will come in nicely to make something else."[71]

THE BRITISH MODERNISTS

There were thiry-eight European artists and twenty-five British artists in Rutter's show. However, over one half of the 203 exhibits were by British artists, so the number of exhibits by European and British artists was more

or less evenly matched. Almost every group of British modernists was included. Only the Bloomsbury group – Bell, Fry and Grant – was not represented. But on the whole "the new movement in English painting", which Rutter proudly introduced, was either harshly criticized or ignored. "There is no phase of Continental naughtiness and sensationalism that does not find an echo in the performance of the young English revolutionaries", wrote Konody.[72] Clive Bell was scathing: "This exhibition shows, there is a school of English Post-Impressionists ... they have swallowed, more or less whole, the formulas which French masters invented and which French masters are now developing and modifying ... too many of the English Post-Impressionists are coming to regard certain simplifications, schematizations, and tricks of drawing, not as means of expression and creation, but as ends in themselves The French masters are being treated by their English disciples as Michael Angelo and Titian were treated by the minor men of the seventeenth century. Their mannerisms are the revolutionary's stock-in-trade."[73]

The only British modernist in Rutter's show who met with Bell's approval was Wyndham Lewis. He showed *Kermesse*, which had been "altered and greatly improved" since Bell first saw it at the AAA in 1912 when it had dominated the arena of the Albert Hall. *Kermesse* was a design originally intended for Mme Strindberg's cabaret-theatre *The Cave of the Golden Calf* (see also p. 96). It aroused much comment at the the time of the AAA show as an example of a British Cubist picture, but few critics described it in detail – it was "painted in squares and cubes" which were "based upon the rhythm of the human figure" and in the centre of the picture "two wicked-looking eyes". In style it probably compared to *The dancers* [fig. 36]. Lewis may have added more recognizable elements before sending it to Rutter's show because several critics mentioned them. Phillips, who thought Lewis was a humorous and accomplished Cubist, said it depicted "some terrible battle of extermination between murderous insects".[74] Konody praised its rhythm of colour and design and said the dancers looked like "some gigantic fantastic insects descended upon earth from some other planet".[75] The descriptions of a "large and lurid canvas" of "monotonous and inexpressive colour" depicting "crabs in anguish" or "boiled lobster legs" suggests that *Kermesse* was predominantly red in colour. Ramiro de Maeztu's

jokey description in the *New Age* provides the clearest picture – "there might be two figures kissing one another on the mouth" while "on the left a crustaceous shape" offered "wine to another headless crustacean, which sat on something perhaps meant to be a chair" and "on the right another crustacean" poured "out a jet of wine into his own crustaceous face".[76]

Kermesse confirmed that Lewis was the "leader of the English cubists"; his two Cubist sympathizers in Rutter's show were Nevinson and Wadsworth who represented "the squares and angles school". By 1914 Nevinson had joined forces with the Italian Futurists, signing the 'Futurist Manifesto' with Marinetti in 1914, a move which precipitated the formation of the Vorticist group. According to Rutter, Nevinson's first Futurist picture was exhibited at the AAA in 1913. His untraced *Arrival of the train de luxe* (see fig. 20 on p. 76), which Rutter used for the exhibition poster, has a noticeable affinity with Severini's images of modern urban life; it also included the letters KUB, an allusion to the jokey references to Cubism in the Braques and Picassos at the *Second Post-Impressionist Exhibition* (see p. 76). Wadsworth's *Omnibus*, which was said to have "the jigsaw touch", showed the same interest in Cubism and Futurism. Not surprisingly British critics used Cubism and Futurism interchangeably and failed to distinguish between a British Futurist and a British Cubist. Most could not detect any originality in the work of Nevinson or Wadsworth. "If I were older, I would advise Nevinson and the more intelligent of this company to shut themselves up for six months, and paint pictures that no one is ever going to see", wrote Clive Bell, who added, "they might catch themselves doing something more personal if less astonishing than what they are showing at the Doré Galleries".[77]

Two strands of modernism were represented in Rutter's show. For the first time the British public was presented with the various 'isms' that are now considered to have constituted modern art. And for the first time various groups of British modernists competed with their own contribution to modern art. When Wyndham Lewis formed the Vorticist group the following year he fully understood that these different European 'isms' had their own inherent individual social, political and cultural identity, and that if British artists were not to be accused of being weak and imitative they must achieve the same.

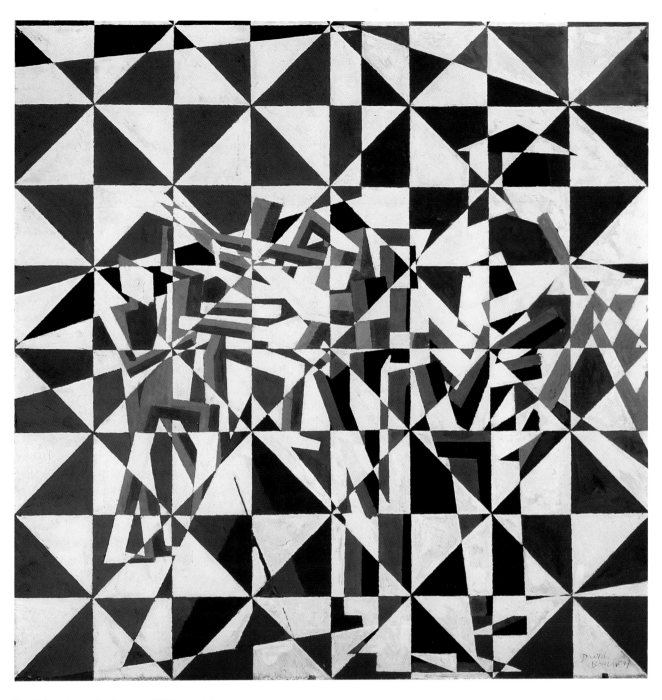

David Bomberg, *Ju Jitsu*, *ca.* 1913, cat. 16

TWENTIETH-CENTURY ART: A REVIEW OF MODERN MOVEMENTS

THE exhibition *Twentieth-Century Art: A Review of Modern Movements* was held from 8 May until 20 June 1914 at the Whitechapel Art Gallery in East London. Radical art movements in the East End! Was not the East End the great fear of middle class London? The establishment of the Whitechapel Art Gallery had its origins in a cultural imperialism that imagined the dominance of the 'West' over a foreign, subordinate 'East'.[1] "This year the Whitechapel Art Gallery will take a very bold step and introduce the East End to the phases of art that have lately proved so disturbing in the West."[2] *The Observer* parodied the alleged untutored response to the show of the predominantly Jewish population of Whitechapel, most of them poor immigrants from eastern Europe.[3] Such sentiments were often combined with the customary suspicion of foreign 'movements' and ideologies, or 'isms'. "Boccioni as well as the English cubists, post-impressionists, rhythmists and other ists at Whitechapel is in deadly earnest. What will be the effect of a whole flood of the various isms being let loose like a cataract on the unprepared East End?", asked Konody in *The Daily Express*. "Here is a complete résumé of the whole rapid evolution, beginning with a revolt against liberal realism and ending in utterly unintelligible abstraction."[4]

Ironically the ranks of the movements assembled in the East were made up largely of British artists. Boccioni did not exhibit. The show's title may have referred to European movements – Post-Impressionism, Fauvism, Cubism, Futurism and Orphism. But this was a show of British art.

The exhibition was organized by the Whitechapel's director, Gilbert Ramsay, and the previous director Charles Aitken who had taken up the post of director of the Tate Gallery in 1911. They were given permission by one of the Trustees of the Whitechapel to dispense with the customary advisory committee on the understanding that they would limit the number of Cubist or Futurist works.[5] Judith Collins suggests, however, that Roger Fry may have advised them on the selection.[6] Certainly this exhibition, as so much else, was informed by the notion of some sort of quasi-Darwinian pattern of evolutionary progress in art. Rutter, for example, said that the exhibition "would show a foreigner what progress is being made by the younger generation of British artists".[7] The preface to

FIG. 37 Catalogue of the exhibition *Twentieth Century Art: A Review of Modern Movements*

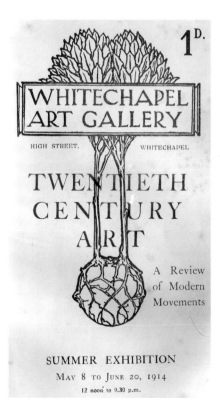

the exhibition catalogue declared that the aim was to show "the progress of art" since Impressionism, and the proliferation of species. "The exhibition will show that however the new artists may differ from the older they differ no less distinctly in aims and methods from one another."[8]

Emergent art movements were seen as subject to laws similar to those which govern nature. In art therefore, as in the natural sciences, there appeared to be a need for systems of classification, to impose an intelligible order out of the apparent chaos of evolutionary creation. The show's 465 exhibits by 133 artists were categorized into four groups.[9]

GROUPINGS WITHIN THE EXHIBITION

The first group depicted common or sordid scenes and luminous landscapes influenced by Sickert and Lucien Pissarro, the only two older artists to be represented. Due attention was paid to the origins of this particular species. "It is now clear that [Sickert and Pissarro] were a source of the new phases that are now prominent."[10] The second group created "imposing decorative design" and showed the influence of Puvis de Chavannes, Alphonse Legros and Augustus John. Ironically none of these artists was included in the exhibition. There was a single landscape by J.D. Innes (cf. cats. 117 and 119, repr. p. 142), who died in August 1914 and who had worked closely with John.

The third group, including Bell, Fry, Grant and Adeney, was said to owe "its origin to a feeling which had begun to appear… in the work of Cézanne, which did not develop in England until after 1910".[11] *The Morning Post* described this process of spiritual rather than natural evolution.[12]

The fourth group had "abandoned representation almost entirely".[13] This included Lewis and the Rebel Art Centre artists, and Bomberg, whose work hung apart in the Small Gallery. What it did not mention was that this was a Jewish section which Bomberg had curated.

The Jewish section consisted of a diverse group of artists brought together by virtue of their shared Jewish origin. Jacob Epstein had introduced Bomberg to Modigliani in Paris the previous year, when he also met Kisling, Ely Nadelman and Jules Pascin. They were included with Bomberg, Gertler and Jacob Kramer (cf. cat. 131, repr. p. 143) amongst others. Modigliani was represented by *Head* [cat. 159, repr. p. 141] and *Drawing for sculpture* (possibly *Caryatid* [cat. 160, repr. p. 141]). Although Epstein was included, his two sculptures *The dreamer* and a bronze bust were displayed elsewhere, in the downstairs gallery.

Juliet Steyn has discussed the significance of the 'Jewish section' in *Twentieth-Century Art* and its implications for British modernism.[14] The Whitechapel Art Gallery was founded by Dame Henrietta Barnett and Canon Samuel Augustus Barnett in 1901, to introduce Jewish immigrants to culture. Both Bomberg and Gertler were brought up locally. In 1906, an exhibition was held at the Whitechapel entitled *Jewish Art and Antiquities*. The organizers of *Twentieth-Century Art* probably decided on a Jewish section as a way of further educating the Jewish community. Nevertheless, it presented a confusing message about Bomberg and other Jewish artists who were engaged with modernism, a message which the critic from the *Jewish Chronicle*, for one, failed to decipher. "The piece of Futurist sculpture by Modigliani is beyond our comprehension", he wrote.[15] *Head* is one of a group of sculpted heads in stone which Modigliani arranged in his studio as an ensemble, and of which he sent five to the Salon d'Automne in 1912. Their dramatic arrangement in the studio, where Modigliani would place lighted candles on top of each one at night, was the subject of much comment from visitors including Epstein. The *Jewish Chronicle*'s passing reference appears to be the only comment made at the time of the Whitechapel show. Even Rutter, who drew attention to the Jewish section, did not mention it. Most of the exhibits were too extreme for the critic of the *Jewish Chronicle* who begrudgingly admired Gertler's depictions of his own family (cf. cat. 61, repr. p. 143) but made it clear that he disliked Bomberg's exhibits intensely – he thought they were a "waste of good pigment, canvas and wall space".[16]

In addition to the four groups, the catalogue pointed to some "excellent landscape work" which could not be categorized (for example, the work of Robert Bevan; cf. cats. 13 and 14, repr. p. 145) and a large display of works from the Omega Workshops.

Of the list of exhibitors some thirty-four, over a quarter, were women. The best known were Vanessa Bell, Anne Estelle Rice and Helen Saunders (cf. cat. 178, repr. p. 147). Their large presence reflected the growing influence of the suffrage movement in the art world.

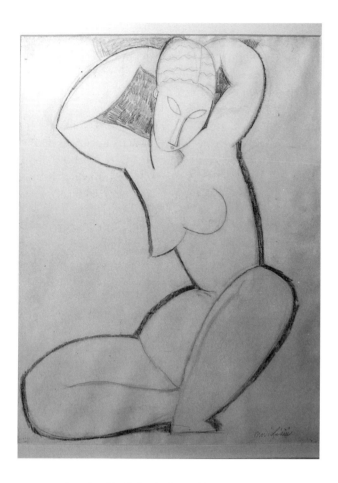

ABOVE Amedeo Modigliani, *Caryatid, ca.* 1912, cat. 160

RIGHT Amedeo Modigliani, *Head, ca.* 1911–12, cat. 159

It is tempting to suggest that other forgotten names are undiscovered British modernists. Some of those who slipped into anonymity such as Vera Waddington do deserve to be better known. Her show of *Chinese Studies* at the Carfax Gallery in 1910 was noticed in the press. She befriended Duncan Grant and worked with him on the Brunswick Square murals. She was also a friend of Ethel Walker and painted in a Post-Impressionist manner. However, whether many of the others merit rediscovery remains to be seen.

The Standard was one of the many popular newspapers which parodied Cubism at the Whitechapel, saying that "the intelligible pictures were banished upstairs" while "Cubists and Futurists splashed one another in the eyes".[17] Others detected corruption. *The*

LEFT ABOVE James Dickson Innes, *The church, Collioure*, 1911, cat. 117

LEFT BELOW James Dickson Innes, *Arenig, sunset*, *ca.* 1911–12, cat. 119

RIGHT Mark Gertler, *Family group*, 1913, cat. 61

BELOW Jacob Kramer, *Meditation – 'the Jew'*, 1916, cat. 131

Westminster Gazette said that "the English disciples of Picasso tread dutifully along the paths of his utter incomprehensibility without having deposited the guarantees of good faith which Picasso himself gave the world in his exquisite early drawings". The reviewer lamented William Roberts's conversion to Cubism. "If such evolutions were legitimately worked out the evil would not be serious. Mr. Roberts has managed to compress the development of a lifetime into six months. He is but an instance of the general insolvency which has followed an overdose of modernism." Grant had allegedly surrendered to cabalistic decoration. Spencer was deemed to have the "potential for being an imaginative painter if he does not succumb to the movement". Praise was reserved for Peploe and for Fergusson, who "stand apart from the turmoil of pastichism as individual art, discovered by independent research While our modern cubists lose themselves in self-created confusion, he [Fergusson] reveals a new truth."[18]

A review in *The Times*, however, reassured sceptics: "We are inclined to think that Cubism as practised by Mr. Wyndham Lewis and Mr. Bomborg [*sic*] is a mistake of the intellect, but we know that those artists are not mere charlatans or incompetents." But would they survive? "The great danger is the weakness of English art. A good many of the Englishmen merely use their discoveries as formulae and seem to think that a use of the latest formula means originality – so there is the old sloppy pettiness of English art even in their excesses."[19]

The Times goes on to praise Fry, Grant, Vanessa Bell and the Sickert school, who "are all much more closely concerned with reality than the Post-Impressionists and the Cubists", and concludes with a schoolmasterly admonishment: "The hope of English painting in the future lies in a marriage of the two schools, and this will only come if each is unwearying in effort and experiment."[20]

Rutter on the other hand welcomed the movements unequivocally: "The organisers have pursued the twists and turnings of modern painting through the mazes of post-impressionism, cubism and expressionism." Once again he pointed out the importance of Impressionist colour theory for modern paintings, suggesting that even the brilliant colour of Lewis and Wadsworth, "a brilliance which certainly outshines any other painting in the exhibition and possibly is only to be obtained by cubist or expressionist methods", had its roots in Impressionism.[21]

As *The Observer* pointed out, the majority of work at the Whitechapel had been seen before at various exhibitions at the Grafton, Doré, Alpine Club and Carfax galleries and at numerous one-man shows. "The completeness of the present exhibition, which gathers up the different threads in a manner in which they have never been gathered up before, lends itself to comment on the general trend of these varied endeavours".[22] *The Morning Post* commented, "There are a few new things in the show, but the old brought together in this way at the Whitechapel, somehow look different. Displayed down there, they seemed to have got rid of much hocus-pocus."[23]

In fact the idea behind the Whitechapel show was by no means unprecedented. There was Rutter's own *Post-Impressionists and Futurists* the previous autumn, and the *Exhibition of the Camden Town Group and Others*, appropriately subtitled *An Exhibition of the Work of English Post-Impressionists, Cubists and Others*, at Brighton Public Art Galleries in December 1913, which featured different factions of the British avantgarde. While Rutter's show used various European 'isms' as a model, the Brighton show consisted entirely of British artists. It brought together the English Post-Impressionists including Sylvia Gosse, Ginner, Robert Bevan, Gilman, Gore, Sickert and Lucien Pissarro amongst others, and Wyndham Lewis and the English Cubists including Etchells, Nevinson and Wadsworth.

Also included in the Cubist Room in Brighton were Bomberg and Epstein whom Lewis, as his catalogue introduction for the Brighton show makes clear, did not include in the group. Manson's introduction to *English Post-Impressionists* took up Rutter's point about the group's ties with Camille Pissarro in its early days, but he stressed that Gore and Gilman were now the leaders of "the forward movement wherever it might lead". His text is peppered with the vocabulary of the modern movement – new modes of expression, new methods *etc* – which shows the high hopes he had for Gore and Gilman, and also suggests that Sickert was happy to relinquish his rôle as leader of these so called Camden Town artists.

The idea of the English Post-Impressionists joining forces with Lewis is odd, but when they met to form the London Group in the early autumn of 1913

Robert Bevan, *Cumberland
Market, ca.* 1915, cat. 14

Robert Bevan, *Cumberland
Market, north side, ca.* 1915,
cat. 13

Helen Saunders, *Vorticist composition in blue and green,*
ca. 1915, cat. 177

LEFT Edward Wadsworth, *Vorticist composition*, 1915, cat.
191

RIGHT Helen Saunders, *Gulliver in Lilliput, ca.* 1915–16,
cat. 178

FIG. 38 Wyndham Lewis, *Sunset among the Michelangelos, ca.* 1912, Victoria and Albert Museum, London

Sickert and Lewis were close. Lewis's expressed disenchantment with Futurism, Post-Impressionism and other "terms and tags" of modern art as he called them in his preface to "The Cubist Room", as it was termed in the catalogue, would have been welcomed by Sickert, who had been waging his own battle against European 'isms' for nearly thirty years. When the critics compared Lewis with Picasso, Sickert must have been reminded of the similar comparisons that had been made between his own work and Degas. Cubist was Lewis's preferred 'tag' at the end of 1913. But his definition of Cubism as "the reconstruction of a simpler earth, left as choked and muddy fragments" by Cézanne is obscure and perverse.[24]

Lewis's identification of Etchells, Cuthbert Hamilton, Wadsworth (cf. cat. 191, repr. p. 146), Nevinson – the group of painters who joined him after the Ideal Home rumpus, his infamous quarrel with Roger Fry –

who, he said, "are not accidentally associated here, but form a vertiginous, but not exotic, island in the placid and respectable archipelago of English art" shows that it was merely a matter of time before Lewis invented his own 'ism' – Vorticism. Indeed the fledgling movement was announced in *The Egoist* in April 1914, and *Blast No. 1*, the official organ of the Vorticist group, was published on 20 June, the day that the Whitechapel show closed.

Ultimately the alliance of the English Post-Impressionists and Cubists was an uneasy one which ended abruptly when Sickert criticized Lewis's *Creation* (lost) and drawings by Epstein and Gaudier-Brzeska in *The New Age*. "While the faces of the persons suggested are frequently nil, non-representation is forgotten when it comes to sexual organs. Witness … Lewis's 'Creation', exhibited at Brighton." Sickert continued: "The Pornometric gospel amounts to this. All visible nature with

two exceptions is unworthy of study, and to be considered pudendum. The only things worthy of an artist's attention are what we have hitherto called the pudenda! … Basta cosi!"[25] They did show together, however, in the first exhibition of the London Group at the Goupil Gallery in March 1914. Konody astutely commented that the show "appears to be made up of the former 'Camden Town Group', the seceders from Mr. Roger Fry's 'Omega Workshops' and other English Post-Impressionists, Cubists and Futurists".[26] Amongst the exhibits was Bomberg's *Ju Jitsu* [cat. 16, repr. p. 138].

Gore died prematurely in 1914 and was represented posthumously in the Whitechapel show. His central rôle in English Post-Impressionism and the esteem with which he was regarded by Sickert's group, as Manson pointed out in his preface to the Brighton show, has frequently been overlooked. Although Sickert was identified as a significant figure in the catalogue preface Sickert himself denied his influence on "a whole group of moderns" in his review of the exhibition, and suggested that they might be better described as being influ-

enced by Gore (charitably Sickert still acceded to the importance of Lucien Pissarro).[27] Equally Lewis's moving tribute to Gore in *Blast No. 1*, where he referred to his as "this great artist and dear friend", shows that Gore crossed party lines with ease.[28] Gore's premature death earlier in the year does not explain Sickert's high regard for him. Gore usually is regarded as belonging to Sickert's Camden Town group, but this label takes no account of the radical changes that occurred in his painting during the last two years of his life. Most recently, as Sickert pointed out, Gore had "assimilat[ed] the qualities of Cézanne" and "moved towards a simplification of planes, and a sharpened interest in accentuated direction of lines", as evident in *Cambrian Road, Richmond* [cat. 99, repr. this page], one of a series of pictures that showed Cézanne's influence.[29] It illustrates yet again the pervasive high regard for Cézanne in Britain. The publication of Clive Bell's *Art* in 1914, which hailed Cézanne as 'the Christopher Columbus of Modern Art', rekindled the interest in Cézanne.

The brightly coloured palette of many of Gore's

Pierre-Albert Marquet, *La Fête foraine au Havre*, 1906, cat. 146

Letchworth paintings (cf. cat. 94, repr. p. 103) and in his study of holiday-makers at *Brighton Pier* [cat. 98, repr. p. 151] – reproduced by Lewis in *Blast No. 1* and which owed much to Marquet (cf. cat. 146, repr. this page) and Matisse – seems far more advanced than the subdued palette of his late work. Equally Gore's late work has little in common with that of Sickert. Plotting the various European influences on Gore's painting ultimately has little value as Sickert was aware: "The historian of art may classify movements and register influences, but the essential factor, the factor of personal talent, escapes with laughter from all his nets."[30] Gore was "a great modern" whose sensual use of colour

makes his painting unique amongst his Camden Town associates. In this respect his work is closer to that of Vanessa Bell, Fry and Grant, who shared Gore's high regard for Cézanne and Matisse.

We can trace their admiration for Cézanne in three still-life paintings by Fry [cat. 48, repr. p. 153], Grant [cat. 114], and Gore [cat. 91, repr. p. 152]. Each artist interpreted Cézanne in his own way. The placement of the objects and the complexities of the spatial configuration in the arrangement of the table in Grant's *The coffee pot* [cat. 114] which is played off against the stretched canvases and picture frames behind, and the patches of diagonal strokes of colour are different from

Spencer Gore, *Brighton Pier*, 1913, cat. 98

the more sombre approach of Fry's *Still life with bananas* [cat. 48]. Gertler's *Still life* [cat. 62, repr. p. 153] also has an affinity with Cézanne

Vanessa Bell, Grant and Fry had been excluded from Rutter's *Post-Impressionists and Futurists* and from *English Post-Impressionists, Cubists and Others*. Rutter had his own quarrel with Fry and was jealous of his success. Lewis's rupture with Fry precluded the possibility of any of Fry's group being included in the Brighton show. Lewis of course was a master of dissent. The Brighton show set the stage for a period of intense rivalry between

Bomberg and Lewis, as Richard Cork has recorded. After trying to leave Bomberg's *Vision of Ezekiel* (London, Tate Gallery) behind in London and hanging it behind a door in the exhibition so that it could hardly be seen, Lewis decreed that another painting by Bomberg was "academic" in form and subject-matter.[31] It is little wonder that Bomberg refused to join the Vorticists, arranged his own successful show at the Chenil Gallery in 1914, and was happy to join the group of Jewish artists which he was asked to select for the Whitechapel show.

Spencer Gore, *Still life with apples*, 1912, cat. 91

BRITISH MODERNISM

The petty quarrels of these British modernists have determined the tenor of much of the subsequent scholarship, so that the social formations within British modernism have been the subject of much discussion. This detracts from their shared interest in European modernism and the close visual connections in their painting. At a simple level this could be the preference for the colour red used in an anti-naturalistic manner. Gore was only too aware of the function of the colour red in Gauguin's *Vision after the sermon* [fig. 16], and he used red freely in his Letchworth painting *The cinder path* [cat. 93, repr. p. 103]. The all-over red background of Matisse's *The red studio* [fig. 21, p. 79] is an obvious source for the vibrant red in the two portraits of *Iris Tree* [cats. 10 and 111, repr. p. 154 & 155], whom Bell, Grant and Fry painted on the same occasion. There also is a noticeable preference for the colour red, and its derivative pink, in paintings by Bomberg, Lewis and Wadsworth [cat. 191, repr. p. 146]. For example, the red in *The mud bath* (London, Tate Gallery) by Bomberg, which makes the background area of the "bath an active rather than a passive element in the painting",[32] serves a function which is similar to the function of red in *The red studio*. Bell and Grant's work has a distinctive inward-looking quality. Seeing Matisse's *The red studio* encouraged their interest in painting as a process of internalization which becomes increasingly self-referential.

Futurism is usually seen to have divided British modernist artists. While Fry was not as critical of Futurism as he is sometimes seen to have been, it is nevertheless true that neither Fry nor Bell nor Grant were engaged with the modern urban world. The "melodrama of modernity", as Lewis termed it, simply did not appeal.

Nevertheless, Bomberg's inflammatory "I APPEAL to a sense of Form ... I Completely abandon Naturalism and Tradition. I am searching for an Interior expression ... where I use Naturalistic Form, I have stripped it of all irrelevant matter", his Futurist-inspired manifesto in the foreword to the catalogue for his one-man show at the Chenil Galleries in 1914, reflects an underlying aesthetic that has been borrowed from Fry.[33]

Roger Fry, *Still life with bananas*, ca. 1915, cat. 48

Mark Gertler, *Still life – the geranium plant*, 1919, cat. 62

Bomberg may have been happy to see himself as a Jewish Futurist, as the *Jewish Chronicle* described him in an interview shortly before the opening of the Whitechapel exhibition, and have even allowed a definition of a Jewish Futurist, but he refused to have anything to do with Marinetti's various attempts to coerce him into the Futurist movement. Moreover, Bomberg appears to have been equally happy to be viewed as a Cubist. Asked by the *Jewish Chronicle* to list the modern artists most important to him, he named Matisse and Picasso.[34] This probably would have been much the same answer that Bell and Grant would have given in 1914, although it is unlikely they would have added Archipenko, the third artist on Bomberg's list.

Bell and Grant took a further interest in Picasso after the *Second Post-Impressionist Exhibition*. Sometime before 1914, Fry acquired Picasso's *Head of a man* (New York, Richard S. Ziesler) from Kahnweiler, whose gallery Fry, Grant and Bell were in the habit of visiting in Paris in order to see the latest work by Picasso and the other gallery artists. *Head of a man* is worked in oil, charcoal, ink and pencil but it closely resembles the *papier collé* works made by Picasso in 1913. Fry and Vanessa Bell finally visited Picasso in his studio in March, where they saw Picasso's newest work, which Bell thought was "lovely", and "amazing arrangements of coloured papers and bits of wood". Picasso apparently told them that he wanted to execute some of his constructions in iron and Fry recommended that he try aluminium. Soon after, Grant visited Picasso and took him some wallpaper that he had found in his Paris hotel room to use for his *papier collé*. These visits stimulated Fry, Grant and Bell's interest in collage and *papier collé*. The composition of Fry's *Essay in abstract design* [cat. 47, repr. p. 158] resembles the composition of Picasso's *Head of a man* but the pasted collage elements were inspired by the works he saw in the studio in 1914. Shortly after this visit, Bell began work on *Triple Alliance* [cat. 8, repr. p. 156]. Bell first made collages with coloured papers while convalescing in Italy in 1912. She also used this method for her designs for marquetry for the Omega Workshops. *Triple Alliance* deploys collage material similar to that found in the work of Picasso. It consists of newspapers dated 12 September 1914 which record the deaths from the first fighting in France, a torn map of Europe, bottle labels and two cheques. *Triple Alliance* may not be visually subversive in the way of

Vanessa Bell, *Portrait of Iris Tree*, 1915, cat. 10

Duncan Grant, *Still life, ca.* 1915, cat. 113

Duncan Grant, *Portrait of Iris Tree*, 1915, cat. 111

Duncan Grant, *Interior at Gordon Square*, 1915, cat. 112

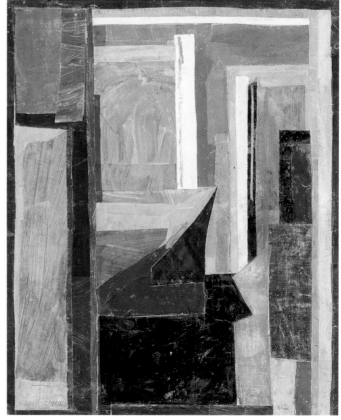

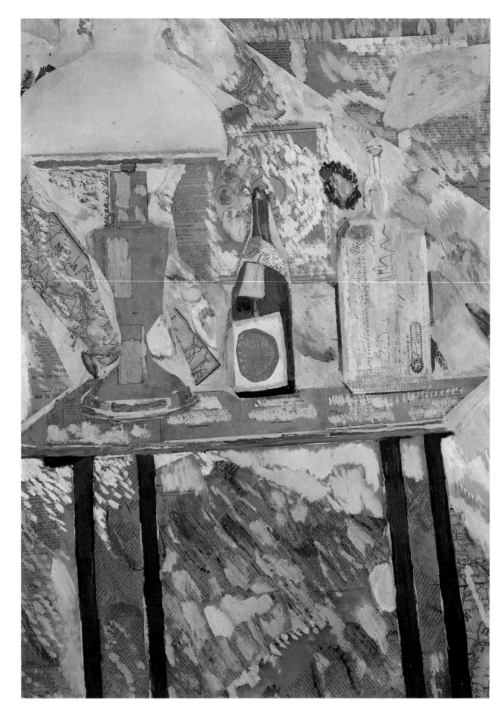

Vanessa Bell, *Triple Alliance*, 1914, cat. 8

RIGHT Vanessa Bell, *Composition*, *ca.* 1914, cat. 9

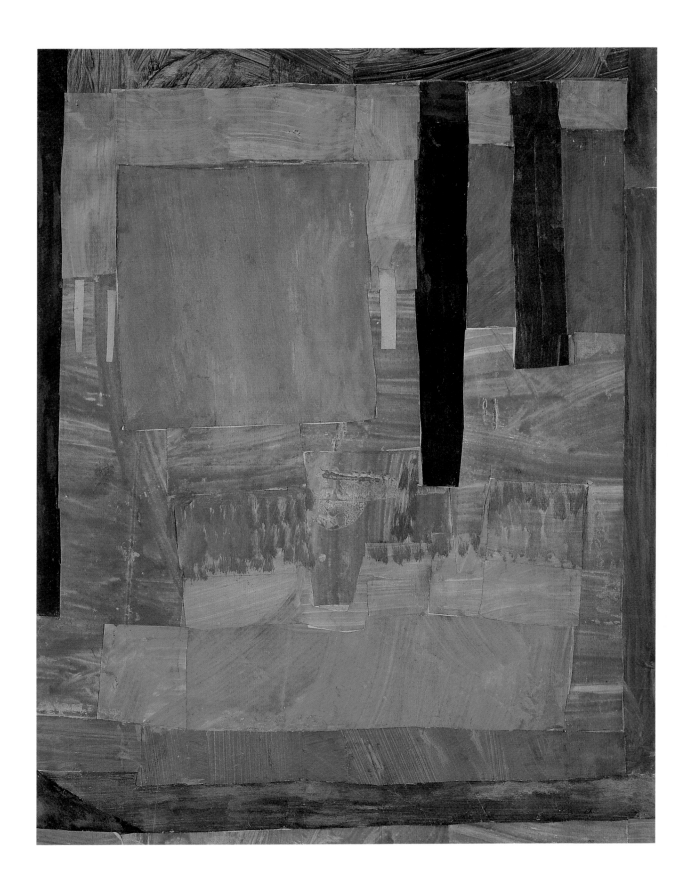

Roger Fry, *Essay in abstract design*, 1914–15, cat. 47

Picasso's *papier collé*, but its message is disconcerting nonetheless. The illusion of comfort evoked by the lamp, whisky bottle and syphon is shattered by the references to war in the collage elements. In spirit, *Triple alliance* is very different from the abstract *papier collé* works by Bell such as *Composition* [cat. 9, repr. p. 157], in pasted paper, oil and gouache. The painted elements of *Composition* have a painterly quality more reminiscent of paintings by Matisse which Grant's *papier collé* (*Still life*; cat. 113, repr. p. 154) shares. Indeed, the soft pastel palette that frequently characterizes Matisse's intimate studies of women in interiors, seen for example in *The inattentive reader* [cat. 157, repr. p. 160], compares with the palette of many of Bell's abstract compositions. Other *papiers collés* by Bell and Grant combine painted elements giving the illusion of patterned paper that closely resemble those in Picasso's *Head of a man*.

It is worth noting that the two factions who were most at odds in 1914, Fry, Bell and Grant and Lewis and the Vorticists, were both experimenting with non-representational painting. Much of the polemic that Lewis launched in *Blast No. 1* was a tirade against the aspects of European modernism which had had most effect in Britain – Cézanne, Picasso's *Le Bouillon Kub* (for being a bad pun), the Cubist picture which had caused a stir at the *Second Post-Impressionist Exhibition*, and Picasso's *papiers collés*, which were the subject of a long abusive tirade.[35] Earlier in 1914, Lewis had been identified as "the leader of the English Cubists", a label, as we know, he used himself at the time of the Brighton show. Equally, Lewis also expressed dissatisfaction with the liberal frequency with which Futurism was used as a label to describe every modern aspect of British art: "Of all the tags going, 'Futurist', for general application, serves as well as any of the active painters of to-day. It is picturesque and easily inclusive. It is especially justifiable here in England where no particular care or knowledge of the exact (or any other matters of art) signification of this word exist."[36] Fry's insistence on calling Lewis's exhibits at the first London Group exhibition in March 1914 "abstract designs" and Bomberg's pictures "patch-work design" must have been equally galling.[37] The confusion about terminology and its odd application in *Twentieth-Century Art: A Review of Modern Movements* determined an entirely new label for the Vorticist group. Yet this label has disguised the shared links of British modernism.

POSTSCRIPT: MATISSE AND MAILLOL AT THE LEICESTER GALLERIES, 1919

CATALOGUE OF AN EXHIBITION
OF PICTURES BY HENRI·MATISSE
AND SCULPTURE BY MAILLOL

ERNEST BROWN & PHILLIPS
(W. L. PHILLIPS, C. L. PHILLIPS, O. F. BROWN)
THE LEICESTER GALLERIES
LEICESTER SQUARE, LONDON

ᴇXHIBITION No. 283. NOVEMBER-DECEMBER, 1919.

THE exhibition of Matisse paintings and small terracottas by Maillol at the Leicester Galleries in November–December 1919 was the idea of Michael Sadleir, who, according to Oliver Brown, the proprietor of the Leicester Galleries, was a mine of information and advice about the Paris art world. Brown had initially approached Sadleir about the possibility of an exhibition of French Impressionist painting. Brown recalled that they had "welcomed the proposal in view of the international fame Matisse had acquired". They decided to overlook the fact that Matisse "had been one of the artists most abused by the British press" in 1910 and 1912, "which was still a recent memory in Britain", but they were still "doubtful if his work would find favour with English collectors".[1]

Sadleir arranged "to borrow a small collection" of Matisse paintings. Apparently Montague Shearman, a Foreign Office official, was the only known British collector of Matisse. Shearman, who lent two pictures by Matisse, including *The inattentive reader* [cat. 157, repr. p. 160], had been bowled over by the display of Matisse at Fry's exhibition and had purchased his first picture by Matisse in Paris in 1918. Initially there were not enough pictures to make a proper show. Matisse, who was in London designing sets for *Le Chant du rossignol*, arrived at the gallery unexpectedly to see what pictures Brown had assembled, and arranged to have more pictures sent from Paris, although none of these was for sale. Fifty-one works by Matisse were exhibited. Earlier in 1919, the Bernheim-Jeune gallery had held Matisse's first one-artist show since 1913. According to Brown, "Matisse came into the Leicester Galleries many times, was taken to lunch at Stone's, the English chophouse, by the gallery partners, and seemed surprised that the English should want to show his work". When the pictures sold for a total of more than £5000, Matisse's "surprise was tinged with amusement: 'Ils sont foux – les Anglais!' he cried".[2]

Vanessa Bell thought that *Woman seated in an armchair* [cat. 158, repr. p. 163] was "one of the best" of the "rather slight sketches" for sale in the Leicester show and she and Grant persuaded the economist Maynard Keynes to buy it. Grant's *Self-portrait* [cat. 115, repr. p. 163], which includes the painting reflected in the mirror that Grant faces, is a poignant reminder of the Bloomsbury group's high regard for Matisse.[3] Other

Henri Matisse, *The inattentive reader*, 1919, cat. 157

collectors who bought works from the Leicester Gallery exhibition included Michael Sadler, Brandon Davis, Walter Taylor, George Eumorphopolous, Arnold Bennett and some "unknown English visitors" who "bought modest recent landscapes". The Contemporary Art Society allowed £50 "towards the purchase of an approved picture by Matisse" in December 1912.[4] Michael Fitzgerald records that Matisse's dealers, the Bernheim-Jeune Gallery, set prices for Matisse's oil paintings at between 450 francs [approximately £33] and 1875 francs [approximately £136] in 1909 and that those prices remained the same in 1912.[5] However, there is no evidence to show that the £50 was spent. Presumably no painting by Matisse in the *Second Post-Impressionist Exhibition* met with the Contemporary Art Society's approval.

The success of the Leicester show indicates that Matisse's fortune in Britain had taken a dramatic turn. Institutional acceptance of Matisse took longer. In 1920 the British Museum accepted *Nude* [cat. 150, repr. p. 81] from R.E.A. Wilson, and in 1931 the Contemporary Art Society donated *Standing nude* [cat. 151]. The Contemporary Art Society purchased Matisse's *Reading woman with parasol* (1921) specifically for presentation to the Tate Gallery. Matisse chose it because he thought – wrongly as it happened – that "it won't frighten the acquisitions committee of the Modern Museum in London".[6] As Ronald Alley records, it was turned down by the Trustees of the Tate Gallery in 1929 and was not accepted by them until 1938. Between 1933 and 1940 the Trustees also accepted bequests from Frank Stoop and Montague Shearman. In 1949 money from the Courtauld Fund, which had been established by Samuel Courtauld in 1923, finally was used to purchase Matisse's *Notre-Dame* (*ca.* 1900).[7] But the most spectacular lack of faith in Matisse was the refusal of the Tate Gallery to purchase *The red studio* [fig. 21, p. 79], which was offered to the Trustees after having been displayed in a London drinking club between 1926 and 1941.

In the 1920s the Leicester Galleries held a series of one-artist exhibitions, including Gauguin, Van Gogh and Picasso, in which many of the works first shown in London between 1910 and 1914 were offered for sale once again.

Vanessa Bell, *Duncan Grant in front of a mirror (with a cold)*, *ca.* 1919, cat. 11

Duncan Grant, *Vanessa Bell painting*, 1913, cat. 109

Duncan Grant, *Self-portrait*, 1919, cat. 115

Henri Matisse, *Woman seated in an armchair*, 1919, cat. 158

CATALOGUE

NOTE TO USERS

For two-dimensional works image sizes are given height before width. For three-dimensional works, height before length, followed by depth.

The placing of signatures and inscriptions on the work is given where known, indicated by the following abbreviations:
t.r. – top right
b.r. – bottom right
r.c. – right centre
t.c. – top centre
b.c. – bottom centre
l.c. – left centre
t.l. – top left
b.l. – bottom left

Where works are known to have been included in the exhibitions listed in the Appendix (see pp. 186–92), this is indicated at the end of the entry. Catalogue numbers are given in brackets.

MAURICE ASSELIN (1882–1942)

Fry and Rutter admired Asselin's 'Cézannesque' pictures at the Salon d'Automne in Paris and consequently included his work in their exhibitions. Rutter tipped him as a promising watercolour painter and Sickert painted his portrait.

1 *Parc de Versailles*, 1911
Watercolour on paper, 30 × 24.5 cm
Signed and dated b.r.
Trustees of the British Museum, London (repr. p. 121)

VANESSA BELL (1879–1961)

Born in London, the sister of Virginia Woolf, Bell was an influential figure in a circle of artists and critics that included her husband Clive Bell (married 1907), Roger Fry and Duncan Grant – with whom she formed a lasting relationship and working partnership. They painted many of the same subjects. Her *Friday Club* (founded 1905) exhibitions were a forum for modern art. After 1910 she was a committed modernist who adapted aspects of Matisse and Picasso in her own paintings which are striking for their simplicity and clarity of purpose. Between 1913 and 1919 she was an important designer and co-director for the Omega Workshops. Fry, Sickert and Michael Sadler, who once owned cat. 8, were also early admirers of her work.

2 *A bridge, Paris*, 1911
Oil on canvas, 29 × 42 cm
Signed and dated b.r.
Rye Art Gallery Trust (repr. p. 44)

3 *The bathers, Studland Beach*, 1911
Oil on cardboard, 63.5 × 76.2 cm
Private collection (repr. p. 27)

4 *Studland Beach*, ca. 1912
Oil on canvas, 76.2 × 101.6 cm
Trustees of the Tate Gallery, London (repr. p. 86)

5 *Nursery tea*, 1912
Oil on canvas, 76.9 × 105.3 cm
Private collection (repr. p. 86)

6 *Virginia Woolf*, 1912
Oil on canvas, 39.5 × 33 cm
National Portrait Gallery, London (repr. p. 89)

7 *Summer camp*, 1913
Oil on board, 78.7 × 83.8 cm
Bryan Ferry

8 *Triple Alliance*, 1914
Collage (paper, paint, pastel) on sized canvas, 81.9 × 60.3 cm
The University of Leeds Art Collection (repr. p. 156)
EXHIBITION
1917 *The New Movement in Art* (16)

9 *Composition*, ca. 1914
Oil, gouache, and pasted paper, 55.1 × 43.7 cm
The Museum of Modern Art, New York, The Joan and Lester Avnet Collection (repr. p. 157)

10 *Portrait of Iris Tree*, 1915
Oil on canvas, 122 × 91.5 cm
Signed and dated t.r.
Private collection (repr. p. 154)

11 *Duncan Grant in front of a mirror (with a cold)*, ca. 1915–16
Oil on wood, 56.5 × 45.7 cm
Private collection, on loan to The Metropolitan Museum of Art, New York (repr. p. 162)

ROBERT BEVAN (1865–1925)

Born in Hove, Sussex, Bevan met Gauguin in Brittany ca.1893. His early landscapes of Poland, which he visited often after marrying Stanislawa de Karlowska (1897; see below), are characterized by their strong colour. After seeing paintings by Cézanne and Gauguin he introduced greater structure, crisp outlines and unusual viewpoints into his painting. He was a member of the Fitzroy Street Group, the Camden Town Group (1911), the London Group (1913), and the Cumberland Market Group – named after one of the surviving squares designed by Nash in Camden Town where Bevan lived.

12 *Still life – whisky and soda*, 1914
Oil on canvas, 38.6 × 46.4 cm
Private collection

13 *Cumberland Market, north side*, ca. 1915
Oil on canvas, 51.1 × 61 cm
Southampton City Art Gallery (repr. p. 145)

14 *Cumberland Market*, ca. 1915
Oil on canvas, 48.3 × 61 cm
Signed b.l.
Miss K. McCreery (repr. p. 145)

UMBERTO BOCCIONI
(1882–1916)

Born in Reggio Calabria, Boccioni worked with Severini and Balla (1905–06) in Rome before travelling to and working in Paris and Milan (1908) where he met Carra, Russolo and Marinetti. He was the main author of the first *Futurist Painting Manifesto* in 1910. He participated in many Futurist events, including three Futurist exhibitions in London in 1912 and two in 1914 when his *Futurist Manifesto of Sculpture* was published in the catalogue.

15 *A modern idol*, 1911
Oil on panel, 59.7 × 58.4 cm
Signed b.l.
Eric and Salome Estorick Foundation, London (repr. p. 59)
EXHIBITION
1912 *Paintings by the Futurists* (8)

DAVID BOMBERG
(1890–1957)

Born in Birmingham, in 1895 Bomberg moved with his family to London's East End. He studied with Sickert before attending the Slade School of Art (1911–13). He quickly responded to the stimulus of European art works, including Severini's *Dancers* (see cats. 182 and 183), some aspects of Picasso's Cubism and the bright palette of Matisse. In spring 1913 he travelled to Paris, where he met Modigliani and other artsits who formed the Jewish section of the *Twentieth-Century Art* exhibition. His 'Cubist' work attracted the attention of the London art world even before his controversial one-artist show at the Chenil Gallery in July 1914. Wyndham Lewis regarded Bomberg as a rival and attempted to exclude him from the prototype exhibition for the London Group in Brighton in 1913. Bomberg did not join the Vorticist group.

16 *Ju Jitsu*, ca. 1913
Oil on cardboard, 62 × 62 cm
Signed b.r.
Trustees of the Tate Gallery, London (repr. p. 138)
EXHIBITION
1914 *London Group*

17 *The dancer*, ca. 1914
Watercolour and chalk on paper,
36 × 26 cm
Private collection

PIERRE BONNARD
(1867–1947)

Bonnard was a member of Nabis (1890), the group which included Denis and Vuillard for whom Gauguin was an important stimulus. In his early career he executed many decorative schemes. He became friendly with Sickert, with whom he and Vuillard had critiques about their painting. There are notable affinities in the compositions and the blending of portraiture and domestic genre in the intimate domestic interiors painted after 1900. From 1909, when Bonnard stayed at St-Tropez, the strong Mediterranean light had an important effect on his palette. There is more emphasis on an overall play of colour. This pleased Fry, who included Bonnard in the *Second Post-Impressionist Exhibition* and once owned cat. 18.

18 *Young woman in an interior*, 1906
Oil on canvas, 48.9 × 44.5 cm
Signed b.r.
Courtauld Institute Galleries, London (Fry Bequest)

PAUL CÉZANNE (1839–1906)

Born in Aix-en-Provence, Cézanne exhibited in the first Impressionist exhibition (1874), but he did not rise to prominence until after Vollard began to deal in his pictures in 1895. A retrospective exhibition of his work in Paris in 1907 was an important catalyst for a large number of modern artists. His work was hardly known in England until 1910, when he was hailed as the 'father of modern art'. This probably explains why he is relatively well represented in public collections in Britain. Herbert Coleman, Michael Sadler and Gwendoline and Margaret Davies were early British collectors whose interest preceded that of Sir Samuel Courtauld. Although Fry was an avid collector and wrote an important monograph, *Cézanne* (1927), he did not own a work by Cézanne.

19 *The shed*, ca. 1880
Pencil and watercolour on paper,
31.4 × 47.5 cm
Courtauld Institute Galleries, London (The Samuel Courtauld Trust)
EXHIBITION
1912 *Second Post-Impressionist Exhibition* (102)

20 *The viaduct at L'Estaque*, ca. 1883
Oil on canvas, 53 × 63.5 cm
The Finnish National Gallery, Helsinki (Collection Antell Ateneum)
(repr. p. 22)
EXHIBITION
1910 *Manet and the Post-Impressionists* (20)

21 The 'small' *Bathers*, 1896–97
Lithograph on paper, 22.4 × 27.4 cm
Signed b.r.
Trustees of the British Museum, London
EXHIBITION
1913 *Post-Impressionist and Futurist Exhibition* (10)

22 The 'large' *Bathers*, 1897–98
Colour lithograph on paper,
40.3 × 49.2 cm
Trustees of the Tate Gallery, London (repr. p. 25)
EXHIBITION
1913 *Post-Impressionist and Futurist Exhibition* (148)

HENRI EDMOND CROSS
(1856–1910)

Born in Douai, Cross settled in Paris in 1881. Around 1890 he adopted a pointillist technique which became increasingly individual. In 1891 he moved to the South of France where he painted landscapes and sent them to the Salon des Indépendants of which he was founder member (1884). From the mid-1890s he painted in watercolour. Included in the exhibition *Manet and the Post-Impressionists*, he continued to attract notice in England. Cat. 23 was acquired from Percy Moore Turner of the Independent Gallery.

23 *Mediterranean landscape*, ca. 1908–09
Watercolour and pencil on paper,
30.5 × 43.6 cm
Signed b.r.
The Whitworth Art Gallery,
The University of Manchester

STANLEY CURSITER
(1887–1976)

The exhibitions of modern art in London in 1912 had an immediate effect on Cursiter, who began painting Futurist pictures the following year. His commitment to Futurism was not long-lasting. He was appointed Director of the National Gallery of Scotland in 1930.

24 *The Regatta*, 1913
Oil on canvas, 50.4 × 60.8 cm
Scottish National Gallery of Modern
Art, Edinburgh (repr. p. 58)

ROBERT DELAUNAY (1885–1941)

Delaunay trained as a theatre designer
before turning to painting in 1904. Like
many young artists in turn-of-the-
century Paris, Delaunay experimented
with Impressionism and a Cézannesque
manner of painting before falling under
the influence of Cubism. His strong
interest in colour theory led to the inven-
tion of paintings composed of planes of
simultaneously contrasting colour which
Apollinaire dubbed 'Orphist'. Initially
these works were non-representational.
Delaunay also used a combination of
representational 'modern life' imagery
and non-representational elements. News
of the new Orphist movement reached
Rutter quickly; he mentioned it in his
introduction to the 1913 catalogue. Cat.
25 was one of the few major works that
Rutter borrowed for his exhibition from a
contemporary European artist.

25 *The Cardiff Football Team*, 1913
Oil on canvas, 195.5 × 132 cm
Stedelijk Van Abbemuseum, Eindhoven
(repr. p. 6)
EXHIBITION
1913 *Post-Impressionist and Futurist* (30)

MAURICE DENIS (1870–1943)

Denis was an influential member of the
Nabis and the chief theorist of their
artistic programme. After 1900 his easel
paintings, large-scale decorative schemes
and critical writings reflected an increas-
ing interest in religious values and a
return to classicism. His analysis of the
classical tendencies in Cézanne's art was
influential for Fry. That Fry and
Tancred Borenius advised the Antell
Ateneum to purchase cat. 26 is evidence
of Fry's high estimation of Denis.

26 *Ulysses and Calypso*, 1905
Oil on canvas, 82 × 117 cm
Signed and dated b.l.
The Finnish National Gallery, Helsinki
(Collection Antell Ateneum)
(repr. p. 26)
EXHIBITION
1910 *Manet and the Post-Impressionists*
(82)

ANDRÉ DERAIN (1880–1954)

After painting with Matisse at Collioure
in 1905, Derain came to London at the
beginning of 1906 to paint a series of
brilliantly coloured pictures of the
Thames (cf. cat. 27). Around 1908 his
work became increasingly 'Cézannesque'
– which impressed Fry, who preferred
this more sombre classicism, and Clive
Bell, who became a close friend. Rutter
was another British friend. Fry selected
these later, tradition-inspired pictures
with Cézannesque tendencies for the two
Post-Impressionist exhibitions.

27 *Barges on the Thames*, 1906
Oil on canvas, 81.3 × 99 cm
Signed b.l.
Leeds Museums and Galleries (City Art
Gallery) (repr. p. 11)

28 *Parc à Carrières*, 1909
Oil on canvas, 54.1 × 65 cm
Courtauld Institute Galleries, London
(Fry Bequest)
EXHIBITION
1910 *Manet and the Post-Impressionists*
(118)

29 *Window at Vers*, 1912
Oil on canvas, 130.8 × 89.5 cm
The Museum of Modern Art, New York
(repr. p. 67)
EXHIBITION
1912 *Second Post-Impressionist Exhibition*
(13)

JESSICA DISMORR (1885–1939)

Born Gravesend, Kent, Dismorr studied
at the Slade School and at the Atelier de
la Palette, where she met Fergusson. By
1911 she was a member of the British-
American Fauve group based in Paris.
She showed with them at the Stafford
Gallery and contributed to *Rhythm*. She
was a signatory to the Vorticist mani-
festo in *Blast No. 1* and exhibited with
the Vorticists in London (1915) and
New York (1917). Dismorr also exhib-
ited at the Salon d'Automne, the AAA,
the London Group and the Seven and
Five Society.

30 *Landscape with figures*, ca. 1912
Oil on board, 31 × 39.5 cm
Sheffield City Art Galleries
(Graves Art Gallery) (repr. p. 113)

MALCOLM DRUMMOND (1880–1945)

Born at Boyne Hill, Berkshire, Drum-
mond studied at the Slade School
(1903–07) and with Sickert at the West-
minster School of Art. He was a member
of the Camden Town Group and a
founder-member of the London group.
Drummond responded positively to see-
ing Van Gogh's pictures in 1910. Cat.
31 pays double homage to Van Gogh,
by emulating both his technique and the
manner of a series of self-portraits that
Van Gogh, Gauguin and Bernard
exchanged in 1888.

31 *Portrait of Charles Ginner*, ca. 1911
Oil on fibreboard, 60.3 × 49 cm
Southampton City Art Gallery
(repr. p. 167)
EXHIBITION
December 1911 *Camden Town* (41)

32 *A Chelsea street*, ca. 1912
Oil on canvas, 60 × 45 cm
The Visitors of the Ashmolean Museum,
Oxford

JACOB EPSTEIN (1880–1959)

Born in New York, Epstein went to
Paris (1902) before moving to London
in 1907. While working in France
(1911) on the tomb of Oscar Wilde he
met Brancusi. He also befriended
Modigliani, who gave him a drawing
(cat. 160). Epstein's sculptures borrowed
heavily from non-European sources and
caused controversy when they were
exhibited at the AAA and elsewhere.
After moving to Pett Level, Sussex, at
the end of 1912, he worked on groups of
sculpture with a single theme (cf. cat.
34) in the manner of Brancusi and
Modigliani. Many, including Sickert,
considered his erotically charged themes
to be pornographic. He was associated
with the Vorticist group although he did
not become a member.

33 *Sketch of doves*, 1913
Black chalk and coloured wash on paper,
57 × 44.5 cm
Walsall Museum and Art Gallery
(Garman Ryan Collection)

34 *Doves (first version)*, 1913
Sculpture, marble,
34.7 × 50.3 × 18.5 cm
Hirshhorn Museum and Sculpture
Garden, Smithsonian Institution,

Malcolm Drummond, *Portrait of Charles Ginner, ca.* 1911, cat. 31

Washington, D.C. (Gift of Joseph H. Hirshhorn, 1966) (repr. p. 135)

EXHIBITION
1913 Allied Artists Association (1205)?

35 *Birth*, 1913
Relief, stone, 30.6 × 26.6 × 10.2 cm
Art Gallery of Ontario, Toronto
(repr. p. 135)

FREDERICK ETCHELLS
(1886–1973)

Born in Newcastle upon Tyne, Etchells took a studio in Paris in 1911 where he met Picasso, Braque and Modigliani. He contributed to several mural schemes, including the Borough Polytechnic murals (1911) and the Brunswick Square murals. He joined the Omega Workshops but left with Lewis and the other rebels in October 1913. He joined the Rebel Art Centre (1914), contributed to *Blast No. 1* and *Blast No. 2* and participated in the Vorticist exhibitions in London (1915) and New York (1917). He later trained as an architect.

36 *The dead mole*, 1912
Oil on canvas, 167 × 106 cm (in frame designed by the artist)
Signed b.l.
Provost and Fellows of King's College, Cambridge (Keynes Collection), on loan to the Fitzwilliam Museum, Cambridge (repr. p. 98)

EXHIBITION
1912 *Second Post-Impressionist Exhibition* (103)

JOHN DUNCAN FERGUSSON
(1874–1961)

Born in Scotland, Fergusson lived in Paris between 1907 and 1914 where he taught at the Atelier de la Palette. He was an early admirer of Matisse and an influential figure, who, with Anne Estelle Rice, established a British-American Fauve group. He was influenced by Bergson's ideas and called himself a Rhythmist in deference to Bergson. As art editor of *Rhythm* (from its inception in summer 1911 to November 1912),

which took its title from the painting cat. 39, Fergusson published work by Picasso, Derain and others. Through his connection with its founders J. Middleton Murry and Michael Sadleir, he and his group were introduced to the Stafford Gallery. This circle and Rutter gave the group their full support but they did not find favour with Fry.

37 *Portrait of Anne Estelle Rice*, 1908
Oil on board, 66.5 × 57.5 cm
Scottish National Gallery of Modern Art, Edinburgh (repr. p. 110)

38 *The blue hat, Closerie des Lilas*, 1909
Oil on canvas, 76.2 × 76.2 cm
City Art Centre, Edinburgh
(repr. p. 110)

39 *Rhythm*, 1911
Oil on canvas, 163 × 115.5 cm
University of Stirling (J.D. Fergusson Collection) (repr. p. 111)

EXHIBITIONS
1911 Salon d'Automne, Paris (494);
1913 *Post-Impressionist and Futurist Exhibition* (83)

Othon Friesz, *Hilly landscape, ca.* 1923, cat. 42

40 *Cassis from the west*, 1913
Oil on board, 26.5 × 34.5 cm
The Fergusson Gallery, Perth and
Kinross Council (repr. p. 113)

OTHON FRIESZ (1879–1949)

Born in Le Havre, Friesz formed a close
association with Matisse in 1905, and
exhibited with him in that year as a
'Fauve' at the Salon d'Automne. He also
formed a close friendship with Braque,
with whom he painted at La Ciotat,
where he produced some of his most
brightly coloured, lyrical landscapes (cf.
cat. 41). Later that year he began to
emulate Cézanne's *Bathers* in a series of

classically inspired landscapes with fig-
ures treated in a Cézannesque manner.
They won acclaim at the Salon
d'Autumn and Fry included one in his
second Post-Impressionist exhibition.
Cat. 41 once belonged to Hugh Blaker,
who advised the Davies sisters.

41 *La Ciotat*, 1907
Oil on canvas, 27.3 × 36.1 cm
Signed b.r.
National Museum of Wales, Cardiff

42 *Hilly Landscape, ca.* 1923
Oil on canvas, 64 × 80 cm
Signed b.r.
The Visitors of the Ashmolean Museum,
Oxford (repr. this page)

ROGER FRY (1866–1934)

Born in London, Fry studied science at
Cambridge before becoming a painter.
In the early 1890s he began writing on
art and studying the Italian Renaissance.
In 1906 he became curator of the
Department of Painting at the Metropol-
itan Museum of Art, New York. After
returning to England, he was appointed
editor of *The Burlington Magazine*
(1909). After defending Cézanne and
Gauguin in *The Burlington Magazine* in
1908, he quickly became a proselytizer
for modern art, which he introduced to
Britain with the two Post-Impressionist
shows in 1910 and 1912. These exhibi-

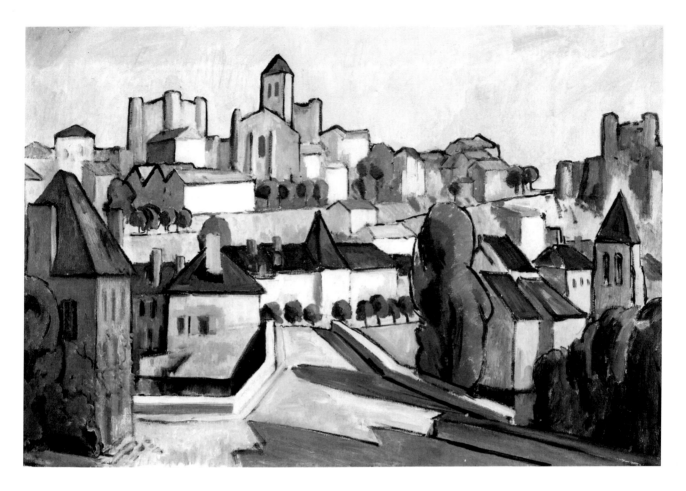

Roger Fry, *Chauvigny*, 1911, cat. 43

tions, and Fry's writings on modern art, had a profound effect on subsequent critical thought. An indefatigable organizer, he formed the Omega Workshops (1913) to produce original designs and decoration in the applied arts. A close friend of Vanessa Bell, whom he painted on several occasions, including cat. 45, he was a committed artist whose work reflects the range of his critical enthusiasms including Cézanne, Matisse and Picasso. His art was admired by his peers, including Michael Sadler, who once owned cat. 43.

43 *Chauvigny*, 1911
Oil on canvas, 61 × 91.4 cm
Signed and dated b.l.
The University of Leeds Art Collection
(repr. this page)
EXHIBITION
1912 *Roger Fry*

44 *The Black Sea coast*, 1911
Oil on canvas, 71.1 × 91.4 cm
Swindon Museum and Art Gallery
(repr. p. 18)

45 *Summer in the garden*, 1911
Oil on panel, 44.5 × 55.9 cm
Signed
Private collection (repr. p. 89)

46 (Also attributed to Vanessa Bell)
The Matisse room at the Second Post-Impressionist Exhibition at the Grafton Galleries, London, 1912
Oil on wood, 51.3 × 62.9 cm
Musée d'Orsay, Paris (Mrs Pamela Diamond Gift, 1959) (repr. p. 78)

47 *Essay in abstract design*, 1914–15
Oil on paper and bus tickets on veneer board, 36.2 × 27 cm
Trustees of the Tate Gallery, London
(repr. p. 158)

48 *Still life with bananas*, ca. 1915
Collage, gouache and oil on cardboard, 50 × 37 cm
Courtauld Institute Galleries, London
(Mrs Pamela Diamond Gift)
(repr. p. 153)

49 *Nude, seated model (Nina Hamnett)*, ca. 1918
Pen on coarse paper, 35 × 23.5 cm
The University of Leeds Art Collection

50 *Quarry, Bo Peep Farm, Sussex*, 1918
Oil on canvas, 54.6 × 75 cm
Signed and dated b.l.
Sheffield City Art Galleries (Graves Art Gallery) (repr. p. 23)

HENRI GAUDIER-BRZESKA (1891–1915)

Born near Orléans, he met Sophie Brzeska (cf. cat. 53), whose name he added to his own, in Paris in 1910. By 1911 the couple were living in London, where Gaudier-Brzeska soon encountered Horace Brodsky (cf. cat. 52), Epstein and Lewis amongst others. His first exhibition success was at the AAA in 1913. Shortly afterwards he gave up a desk job to devote himself to art, quickly absorbing a variety of sources from modern art. He was a member of the Rebel Art Centre, and contributed to *Blast* and the Vorticist London exhibition (1915). He was killed in action fighting for France (5 June 1915); Ezra Pound published a moving tribute, *Gaudier-Brzeska. A Memoir*, 1916.

51 *The wrestler*, 1912
Sculpture, lead, 66 × 39 × 41 cm
Signed and dated
Leeds Museums and Galleries (City Art Gallery) (repr. p. 129)
EXHIBITION
1913 Allied Artists Association

52 *Horace Brodsky*, 1913
Sculpture, bronze, 69.2 × 53 × 33 cm
Signed and dated
Leeds Museums and Galleries (City Art Gallery)
EXHIBITION
1913 Allied Artists Association

53 *Sophie*, 1913
Pastel on paper, 72.6 × 53.5 cm
Signed and dated b.r.
Southampton City Art Gallery
(repr. p. 94)

54 *Self-portrait*, 1913
Pastel on paper, 51.7 × 36.5 cm
Signed (in monogram) and dated t.r.
Southampton City Art Gallery
(repr. p. 94)

55 *Bird swallowing a fish*, 1914
Sculpture, bronze, 31 × 61 × 28 cm
Kettle's Yard, University of Cambridge
(repr. p. 60)

PAUL GAUGUIN (1848–1903)

Born in Peru, Gauguin achieved fame in his own lifetime when he showed in group exhibitons from 1879 and later as the self-acknowledged leader of a group of young artists in Brittany. He visited Martinique in 1887, lived in Tahiti 1891–93 and 1895–1901, before settling in the Marquesas Islands, where he died. His exotic Tahitian images caught the British imagination when they were shown at the first Post-Impressionist exhibition. Initially horror was expressed but opinion quickly changed. By 1911 Gauguin was regarded as a great Post-Impressionist master. Michael Sadler was an important early British collector. By 1912 he owned at least four major oil paintings, one of which, *Vision after the sermon* (National Gallery of Scotland; fig. 16) remains in Britain. Fry acquired cat. 58 shortly after the first Post-Impressionist exhibition for £30 and presented it to the Tate Gallery through the Contemporary Art Society in 1917.

56 *Manao tupapau*, 1894
Lithograph, 42.3 × 57.5 cm
Signed (in monogram) t.l.
Trustees of the Victoria and Albert Museum, London (repr. p. 8)

57 *The black pigs*, 1891
Oil on canvas, 91 × 72 cm
Signed and dated b.r.
Szépművészeti Múzeum, Budapest
(repr. p. 34)
EXHIBITION
1910 *Manet and the Post-Impressionists* (28)

58 *Tahitians, ca.* 1891
Oil, crayon and charcoal on paper, 85.4 × 101.9 cm
Trustees of the Tate Gallery, London
(repr. p. 34)
EXHIBITION
1910 *Manet and the Post-Impressionists* (128)

59 *Tahitian women bathing*, 1892
Oil on canvas, 109.9 × 89.5 cm
The Metropolitan Museum of Art, New York (Robert Lehman Collection, 1975) (repr. p. 31)
EXHIBITION
1910 *Manet and the Post-Impressionists* (86)

60 *Three Tahitians*, 1899
Oil on canvas, 73 × 94 cm
Signed and dated b.l.
National Gallery of Scotland, Edinburgh
(repr. p. 30)
EXHIBITION
1910 *Manet and the Post-Impressionists* (120)

MARK GERTLER (1891–1939)

Born in East London, Gertler attended the Slade School, where he met Nevinson and Wadsworth amongst others. The simplicity of effect in his studies of his family (see cat. 61) can be compared to work by Picasso (*ca.* 1905–06) which was shown in London in 1912. Gertler came to public notice when he was included in the Jewish section of *Twentieth-Century Art*, where *Jewish Family* (Tate Gallery), which is similar to cat. 61, attracted notice. He also experimented in a series of still lifes (see cat. 62) with a Cézannesque handling which became more exaggerated after he met Roger Fry.

61 *Family group*, 1913
Oil on canvas, 92.4 × 61 cm
Southampton City Art Gallery
(repr. p. 143)

62 *Still life – the geranium plant*, 1919
Oil on canvas, 40.6 × 63.5 cm
Signed and dated b.r.
Private collection (repr. p. 153)

ERIC GILL (1882–1940)

Born in Brighton, Gill trained as a stonecutter before carving his first stone sculpture in 1910. His exhibits at his first one-artist exhibition at the Chenil Gallery in January 1911 were compared to Cézanne, Gauguin and Van Gogh. His sculpture quickly caught the attention of the newly-formed Contemporary Art Society and he was the only British sculptor to be included in Fry's *Second Post-Impressionist Exhibition*, where his work was displayed prominently alongside that of Matisse, of whose sculpture he was in awe. In 1912 he was commissioned by Mme Strindberg to sculpt an effigy for her night club, the Cave of the Golden Calf (cf. cat.63). He also worked as a printmaker and typographer.

63 *The Golden Calf*, 1912
Sculpture, Hoptonwood stone with added colour, originally gilded, 42 × 55.5 × 20.5 cm
Harry Ransom Humanities Research Center, The University of Texas at Austin (repr. p. 100)
EXHIBITION
1912 *Second Post-Impressionist Exhibition* (34)

HAROLD GILMAN
(1876–1919)

Born in Rode, Somerset, he attended the Slade School where he met Spencer Gore. Under Sickert's influence he turned to prosaic subject-matter and painted intimate interiors which can be compared to Vuillard. His painting changed dramatically after the first Post-Impressionist exhibition and after he saw a group of works by Van Gogh in Paris where he went with Rutter and Ginner late in 1910. He hero-worshipped Van Gogh, emulating his subjects, palette, technique and drawing style. Yet his work is individual. His later work is characterized by broadly painted planes of colour and crisp outlines. He was a founder member of the Camden Town Group (1911), the first president of the London Group (1914), and co-founder of the Cumberland Market Group (1914). In 1913 he showed with Gore at the Carfax Gallery. The following year he showed with Ginner at the Goupil Gallery. He died in the influenza epidemic of 1919. Cats. 64 and 68 were once owned by Hugh Blaker.

64 *The old lady, ca.* 1910
Oil on canvas, 34.3 × 29.8 cm
Bristol Museums and Art Gallery

65 *Contemplation, ca.* 1911
Oil on canvas, 35.6 × 29.2 cm
Signed b.r.
Private collection

66 *A nude in an interior,* 1911
Oil on canvas, 50.3 × 35.3 cm
Yale Center for British Art, New Haven (Paul Mellon Fund) (repr. p. 123)

67 *Portrait of Sylvia Gosse,* 1912–14
Oil on canvas, 69.5 × 53.4 cm
Signed b.r.
Southampton City Art Gallery
(repr. p. 95)
EXHIBITION
1914 *London Group* (92); *Gilman-Ginner*

68 *The mountain bridge,* 1913
Oil on canvas, 62 × 80 cm
Signed b.r.
Worthing Museum and Art Gallery
EXHIBITION
1913 *Post-Impressionist and Futurist Exhibition* (52)

69 *Eating house, ca.* 1914
Oil on canvas, 45.7 × 61 cm
Signed b.r.
Richard Burrows (repr. p. 127)
EXHIBITION
1914 *London Group; Gilman-Ginner*

70 *Girl with a teacup, ca.* 1914
Oil on canvas, 62.2 × 52.1 cm
Signed b.r.
Private collection

71 *Mrs Mounter, ca.* 1916
Oil on canvas, 91.8 × 61.5 cm
Signed b.r.
Board of Trustees of the National Museums and Galleries on Merseyside (Walker Art Gallery, Liverpool) (repr. p. 124)

72 *The farmhouse bedroom, ca.* 1916
Pen and ink on paper, 18.5 × 28 cm
The British Council

73 *Interior with Mrs Mounter,*
ca. 1916–17
Oil on canvas, 69 × 51 cm
The Visitors of the Ashmolean Museum, Oxford (repr. p. 127)

74 *Seascape: breaking waves,* 1917
Pen and ink on paper, 29.8 × 43 cm
Signed b.r.
The Visitors of the Ashmolean Museum, Oxford (repr. p. 124)

CHARLES GINNER
(1878–1952)

Born in France, Ginner settled in England in 1909 after meeting Gilman and Gore when he exhibited at the AAA (1908). In 1912 he contributed to the decoration of the Cave of the Golden Calf (see above). Initially a passionate advocate of French Post-Impressionist art, he later denounced what he saw as its pernicious influence on British painting in 'Neo-Realism', the preface to the catalogue for his joint exhibition with Gilman at the Goupil Gallery in 1914. His keen awareness of the old and new aspects of landscape can be compared to Gore's and also to Van Gogh's. He was befriended by Rutter whom he often visited with Gilman in Leeds, and he may have been influenced by the aesthetic theories of the Leeds Arts Club. Rutter once owned cat. 78.

75 *Neuville Lane,* 1911
Oil on board, 28.6 × 17.8 cm
Signed b.r.
Private collection (repr. p. 125)

76 *Design for tiger-hunting mural in the Cave of the Golden Calf,* 1912
Oil and pencil on cardboard,
34 × 57.5 cm
Yale Center for British Art, New Haven (Paul Mellon Fund) (repr. p. 101)

77 *Clayhidon,* 1913
Oil on canvas, 38.4 × 63.9 cm
Signed b.l.
Royal Albert Memorial Museum, Exeter
EXHIBITION
1913 *English Post-Impressionists and Cubists*

78 *Rottingdean,* 1914
Oil on canvas, 64.8 × 81.2 cm
Signed b.r.
Worthing Museum and Art Gallery
(repr. p. 126)
EXHIBITIONS
1914 *London Group* (91); *Gilman-Ginner* (33)

VINCENT VAN GOGH
(1853–1890)

Van Gogh worked briefly in England in the 1870s and he was befriended in Paris by the Scottish dealer Alexander Reid, whose portrait he painted, but there was little interest in his work in Britain before 1910. It was his supposed madness rather than his stunning paintings that formed the basis of most critical discussion. He attracted a loyal following of several British artists including Gilman and Gore. The playwright Alfred Sutro and Frank Stoop, who owned cats. 80 and 81, were amongst the first British collectors of his work.

79 *Pietà (after Delacroix),* 1889
Oil on canvas, 73 × 60.5 cm
Van Gogh Museum (Vincent van Gogh Foundation), Amsterdam (repr. p. 39)
EXHIBITION
1910 *Manet and the Post-Impressionists* (74)

80 *A corner of the garden of St Paul's Hospital at St-Rémy,* 1889
Reed pen and ink, pencil and chalk on paper, 62.2 × 48.3 cm
Trustees of the Tate Gallery, London
(repr. p. 37)

81 *The Oise at Auvers,* 1890
Gouache and pencil on paper,
47.3 × 62.9 cm
Trustees of the Tate Gallery, London
(repr. p. 38)

82 *Hayricks*, 1890
Pen and ink and brush with chalk on
paper, 46.5 × 60.7 cm
The Whitworth Art Gallery,
The University of Manchester
(repr. p. 126)

NATALIA GONTCHAROVA (1881–1962)

Gontcharova and her close companion
Larionov are the best known of the
Russsian artists in Fry's *Second Post-
Impressionist Exhibition*. She was repre-
sented by Neo-Primitivist work which
drew on Russian popular sources. The
Russian presence increased the sense of
an international culture of modern art.

83 *Evangelist (in blue)*, 1910
Oil on canvas, 204 × 58 cm
The State Russian Museum,
St Petersburg (repr. p. 106)
EXHIBITION
1912 *Second Post-Impressionist Exhibition*
(171)

84 *Evangelist (in red)*, 1910
Oil on canvas, 204 × 58 cm
The State Russian Museum,
St Petersburg (repr. p. 106)
EXHIBITION
1912 *Second Post-Impressionist Exhibition*
(171)

85 *Evangelist (in grey)*, 1910
Oil on canvas, 204 × 58 cm
The State Russian Museum,
St Petersburg (repr. p. 107)
EXHIBITION
1912 *Second Post-Impressionist Exhibition*
(171)

86 *Evangelist (in green)*, 1910
Oil on canvas, 204 × 58 cm
The State Russian Museum,
St Petersburg (repr. p. 107)
EXHIBITION
1912 *Second Post-Impressionist Exhibition*
(171)

SPENCER GORE (1878–1914)

Born in Epsom, Surrey, Gore studied at
the Slade School, where he formed a
friendship with Gilman and Lewis. His
early subjects were influenced by Sickert
whom he met in 1904. In style they are
closer to the modified Neo-Impressionist
technique of Lucien Pissarro, who
turned Gore's attention to modern
industrial landscape. The two Post-

Impressionist exhibitions had a profound
effect on Gore, who admired Cézanne,
Gauguin, the Fauve landscapes of Mar-
quet, and Matisse. His landscapes of
Letchworth (cf. cat. 94) reflect his keen
awareness of the effect of the new Gar-
den City development on the existing
landscape. His decorative schemes for
the Cave of the Golden Calf (cats 96.
and 97) show an appreciation of
Kandinsky, who he had admired since
1910. His premature death ended the
career of one of the period's finest
painters. He was a founder member of
the Allied Artists Association, the Cam-
den Town Group and the London
Group. Cats. 88 and 89 were once
owned by Michael Sadler.

87 *Girl seated on a bed*, 1910
Oil on canvas, 50.8 × 40.6 cm
Private collection

88 *Nearing Euston Station*, 1911
Oil on canvas, 49.8 × 60 cm
Syndics of the Fitzwilliam Museum,
Cambridge (repr. p. 102)

89 *Gauguins and connoisseurs at the
Stafford Gallery*, 1911
Oil on canvas, 83.8 × 71.7 cm
Signed b.r.
Private collection (repr. p. 55)

90 *The balcony at the Alhambra*, 1911
Oil on canvas, 48.5 × 35.5 cm
Signed (stamped) b.l.
York City Art Gallery

91 *Still life with apples*, 1912
Oil on canvas, 38.1 × 50.8 cm
Signed b.r.
Ferens Art Gallery, Kingston-upon-Hull
City Museums and Art Galleries
(repr. p. 152)

92 *The cinder path*, 1912
Oil on canvas, 35 × 40 cm
Signed b.r.
The Visitors of the Ashmolean Museum,
Oxford

93 *The cinder path*, 1912
Oil on canvas, 68.6 × 78.7 cm
Trustees of the Tate Gallery, London
(repr. p. 103)
EXHIBITION
1913 *Second Post-Impressionist Exhibition*
(extended version: 116)

94 *Letchworth Station*, 1912
Oil on canvas, 63.2 × 76.2 cm
National Railway Museum, York
(repr. p. 103)

EXHIBITION
1912 *Second Post-Impressionist Exhibition*
(133)

95 *Flying at Hendon*, 1912
Oil on canvas, 50.8 × 61 cm
Signed (stamped) b.r.
Private collection

96 *Sketch for a mural decoration for The
Cave of the Golden Calf*, 1912
Oil on paper, 30.5 × 60.3 cm
Signed
Trustees of the Tate Gallery, London

97 *Design for deer-hunting mural in the
Cave of the Golden Calf*, 1912
Oil and chalk on paper, 28 × 61 cm
Yale Center for British Art, New Haven
(Paul Mellon Fund) (repr. p. 101)

98 *Brighton Pier*, 1913
Oil on canvas, 63.5 × 76.3 cm
Southampton City Art Gallery
(repr. p. 151)
EXHIBITIONS
1913 *Post-Impressionist and Futurist
Exhibition* (197)?; *English Post-
Impressionists and Cubists* (54)?

99 *Cambrian Road, Richmond*, 1913–14
Oil on canvas, 40.6 × 50.8 cm
Signed (stamped) b.l.
Yale Center for British Art, New Haven
(Paul Mellon Fund) (repr. p. 149)

SYLVIA GOSSE (1881–1968)

A close associate of Sickert, Gosse was
co-director of his teaching school, Row-
landson House (1910). Her intimate
domestic interiors studies have an affin-
ity with those by Sickert (whose second
wife, Christine is depicted in cat. 100)
and his associates, but she was excluded
from the all-male Camden Town
Group. She was a member of the Lon-
don Group, was included in *Twentieth
Century Art* , and had her first one-artist
exhibition at the Carfax Gallery in 1916.

100 *The sempstress*, ca. 1914
Oil on canvas, 50.8 × 40.6 cm
National Museum of Wales, Cardiff
(repr. p. 173)

DUNCAN GRANT (1885–1978)

Grant studied at the Atelier de la Palette
Paris (1907), but it was not until Fry's
two Post-Impressionist exhibitions that
he became a committed modernist. His
painting underwent a series of fascinat-

ing changes which reflect an intelligent appraisal of Cézanne, Matisse and Picasso. British critics, including Clive Bell, were suspicious of these 'borrowings' and never fully appreciated that they contributed to his modern style. He was a talented decorative artist whose murals for the Borough Polytechnic (cats. 101 and 102) outshone those of his peers. Together with Fry and Vanessa Bell, he founded the Omega Workshops where he worked on scores of decorative projects. Charleston, Sussex, where he lived with Vanessa Bell, is a lasting monument to their skill at decoration. Grant did not have the funds to collect modern art but he urged his friend Maynard Keynes to buy from the Degas sale works including Cézanne's *Apples* (Fitzwilliam Museum, Cambridge). He also persuaded Keynes to buy the Matisse (cat. 158) which appears in his self-portrait (cat. 115).

101 *Bathing*, 1911
Tempera on canvas, 228.6 × 306.1 cm
Trustees of the Tate Gallery, London
(repr. p. 90)

102 *Football*, 1911
Tempera on canvas, 227.3 × 196.8 cm
Trustees of the Tate Gallery, London
(repr. p. 91)

103 *The dancers*, 1911–12
Oil on canvas, 71 × 92 cm
Private collection (repr. p. 174)
EXHIBITIONS
1912 *Second Post-Impressionist Exhibition* (81); 1914 *Twentieth-Century Art* (310)

104 *Ladies in Friar's Walk, Lewes*, *ca.* 1912
Oil on canvas, 63.5 × 76.2 cm
Barclays Bank Collection (repr. p. 87)

105 Poster for the *Second Post-Impressionist Exhibition*, 1912
Lithograph, 119.4 × 93.8 cm
Board of the Trustees of the Victoria and Albert Museum, London
(repr. p. 64)

106 *The Post-Impressionist ball*, 1912
Pen and oil on headed writing paper,
18.4 × 38.1 cm
The University of Leeds Art Collection
(repr. p. 87)

107 *The artist's camp*, 1913
Oil on board, 61 × 76.2 cm
Bryan Ferry

Sylvia Gosse, *The sempstress*, *ca.* 1914, cat. 100

Erratum: The lower picture is by Gosse, cat. 100, and the upper picture is by Grant, cat. 108.

Duncan Grant, *Portrait of Katherine Cox*, 1913, cat. 108

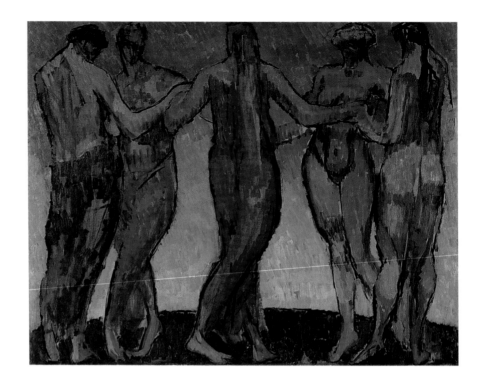

Duncan Grant, *The dancers*,
1911–12, cat. 103

108 *Portrait of Katherine Cox*, 1913
Oil on canvas, 75.9 × 62.7 cm
Signed and dated t.l.
National Museum of Wales, Cardiff
(repr. p. 173)

109 *Vanessa Bell painting*, 1913
Oil on canvas, 76.2 × 55.9 cm
Signed and dated b.r.
Scottish National Gallery of Modern
Art, Edinburgh (repr. p. 162)

110 *The kitchen*, 1914 (reworked
1916–17)
Oil on canvas, 106.7 × 135.9 cm
Provost and Fellows of the King's
College, Cambridge (repr. p. 91)

111 *Portrait of Iris Tree*, 1915
Oil on canvas, 75 × 62 cm
Signed and dated b.l.
The Museum of Reading (repr. p. 155)

112 *Interior at Gordon Square*, 1915
Collage, 60 × 72 cm
Signed b.l.
Private collection (repr. p. 155)

113 *Still life*, ca. 1915
Collage, 72 × 60 cm
Signed b.r.
Private collection (repr. p. 154)

114 *The coffee pot*, ca. 1916
Oil on canvas, 61 × 50.8 cm
The Metropolitan Museum of Art, New
York (Mr and Mrs Milton Petrie Gift,
1981)

115 *Self-portrait*, 1919
Oil on canvas, 61 × 45.8 cm
Scottish National Portrait Gallery,
Edinburgh (repr. p. 163)

JAMES DICKSON INNES
(1887–1914)

Born in Wales, Innes met Augustus John
(see below) while studying at the Slade
School (1907). He lived in France in
1910, after which time he painted oil
panels of the North Wales landscape
(see cats. 116 and 119) with John. He
also painted at Collioure (see cat. 117),
a favourite spot of the Fauves, and else-
where in the South of France.

116 *Mountain, Wales*, 1911
Oil on panel, 23 × 31.8 cm
Signed b.r.
Private collection, on loan to Govern-
ment Art Collection

117 *The church, Collioure*, 1911
Oil on panel, 24 × 33 cm
Signed b.r.
Private collection, on loan to Govern-
ment Art Collection (repr. p. 142)

118 *Fair at Perpignan*, ca. 1911–12
Oil on canvas, 28.5 × 39 cm
Private collection, on loan to Govern-
ment Art Collection

119 *Arenig, sunset*, ca. 1911–12
Oil on panel, 24 × 33 cm
Private collection (repr. p. 142)

AUGUSTUS JOHN
(1878–1961)

Born in Wales, the brother of Gwen,
John quickly rose to prominence as the
most promising student of his generation
while studying at the Slade School
between 1894 and 1898. While living in
Paris, John met Picasso (1907). How-
ever, he ignored the French model of the
Bohemian artist, created his own version
and emulated the gypsy way of life, trav-
elling in a caravan with his family, who
were the subject of many of his pictures.
They appear in the oil panels which
made John's reputation as a Post-
Impressionist artist. John was responsive

to many aspects of European Post-Impressionism, as can be seen in the handling and technique of the oil panels (see cats. 121, 122, 124 and 125). He was invited to show in the English Section of Fry's *Second Post-Impressionist Exhibition* but declined the offer. He had successful exhibitions at the Carfax Gallery, the Chenil Gallery and the Goupil Gallery.

120 *Olive trees by the Etang de Berre, Martigues*, 1910
Oil on canvas, 23.9 × 33 cm
John Adams (repr. p. 47)

121 *Two children in the garden, Martigues*, 1910
Oil on canvas, 23.9 × 33 cm
John Adams (repr. p. 51)

122 *Children paddling*, 1910
Oil on panel, 22.2 × 30.5 cm
Private collection (repr. p. 51)

123 *Blue lake, Martigues, ca.* 1910–12
Oil on canvas, 38.5 × 55 cm
Signed b.r.
Michael Holroyd (repr. p. 47)

124 *Dorelia wearing a yellow and red scarf, ca.* 1910–12
Oil on canvas, 24 × 36 cm
Signed b.r.
Private collection, courtesy of the Pym's Gallery, London (repr. p. 10)

125 *Dorelia standing in a landscape, ca.* 1912
Oil on board, 37.5 × 44.5 cm
Michael Holroyd (repr. p. 50)

126 *Aran Isles*, 1916
Oil on panel, 30 × 50.7 cm
National Museum of Wales, Cardiff (repr. p. 49)

VASSILY KANDINSKY (1866–1944)

Kandinsky first came to notice in Britain at the AAA exhibition in 1909. His work was widely denounced by British critics. Michael Sadleir bought six woodcuts and proofs for *Klange* (cf. cat. 129) in 1911 and engaged in a long correspondence with Kandinsky. He translated *Concerning the Spiritual in Art* (1913) after visiting him in Murnau (1912). Sadleir's father, Michael Sadler, also became a keen collector who owned at least five works by Kandinsky by 1915. In 1913 Fry became a keen supporter

but his work did not sell well in Britain. In 1914 he considered halving the prices for the pictures at the AAA.

127 *Reiterweg*, 1911
Woodcut on paper, 42.3 × 57.5 cm
Board of Trustees of the Victoria and Albert Museum, London

128 *Improvisation 19*, 1911
Woodcut on paper, 15 × 18.5 cm
Signed (in monogram) b.r.
Scottish National Gallery of Modern Art, Edinburgh (repr. p. 132)

129 *Composition II*, 1911
Woodcut on paper, 14 × 20.8 cm
Trustees of the British Museum, London (repr. p. 132)
EXHIBITION
1911 Allied Artists Association (1201)

STANISLAWA DE KARLOWSKA (1876–1952)

Born in Poland, De Karlowska studied in Paris and came to live in England after marrying Robert Bevan (see above). She shared his keen appreciation of Gauguin and Cézanne.

130 *Polish interior*, 1910–14
Oil on canvas, 62.8 × 80.8 cm
Signed b.l.
Southampton City Art Gallery

JACOB KRAMER (1892–1962)

A native of Leeds, Kramer studied at the Slade School. While living in London, he met Epstein, Gertler, John and Bomberg, who included him in the Jewish Section of *Twentieth-Century Art*. Through the Leeds Arts Club, an influential centre for avantgarde ideas, Kramer met Rutter and Michael Sadler who lent him works to study from his collection. Sadler was an important early patron and once owned cat. 131. Many were critical of the extreme simplification of his work but others, including C. Lewis Hind, defended him.

131 *Meditation – 'the Jew'*, 1916
Oil on canvas, 101.5 × 76.2 cm
Signed b.r.
The University of Leeds Art Collection (repr. p. 143)

HENRY LAMB (1883–1960)

Lamb was an early admirer of Picasso. He claimed to be disappointed by the drawings shown in London in 1912, but he was protesting too much, since his drawing (cat. 132) draws on one of those he saw by Picasso, *Horse with a youth in blue* (Tate Gallery, London).

132 *Allegorical scene*, 1912
Crayon and pastel on paper, 34.3 × 22.5 cm
City of Salford Art Gallery

WYNDHAM LEWIS (1882–1957)

Lewis studied at the Slade School and in Paris. He came to prominence as a modernist painter around 1912 when he was compared to Picasso. For example, Picasso's *Woman and mustard pot* (cat. 169) was clearly influential for *Sunset among the Michelangelos* (fig. 38). He was represented in the *Second Post-Impressionist Exhibition* with a number of works, including four unidentified lithographs from the *Timon and Athens* series (cf. cats. 137–40). Surviving sketches show that *Kermesse*, his decorative scheme for the Cave of the Golden Calf (see above), was highly original. Like many of Lewis's early works it has been lost or destroyed. Fry and Clive Bell were sympathetic critics but Lewis quarrelled with Fry over a commission for the Omega Workshops. He was friendly with the Futurists until Nevinson added his name to a Futurist manifesto without mentioning the Rebel Art Centre which Lewis founded in 1914. He realised his ambition to form an independent group with the Vorticists, at which point he denounced many of the European modernists who had been so influential in his formative period.

133 *Smiling woman ascending a stair*, 1911–12
Crayon, watercolour and bodycolour on paper, 96.5 × 64.8 cm
Signed b.r.
Private collection (repr. p. 99)

134 *Mother and child*, 1912
Pen and ink, chalk and watercolour on paper, 30.5 × 24 cm
The Board of Trustees of the Victoria and Albert Museum, London

135 *Le Penseur*, 1912
Ink and chalk on paper, 28 × 18 cm
The Board of Trustees of the Victoria
and Albert Museum, London

136 *Two women* or *The starry sky*, 1912
Pencil, ink, wash, gouache and collage
on paper, 48 × 62.5 cm
Signed and dated b.r.
Arts Council Collection, Hayward
Gallery, London

137 *Timon of Athens: Alcibiades*, 1912–13
Lithograph on paper, 38.5 × 26 cm
Private collection

138 *Timon of Athens: Composition*,
1912–13
Lithograph on paper, 38.5 × 26 cm
Private collection

139 *Timon of Athens: Act III*, 1912–13
Lithograph on paper, 38.5 × 26 cm
Signed
Private collection

140 *Timon of Athens: Act IV*, 1912–13
Lithograph on paper, 38.5 × 26 cm
Signed
Private collection

141 *At the seaside*, 1913
Pen and ink and watercolour on paper,
47.5 × 31.5 cm
The Board of Trustees of the Victoria
and Albert Museum, London

ANDRÉ LHOTE (1885-1962)

Born in Bordeaux, Lhote's work
reflected his admiration for Cézanne and
drew comparison with the Salon Cubists
from 1911, when his work hung in a
room adjacent to theirs at the Salon des
Indépendants. At the Salon d'Automne
Port de Bordeaux (cf. cats 142 and 143)
was surrounded by Cubist work which
drew Fry's attention to it. In 1912 he
showed with the Cubists in the Salon de
la Section d'Or. Later he became a
teacher and an art theorist, writing on
Cézanne and Cubism.

142 *Port de Bordeaux*, 1912
Oil on canvas, 58 × 77 cm
Signed b.l.
Private collection
EXHIBITION
1912 *Second Post-Impressionist Exhibition*
(ex-catalogue)

143 *Port de Bordeaux*, 1912
Oil on canvas, 72.4 × 70.9 cm
Signed b.l.
Private collection (repr. p. 71)
EXHIBITION
1912 *Second Post-Impressionist Exhibition*
(86)

JEAN MARCHAND (1883-1941)

Marchand also showed in the Salon de la
Section d'Or in 1912 but his work has a
greater affinity with Cézanne than with
Cubism, which intrigued Fry.

144 *Still life*, 1911
Oil on canvas, 61 × 52 cm
Signed and dated b.l.
Private collection (repr. p. 66)
EXHIBITION
1912 *Second Post-Impressionist Exhibition*
(10)

145 *Place de Ceret*, ca. 1912
Oil on canvas, 58.4 × 48.3 cm
Private collection (repr. p. 72)

PIERRE-ALBERT MARQUET (1875-1947)

Marquet met Matisse, Camoin, Man-
guin and Puy as a student. The Fauve
period was a lasting source of inspiration
for his studies of seaside resorts and
urban streets. These works made a
powerful impression on Gore, whose
paintings of Letchworth (cf. cat. 99) and
Brighton (cf. cat. 98) can be compared
to Marquet (cf. cat. 146). Fry and Bell
preferred his smoothly painted studies of
the female nude. Fry included two of
them (cf. cat. 147) in the *Second Post-
Impressionist Exhibition*.

146 *La Fête foraine au Havre*, 1906
Oil on canvas, 65 × 81 cm
Signed b.l.
Musée des Beaux-Arts, Bordeaux
(repr. p. 150)

147 *Nu à contre-jour*, 1911
Oil on canvas, 73 × 60 cm
Signed b.r.
Musée des Beaux-Arts, Bordeaux
EXHIBITION
1912 *Second Post-Impressionist Exhibition*
(55)

HENRI MATISSE (1869-1954)

After 1910 Matisse had a loyal following
of British critics including Fry and Hind,
and artists including Grant and Vanessa
Bell. They visited his studio and met
him at the home of the Steins who were
important collectors. Greater public
recognition of his work was slow to
come in Britain. None of the paintings
exhibited in the two Post-Impressionist
exhibitions remain in this country. His
sculpture was also controversial. The
many drawings and prints that he sent
for show have not been identified. Rutter
and Fry were early collectors of litho-
graphs by Matisse. Sales of his post-War
pictures at the Leicester Gallery in 1919
were good. This caused Matisse, who
was in London at the time, to decide
that the English were "mad".

148 *Nude squatting in an armchair*, 1906
Transfer lithograph on paper,
44.5 × 27.7 cm
Signed (in monogram) b.r.
Courtauld Institute Galleries, London
(The Samuel Courtauld Trust)
(repr. p. 81)

149 *Seated nude*, 1906
Woodcut on paper, 47.5 × 38.3 cm
Signed b.r.
Scottish National Gallery of Modern
Art, Edinburgh
EXHIBITION
1912 probably *Second Post-Impressionist
Exhibition* (184)

150 *Nude*, 1907
Graphite on paper, 30.7 × 22.2 cm
Signed b.r.
Trustees of the British Museum,
London (repr. p. 81)

151 *Standing nude*, ca. 1907
Pen and ink on paper, 30.2 × 22.8 cm
Signed b.r.
Trustees of the British Museum,
London

152 *Reclining nude no. 1*, 1907
Sculpture, bronze, 34.7 × 50.1 × 28 cm
Signed and marked rear l. corner of base
Albright-Knox Art Gallery, Buffalo NY
(repr. p. 82)
EXHIBITION
1910 *Manet and the Post-Impressionists*
(13)

153 *Jeannette II*, 1910
Sculpture, bronze, 26.5 × 22.5 × 24 cm
Scottish National Gallery of Modern
Art, Edinburgh (repr. p. 88)
EXHIBITION
1912 *Second Post-Impressionist Exhibition*
(plaster cast, A)

154 *Nu de trois-quarts*, 1913
Lithograph on paper, 50.1 × 30.3 cm
The Board of Trustees of the Victoria
and Albert Museum, London

155 *La Lecture nu de profil*, 1913
Lithograph on paper, 50.1 × 30.3 cm
The Board of Trustees of the Victoria
and Albert Museum, London

156 *Nu à rocking chair*, 1913
Lithograph on paper, 48.1 × 27.2 cm
The Board of Trustees of the Victoria
and Albert Museum, London

157 *The inattentive reader*, 1919
Oil on canvas, 73 × 92.5 cm
Signed b.l.
Trustees of the Tate Gallery, London
(Bequeathed by Montagu Shearman
through the Contemporary Art Society,
1940) (repr. p. 160)
EXHIBITION
1919 *Pictures by Henri Matisse and
Sculpture by Maillol* (33)

158 *Woman seated in an armchair*, 1919
Oil on millboard, 40 × 32 cm
Signed b.r.
Provost and Fellows of King's College,
Cambridge (Keynes Collection),
on loan to the Fitzwilliam Museum,
Cambridge (repr. p. 163)
EXHIBITION
1919 *Pictures by Henri Matisse and
Sculpture by Maillol* (19)

AMEDEO MODIGLIANI (1884–1920)

Born in Italy, Modigliani moved to Paris
in 1906. From 1909 he had a studio
next to Brancusi. He was befriended by
Epstein who saw him every day for six
months in 1912 while Epstein was living
in Paris working on the tomb of Oscar
Wilde. A series of heads carved in stone,
including cat. 159, made a lasting
impression on Epstein. As a gesture of
their friendship Modigliani gave Epstein
a drawing (cat. 160). In 1913 Epstein
introduced Bomberg to Modigliani and
other Jewish artists working in Paris who
Bomberg would include in the Jewish

Section of *Twentieth-Century Art*.

159 *Head, ca.* 1911–12
Sculpture, stone, 63.5 × 12.5 × 35 cm
Signed
Trustees of the Tate Gallery, London
(repr. p. 141)
EXHIBITION
1914 *Twentieth-Century Art* (287)

160 *Caryatid, ca.* 1912
Pencil and blue crayon on paper,
55 × 41.5 cm
Signed b.r.
Walsall Museum and Art Gallery (The
Garman Ryan Collection) (repr. p. 141)

CHRISTOPHER NEVINSON (1889–1946)

After studying at the Slade School,
Nevinson went to Paris in the winter of
1912–13, where he shared a studio with
Modigliani and met the Italian Futurists.
Nevinson's grim industrial landscapes
painted in pulsating, separate strokes of
colour have affinity with those by the
Futurists, including Severini with whom
Nevinson formed a friendship. He had
an equally strong interest in Cubism. His
Arrival of the train de luxe (fig. 20),
which employed the letters Kub, was an
answer to Picasso's and Braque's use of
the word in several works they sent to
London in 1912. On 7 June 1914
Nevinson and Marinetti published the
Futurist manifesto 'Vital English Art' in
several British newspapers, suggesting
that there was a close link between Lewis
and the Futurists. This caused a rupture
between Nevinson and Lewis's group.

161 *The railway bridge, Charenton*,
1911–12
Oil on canvas, 40.9 × 51.5 cm
Manchester City Art Galleries
(repr. p. 60)
EXHIBITION
1912 *Friday Club*; 1913 *Post-Impressionist
and Futurist Exhibition* (149 or 150)?

EMIL NOLDE (1867–1956)

Born in north Schleswig, Nolde worked
as a designer, carver and drawing mas-
ter. He took up art seriously in 1902,
and was briefly a member of the Brücke
in Dresden. After seeing Nolde's work at
a German dealer's gallery in 1912,
Michael Sadler immediately wrote to ask
him about the prices of his woodcuts

and acquired cat. 162 shortly afterwards
for his large collection of prints by con-
temporary German artists.

162 *Freihafen, Hamburg*, 1910
Woodcut on oatmeal paper,
30 × 39.5 cm
Signed b.r.
Private collection (repr. p. 130)
EXHIBITION
1913 *Post-Impressionist and Futurist*
(161: catalogued as an etching)

SAMUEL JOHN PEPLOE (1871–1935)

Peploe studied in Scotland and Paris
before returning to live in Paris between
1910 and 1912. He painted at Royan, Ile
de Bréhat and Cassis, sometimes in the
company of Fergusson and Rice, before
seeking out remote areas of Scotland.
His work has an affinity with that of
both artists. Peploe's flat in Paris was a
meeting place for the British-American
Fauve circle.

163 *Ile de Bréhat*, 1911
Oil on canvas, 32.7 × 40.9 cm
Signed b.l.
Scottish National Gallery of Modern
Art, Edinburgh (repr. p. 113)

164 *Still life*, 1913
Oil on canvas, 55 × 46 cm
Signed b.r.
Scottish National Gallery of Modern
Art, Edinburgh (repr. p. 114)

PABLO PICASSO (1881–1973)

The quick succession with which Picasso
changed style fascinated Fry – as illus-
trated by his selection of Picasso's works
for the *Second Post-Impressionist Exhibi-
tion*, which ranged in date from 1904 to
1912. One talking point was cat. 169,
which was treated with derision by some
critics who interpreted its title too liter-
ally. It was an important source of inspi-
ration for Lewis. During this period
several critics and artists visited Picasso
in his studio including Fry, Rutter,
Grant and Vanessa Bell, who persuaded
H.T.J. Norton to buy the Cubist still life
Bottle and books, exhibited in 1912. In
1919 Clive Bell and Maynard Keynes
held a dinner for Picasso who was in
London designing sets for Diaghilev's
Ballets Russes. Michael Sadler once
owned cat. 166.

Pablo Picasso, *Nature morte*, 1909, cat. 168

165 *Poverty (Les Misérables)*, 1903
Pen and ink and watercolour,
37.5 × 26.7 cm
Signed b.r.
The Whitworth Art Gallery,
The University of Manchester
(repr. p. 70)
EXHIBITION
1912 *Exhibition of Drawings by Pablo
Picasso* (16)?

166 *Le Repas frugal*, 1904
Etching on paper, 46.3 × 37.7 cm
The Whitworth Art Gallery, The
University of Manchester (repr. p. 128)
EXHIBITION
1913 *Post-Impressionist and Futurist
Exhibition* (126 or 127)

167 *Two trees*, 1907
Gouache on laid paper, 48 × 62.8 cm
Signed and dated on reverse
Philadelphia Museum of Art (Louise
and Walter Arensberg Collection)
(repr. p. 74)
EXHIBITION
1912 *Second Post-Impressionist Exhibition*
(62)

168 *Nature morte*, 1909
Drypoint on paper, 33 × 28 cm
Signed b.r.
The Board of Trustees of the Victoria
and Albert Museum, London
(repr. this page)

169 *Woman and mustard pot*, 1909–10
Oil on canvas, 96 × 83.9 cm
Signed t.l.
Haags Gemeentemuseum, The Hague
(repr. p. 75)
EXHIBITION
1912 *Second Post-Impressionist Exhibition*
(71)

LUCIEN PISSARRO
(1863–1944)

The eldest son of Camille Pissarro,
Lucien Pissarro moved to London in
1890. He belonged to the Fitzroy group
and the Camden Town group and was
an important influence on the younger
members including Gore, who shared
his interest in industrial landscapes and
Neo-Impressionism. He was a friend to
Rutter.

170 *Wells Farm Bridge*, 1907
Oil on canvas, 45.7 × 54.5 cm
Signed (in monogram) and dated b.r.
Leeds Museums and Galleries (City Art
Gallery) (repr. p. 102)

ANNE ESTELLE RICE
1877–1959

Born near Philadelphia, Rice moved to
Paris in 1906 where she met Fergusson.
She was elected a *sociétaire* of the Salon
d'Automne and in 1910 her *Egyptian
dancers* was awarded a place of honour.
Rice and Fergusson were regarded as the
leaders of a group of British-American
Fauves including Dismorr and Peploe.
She contributed illustrations to *Rhythm*
based on the theme of dance. In 1913
she married the critic O. Raymond Drey
who wrote sympathetic accounts of
modern art. Shortly afterwards they
moved to England.

171 *Restaurant*, 1909
Oil on canvas, 54 × 64 cm
Signed on reverse
Mrs David Drey

EXHIBITION
1912 *Exhibition of Pictures by S.J. Peploe, J.D. Fergusson, Joseph Simpson, Anne E. Rice (etc.)* (15)?

172 *Twilight,* 1911
Oil on board, 33 × 40 cm
Signed and dated on reverse
Mrs David Drey

173 *Staffordshire figures,* ca. 1912
Oil on board, 44.7 × 38 cm
Signed b.l.
University of Hull Art Collection, Kingston upon Hull (repr. p. 112)

HELEN SAUNDERS (1885-1963)

Born in London, Saunders studied at a teaching studio before training at the Slade (1907) and Central Schools. In 1912 she came to notice when she exhibited at the Friday Club, at Fry's *Quelques Indépendants Anglais,* Paris, and at the AAA and also met Lewis and Dismorr. She was included in *Twentieth-Century Art* and was one of the signatories of the Vorticist manifesto published in *Blast No 1,* exhibited in the Vorticist exhibition, London (1915), and contributed a poem and drawings to *Blast No.2.*

174 *Litlington Church and Farm,* ca.1912
Oil on canvas, 50.5 × 61 cm
Private collection

175 *Hammock,* ca. 1913
Pen and ink and watercolour on paper, 33.5 × 41 cm
Private collection

176 *Vorticist composition with bending figure,* ca. 1914
Pencil, ink and gouache on paper, 25 × 35 cm
Private collection

177 *Vorticist composition in blue and green,* ca. 1915
Pencil and watercolour on paper, 25 × 19.5 cm
Private collection (repr. p. 147)

178 *Gulliver in Lilliput,* ca. 1915–16
Pencil, ink, crayon and gouache on paper, 38.5 × 30.5 cm
Private collection (repr. p. 147)

ANDRÉ DUNOYER DE SEGONZAC (1884-1974)

Dunoyer de Segonzac's *The boxers* (destroyed) caused a sensation at the Salon d'Automne in 1911 and again in 1913 at *Post-Impressionists and Futurists.* His work had affinities with Cubism but he was not recognized as a Cubist by the French critics. His masculinist subject-matter was admired by Fergusson who included a drawing of boxers (cf. cat. 179) in *Rhythm.* He was friendly with Clive Bell and wrote an introduction to an exhibition by Vanessa Bell (1961).

179 *The boxers,* ca. 1911
Pen and ink on paper, 25.7 × 42.5 cm
Signed b.r.
Syndics of the Fitzwilliam Museum, Cambridge (repr. p. 129)

PAUL SÉRUSIER (1865-1927)

Born in Paris, Sérusier met Gauguin in 1888, which led to the formation of the Nabis, a group which included Bonnard and Vuillard. He was an early admirer of Cézanne, as can be seen in his still-life paintings. Michael Sadler bought work by Sérusier from *Manet and the Post-Impressionists* and owned three works including cat. 180.

180 *Le café,* 1907
Oil on canvas, 54.6 × 64.8 cm
Signed and dated b.l.
The University of Leeds Art Collection

GINO SEVERINI (1883-1966)

After falling under the influence of Balla and Boccioni in Rome, where he adopted a version of the Neo-Impressionist technique, Severini went to Paris where he moved in an avantgarde circle. His depictions of urban Paris combine a broken brush technique and fractured forms and were influential for a number of British artists when they were exhibited at the Sackville Gallery in 1912. R. Meyer-See, the gallery manager, acquired cat. 182. The following year he arranged for Severini to show at his new gallery, where his series of scintillating pictures of dancers excited attention. Severini was befriended by a number of British admirers including Nevinson.

181 *The boulevard,* 1910–11
Oil on canvas, 63.5 × 91.5 cm
Eric and Salome Estorick Foundation, London (repr. p. 58)

EXHIBITION
1912 *Exhibition of Works by the Italian Futurist Painters* (33)

182 *Yellow dancers,* ca. 1911–12
Oil on canvas, 45.7 × 61 cm
Signed on reverse
Fogg Art Museum, Harvard University Art Museums, Cambridge MA, (Gift of Mr and Mrs Joseph H. Hazen) (repr. p. 62)

EXHIBITION
1912 *Exhibition of Works by the Italian Futurist Painters* (31)

183 *Dancer no. 5,* 1916
Oil on canvas, 93 × 74 cm
Signed b.r.
Pallant House, Chichester (Kearley Bequest) (repr. p. 63)

WALTER SICKERT (1860-1942)

Born in Munich, Sickert came to England as a child in 1868. During the 1880s he worked with Whistler, and came to know Degas who was to have a formative influence. He lead the London Impressionists (1889), the first British group to acknowledge French avantgarde art. Between 1898 and 1905 he lived largely in Dieppe. During this time he established closer links with a cosmopolitan group including Bonnard and Vuillard. In handling and treatment his studies of the nude and intimist compositions have an affinity with those artists. Sickert was a teacher, polemicist, organizer and prolific art critic who had an enormous influence on Gore, Gilman and the others in the Camden Town group. Although he was ambivalent about many of the modern European artists who were introduced to England between 1910 and 1914, he remained loyal to those British artists when they incorporated aspects of modern European painting into their own work.

184 *Oeuillade, ca.* 1911
Oil on canvas, 38.1 × 30.5 cm
Signed b.l.
Syndics of the Fitzwilliam Museum,
Cambridge (repr. p. 119)
EXHIBITIONS
1912 *Paintings and Drawings by Walter
Sickert* (18);
1913 *English Post-Impressionists and
Cubists* (58)?

185 *The blue hat, ca.* 1912–13
Oil on canvas, 50.7 × 40.6
Manchester City Art Galleries

186 *Nude seated on a couch,* 1914
Oil on canvas, 50.8 × 40.6 cm
Signed b.r.
Manchester City Art Galleries

187 *Redcurrants, ca.* 1919
Oil on board, 20.3 × 25.4 cm
Signed b.r.
Private collection

MAURICE DE VLAMINCK
(1876–1958)

Vlaminck met Derain in 1900 and
shared a studio with him. Like Derain he
abandoned his brightly coloured Fauve
palette (around 1908) for a more Cézan-
nesque manner of working. These
Cézanne-influenced pictures were popu-
lar with Clive Bell and Fry, who once
owned cat. 188. In 1911 Vlaminck
followed in Derain's footsteps and made
his first trip to London to paint views of
the Thames.

188 *Buzenval,* 1911–12
Oil on canvas, 72.4 × 91.4 cm
Signed b.r.
Private collection (repr. p. 66)
EXHIBITION
1912 *Second Post-Impressionist Exhibition*
(14)

EDOUARD VUILLARD
(1868–1940)

A member of the Nabis, Vuillard made
his reputation with the decorative com-
missions he undertook in the 1890s. Like
Bonnard his painting became more natu-
ralistic after 1900 but it remained experi-
mental in handling and composition.
During the 1900s Bonnard, Vuillard and
Sickert made critiques of each other's
painting. His studies of figures in
interiors set in highly recessed space
were influential for Gilman. Vuillard's

work was well known in Britain before
1910 and was first acquired by a British
collector in the 1890s.

189 *Mme Hessel on the sofa,* 1900
Oil on cardboard, 54.6 × 54.6 cm
Signed b.r.
Board of Trustees of the National
Museums and Galleries on Merseyside
(Walker Art Gallery, Liverpool)
(repr. p. 118)

190 *Interior with a screen, ca.* 1909–10
Oil on paper on panel, 35.8 × 23.8 cm
Signed b.r.
Courtauld Institute Galleries, London
(The Samuel Courtauld Trust)
(repr. p. 122)

EDWARD WADSWORTH
(1889–1949)

Wadsworth was included in the rehang
of the *Second Post-Impressionist Exhibi-
tion* at the beginning of 1913 and invited
to participate in the Omega Workshops.
In 1913 he sided with Lewis in his dis-
pute with Fry. He joined the Rebel Art
Centre, signed the Vorticist manifesto in
Blast No. 1, and contributed to the first
Vorticist exhibition (1915). Between
1911 and 1915 his work went through
rapidly changing phases ranging from a
study of bathers that compares to Denis
to modern urban subjects in a Cubist
style and adventurous non-figurative
work.

191 *Vorticist composition,* 1915
Oil on canvas, 76.3 × 63.5 cm
Signed and dated b.l.
Fundación Colección Thyssen-
Bornemisza, Madrid (repr. p. 146)

EXHIBITION CATALOGUES

192 *Manet and Post-Impressionists,* 1910
Catalogue of the exhibition at the
Grafton Galleries, 8 November 1910–
15 January 1911; bound with *Notes
on the Post-Impressionist painters* by
C.J. Holmes
(Cover size) 18.5 × 12.5 cm
Ashmolean Library, Oxford (cf. fig. 4)

193 *Exhibition of Works by the Italian
Futurist Painters,* 1912
Catalogue of the exhibition at the
Sackville Gallery, March 1912
(Cover size) 15.3 × 12.5 cm
Ashmolean Library, Oxford (cf. fig. 17)

194 *Second Post-Impressionist Exhibition,*
1912
Catalogue of the exhibition at the
Grafton Galleries, 5 October –
31 December 1912
Cover designed by Vanessa Bell and
Duncan Grant
(Cover size) 23.3 × 15 cm
Berinda and Richard Thomson

195 *Second Post-Impressionist Exhibition,*
1912
Catalogue of the exhibition held at the
Grafton Galleries, 5 October –
31 December 1912, with 39 half-tone
reproductions and frontispiece in four
colours
(Cover size) 23.3 × 15 cm
Ashmolean Library, Oxford

195A *Second Post-Impressionist Exhibition,*
1912
Catalogue of the exhibition at the
Grafton Galleries, 5 October –
31 December 1912, annotated with
watercolour by an unknown hand,
sketch of Matisse's *The red Madras hat*
and *Goldfish and sculpture*
(Cover size) 23.3 × 15 cm
Trustees of the Tate Gallery, London

196 *Exhibition of the Works of the Italian
Futurist Painters and Sculptors,* 1914
Catalogue of the exhibition at the Doré
Galleries, 1914
(Cover size) 15.3 × 12.5 cm
Ashmolean Library, Oxford

197 *Post-Impressionist and Futurist Exhi-
bition,* 1914
Catalogue of the exhibition at the Doré
Galleries, 1914
(Cover size) 15.3 × 12.5 cm
Ashmolean Library, Oxford
(repr. p. 116)

CHRONOLOGY

1908

MARCH Roger Fry, 'Last Phase of Impressionism', letter to *The Burlington Magazine*, p. 374. Fry defended Signac, Cézanne, Gauguin, Denis and Simon Bussy in reply to an Editorial written by C.J. Holmes, who expressed contempt for Cézanne and Gauguin, in the February issue.

1909

APRIL Fry, MacColl, Holmes and Ottoline Morrell founded the Modern Art Association. The name was changed to Contemporary Art Society a year later.

21 OCTOBER *Art News*, "the only Art Newspaper in the United Kingdom", edited by Frank Rutter, included J.D. Fergusson's 'The Autumn Salon', praising Matisse as "the painter who annoys the bourgeoisie the most" and discusses the Matisseites.

OCTOBER C.J. Holmes appointed Director of the National Portrait Gallery.

Fry saw the Salon d'Automne, Paris.

Ottoline Morrell and Dorelia John travelled to Paris and stayed with Mrs Emily Chadbourne – a friend of Augustus John and the wife of a rich Chicago industrialist. They saw the Salon d'Automne and the Pellerin collection of Manet and Cézanne. Morrell and Mrs. Chadbourne visited Matisse's studio (Mrs Chadbourne purchased a Matisse sculpture), tracked down Picasso in Montmartre and Vollard at home, who showed them his own collection.

1910

JANUARY Fry translated and introduced Maurice Denis's 'Cézanne' in *The Burlington Magazine*.

Clive and Vanessa Bell met Roger Fry by chance on a train from Cambridge to London. Clive Bell had already formed an enthusiasm for Matisse and Gauguin.

APRIL Marinetti lectured at the Lyceum Theatre.

MAY The Contemporary Art Society met for the first time.

SPRING C. Lewis Hind visited Cassirer's gallery in Berlin, Amsterdam – where he saw Van Gogh and Cézanne – and Paris – where he saw Michael and Sarah Stein's Matisse collection.

JUNE The exhibition *Modern French Artists* organized by Robert Dell at Brighton Art Gallery, included Bonnard, Cézanne, Derain, Denis, Flandrin, Friesz, Gauguin, Matisse, Redon, Puy, Serusier, Signac, Valloton, Vuillard, Vlaminck.

Friday Club exhibition at the Alpine Club Gallery

6 JUNE Fry visited Matisse at Issy-les-Moulineaux where he saw *Dance II*.

SEPTEMBER Fry and MacCarthy travelled to Paris to make initial selection for *Manet and the Post-Impressionists*. Fry wrote to Ottoline Morrell urging her to travel back from the South of France through Paris so that she could see the Cézannes and Van Goghs he was planning to bring to England.

3 OCTOBER Fry asks C.J. Holmes to join the Exhibition Committee for the Cézanne, Van Gogh, Gauguin show "to lend approval to the idea that people may be allowed to look at them".

OCTOBER Fry returned to Paris to arrange more loans. Some works were selected from the Salon d'Automne which Fry reviewed for *The Nation*.

15 OCTOBER 'Le Salon d'Automne', *Art News*, referred to Matisse as "the Marat of the painter's revolution", praising the figures in *Dance II* as "astonishingly vital and expressive", and drawing attention to Metzinger as a "follower of Picasso" who had invented "a new painting in which form is expressed by a series of cubes".

5 NOVEMBER–JANUARY *Manet and the Post-Impressionists*, Grafton Galleries: Cézanne (18), Cross (2), Denis (4), Derain (3), Girieud (5), Flandrin (4), Friesz (7), Gauguin (46), Van Gogh (21), Herbin (4), Laprade (5), Maillol (3), Manet (6), Manguin (4), Marquet (4), Matisse (11), Picasso (7), Puy (1), Redon (3), Rouault (6), Seurat (2), Serusier (5), Signac (3), Vallotton (4), Valtat (1), Vlaminck (8). (The numbers in brackets refer to the works listed in the catalogue; however, many more were exhibited.)

DECEMBER Mock exhibition of *Manet and the Post-Impressionists* organised by Robert Ross at the Chelsea Arts Club.

15 DECEMBER Sickert lectured at the Grafton Galleries on Post-Impressionism. The substance of the lecture was published in *The Fortnightly Review* in January 1911.

20 DECEMBER Frank Rutter's *Revolution in Art* published.

1911

C. Lewis Hind, *The Post Impressionists*, published London

JANUARY *Drawings by Walter Sickert*, Carfax Gallery (49).

Landscapes by J. D. Innes, Chenil Gallery (25).

26 JANUARY Fry gave Clive Bell letters to take to Gertrude Stein and to Matthew Stewart Pritchard (1865-1936), a British Byzantinist, aesthete and mystic who became a committed follower of Henri Bergson and a friend of Matisse.

Rutter lectured on Cézanne at Brighton City Art Galleries.

FEBRUARY Vanessa Bell, Fry and Grant showed together for the first time at *The Friday Club* exhibition, Alpine Club Gallery, Mill Street.

MARCH–APRIL *Paintings by Spencer Gore*, Chenil Gallery.

APRIL Grant visited Matisse in his studio for the first time.

6 MAY Fry began to organize designs for Borough Polytechnic commission, which was arranged by Basil Williams, an old Cambridge friend and chairman of the house committee. The decoration consisted of the student's dining room and the walls and passage leading to it. The schemes by Bernard Adeney, Etchells, Fry and Grant were approved in June. MacDonald Gill and Albert Rothenstein also contributed. The scheme was completed in August. The walls and passage were painted in "sky-blue, orange, white and primrose blocks of colour". The murals started halfway up the wall and continued on to the ceiling. Each mural had a geometric design around the edge (cf. cats. 101 and 102).

22 MAY Fry declared his growing sympathy for Matisse in a letter to Simon Bussy and said that after studying all his paintings he was convinced that Matisse was a genius.

JUNE F. Melian Stawell, 'The Letters of Vincent Van Gogh', *The Burlington Magazine*: a sympathetic review in which Stawell recalled the compelling effect of Van Gogh's *Dr Gachet* and *La Berceuse* when he saw them at *Manet and the Post-Impressionists*.

The *First Exhibition of the Camden Town Group* which had formed earlier in the spring.

27 JUNE *An Exhibition of Pictures by Walter Sickert*, Stafford Gallery.

SUMMER First issue of *Rhythm* published. J.D. Fergusson was the art editor until November 1912. He included illustrations by Dismorr, Rice and Margaret Thompson and reproductions of Friesz, Marquet, Picasso and Segonzac amongst others.

JULY *Esperantist Vagabond Club* (Bevan, Fergusson, Ginner, Gilman and Gore), Goupil Gallery.

AUGUST *Augustus John Paintings, Drawings, and Etchings*, Chenil Gallery.

15 AUGUST 'Manifesto of the Futurist Painters', *Art News*.

17 AUGUST Derain visited London for a few days.

First Performance of Diaghilev's Ballets Russes, Royal Opera House, Covent Garden.

AUTUMN J.B. Manson visited Picasso in his Paris studio.

Vlaminck in London.

13 OCTOBER *Exhibition of Pictures by Camille Pissarro*, Stafford Gallery.

19 OCTOBER Vanessa and Clive Bell bought Picasso's *Jars and lemon* (1907; Daix 65), for £4 from Kahnweiler. They visited the Salon d'Automne as did Fry and Grant. Fry reviewed the Cubist room (*The Nation*, 11 November 1911).

20–28 OCTOBER Henri Bergson gave four lectures at University College London.

23 NOVEMBER *Exhibition of Pictures by Paul Cézanne and Paul Gauguin*.

23 NOVEMBER Huntley Carter's 'The Plato-Picasso Idea', published in *The New Age*, reproduced Picasso's *Mandolin and glass of pernod* (private collection, Prague; Daix 387), a Cubist still life painted in spring 1911, which had been chosen for the purpose from the Kahnweiler gallery.

30 NOVEMBER John Middleton Murray published a reply to Huntley Carter in *The New Age*: "It is because I am convinced of the genius of the man [Picasso], because I know what he has done in the past, that I stand aside, knowing too much to condemn, knowing too little to praise".

DECEMBER *Second Camden Town Group Exhibition*, Carfax Gallery.

15 DECEMBER *The Art News* published Fry's preface to the Contemporary Art Society Exhibition at Manchester City Art Gallery, which included Bevan, Etchells, Fergusson, Fry, Gauguin, Gilman, Ginner, Grant, Innes, John, Picasso, Lucien Pissarro and Sickert. Referring to Grant and Etchells, Fry wrote: "In both one sees evidence of a profound study of primitive art and the application of its principles in an entirely modern and original manner. Both realise more clearly than any other modern English artists the value of the bare statement of structural planes and lines of movement and the importance of scale and interval in design. But here the likeness ends, since Duncan Grant's *Harvesters* shows him to have a spontaneous lyrical feeling of singular purity and intensity, while Etchells has a more dramatic sense of character and the contrasts of life ... his two pictures show what real gifts he possesses both as a designer and a colourist. His large figure shows how fast art has moved in the direction of discarding all that has not direct symbolical value since John's *Smiling Woman*." The exhibition then travelled to Leeds and Newcastle.

1912

JANUARY Review in *Art News* of Fry's exhibition at the Alpine Club gallery, praising *Chauvigny*.

Michael Sadler appointed Vice-Chancellor, Leeds University

Frank Rutter appointed Curator, Leeds City Art Gallery. As a result the activities of the Leeds Art Club focused sharply on post-impressionist painting. Sadler held monthly club meetings at his home in Leeds where his collection was on show.

The Letters of a Post-Impressionist. Being the Familiar Correspondence of Vincent Van Gogh, trans. with an introduction by Anthony M. Ludovici, published London.

Huntly Carter, *The New Spirit in Drama and Art*, London, discussed Boccioni, Chabaud, Derain, Dunoyer, Segonzac, Feininger, Fergusson, Friesz, Gibb, Gore, Peploe, Picasso, Rice, Severini and Wolmark.

7 FEBRAURY Frank Rutter's 'Modern Movements in Art'. *Art News* translated Signac's *D'Eugène Delacroix au Neo-Impressionisme*, reproducing Signac woodblocks lent by Bernheim-Jeune and giving general introduction to Neo-Impressionism.

10–24 FEBRUARY *Friday Club* exhibition, Alpine Club Gallery, including Bell, Etchells, Grant, Wadsworth.

MARCH *Paintings by J.D. Fergusson*, The Stafford Gallery

Italian Futurist Painters, Sackville Gallery, including Boccioni (10), Carra (11), Russolo(6), Severini (8).

9 MARCH Rutter's article on Neo-Impressionism continued and Michael Sadleir's 'Kandinsky's Book of Art' was published in *Art News*.

19 MARCH Marinetti lecture, Bechstein Hall.

23 APRIL *Exhibition of Drawings by Pablo Picasso*, Stafford Gallery (26).

MAY *Paintings and Drawings by Walter Sickert*, Carfax Gallery.

1–15 MAY *Quelques Artistes Indépendants Anglais* organized by Fry at the Galerie Barbazanges, 109 Faubourg St-Honoré, including Vanessa Bell, Frederick Etchells's *The Entry into Jerusalem* and *The dead mole* [cat. 36], Jessie Etchells, Roger Fry, Ginner, Gore, Grant's *The Queen of Sheba*, *Dancers*, *View of Corfe* and *Preparations for the whippet race*, Holmes, Lewis and Saunders.

JUNE Galerie Barbazanges's British exhibits went to Cardiff for an exhibition organized by Spencer Gore.

26 JUNE The Cabaret Theatre Club opened at 9 Heddon Street, off Regent Street. The *Cave of the Golden Calf*, the central room of the club, was decorated with work commissioned by the club's owner, Mme Frida Strindberg, including murals by Gore (*Deer-hunting* [cat. 97]) and Ginner (*Tiger-hunting* [cat. 76], *Birds and Indians*, and *Chasing monkeys*). Gill's sculpture *The Golden Calf* [cat. 63] does not appear to have been installed.

JULY Fry visited Paris to select work for the *Second Post Impressionist Exhibition*. Once again he was assisted by Robert Dell.

SUMMER While living in Paris, working on Oscar Wilde's tomb, Epstein met Modigliani, who he saw every day for six months, and visited Brancusi's studio with Ortiz de Zarate. He also met Picasso.

JULY Fry visited the Sonderbund exhibition in Cologne with the Bells.

AUGUST Michael Sadler and son also saw the Sonderbund exhibition. Sadler bought Gauguin's *Poèmes barbares*.

3 OCTOBER Exhibition of pictures by J.D. Fergusson and other artists in the Rhythm group.

5 OCTOBER *Second Post-Impressionist Exhibition*, Grafton Galleries:

French
Bonnard (2), Braque (1), Bussy (1), Camis (1), Cézanne (38), Chabaud (5), Derain (4), Van Dongen (4), Doucet (7), Flandrin (6), Friesz (4), Girieud(6), Herbin (10), Lhote (8), Marchand (6), Marquet (3), Marval (2), Matisse (21), Ottman (3), Picart (2), Picasso (12), Puy (2), Thiesson (4), Vlaminck (5).

Russian
Bogaevsky (2), Čiurlianis (3), Goncharoff (3), Hasenberg (3), Joukoff (1), Komarovsky (1), Larinoff (1), Lewitzka (2), Ottman (3), Petroff-Wodkine (2), Roerich (6), Stelletzky (6), Zak (2).

British
Bell (4), J. Etchells (1), F. Etchells (5), Fry (5), Gill (8), Gore (3), Grant (7), Hamilton (4), (extended version), Lamb (1), Lewis (8), Spencer (1), Wadsworth (2)

The poet Charles Vildrac was invited to London to represent modern French literature.

NOVEMBER Rutter formed the Leeds Art Collections Fund.

DECEMBER *The Third Exhibition of the Camden Town Group*, Carfax Gallery.

1913

24 JANUARY–11 FEBRUARY *Friday Club* exhibition, Alpine Club Gallery, including Wadsworth.

French and British pictures chosen by Fry from the *Second Post Impressionist Exhibition* exhibited at the Sandown Studios, Liverpool. Lewis was the only British artist to be excluded.

At the Leicester Palette Club, Sidney Gimson, with the help of the Contemporary Art Society, organized Post-Impressionist show at which Fry lectured.

FEBRUARY *Armory Show*. Many of the exhibits in the *Second Post-Impressionist Exhibition* were sent to New York. British artists included Sickert and John.

MARCH Fry's plans for the Omega Workshops came to fruition when he took the lease of 33 Fitzroy Square. In May the Omega Workshops were registered as a limited company.

11 MARCH Michael Sadler wrote to Kandinsky to say that Fry had visited Leeds and that he was "deeply interested in your drawings".

15–31 MARCH *First Grafton Group Exhibition*, Alpine Club Gallery. Members: Bell, Etchells, Fry, Grant and Lewis, plus twelve other artists including Cuthbert Hamilton, Kandinsky (two watercolours borrowed from Sadler).

MARCH *Studies and Drawings by Walter Sickert*, Carfax Gallery.

APRIL *Gino Severini's Exhibition* Marlborough Gallery.

14–19 APRIL Duncan Grant saw exhibition of fourteen of Matisse's recent Morocco pictures at the Bernheim-Jeune Gallery.

SPRING Rutter first met Picasso in his studio in Paris. Picasso explained that he was developing a new realism. "When I first met him at Paris in 1913 Picasso

said not a word of abstraction, but claimed to be a realist."

7 JUNE *A Loan Exhibition of Post-Impressionist Paintings and Drawings* opened at the Leeds Arts Club. The Exhibition Committee consisted of A.M. Daniel, Michael Sadler, Mrs R.E. Clarke, W.P. Irving, Ernest Forbes, T.A. Lamb and Frank Rutter. The catalogue foreword and notes were written by Frank Rutter and M.T.H. Sadler. Sixty-three works included Cézanne, Gauguin, Van Gogh, Kandinsky, Matisse, Picasso and Toulouse Lautrec.

12 JUNE Sadleir gave a talk on 'Post-Impressionism and Public Galleries' in Leeds.

SUMMER Epstein and Bomberg travelled to Paris where they meet Derain, Picasso and Modigliani amongst others.

7 JULY AAA exhibition, including Brancusi, Kandinsky, Zadkine.

OCTOBER Lewis sent a round robin letter complaining about his treatment at Omega and suggesting that Fry had attempted to have his work and that of Etchells excluded from Rutter's *Post-Impressionists and Futurists*.

12 OCTOBER *Post-Impressionists and Futurists*. Rutter lectured in the evenings on modern art, used Nevinson's *Departure of the train de luxe* on the private view card. Bell, Fry and Grant were not invited to exhibit.

NOVEMBER A new exhibiting society was formed, to be named The London Group the following year. Its first exhibition, *English Post-Impressionists and Others*, opened in Brighton.

18 NOVEMBER Etchells, Wadsworth, Hamilton, Nevinson and Lewis gave a dinner for Marinetti at the 'Florence' restaurant. Marinetti was in London participating in a series of *soirées* at which he gave recitals of his poetry and lectures.

16–20 NOVEMBER Stanley Cursiter borrowed a number of works from the *Second Post-Impressionist Exhibition* which were shown at the Society of Scottish Artists in Edinburgh.

DECEMBER Kandinsky sent Sadler a purely abstract painting which Sadler described in a later talk, 'Premonitions of the War in Modern Art'.

1914

2 JANUARY–30 JANUARY *Second Grafton Group Exhibition* included five sculptures by Gaudier-Brzeska and work by Chabaud, Doucet, Friesz, Lhote, Marchand, Vilette, Bell, Fry, Grant, Winifred Gill, Hamnett, William Roberts and a Derain and Picasso owned by Fry.

22 JANUARY T.E. Hulme explained the philosophy behind the new art including Epstein, Gaudier-Brzeska, Lewis and Bomberg in a lecture 'The New Art and its Philosophy' to the Quest Society.

JANUARY–MARCH Sickert edited a series of 'Modern Drawings' for *The New Age*.

13 FEBRUARY A sale of the assets of the Cabaret Theatre Club was held after the club went into liquidation.

FEBRUARY *Pictures by John Duncan Fergusson*, Doré Gallery.

25 FEBRUARY *Modern German Art*, including Kandinsky and Marc, opened at the Twenty-One Gallery, with a catalogue introduction by Wyndham Lewis.

MARCH The Rebel Art Centre opened at 38 Great Ormond Street.

Clive and Vanessa Bell and Roger Fry were taken to Picasso's studio by Gertrude Stein. While staying in Paris they also visited Matisse in his studio, saw Michael and Sarah Stein's collection and viewed pictures at the Kahnweiler gallery and at Vollard's gallery.

First exhibition of the London Group, Goupil Gallery.

Michael Sadleir translated Kandinsky's *The Art of Spiritual Harmony*, which was praised by Wadsworth and Hulme.

MARCH–APRIL T.E. Hulme edited 'Contemporary Drawings' in *The New Age*, including Gaudier-Brzeska, Bomberg, Roberts, Nevinson and Wadsworth.

26 MARCH Sickert launched an attack on the English Cubists in *The New Age*. Lewis published a counter-attack on 2 April.

27 MARCH Death of Spencer Gore. Sickert's appreciation was published in *The New Age* (9 April 1914). Lewis published a tribute in *Blast No. 1* (20 June 1914).

APRIL *Paintings and Drawings by Walter Sickert*, Carfax Gallery.

Paintings and Drawings by Robert Bevan, Carfax Gallery.

'Exhibition of the works of the Italian Painters and Sculptors', Doré Galleries. The catalogue republished the 'Initial Manifesto of Futurism', a slightly modified version of the introduction to the 1912 Sackville catalogue, and a preface by Boccioni that had appeared in the catalogue of the first exhibition of Futurist sculpture (1913). Seventy-three paintings by Balla, Boccioni, Carra, Russolo, Severini and Soffici, four sculptures by Boccioni, a self-portrait by Marinetti and a *tavola polimaterica* by Marinetti and Canigiullo were included.

28 APRIL Marinetti lectured at the Doré Galleries.

MAY *Futurist Sculpture*, Doré Galleries.

In a speech at the opening of a Leeds art club exhibition of Cubism and Futurism he had organized, Wyndham Lewis said that there were three movements in modern painting: Cubism, Futurism, Expressionism. He expressed hope that these subdivisions would cease to exist and there would only be modern art. A little more than two months later Lewis formed his own Vorticist group.

6 MAY Marinetti conference at the Rebel Art Centre.

MAY–JUNE *Spencer Gore Memorial Exhibition*, Goupil Gallery.

8 MAY–20 JUNE *Twentieth–Century Art: A Review of the Modern Movements*, Whitechapel Art Gallery. This included eighty objects by the Omega Workshops, and exhibitors were Clifford Adeney, Alfred Allinson, Boris Anrep, M.E. Atkins, Mrs E.C. Austen-Brown, C.H. Collins Baker, Muriel Baker, Harry Becker, George Belcher, M.A. Bell, Vanessa Bell, J.M.B. Benson, Robert Bevan, Clara Birnberg, Henry Bishop, David Bomberg, Marjorie Brend, Horace Brodsky, Austen Brown, Herbert Budd, Walter Burrows, Maud Ireland Buxton, Frederick Carter, Ernest H.R. Collings, Hilda Coltman, John Copley, John Currie, Stanley Cursiter, Mrs Bernard Darwin, E.M. Darwin, G.D. Davison, Walter Dobson, Amy

Drucker, Malcolm Drummond, John Duncan, Jacob Epstein, Frederick Etchells, Jessie Etchells, A.L. Falkner, J.D. Fergusson, Muriel Fewster, Fred F. Foottet, Arnold Forster, Adeline Fox, Douglas Fox-Pitt, Roger Fry, H.F. Garrett, Henri Gaudier-Brzeska, Mark Gertler, Colin Gill, MacDonald Gill, Harold Gilman, Charles Ginner, Morris Goldstein, Spencer Gore, Sylvia Gosse, Duncan Grant, A. Gwynne Jones, J. Hamilton Hay, Margaret Hannay, Jessie Hebbert, Vernon Hill, Nan Hudson, R. Ihlee, J.D. Innes, Darsie Japp, Stanislasa de Karlowska, Moses Kisling, Jacob Kramer, Lilian Lancaster, Henry Lamb, Mervyn Laurence, Clarence King, Mable Layng, Derwent Lees, Therese Lessore, Wyndham Lewis, Gordon Lightfoot, Albert Lipeninski, Mrs Julian Lousada, Donald Maclaren, E. MacNaught, J.B. Manson, Josephine Mason, Fred Mayor, Bernard Meninsky, Malcolm Milne, Eli Nadleman, John Nash, Paul Nash, Christopher Nevinson, Katharine Ollivant, Pascin, Maresco Pearce, S.J. Peploe, Louise Pickard, Lucien Pissarro, Vladimir Polunia, John K. Pringle, Amedeo Modigliani, Gwen Raverat, William Ratcliffe, Anne Estelle Rice, William Roberts, Issac Rosenberg, Ethel Sands, Helen Saunders, Hubert Schloss, William Shackleton, Agatha Hall Shore, Walter Sickert, Noel Simmons, Joseph Simpson, Howard Somerville, Stanley Spencer, Harold Squire, Ian Strang, N. Munro Summers, Horace Taylor, Walter Taylor, Samuel Teed, Mrs Tyrwhitt, Vassilieff, Mark Weiner, Vera Waddington, Edward Wadsworth, Ethel Walker, Wilfrid Walter, Diana White, Philip Sidney Woolf, Alfred Wolmark and Ethel Wright.

12 JUNE Seventh London Salon of the AAA, Holland Park Hall.

15–20 JUNE Twelve noise-tuner concerts at the Coliseum and Albert Hall by Marinetti, Russolo and Piatti.

20 JUNE First issue of *Blast* published. *No. 1*.

JULY *Works by David Bomberg*, 55 works. Bomberg's large one man show at the Chenil gallery included *The mud bath*, which Bomberg hung outside the gallery and decorated with Union Jacks. Brancusi and Duchamp-Villon visited the exhibition.

Charles Ginner published 'Neo-Realism' in *The New Age* .

4 AUGUST War declared.

1915

5 JANUARY–25 FEBRUARY Ezra Pound wrote a series of seven articles on modern art and society.

5 JUNE Gaudier-Brzeska killed in action in France.

10 JUNE *The Vorticist Exhibition*, Doré Galleries.

20 JULY *Blast No. 2* published.

NOVEMBER Fry's one man show at the Alpine Club, including *Essay in abstract design* [cat. 47].

1916

3 JULY Fry returned from Paris having seen Matisse and Picasso. While there he showed Matisse photographs of recent English work. "The new Matisses are magnificent, more solid and more concentrated than ever. Picasso a little dérouté for the moment but doing some splendid things all the same"

8–28 AUGUST *Englische Moderne Malerei*, Zurich, an exhibition organized by the Contemporary Art Society as a propaganda exercise. Included were Vanessa Bell, Etchells, Fergusson, Gertler, Gilman, Ginner, Grant, John, Lewis, Nevinson, Sickert, Steer and Tonks.

1916 Read and Rutter collaborated on the journal *Art and Letters*.

1917

Rutter sacked from post at Leeds City Art Gallery, allegedly over dispute about the purchase of a Pissarro painting.

JULY Fry organized an exhibition of the varied trends of the new modern movement – *An exhibition of works representative of the new movement in art* – at the Royal Birmingham Society of Artists.

17 JULY–MID SEPTEMBER Sadler bought six works including Bell's *Triple alliance*. A reduced version at the Mansard Gallery, Heal & Son's, London, 8–26 October, included works from Fry's own collection including his Brancusi and Gris and from those of friends including Montagu Shearman.

10 NOVEMBER Mixed group show at Omega workshops, including Grant's *The kitchen* [cat. 110].

1918

Percy Moore Turner's Independent Gallery opened at 7A Grafton Street. Moore Turner would advise Sir Samuel Courtauld on purchases.

1919

FEBRUARY Death of Harold Gilman. Memorial Exhibition held at the Leicester Galleries in October with a preface by Charles Ginner (first published in *Arts and Lettters*). *Harold Gilman: An Appreciation* by Wyndham Lewis and Louis Fergusson was published in summer.

MAY Derain visited Fry in London. Fry arranged for him to sublet Vanessa Bell's London studio. In October Fry paid Derain a reciprocal visit.

AUGUST O. & S. Sitwell organized an exhibition of modern French art at the Mansard Gallery which was reviewed by Fry in *The Athenaeum*, 15 August. He wrote favourably about Matisse, Derain and Picasso.

NOVEMBER–DECEMBER *Pictures by Henri Matisse and Sculptures by Maillol*, Leicester Galleries. During the autumn Matisse visited London and designed the decor and costumes for Igor Stravinsky's *Le Chant du rossignol*, produced by Sergei Diaghilev's Ballets Russes de Monte Carlo.

APPENDIX

EUROPEAN WORKS OF ART EXHIBITED IN LONDON BETWEEN 1910 AND 1914

ABBREVIATIONS

Abbreviations are shown in square brackets within the Bibliography.

NOTE

The first title given is that by which the picture is currently known; the title under which it was exhibited is afterwards given in brackets. An asterisk after the title indicates that the work was illustrated in the catalogue.

MANET AND THE POST-IMPRESSIONTS

CÉZANNE

2. *Les Ondines*
Private collection (V538, R588)

5. *Still life with basket of apples* (*Nature morte*)
Art Institute of Chicago (V600)

8. *The Bay of L'Estaque* (*L'Estaque*)
Philadelphia Museum of Art
(V489, R444)

9. *Nature morte*

10. *Portrait of the Artist* (*Portrait de l'artiste*)
Private collection (V578, R876)

11. *Mme Cézanne in a striped skirt* (*Portrait de Mme Cézanne*)
Museum of Fine Arts, Boston
(V292, R324)

12. *Les Petunias*
Private collection (V198, R470)

13. *Old woman with a rosary* (*Dame au chapelet*)
National Gallery, London
(V702, R808)

14. *La Toilette*
Barnes Foundation, Philadelphia
(V254, R594)

19. *The bathers* (*Baigneurs*)
Fondation Jean-Louis Prevost, Musée d'Art et d'Histoire, Geneva
(V273, R259)

20. *The great pine* (*Le grand pin*)
São Paulo Museum of Art
(V669, R601)

47. *Portrait d' homme au cravate blue* (*sic*)
(*Uncle Dominic the lawyer*)
Wellesley College Museum (V74, R106)

61. *Maison à Anvers* (*sic*)
(V194, R196)

62. *La Maison du pendu*
Stephen Henn collection, New York
(V651, R351)

63. *The viaduct at l'Estaque* (*La maison jaune*)
Helsinki Museum (Antell Ateneum)
(V402, R439)

Ex-cat. *Portrait of the artist's wife in a striped dress*, 1883–85
Art Salon Takahata, Osaka

CROSS

58. *Coup de vent d'est*
repr. *The Sketch* 16.11.10

DENIS

33. *Orphée*
lent by Charles Pacquemont
repr. *Illustrated London News* 26.11.10

82. *Ulysses and Calypso* (*Calypso*)
lent by Druet
Helsinki Museum (Antell Ateneum)

91. *St George* (*St. Georges*)
lent by Druet
repr. *The Graphic* 19.11.10.

100. *Nausicaa* (*The Shepherd*)
lent by Druet
repr. *The Graphic* 26.10.10
Pushkin Museum, Moscow

124. *Madonne au jardin fleuri*, 1907
repr. *The Graphic* 26.11.10
Private collection (sold Sotheby's, London 25.6.86, lot 164)

DERAIN

115. *Vue de Martigues* (*Martigues*), 1908
lent by Kahnweiler
Kunsthaus, Zurich (AB)

116. *Église de Carrières* (*Landscape at Carrières-sur-Seine*), 1909
lent by Kahnweiler
repr. *The Sketch*, 16.11.10
Statens Museum for Kunst, Copenhagen (K170)

118. *Le Parc de Carrières*
lent by Kahnweiler
Courtauld Institute Galleries, London
(K171)

FLANDRIN

27. *La Danse des vendages*
lent by Druet
repr. *The Sketch* 16.11.10

GAUGUIN

23. *Adam and Eve*
Ordrupgaardsamling, Copenhagen
(W628)

28. *The black pigs* (*Vue sur la Martinique*)
repr. *The Sketch* 16.11.10
Szépművészeti Múzeum, Budapest
(W446)

37. *Portrait of a woman, with still life by Cezanne (Portrait de Mme X)*
repr. *The Graphic* 26.11.10
Chicago Art Institute (W387)

39. *Marquesan man in a red cape (L'Appel)*, 1902
repr. *The Sketch* 16.11.10
Musée des Beaux Arts, Liège (W616)

40. *The Sister of Charity (La Réligieuse)*, 1902
McNay Art Museum, San Antonio (W617)

41 *Two Tahitian women* (probably *Negresses)*, 1899
repr. *The Graphic* 16.11.10 and Hind
The Metropolitan Museum of Art, New York (W583)

42. *Manao tupapau* or *The spirit of the dead watching (L'Esprit veille)*
Albright-Knox Art Gallery, Buffalo NY (W457)

43. *Parau na te varua ino* (Words of the Devil) *(L'Esprit du Mal)*
repr. *Tatler* 23.11.10
National Gallery of Art, Washington (W458)

44. *Maternity (Maternité)*
Private collection (W582)

45. *Reverie (Faaturuma)*, 1891
Nelson-Atkins Museum of Art, Kansas City MI (W424)

81. *Still life with sunflowers and mangos* (probably *Fleurs de soleil)* (W606)

83. *Les Laveuses*
Possibly W302 or 303. Both these works were lent by Gustav Fayet anonymously.

85. *Christ in the Garden of Olives (Le Christ au Jardin des Oliviers)*
repr. *The Sketch* 16.11.10
Norton Gallery and School of Art, West Palm Beach FL (W326)

86. *Tahitian women bathing (Grandes Baigneuses)*
repr. *The Sketch* 16.11.10
The Metropolitan Museum of Art, New York, Robert Lehman Collection (W462)

88. *Le Gardeur d'oies* (erroneously attributed to Van Gogh in the catalogue) is probably *The Breton goose-boy*, 1889
(I am grateful to Belinda Thomson for this suggestion.)
On loan to Museum of Fine Arts, Houston, 1981 (W367)

120. *Tahitian family* (probably *Three Tahitians)*, 1898
repr. *The Sphere* 5.11.10
National Gallery of Scotland, Edinburgh (W573)

127. *Joseph and Potiphar's Wife*
São Paulo Museum of Art (W536)

128. *Tahitiens* (oil painting)
Tate Gallery, London (W516)

The following can be identified from reproductions in the Press; however I have been unable to match them to a catalogue number:

The harvest at Arles or *Human miseries*
Ordrupgaardsamling, Copenhagen
repr. *The Sphere* 5.11.10 (W304);
Tatitian fisherwomen
repr. *The Art Chronicle* 26.11.10, p. 52 (W429);
Tahitian pastorals
repr. Hind 1911
The State Hermitage Museum, St. Petersburg (W470)

Amongst the works on paper by Gauguin in the exhibition, two water-colours and two drawings were lent by Mrs Chadbourne. A monotype, *Natives and peacocks* (1902), is part of Mrs Chadbourne's bequest to the Art Institute of Chicago.

VAN GOGH

50. *Garden of Daubigny in Auvers-sur-Oise*
lent by Mrs Van Gogh Bonger
Van Gogh Museum, Amsterdam (F765)

61. *Paysage*, probably *The Plain of Auvers*
repr. Hind 1911
Carnegie Institute of Art, Pittsburgh (F781)

65. *Irises (Iris)*
lent by Mrs Van Gogh Bonger
Van Gogh Museum, Amsterdam (F678)

66. *The Postman Roulin (Le Postier)*
lent by Druet
Barnes Foundation, Philadelphia (F435)

67. *Young man with a cornflower (Jeune fille au bleuet* [the mad girl in Zola's *Germinal]*)
lent by Bernheim-Jeune
Private collection (F787)

68. *Le Pont d'Asnières*
lent by Druet
E.G. Bührle Foundation, Zurich (F301)

69. *Les Usines*
lent by Bernheim-Jeune
St Louis Art Museum (F317)

71. *Crows over wheatfield (Cornfield with rooks)*
lent by Mrs Van Gogh Bonger
Van Gogh Museum, Amsterdam (F779)

72. *Sunflowers (Les Soleils)*
lent by Paul von Mendelsohn-Bartholdy
Yasuda Fire & Marine Insurance Co., Tokyo (F547)

73. *Dr. Gachet*
repr. *The Illustrated London News* 26.11.10
Private collection (F753)

74. *Pietà (after Delacroix)*
lent by Mrs Van Gogh Bonger
Van Gogh Museum, Amsterdam (F630)

75. *The Resurrection of Lazarus* (after Rembrandt's etching)
lent by Mrs Van Gogh Bonger
Van Gogh Museum, Amsterdam (F677)

76. *La Berceuse*
lent by Bernheim-Jeune
The Hon. Mr and Mrs Walter Annenberg (F504)

123. *View of Arles with irises in the foreground*
lent by Mrs Van Gogh Bonger
Van Gogh Museum, Amsterdam (F409)

144. *Evening landscape*
lent by Mrs Van Gogh Bonger

145. *Tournesols*, probably *The sunflowers*
The National Gallery, London (F454)

Ex-cat.:
Hugo von Tschudi lent the following:
Rain effect behind the hospital,
Philadelphia Museum of Art (F650);
Roadmenders at Saint-Rémy (Large plane trees), repr. *The Sketch* 16.11.10 and Hind 1911
Phillips Collection, Washington (F658);
and *Self-portrait*
Fogg Art Museum, Cambridge MA (F474), from his own collection.
Around the beginning of December Mrs Van Gogh Bonger sent four drawings including at least two landscapes and *Self-portrait in front of an easel*, repr. *The Sphere* and Hind 1911, Van Gogh Museum, Amsterdam (F522). Rutter described another picture as "the oblong

of the asylum among the pine trees", which was possibly *The grounds of the asylum* (F643). Sickert referred to *Les Aliscamps*, probably F486 or 487. *Landscape with carriage and train*, Pushkin Museum, Moscow (F760), was almost certainly exhibited. It is reproduced in Hind 1911 and described by Holmes.

HERBIN

101. *Bruges* (*Scène de Ville, Bruges*), 1907
Sold Sotheby's, New York 16.5.84, lot 371

103. *Maison au quai vert*
repr. *Tatler* 23.11.10

MANET

According to *The Times* all the Manet exhibits were from the Pellerin collection.

1. *Portrait d'enfant*

3. *Mademoiselle Lemonnier* (*Portrait of Isabelle Lemonnier*)
(RW 301)

4. *L'Amazone* (*Jeune femme au chapeau rond*)
The Henry and Rose Pearlman Foundation (RW 305)

7. *A bar at the Folies-Bergère* (*Un bar aux Folies Bergère*)
Courtauld Institute Galleries, London (RW 388)

15. *La femme aux souliers roses* (*Berthe Morisot au soulier rose*)
(RW 177)

17. *Au café*
repr. *The Art Chronicle*, Dec. 1910
Oscar Reinhart collection, Winterthur (RW 278)

21. *Baigneuses*
São Paulo Museum of Art (RW 226)

22. *La Promenade*
National Gallery of Art, Washington (RW 338)

151. *Miss Campbell* (*Portrait of Miss Claire Campbell*), pastels
Cleveland Museum of Art (RW 69)

MATISSE

77. *Paysage*
lent by Leo Stein
A description in *The Daily Graphic* 7.11.10 identifies this as *Collioure*, 1906, in the Barnes Foundation, Philadelphia.

77a. *Paysage*
lent by B. Berenson
National Museum, Belgrade

111. *Girl with green eyes* (*La femme aux yeux verts*), 1908
lent by Mme L. (Harriet Levy)
San Francisco Museum of Art

195. *Marguerite* (*Tête de femme*), 1906, pen drawing
lent by Alphonse Kann
repr. *The Nation* 31.12.10
See Jack Flam, *Matisse: A Retrospective*, New York 1988, p. 53.

Matisse lent eight bronzes including:

2. *Le Serf*, 1900–03

14. *Woman leaning on her hands* (*Femme s'appuyant sur les mains*), 1905

15. *Femme couchée*, probably *Reclining nude no. 1*, repr. *Tatler* 23.11.10

22. *Buste de jeune fille*, possibly *Head of a young girl*, 1906

Mrs Chadbourne lent three of the twelve drawings by Matisse. They may have included: *Marguerite with a black cat* 1910, crayon on paper, 27.5 × 21.4 cm, Art Institute of Chicago, Gift of Mrs Emily Crane Chadbourne; and *Seated model clasping her knees*, 1909, pen and ink, 29.4 × 23.5 cm

PICASSO

30. *Young girl with a basket of flowers* (*Nude girl with basket of flowers*), 1905
lent by Leo Stein
Private collection (DB XIII, 8)

117. *Portrait of Clovis Sagot*, 1909
Kunsthalle, Hamburg (Daix 270)

Only one of the seven drawings by Picasso has been tentatively identified:

182. *Les Deux Soeurs*
lent by Sagot
probably Zervas VI, 435 or XXI, 369

Ex-cat.:
Salome, etching (G17)

SEURAT

55. *Lighthouse and Mariners' Home, Honfleur* (*Le Phare à Honfleur*), 1886
lent by Bernheim-Jeune
National Gallery of Art, Washington (DR 168)

SÉRUSIER

96. *Vallée temps gris*, 1907
Formerly coll. Michael Sadler (MG 216)

VLAMINCK

109. *Poissy-le-Pont* (*Le pont*), 1909
lent by Vollard; Clive Bell bought this from the exhibition.
Sold Sotheby's, London 3.12.58, lot 156

112. *La Voile*
lent by Vollard
repr. *The Sketch* 16.11.10

EXHIBITION OF PICTURES BY PAUL CÉZANNE AND PAUL GAUGUIN, 1911

CÉZANNE

3. *La Montagne Sainte Victoire et le chemin*
Barnes Foundation, Philadelphia (V44, R397)

5. *La Maison abandonnée*
Stephen Hann Collection, New York (V659, R351)

GAUGUIN

11. *The studio* (*The Schuffnecker Family*)
Musée d'Orsay, Paris (W313)

13. *The umbrella*, 1881, probably *Jardin Quai de Ponthius, à Pontoise*
Whereabouts unknown (W58)

14. *Entrée de village*, probably *Rue Carcel in snow*, 1883
Private collection (W80)

16. *Vision after the sermon: The struggle of Jacob and the Angel*
National Gallery of Scotland (W245)

17. *Ronde Bretonne* (*Breton girls dancing*)
National Gallery of Washington (W251)

18. *La Cueillette*, Tahiti 1892 (probably *La Cueillette des citrons*)
(W475)

20. *Christ in the Garden of Olives (Christ at the Mount of Olives)*
Norton Gallery of Art, West Palm Beach FL (W326)

21. *Nude Woman on a divan seen sideways mending a chemise (Portrait of a girl)*, 1880
Ny Carlsberg Glyptotek, Copenhagen (W39)

22. *Manao tupapau (L'Esprit veille)*
Albright Knox Gallery, Buffalo (W457)

EXHIBITION OF DRAWINGS BY PABLO PICASSO, 1912

5. *Horse with a youth in blue (Cheval avec jeune homme en bleu)*, 1905–06, £22
London, Tate Gallery (Alley, p. 593)

6. *Tête d'âne (Gosol)*, 1906, £5
repr. in *The Art Chronicle*, vol. 8, no. 1, 3 May 1912, pp. 270–71
Mr and Mrs F. Kirchheimer, Kusnacht (McCully, p. 84; DB XV, 19; Zervas XXII, 343)

13. *Femme étendue*, possibly *Peasants from Gosol*, 1906, pen drawing, £4
Art Institute of Chicago

16. *Vieux miséreux*, "dessin en bleu", £12.10s., possibly *Poverty*, 1903, Whitworth Art Gallery, Manchester

25. *Nature morte: poisson (Nature morte a la bete (sic) de mort)*, August 1907, £15, 48 × 63 cm
(Zervas XXVI, 193; McCully, p. 84)

26. *L'Apéritif (Portrait de Salmond)*, F. de Sota au café, 1901
Columbus Gallery of Fine Art OH (probably Zervas XXI, 163; McCully, p. 84)

Rhythm, which had close connections with the Stafford Gallery, published four Picasso drawings including *Peasants from Andorra*, 1906, pen, Art Institute of Chicago (repr. Daix p. 292).

THE FUTURIST EXHIBITION

BOCCIONI

1. *Leave-taking*
The Museum of Modern Art, New York (CC 723)

2. *Those who are going away*
The Museum of Modern Art, New York (CC 724)

3. *Those who remain behind*
The Museum of Modern Art, New York (CC 725)

4. *The street enters the house*
Kunstmuseum, Hanover (CC 745)

5. *Laughter*
The Museum of Modern Art, New York (CC 701)

6. *The rising city*
The Museum of Modern Art, New York (CC 675)

7. *Simultaneous visions*
Von der Heydt Museum, Wuppertal (CC 744)

8. *A modern idol*★
Eric and Salome Estorick Foundation, London (CC 709)

9. *The forces of the street*
Private collection (CC 747)

10. *The police raid*

CARRA

11. *The funeral of the anarchist Galli*
The Museum of Modern Art, New York (MC 8/11)

12. *Jolts of a cab (The jolting cab)*, 1911
The Museum of Modern Art, New York (MC)

13. *The motion of moonlight*

14. *What the street-car told me (What I was told by the Tramcar)*, 1910–11
On loan to Städelsches Kunstinstitut, Frankfurt (MC 6/11)

15. *Portrait of the poet Marinetti*
Private collection (MC 3/11)

16. *Girl at the window*
(MC 1/12)

17. *A swim*
(MC 4/10)

18. *Leaving the theatre*
Eric and Salome Estorick Foundation, London (MC 4/09)

19. *Woman in a café (Woman and absinthe)*, 1911
Private collection (MC 4/11)

20. *The street of balconies*
(MC 1/12)

21. *The station at Milan*
Staatsgalerie, Stuttgart (MC 1/11)

RUSSOLO

22. *Revolt (Rebellion)*, 1911
Geementemuseum, The Hague

23. *The memory of a night*

24. *Train at full speed*

25. *One-three heads*

26. *Tina's hair*

26. *A portrait of the artist*

SEVERINI

27. *The Pan-Pan dance at the Monico*, destroyed, replica in Musée d'Art Moderne, Paris (RF 97)

28. *Travelling impressions*

29. *The black cat*, 1911
National Gallery of Canada, Ottawa (RF 93)

30. *The haunting dancer*, 1911
Private collection (RF 94)

31. *Yellow dancers*★, 1911
Fogg Art Museum, Harvard University Art Galleries, Cambridge MA (RF 96)

32. *The milliner*
Private collection (RF 95)

33. *The boulevard*★, 1911
Eric and Salome Estorick Foundation, London (RF 91)

34. *The rhythms of my room*
Private collection (RF 91)

SECOND POST-IMPRESSIONIST EXHIBITION

There were at least four different versions of the catalogue; the most lavish had thirty-six illustrations.

ASSELIN

214. *Usine à St-Denis**

BONNARD

157. *The waterfall (La Cascade)**, 1912
lent by Léonce Rosenberg
Private collection (J731)

BRAQUE

61. *Violin: "Mozart/Kubelick" ('Kubelik')*, 1912
lent by Kahnweiler
Private collection (Romilly 121)

CÉZANNE

Initially Cézanne was represented by six landscapes and six watercolours.

2. *Le Château Noir*
National Gallery of Art, Washington
(V796, R937)

4. *Le Dauphin de Jas de Bouffon*, nfs
lent by Bernheim-Jeune
Presumed destroyed (V166, R379)

5. *The harvest (Les Moissonneurs)**, nfs
lent by Bernheim-Jeune
Private collection, Japan (V249, R301)

6. *Gennevilliers**, nfs
lent by Bernheim-Jeune
Presumed destroyed (V322, R494)

167. *Une Cabanne (Maisons)*
lent by Bernheim-Jeune
Courtauld Institute Galleries, London
(JR 102)

168. *La Montagne Sainte Victoire, vue des environs de Saint Marc (Village et la Montagne Sainte Victoire)*, ca. 1906
lent by Bernheim-Jeune
Musée Granet, Aix-en-Provence
(R598)

169. *Maison sur une colline aux environs d'Aix (La Maison sur la colline)*, 1895–1900
lent by Bernheim-Jeune
Philadelphia Museum of Art (JR 464)

170. *Nature morte: objets de toilette (Nature morte)*
lent by Bernheim-Jeune
(JR 170)

171. *Le Pistachier dans la cour du Château Noir, I (La Cahute)*, ca. 1900
lent by Bernheim-Jeune
(JR 515)

172. *Femme à la mante*
(JR 383)

In January 1913 a number of the exhibits were sent to New York. Thirty unidentified watercolours and oil paintings by Cézanne were added to the exhibition, including:

32. *Mountains in Provence*
(V490, NR 391)

CHABAUD

41. *Chemin dans la Montagnette*
Private collection

54. *Le Troupeau sort après la pluie**

DERAIN

13. *Window on the park (La Fenêtre sur le parc)**, 1912
lent by Kahnweiler
The Museum of Modern Art, New York

90. *La Table (Le Pot bleu)*, probably 1911
lent by Kahnweiler
Metropolitan Museum, New York
(MJ)

VAN DONGEN

Portrait of Mme van Dongen
repr. *The Sketch* 9.10.12
Private collection, London

52. *Le Doigt sur la joue**
lent by Bernheim-Jeune
Boymans van Beuningen, Rotterdam

FRIESZ

38. *La Paresse (Composition)**, 1909
lent by Druet
Sold by Christie's, London 27.6.72

GONTCHAROVA

246. *The Apostles**

247. *A street in Moscow**

HERBIN

111. *Nature morte (Livres et corbeille)*
lent by Clovis Sagot

LHOTE

86. *Port de Bordeaux**
Private collection

Ex-cat.: *Port de Bordeaux*
Private collection

MARCHAND

10. *Still life (Nature morte)*, 1912
lent by Clovis Sagot
Private collection

89. *Vue de Ville**
lent by Clovis Sagot

MARQUET

53. *Femme au 'rocking chair'*
Sold Paris 1995
Whereabouts unknown

55. *La nue à contre-jour*
Musée des Beaux Arts, Bordeaux (AB)

MATISSE

The catalogue lists nineteen oil paintings, eleven drawings, two watercolours, seven sculptures, some lithographs and a woodcut.

1. *Back 1 (Le Dos)**, 1909
plaster cast

A. *La Serpentine (L'Araignée)*, 1909
plaster

A. *Head of Jeannette III (Buste de Femme, troisième état)**, 1911

A. *Head of Jeannette II (Buste de Femme, deuxième état)**, 1910, plaster

C. *Seated nude (Olga) (Femme Accroupie)**, 1910

E. *Head of Jeannette IV (Buste de femme)**, 1911, bronze

F. *Head of Jeannette I (Buste de femme, premier état)**, 1910, plaster

G. Copy after Barye's *Jaguar devouring a hare (Jaguar dévorant un tigre, d'après Barye)*, 1899–1901, plaster

9. *Carmelina* (*La pose du nu*) ★, 1903
lent by Bernheim-Jeune
Museum of Fine Arts, Boston

22. *Nasturtiums with Dance II* (*Les Capucines*), 1912
The Pushkin Museum of Fine Arts, Moscow (PM 93 (150))

23. *Joaquina*, 1911
lent by Bernheim-Jeune
National Gallery, Prague

24. *Nude by the Sea* (*Nu au bord de la mer*), 1909, nfs
Private collection (Barr 1951)
This is confirmed by the description in the *The Morning Advertiser* 4.10.12: "the nude, the sea and the shore will alike be sought for in vain."

26. *La Coiffure* (*La Coiffeuse*)★, 1907
lent by Michael Stein
Staatsgalerie, Stuttgart

27. *Purple cyclamen* (*Cyclamens*) 1911–12
Private collection (PM 93 (84))

28. *Conversation*★, 1909–12
lent by Serge Tschoukine [Shchukin]
The Hermitage Museum, St Petersburg

29. *Goldfish* (*Les poissons rouges*), 1912
lent by Bernheim-Jeune
J. Rump collection, Statens Museum for Kunst, Copenhagen (PM 93 (100))

30. *Marguerite with black cat* (*Portrait de Marguerite*)★, 1910, nfs
Illustrated as coloured frontispiece in catalogue
Private collection

31. *The red Madras hat* (*Portrait au madras rouge*), 1907, nfs
lent by Michael Stein
Barnes Foundation, Philadelphia
The Tate Gallery copy of the catalogue is annotated with a sketch of this painting.

32. *Le Luxe II* (*Le Luxe*), 1907
Statens Museum for Kunst, Copenhagen

33. *Still life with aubergines* (*Les Aubergines*), 1911
lent by Bernheim-Jeune
The Museum of Moden Art, New York, Promised Gift of Mrs Bertram Smith

34. *The wild daffodils* (*Coucous sur le tapis bleu et rose*)★, 1911
lent by Bernheim-Jeune

35. *The red studio* (*Le Panneau rouge*)★, 1911
The Museum of Modern Art, New York

36. *The young sailor II* (*Jeune marin*) 1906–07, nfs
The Gelman Foundation

37. *Goldfish and sculpture* (*Les Poissons*), 1912, nfs
lent by Madame Matisse
The Museum of Modern Art, New York
The Tate Gallery copy of the catalogue is annotated with a watercolour sketch of this painting.

185. 'Design for a decoration in Prince Tschoukine's Palace at Moscow', *Dance I* (*La Danse*)★, 1909
The Museum of Modern Art, New York

PICASSO

46. *Composition: The Peasants* (*Composition*)★
lent by Vollard
Barnes Foundation, Philadelphia (DB XV62)

65. *Portrait of Suzanne Bloch* (*Mademoiselle L.B.*), 1904
lent by Kahnweiler
Formally in the Sichowski collection, London
São Paulo Museum of Art (DB)

67. *Still life with bananas* (*Les Bananes*)
lent by Kahnweiler
(Daix 68)

60. *Green bowl and black bottle*★
lent by Leo Stein
The State Hermitage Museum, St. Petersburg
(Daix 173)

62. *Landscape with two trees* (*Les Arbres*)
lent by Kahnweiler
Philadelphia Museum of Art (Daix 179)

66. *Head and shoulders of a man* (*Tête de femme*)
lent by Kahnweiler
Galerie Beyeler, Basle (Daix 253)

64. *Head of a woman* (*Tête de Femme*)★
lent by Kahnweiler
The Museum of Modern Art New York (Daix 266)

71. *Woman and mustard pot* (*La Femme au pot de moutarde*)
lent by Kahnweiler
Gemeentemuseum, The Hague (Daix 324)

69. *Bottle and books* (*Livres et flacons*)
lent by Kahnweiler
Private collection (Daix 371)

70. *Buffalo Bill*
lent by Kahnweiler
Carlos Hank (Daix 396)

16. *The stock cube* (*Le Bouillon Kub*)
lent by Kahnweiler (Daix 454)

68. *Head of a man with a moustache* (*Tête d'homme*)★
Musée d'Art Moderne, Paris (Daix 468)

Plus three drawings lent by Kahnweiler.

VLAMINCK

14. *Buzenval*★
lent by Kahnweiler
Private collection

17. *Les Figues*★
lent by Kahnweiler

POST-IMPRESSIONIST AND FUTURIST EXHIBITION

CÉZANNE

10. *The small bathers* (*Boys bathing*), lithograph

DELAUNAY

30. *The Cardiff Football Team*
Stedelijk van Abbe Museum, Eindhoven

GAUGUIN

13. *Mahna no varua ino*, ca. 1893, lithograph, probably *Portrait of the artist with idol*
McNay Art Museum, San Antonio (W415)

VAN GOGH

13. *Interior of a restaurant in Arles* (*Interior of a Café Restaurant*), 1888
lent by Alfred Sutro
(F549)

NOLDE

161. *Freihafen, Hamburg*, woodcut, erroneously described as an etching in the catalogue
Private collection

PICASSO

101. *Composition of a death's head*, probably *Study for Composition with Skull*, 1908
Pushkin Museum, Moscow (Daix 171)

126. *Le Repas frugal*, etching

127. *Salome*, etching

ALLIED ARTISTS ASSOCIATION, THE LONDON SALON

1909

KANDINSKY

1068. *Yellow cliff (Jaune et rose)*, 1909, £50
(RB 267)

1069. *Murnau landscape with green house (Paysage)*, £50
(RB 277)

1923. *Frame with twelve engravings*

1910

KANDINSKY

961. *Composition no. 1*
destroyed

962. *Improvisation 6*
Städtische Galerie, Munich (RB 287)

963. *Landscape*

1911

1201. *Six Woodcuts and Album with Text*
£1 each: Proofs for *Klange: Composition II* (Roethel 97), The British Museum; *Reiterweg* (Roethel 526); *Improvisation 7* (Roethel 124); *Improvisation 19* (Roethel 127); *Motiv au Improvisation 10* (Roethel 135). The five woodcuts were sold at Sotheby's 16/17.5.80, lots 525–29. It has been suggested that the set always consisted of five proofs; however, when Michael Sadleir lent them to an exhibition in Leeds in 1913, the catalogue listed six proofs.

1913

BRANCUSI

1167. *Sleeping muse (Muse endormie)*, bronze, £48
Art Institute of Chicago

Two other heads by Brancusi were exhibited ex-catalogue. I am suggesting they were:

1. *Mademoiselle Pogany*, 1913, bronze possibly ex-coll. Roger Fry who owned one of the four casts of the sculpture.
2. *Prometheus*, 1911?, cement
Kettle's Yard, University of Cambridge.

KANDINSKY

285. *Improvisation 29*, £50
Philadelphia Museum of Art (RB 441)

286. *Improvisation 30*, £40
Art Institute of Chicago (RB 452)

287. *Landscape with River Pappeln (Landscape with two poplars)*
Art Institute of Chicago (RB 437)

1914

KANDINSKY

1559. *Study for Improvisation 7*
Yale University Art Gallery (RB 332)

1558. *Little painting with yellow*
Philadelphia Museum of Art (RB 484)

TWENTIETH-CENTURY ART: A REVIEW OF THE MODERN MOVEMENTS

MODIGLIANI

287. *Head, ca.* 1911–12, stone
Tate Gallery (Alley)

SELECT BIBLIOGRAPHY

Ronald Alley, *Catalogue of The Tate Gallery's Collection of Modern Art*, London 1981 [Alley]

Mark Antliff, *Inventing Bergson. Cultural Politics and the Parisian Avant-Garde*, Princeton NJ 1993

Friedrich Teja Bach, Margit Rowell, Ann Temkin, *Constantin Brancusi*, Cambridge MA and London 1995

Wendy Baron, *Sickert*, London 1973

The Camden Town Group, London 1979

Alfred H. Barr, *Matisse: His Art and His Public*, New York 1951

Clive Bell, *Art*, London 1914

Pot-Boilers, London 1917

Since Cézanne, London 1922

Old Friends, London 1956

Quentin Bell, *Bloomsbury*, London 1968 and 1976

Quentin Bell, Angelica Garnett, Henrietta Garnett, Richard Shone, *Charleston. Past & Present*, revised edn. London 1987

Alan Bowness *et al.*, *British Contemporary Art 1910–1990. Eighty Years of Collecting by the Contemporary Art Society*, London 1991

Oliver Brown, *Exhibition: The Memoirs of Oliver Brown*, London 1968

Bruneau, Anne-Pascale, 'Aux sources du post-impressionisme. Les expositions de 1910 et 1912 aux Grafton Galleries de Londres', *Revue de l'Art*, no. 113, 1996, pp. 7–18 [AB]

Ed. J.B. Bullen, *The Post-Impressionists in England*, London and New York 1988

Maurizio Calvesi and Ester Coen, *Boccioni. L'opera completa*, Milan 1980 [CC]

Cambridge, Fitzwilliam Museum, *Maynard Keynes. Collector of pictures, books and manuscripts*, exhib. cat. by David Scrase and Peter Croft, 1983

Cambridge, Kettle's Yard, *C.R.W. Nevinson*, 1988

Canterbury, Royal Museum, *Vanessa Bell Paintings 1910–1920*, 1983

Cardiff, National Museums and Galleries of Wales, *Themes and Variations. The Drawings of Augustus John 1901–1931*, essays by Michael Holroyd, Mark Evans, and Rebecca John, 1996

Frances Carey and Anthony Griffiths, *The Print in Germany 1880–1933*, 2nd edn. London 1993

Massimo Carra, *Tutta l'opera pittorica*, vol. I, Milan 1967 [MC]

Hugh and Mirabel Cecil, *Clever Hearts*, London 1990

Genevieve Claisse, *Herbin*, Lausanne 1993

Keith Clements, *Henry Lamb. The Artist and his Friends*, Bristol 1985

Douglas Cooper, *The Courtauld Collection*, London 1954

Richard Cork, *Vorticism and Abstract Art in the First Machine Age, Origins and Development*, vol. 1; *Synthesis and Decline*, vol. 2, London 1975–76

Art Beyond the Gallery in Early 20th Century England

David Bomberg, New Haven and London 1987

Judith Collins, *The Omega Workshops*, London 1983

Ed. Karen Csengeri, *The Collected Writings of T. E.Hulme*, Oxford 1994

Pierre Daix and Georges Boudaille, with Joan Rosselet, *Picasso. The Blue and Rose Periods*, trans. Phoebe Pool, London 1967 [DB]

Pierre Daix and Joan Rosselet, *Picasso. The Cubist Years 1907–1916*, London 1979 [Daix]

Reed Way Dasenbrock, *The Literary Vorticism of Ezra Pound & Wyndham Lewis*, Baltimore and London 1985

Henry-Jean Dauberville, *Bonnard*, 4 vols., Paris 1966–74

Henri Dorra and John Rewald, *Seurat: l'oeuvre peint, biographie et catalogue critique*, Paris 1959 [DR]

Susan Drees, 'Urban Enlightenment? Northern Collectors and a Loan Exhibition of Post-Impressionism, Leeds 1913', diss., University of Leeds 1995

Ian Dunlop, *The Shock of the New*, New York 1972

Malcolm Easton and Michael Holroyd, *The Art of Augustus John*, London 1974

Edinburgh, Scottish Arts Council, *Colour, Rhythm & Dance. Paintings and Drawings by J.D. Fergusson and his Circle in Paris*, exhib. cat. by Elizabeth Cumming, John Drummond, Sheila McGregor, 1985

Edinburgh, Scottish National Gallery of Modern Art, *S.J. Peploe 1871–1935*, essay by Guy Peploe, 1985

Ed. Paul Edwards, *Wyndham Lewis. Creatures of Habit and Creatures of Change, Essays on Art, Literature and Society 1914–1956*, Santa Rosa 1989

Bridget Elliott and Jo-Ann Wallace, *Women Artists and Writers. Modernist (im)positionings*, London and New York 1994

J.-B. de la Faille, *The Works of Vincent van Gogh: His Paintings and Drawings*, Amsterdam 1970 [F]

Denis Farr, *English Art 1870–1940*, Oxford 1979

Walter Feilchenfeldt, *Vincent van Gogh and Paul Cassirer, Berlin. The reception of Van Gogh in Germany from 1901 to 1914*, Zwolle 1988

Michael C. Fitzgerald, *Making Modernism. Picasso and the Creation of the Market for Twentieth Century Art*, New York 1995

Jack Flam, *Matisse. The Man and his Art 1869–1918*, London 1986

Ed. Jack Flam, *Matisse. A Retrospective*, New York 1988

Daniela Fonti, *Gino Severini. Catalogo ragionato*, Milan 1988 [DF]

Roger Fry, *Vision and Design*, ed. J.B. Bullen, Oxford 1981

Donald Gordon, *Modern Art Exhibitions*, Munich 1974

Christopher Green, *The European Avant-Gardes. Art in France and Western Europe 1904–c.1945. The Thyssen-Bornemisza Collection*, London 1995

Michel Guicheteau, with Paule H. Boutarie, *Paul Sérusier*, Paris 1976 [MG]

Miriam Hansen, 'T.E. Hulme, Mercenary of Modernism, or Fragments of Avant-garde sensibility in pre-World War I Britain', *English Literary History*, no. 47, 1980

Charles Harrison, *English Art and Modernism 1900–1939*, London 1981

Nathalie Heinich, *The Glory of Van Gogh. An Anthropology of Admiration*, trans. Paul Leduc Browne, Princeton 1996

Linda Dalrymple Henderson, 'Mysticism is the "Tie that Binds": The Case of Edward Carpenter and Modernism', *Art Journal*, vol. 46, no. 1, spring 1987, pp. 29–37

C. Lewis Hind, *The Post-Impressionists*, London 1911

The Consolations of a Critic, London 1911

Janet Hobhouse, *Everybody Who Was Everybody*, London 1975

C.J. Holmes, *Notes on the Post-Impressionist Painters*, London 1910

Michael Holroyd, *Augustus John. The New Biography*, London 1996

T.E. Hulme, ed. Sam Hynes, *Further Speculations*, Minneapolis 1955

Hull, The University of Hull, *Anne Estelle Rice Paintings*, with a biographical study of the artist by O. Raymond Drey, with an appendix: 'Anne Estelle Rice and the Artists of *Rhythm*'

Pontus Hulten, *Futurismo & Futurismi*, Venice 1986, English trans. London 1987

Merlin James, 'André Derain. Catalogue raisonné de l'oeuvre peint. Tome I (1895–1914)', *The Burlington Magazine*, 1993, pp. 301–03. [MJ]

Daniel Kahnweiler, *The Rise of Cubism*, trans. Henry Aronson, New York 1949

Daniel Kahnweiler with Francis Cremieux, *My Galleries and Painters*, trans. Helen Weaver, London 1971

Michel Kellermann, *André Derain. Catalogue raisonné de l'oeuvre peint. Tome I (1895–1914)*, Paris 1992 [MK]

Jane Lee, *Derain*, Oxford 1990

Leeds, Leeds City Art Gallery, *Jacob Epstein*, exhib. cat. by Evelyn Silber, Terry Friedman *et al*, 1987

Leeds, Leeds University Gallery, *Michael Sadler*, exhib. cat. by Hilary Diaper, Peter Godsen, W.T. Oliver, David Thistlewood, M.A. Hann and Graham R. Kent, 1989

Wyndham Lewis, edd. Walter Michel and C.J. Fox, *Wyndham Lewis on Art*, London 1969

Liverpool, Bluecoat Gallery, *Duncan Grant – Designer*, exhib. cat. by Judith Collins and Richard Shone, 1980

Liverpool, Walker Art Gallery, *Maurice Denis 1870–1943*, exhib. cat. by Therese Barruel, Jean Paul Boullion, Guy Cogeval, Ekkehard Mai, Gilles Genty, Jane Lee, Dario Gamboni, Anne Gruson, 1995

London, Anthony d'Offay Gallery, *The Omega Workshops. Alliance and Enmity in English Art 1911–1920*, chronology by Judith Collins, 1984

London, Arts Council, *Vision and Design. The life, work and influence of Roger Fry*, exhib. cat. by Quentin Bell and Philip Troutman, 1966

Vorticism and its Allies, exhib. cat. by Richard Cork, 1974

Harold Gilman, exhib. cat. by Andrew Causey and Richard Thomson, 1981

The Drawings of Henri Matisse, exhib. cat. by John Elderfield, 1984

The Sculpture of Henri Matisse, exhib. cat. by Isabel Monod-Fontaine, 1984

London, Barbican Art Gallery, *The Edwardian Era*, exhib. cat. by Deborah Cherry, Jane Beckett *et al*, 1987

Eric Gill Sculpture, exhib. cat. by Judith Collins, 1992

London, Camden Arts Centre, *Mark Gertler. Paintings and Drawings*, essays by Andrew Causey and Juliet Steyn, 1992

London, Christie's, *The Painters of Camden Town*, 1988

London, Courtauld Institute Galleries, *Portraits by Roger Fry*, exhib. cat. by Frances Spalding, 1976

Impressionism for England. Samuel Courtauld as Patron and Collector, exhib. cat. by John House with contributions by John Murdoch, Andrew Stephenson, William Bradford and Elizabeth Prettejohn, 1994

London, The Fine Art Society, *J.D. Fergusson 1874–1961*, exhib. cat. by Roger Billcliffe, 1974

Camden Town Recalled, exhib. cat. by Wendy Baron, 1976

London, Mercury Gallery, *Jessica Dismorr 1885–1939*, exhib. cat. by Quentin Stevenson, 1974

London, Michael Parkin Gallery, *André Lhote and Friends*, introduction by James Beechey, 1996

London, Royal Academy of Arts, *Post-Impressionism. Cross-Currents in European Painting*, exhib. cat. by Sandra Beresford, Alan Bowness, John House, Anna Gruetzner, Norman Rosenthal, MaryAnne Stevens, 1979

British Art in the Twentieth Century, exhib. cat., ed. Susan Compton, 1987

Sickert Paintings, exhib. cat., edd. Wendy Baron and Richard Shone with contributions by Patrick O'Connor and Anna Gruetzner Robins, 1992

London, Tate Gallery, *The Essential Cubism 1907–1920. Braque, Picasso and their Friends*, exhib. cat. by Douglas Cooper and Gary Tinterow, 1983

Pound's Artists. Ezra Pound and the Visual Arts in London, Paris and Italy, exhib. cat. by Richard Humphries *et al.*, 1985

On Classic Ground: Picasso, Léger, de Chirico and the New Classicism 1910–1930, exhib. cat. by Elizabeth Cowling and Jennifer Mundy, 1990

London, Whitechapel Art Gallery, *British Sculpture in the Twentieth Century*, exhib. cat., edd. Sandy Nairne and Nicholas Serota, 1981

Los Angeles County Museum, *The Fauve Landscape: Matisse, Derain, Braque and their Circle 1904–1908*, exhib. cat. by Judi Freeman, with John Klein, James D. Herbert, Alvin Martin and Roger Benjamin, 1991

Desmond MacCarthy, 'The Art Quake of 1910', *The Listener*, February 1943, pp. 124–25

Manchester City Art Galleries, *Wyndham Lewis*, exhib. cat. by Jane Farrington with contributions by John Rothenstein, Richard Cork and Omar S. Pound, 1980

Manchester, Whitworth Art Gallery, *French Nineteenth-Century Drawings in the Whitworth Art Gallery*, exhib. cat. by Richard Thomson, 1981

Lucile and Claude Manguin, *Henri Manguin*, Neuchatel 1980

J.B. Manson, 'Mr. Frank Stoop's Modern Pictures', *Apollo*, X, no. 57, September 1929, pp. 127–33

Ed. Regina Marler, *Selected Letters of Vanessa Bell*, introduction by Quentin Bell, London 1993–94

Timothy Materer, *Vortex: Pound, Eliot, and Lewis*, Ithaca 1979

Pound/Lewis, The Letters of Ezra Pound and Wyndham Lewis, London 1985

Ed. Marilyn McCully, *A Picasso Anthology. Documents, Criticisms, Reminiscences*, London 1981 [McCully]

Walter Michel, *Wyndham Lewis Paintings and Drawings*, introductory essay by Hugh Kenner, London 1971

Isabelle Monod-Fontaine, *Daniel-Henry Kahnweiler: Marchand, editeur, ecrivain*, Paris, Musée National d'Art Moderne

Elizabeth Monyan, Eberhard W. Kornfeld, Harold Joachim, *Paul Gauguin. Catalogue raisonné of his prints*, Bern 1988 [MKJ]

Richard Morphet, 'Roger Fry: The nature of his painting', *The Burlington Magazine* , CXXII, July 1980, pp. 478–88

Ottoline Morrell, ed. and introduction by Robert Gathorne-Hardy, *Ottoline. The Early Memoirs of Lady Ottoline Morrell*, London 1963

New Haven, Yale Centre for British Art, *The Camden Town Group*, exhib. cat. by Wendy Baron and Malcolm Cormack, 1980

New York, Davis & Long, *Vanessa Bell. A Retrospective Exhibition*, exhib. cat. by Richard Shone, 1980

New York, Hirschl & Adler Galleries, *British Modernist Art 1905–1930*, 1987

New York, Metropolitan Museum of Art, *Van Gogh in Arles*, exhib. cat. by Ronald Pickvance, 1984

Van Gogh in Saint-Rémy and Auvers, exhib. cat. by Ronald Pickvance, 1986

New York, Museum of Modern Art, ed. William Rubin, *Cézanne. The Late Work*, New York 1977

Picasso and Braque. Pioneeering Cubism, exhib. cat. by William Rubin, 1989

Henri Matisse. A Retrospective, exhib. cat. by John Elderfield, 1992

Benedict Nicolson, 'Post-Impressionism and Roger Fry', *The Burlington Magazine*, January 1951, pp. 11–15

Tom Normand, *Wyndham Lewis the artist. Holding up the mirror to politics*, Cambridge 1992

Felicity Owen, 'Introducing Impressionism. Frank Rutter, Lucien Pissarro and friends', *Apollo*, October 1993, pp. 212–16

Valerie Palmer, 'Gauguin, Primitivism and racism. A Study of Gauguin's critical reception in England 1908–1912 with particular reference to racist ideology', diss., University of Reading 1992

Paris, Centre Georges Pompidou, *Henri Matisse 1904–1917*, exhib. cat. by Yves Alain Bois, Dominique Fourcade, Isabelle Monod-Fontaine, 1993

Paris, Jeu de Paume, *Un siècle de sculpture anglaise*, exhib. cat., especially Richard Cork, 'Jacob Epstein et la sculpture anglaise au debut du siècle', pp. 35–58, 1996

Paris, Musée d'Art Moderne de la Ville de Paris, *André Derain. Le peintre du "trouble moderne"*, 1994

Paris, Musée National d'Art Moderne, *Donation Louise et Michel Leiris. Collection Kahnweiler-Leiris*, 1984

Marjorie Perloff, *The Futurist Moment: Avant-Garde, Avant Guerre, and the Language of Rupture*, Chicago 1986

Philadelphia Museum of Art, *Constantin Brancusi 1876–1957*, exhib. cat. by Friedrich Teja Bach, Margit Rowell, Ann Temkin, 1995

Queensland Art Gallery, *Matisse*, exhib. cat., edd. Caroline Turner and Roger Benjamin, 1995

Christopher Reed, 'The Fry Collection at the Courtauld Institute Galleries', *The Burlington Magazine*, CXXXII, November 1990, pp. 766–72

'Critics to the Left of Us, Critics to the Right of Us', *The Charleston Magazine*, no. 12, autumn/winter 1995, pp.10–17

Ed. Christopher Reed, *A Roger Fry Reader*, Chicago 1996

B.L. Reid, *The Man from New York. John Quinn and his Friends*, Oxford 1968

John Rewald, *Cézanne and America. Dealers, Collectors, Artists and Critics*, London 1989

Paul Cézanne. The watercolours, Boston 1983 [JR]

John Rewald with Walter Feilchenfeldt and Jayne Warman, *The Paintings of Paul Cézanne*, New York and London 1996 [R]

Anna Gruetzner Robins, *Walter Sickert: Drawings. Theory and Practice: Word and Image*, Aldershot 1996

H.K. Roethel, *Kandinsky: Das graphische Werk*, Cologne 1970 [Roethel]

H.K. Roethel and J.K. Benjamin, *Kandinsky. Catalogue raisonné of the oil paintings*, I. *1900–15*, II. *1916–44*, London 1982, 1984 [RB]

Robert Rosenblum, edd. Roland Penrose and John Golding, 'Picasso and the Typopgraphy of Cubism', in *Picasso 1881–1973*, London 1976

Mark Roskill, *The Interpretation of Cubism*, Philadelphia 1985

D. Rouart and D. Wildenstein, *Edouard Manet. Catalogue raisonné*, 2 vols., Geneva 1975 [RW]

Frank Rutter, *Revolution in Art*, London 1910

Evolution in Modern Art, London 1926

Since I was Twenty-Five, London 1927

Art in My Time, London 1933

Michael Sadleir, *Michael Ernest Sadler, A Memoir by his Son*, London 1949

Gino Severini, *The Life of a Painter*, trans. Jennifer Franchina, Princeton NJ 1995

Miranda Seymour, *Ottoline Morrell. Life on the Grand Scale*, London 1992

Emma Shackleton, 'Vanessa Bell (1879–1961): A Study of her work produced between 1905–1920', diss., University of Reading 1989

Sheffield City Art Galleries, *The Absent Presence*, exhib. cat. by Anne Goodchild, 1991

Sheffield, Mappin Art Gallery, *Vanessa Bell 1879–1961*, exhib. cat. by Frances Spalding, 1979

Vincent Sherry, *Wyndham Lewis and Radical Modernism*, New York and Oxford 1993

Richard Shiff, *Cézanne and the End of Impressionism. A Study of the Theory, Technique, and Critical Evaluation of Modern Art*, Chicago and London 1984, 1986

Richard Shone, 'The Friday Club', *The Burlington Magazine*, May 1975, pp. 279–84, reprinted *The Friday Club 1905–1922*, Michael Parkin Gallery, London 1996

Bloomsbury Portraits, London 1976, 1993

Augustus John, Oxford 1979

Evelyn Silber, *The Sculpture of Epstein. With a Complete Catalogue*, Oxford 1986

Frances Spalding, *Roger Fry: Art and Life*, London 1980

Vanessa Bell, London 1983

British Art since 1900, London 1986

'Roger Fry and his critics in a post-modernist age', *The Burlington Magazine*, CXXVII, July 1986, pp. 489–92

Virginia Spate, *Orphism*, Oxford 1979

Peter Stansky, *On or About December 1910. Early Bloomsbury and Its Intimate World*, Cambridge MA and London 1996

Tom Steele, *Alfred Orage and the Leeds Arts Club 1893–1923*, Aldershot 1990

Leo Stein, ed. Edmund Fuller, *Journey into the Self, being. The Letters, Papers and Journals of Leo Stein*, New York 1950

Denys Sutton, *Letters of Roger Fry*, vols. I and II, London 1972

Belinda Thomson, *Vuillard*, Oxford 1988

Lisa Tickner, *The Spectacle of Women. Imagery of the Suffrage Campaign 1907–1914*, London 1987

'Men's Work? Masculinity and Modernism', in *Visual Culture*, edd. Norman Bryson, Michael Ann Holly, Keith Moxey, Hannover NH 1994

'The "Left-handed Marriage": Vanessa Bell and Duncan Grant', in *Significant Others* ed. Whitney Chadwick, , London 1993

'A lost Lewis: the Mother and Child of 1912', *Wyndham Lewis Annual*, 1995, pp. 12–15

S.K. Tillyard, *The Impact of Modernism. The Visual Arts in Edwardian England. Early Modernism and the Arts and Crafts

Movement in Edwardian England*, London and New York 1988

Toronto, Art Gallery of Ontario, *Gauguin to Moore. Primitivism in Modern Sculpture*, exhib. cat. by Alan G. Wilkinson, 1982

Beverly H. Twitchell, *Cézanne and Formalism in Bloomsbury*, Ann Arbor MI 1987

Lionello Venturi, *Cézanne, son art, son oeuvre*, Paris 1936 [V]

'Vorticism', *ICSA Cahier 8/9*, Brussels, 1988

Linda Wagner-Martin, *"Favoured Strangers". Gertrude Stein and her Family*, New Brunswick NJ 1995

Walsall Metropolitan Borough Council, *The Garman-Ryan Collection*, Walsall 1976

Washington, National Gallery of Art, *The Art of Paul Gauguin*, exhib. cat. by Richard Brettell, François Cachin, Claire Freches-Thory, Charles Stuckey and Peter Zeegers, 1988

Simon Watney, *English Post-Impressionism*, London 1980

'The Connoisseur as Gourmet', in *Formations of Pleasure*, London 1983

The Art of Duncan Grant, London 1990

W.C. Wees, *Vorticism and the English Avant-Garde*, Toronto 1972

Wellington, New Zealand, National Art Gallery, *Gontcharova*, 1987

Georges Wildenstein, edd. Raymond Cogniat and Daniel Wildenstein, *Gauguin*, vol. I, Paris 1964 [W]

Virginia Woolf, *Roger Fry*, introduction by Frances Spalding, London 1991

Ed. Lynn Zelevansky, *Picasso and Braque A Symposium*, New York 1992

Christian Zervas, *Pablo Picasso*, 33 vols., Paris 1932–78

Judith Zilczer, *The Noble Buyer, John Quinn, Patron of the Avant-Garde*, Washington 1978

NOTES

INTRODUCTION

1. Some of these exhibitions have been discussed in the following publications: Benedict Nicholson, 'Post-Impressionism and Roger Fry', *The Burlington Magazine*, January 1951, pp. 11–15; Ian Dunlop, *The Shock of the New: Seven Historic Exhibitions of Modern Art*, London, 1972 (on *Manet and the Post-Impressionists*); J.B. Bullen, ed., *Post-Impressionists in England: The Critical Reception*, London and New York, 1988; Stella Tillyard, *The Impact of Modernism. The Visual Arts in Edwardian England 1900–1920. Early Modernism and the Arts and Crafts Movement in Edwardian England*, London and New York, 1988; Peter Stansky, *On or About December 1910. Early Bloomsbury and its Intimate World*, Cambridge MA, and London 1996; and Anne-Pascale Bruneau, 'Aux sources du post-impressionisme. Les expositions de 1910 et 1912 aux Grafton Galleries de Londres', *Revue de l'Art*, no. 113, 1996, pp. 7–18. I am indebted to all these studies.

2. *Charing Cross Bridge* was exhibited as *Vue de Londres – The Embankment and Houses of Parliament*. It can be identified as *Charing Cross Bridge* by the description in *The Art Chronicle*, 25 June 1910, quoted Bullen 1988, p. 12: "Can an artist who paints the Thames Embankment with yellow sky, pink trees and pavements, yellow water, blue cabs and green houses, by any means be serious in his art?" The other work by Derain was entitled *Vue de Londres – St. Paul's*. It may have been *Blackfriars Bridge, London*, Glasgow Art Gallery and Museum.

3. Frank Rutter, 'Round the Galleries. Rebels at Brighton', *The Sunday Times*, 7 August 1910.

4. "Next month, what promises to be the exhibition of the year opens at the Tate. But what do people really think of Cézanne? Is he the father of modern art?" *The Guardian*, 13 January 1996.

5. See Andrew Stephenson, '"An Anatomy of Taste": Samuel Courtauld and Debates about Art Patronage and Modernism in the Interwar Years', in London, Courtauld Institute Galleries, *Impressionism for England*, exhibition catalogue, 1994, pp. 35–46.

MANET AND THE POST-IMPRESSIONISTS

1. The phrase comes from Desmond MacCarthy's 'The Art-Quake of 1910', *The Listener*, 1 February 1943, p. 124.

2. MacCarthy to Molly MacCarthy, 12 September 1910, quoted in Hugh and Mirabel Cecil, *Clever Hearts: Desmond and Molly MacCarthy*, London 1990, p. 108.

3. Cecil, p. 109.

4. Fry to his father Sir Edward Fry, 24 November 1910, in Denys Sutton, *Letters of Roger Fry*, London 1972, I, p. 338.

5. Bullen 1988 provides a selection of reviews.

6. Roger Fry, *Vision and Design* [1920], ed. J.B. Bullen, Oxford 1981.

7. Vera Brittain, *Testament of Youth* [1933], New York (Wideview) 1980, p. 12.

8. See Stansky 1996, pp. 190–91, for a discussion of the members of the committee.

9. The Duchess of Rutland to MacCarthy, 17 November 1910, quoted in Cecil 1990, p. 112.

10. Oliver Brown, *Exhibition: The Memoirs of Oliver Brown*, London 1968, p. 39.

11. Cecil 1990, p. 111.

12. Clive Bell, *Old Friends*, London 1956, p. 82.

13. MacCarthy to Mrs Van Gogh Bonger, 9 January 1910, Van Gogh Foundation Archive b5870v/1996. I am grateful to Louis van Tilborgh for allowing me access to this archive.

14. Stella Tillyard, *The Impact of Modernism. The Visual Arts in Edwardian England*, London and New York 1988, p. 114.

15. Review of 'Manet and the Post-Impressionists', *The Times*, 7 November 1910, p. 12.

16. Hugh Blaker, 'The Post-Impressionists. To the Editor of the Saturday Review', *The Saturday Review*, 7 January 1911, p. 17.

17. R. Meyer Riefstahl, 'Vincent Van Gogh', *The Burlington Magazine*,

November 1910.

18. Fénéon to Mrs Van Gogh Bonger, 8 October 1910, Van Gogh Foundation, Amsterdam, b5771 v/1996.

19. See MacCarthy 1943, p. 125.

20. May Morris to John Quinn, 7 December 1910, quoted in B.I. Reid, *The Man from New York: John Quinn and his Friends*, Oxford 1968, p. 95.

21. The substance of the lecture was published as 'Post-Impressionism' in *The Fortnightly Review*, 1 May 1911; in Bullen 1988, pp. 166–78.

22. MacCarthy 1943, p. 125 .

23. Robert Ross, 'Twilight of the Idols: Post-Impressionism at the Grafton Galleries', *The Morning Post*, 7 November 1910, p. 3.

24. Spencer Gore, 'Cézanne, Gauguin, Van Gogh, & c., at the Grafton Galleries', *The Art News*; in Bullen 1988, p. 141.

25. W.R. Sickert, 'The Post-Impressionists', *The Fortnightly Review*, January 1911; in Bullen 1988, p. 160.

26. *The Fortnightly Review*, January 1911; in Bullen 1988, p. 162.

27. Fry, 'The Post-Impressionists – 2', *The Nation*, 3 December 1910; in Bullen 1988, pp. 28–29.

28. Roger Fry, 'Acquisition by the National Gallery at Helsingfors', *The Burlington Magazine*, February 1911; in Christopher Reed, *A Roger Fry Reader*, Chicago 1996, p. 137.

29. A.J. Finberg, *The Star*, 14 December 1910; in Bullen 1988, p. 138.

30. Claude Phillips, 'The Post-Impressionists', *The Daily Telegraph*, 11 November 1910.

31. D.H. Lawrence, 'Puritanism and the Arts', first published in *The Paintings of D.H. Lawrence* [1929], reprinted in *D.H. Lawrence: Selected Literary Criticism*, ed. A. Beal, London 1960, p. 64.

32. The following descriptions suggest this identification: "the monumental little portrait of the man with the blue tie" (*Daily News*, 7 November); "which certainly has a strange hint of life and character, but the face is twisted in its planes like the face in a concave mirror" (*Manchester Guardian*, 11 November)

and the suggestion in *The Athenaeum*, 12 November, that the face was a "mere wriggle … in which everything writhes unsteadily" and "the head is powerfully characterised and eloquent".

33. Henry Holliday, 'Post Impressionism', *The Nation*, 21 December 1910; in Bullen 1988, p. 142.

34. Fry, 'A Postscript on Post-Impressionism', *The Nation*, 24 December 1910; in Bullen 1988, p. 147.

35. *The Saturday Review*, 7 January 1911.

36. Maurice Denis, 'Cézanne I and II', trans. with an introduction by Roger Fry, *The Burlington Magazine*, January 1910; in Bullen 1988, pp. 60–76.

37. Quoted by Roger Benjamin, *Matisse's 'Notes of a Painter'. Criticism, Theory and Context, 1891–1908*, Ann Arbor 1988, p. 88.

38. Fry, 'The Last Phase of Impressionism', *The Burlington Magazine*, XII, March 1908; in Bullen 1988, p. 48.

39. Three murals survive in the Musée du Petit Palais, Paris.

40. Guillaume Apollinaire, 'Vernissage d'automne', *L'Intransigeant*, 1 October 1910, quoted Jane Lee, 'Maurice Denis and the Ecole de Matisse', in Liverpool, Walker Art Gallery, *Maurice Denis 1870–1943*, exhib. cat., 1995, p. 61.

41. Fry, 'The Autumn Salon', *The Nation*, 29 October 1910, p. 194.

42. *The Burlington Magazine*, February 1911; in Reed 1996, p. 137.

43. C. Lewis Hind, '*The Post Impressionists*, London 1911, p. 11.

44. Haldane MacFall, 'Gauguin: 1848–1903', *The Academy*, 16 December 1911, p. 16.

45. Fry, *The Nation*, 3 December 1910; Bullen 1988, p. 132.

46. *The Morning Post*, 7 November 1910.

47. See Annie Coombes, 'For God and for England: Contributions to an image of Africa in the first decade of the Twentieth Century', *Art History*, VIII, no. 4, December 1985, pp. 453–66.

48. Laurence Binyon, 'Post-Impressionists', 12 November 1910, *The Saturday Review*; in Bullen 1988, p. 112 .

49. For a recent discussion of this racial thinking see Griselda Pollock, *Avantgarde Gambits 1888–1893: Gender and the Colour of Art History*, London 1992.

50. *The Graphic*, 26 November 1910.

51. 'Paint Run Mad: Post-Impressionists at Grafton Galleries', *Daily Express*, 9 November 1910; in Bullen 1988, p. 105.

52. This picture has been identified by Valerie Palmer, in *Gauguin, Primitivism and Racism: A study of Gauguin's critical reception in England 1908–1912 with particular reference to racist ideology*, unpublished M.A. dissertation, University of Reading, 1992, as *Woman at the seaside*, 1899, W582.

53. Frank Rutter, 'Round the Galleries', *The Sunday Times*, 13 November 1910.

54. Desmond MacCarthy, 'The Exhibition at the Grafton Galleries: Gauguin and Van Gogh', *The Spectator*, 26 November 1910; in Bullen 1988, p. 12.

55. 'New Art that Perplexes London', *The Literary Digest*, 10 December 1910, p. 1094.

56. Jacob Tonson [Arnold Bennett], 'Books and Persons', *The New Age*, December 1910; in Bullen 1988, p. 135.

57. Fry, *The Nation*, 1 December 1910; in Bullen 1988, p. 132.

58. *The Spectator*, 26 November 1910, in Bullen 1988, p. 127.

59. MacCarthy, In *The Spectator*, 26 November 1910; in Bullen 1988, p. 127.

60. *The Fortnightly Review*, January 1911; in Bullen 1988, pp. 163–64.

61. MacCarthy to Molly MacCarthy, 11 September 1910; in Cecil 1990, p. 109.

62. MacCarthy to Mrs Van Gogh Bonger, 9 December 1910, Van Gogh Foundation Archive, b5868v/1996.

63. Fry in *The Nation*, 3 December 1910; in Bullen 1988, p. 131.

64. This can be ascertained because Robinov wrote to Mrs Van Gogh Bonger to ask the date after he had purchased the picture. Robinov to Mrs Van Gogh Bonger, 16 January 1911, Van Gogh Foundation Archive, b5872 v/1996.

65. For a fascinating account, see Walter Feilchenfeldt, *Vincent Van Gogh and Paul Cassirer, Berlin. The Reception of*

Van Gogh in Germany from 1901 to 1914, *Cahier Vincent*, Zwolle 1988.

66. P.G. Konody, 'Post-Impressionists at the Grafton Galleries,' *The Observer*, 13 November 1910.

67. *The Daily Telegraph*, 11 November 1910.

68. Carol Zemmel, *The Formation of a Legend: Van Gogh Criticism, 1890–1920*, Ann Arbor 1980, was the first to discuss the reception of Van Gogh in Britain.

69. C. Lewis Hind, 'Maniacs or Pioneers? Post Impressionists at Grafton Galleries', *The Daily Chronicle*, 7 November 1910, p. 8.

70. For a discussion of this aspect of Van Gogh studies see Griselda Pollock's ground-breaking article, "Artists' Mythologies and Media Genius: Madness and Art History", *Screen*, no. 3, 1980, pp. 57–96.

71. Frank Rutter, *Revolution in Art*, London, 1910, p. 34.

72. MacCarthy to Mrs. Van Gogh Bonger, 9 December 1910, Van Gogh Foundation Archive, b 5868 v/1996. It is not known what MacCarthy said in his lecture about Van Gogh's illness.

73. Fry, *The Nation*, 24 December 1910.

74. *The Observer*, 13 November 1910.

75. 'Manet and the Post-Impressionists', *The Athenaeum*, 12 November 1910.

76. *The Daily Chronicle*, 7 November 1910.

77. *The Morning Post*, 7 November 1910.

78. 'Anarchy in High Art', *Tatler*, 23 November 1910.

79. MacCarthy to Mrs Van Gogh Bonger, 9 December 1910, Van Gogh Foundation Archive, b5868v/1996.

80. *The Spectator*, 26 November 1910.

81. *The Sunday Times*, 13 November 1910.

82. *The Daily Telegraph*, 11 November 1910.

83. *The Observer*, 13 November 1910.

84. See New York, Museum of Modern Art, *Four Americans in Paris*, 1970, exhibition catalogue by Margaret Potter, for a list of works in both Stein collections.

85. C. Lewis Hind, 'The New Impressionism', *The English Review*, 7 December 1910, p. 185.

86. *Ibidem*, p. 186.

87. *Ibidem*. The extracts were as follows: "I do not repudiate one of my canvases, and there is not one which I would do differently if I had to do it again." "That which I pursue above all is Expression …. Expression for me does not reside in the passion which breaks upon a face or which shows itself by a violent movement. It is in the whole disposition of my picture." "At one time I did not leave my pictures upon my walls because they reminded me of moments of over-excitement, and I did not like to see them when I was calm. To-day I try to put calmness into them." "Impressionism renders fugitive impressions. A rapid ranslation [*sic*] of the landscape gives only a moment of its duration. I prefer, by insisting on its character, to run the risk of losing the charm in order to obtain more stability." "For me everything is in the conception." "The principal aim of colour should be to serve as much as possible the expression. I place my colours without preconceived intention … I try simply to place or use colours which give (or express) my sensation." "I condense the signification of the body by looking for the essential lines." "That of which I dream is an art of equilibrium, of purity, of tranquility, with no subject to disquiet or preoccupy, which will be for every brain-worker – for the man of business as well as for the man of letters – a sedative, something analogous to a comfortable arm-chair which eases him of physical fatigue."

88. *Ibidem*, p. 181.

89. Hind, *Post Impressionists*, 1911, p. 46.

90. Fry did use an important Matisse, *The red Madras hat*, from the Stein collection, to explain Matisse to his British audience. The picture was reproduced in *The Literary Digest* with the quotation "A return to 'primitive art' is necessary if art is to regain its power to express emotional ideas". The sale of Matisse's work was buoyant; only ten of the sixty-five pictures in Matisse's Bernheim-Jeune show earlier in 1910 had been for sale, which suggests that the gallery had no reason to try the London market.

91. This is reproduced in Jack Flam, ed., *Matisse. A Retrospective*, New York, 1988, p. 53.

92. See Flam 1986, p. 301.

93. *The Nation*, 3 December 1910; in Bullen 1988, pp. 132–33.

94. It is possible that Matisse was thinking about Van Gogh's *Portrait of Père Tanguy*. Rodin owned one of the two versions of it and Rodin and Matisse became neighbours in autumn 1908. The background of *The girl with green eyes* is divided into four sections in a manner that compares to *Père Tanguy* (the Japanese prints and the red and green blocks of colour at the bottom illustrate Van Gogh's growing interest in strong contrasting colour used symbolically), while the model in *The girl with green eyes* stares out, facing towards us in a pose resembling that of *Père Tanguy*.

95. *The Daily Chronicle*, 7 November 1910.

96. *The Observer*, 13 November 1910.

97. C.J. Holmes, *Notes on the Post Impressionist Painters*, London 1910, pp.16–17.

98. *The Daily Chronicle*, 7 November 1910.

99. *The New Age*, 1 December 1910.

100. *The Fortnightly Review*, January 1911.

101. Gertrude Stein, *The Diary of Alice B. Toklas*, New York 1952, p. 52.

102. *The Fortnightly Review*, January 1911; in Bullen 1988, p. 157.

103. *The Builder*, 12 November 1910.

104. Frank Rutter, 'The Autumn Salon' *The Sunday Times*, 1 October 1911, p. 238 . At "the Galerie Kahnweiler, in the Rue Vignon … you will find the very latest works of Picasso, Derain and Vlaminck" and at "M. Sagot's gallery in the Rue Lafitte … you can see some of the earlier work of Picasso as well as the latest work of Auguste Herbin, Chabaud, and many other fascinating young painters".

105. Frank Rutter, *Revolution in Art*, London 1910, p. 53.

106. Frank Rutter, 'Round the Galleries. Pablo Picasso', *The Sunday Times*, 28 April 1912.

107. *The Observer*, 13 November 1910.

PROVENÇAL STUDIES AND OTHER WORKS BY AUGUSTUS JOHN

1. Michael Holroyd, in *Augustus John: The Years of Innocence*, London 1974, and *Augustus John. The New Biography*, London 1996, discusses the critical reactions to the Chenil exhibition. I am indebted to his research.

2. E.S.G. 'The Test of Truth', *The Daily Graphic*, 10 December 1910.

3. Frank Rutter, 'Round the Galleries. Mr. John's Provençal Studies', *Sunday Times*, 4 December 1910.

4. C. Lewis Hind, *The Post Impressionists*, London 1911, p. 72.

5. O.M.W., 'Revolution in Art', *The Art Chronicle*, 15 December 1910, p. 83.

6. *The Sunday Times*, 4 December 1910.

7. *The Sunday Times*, 4 December 1910.

8. *The Daily Graphic*, 10 December 1910.

9. Martin Hardie, 'The Chenil Gallery, Chelsea', *Queen*, 10 December 1910.

10. A.J. Finberg, 'Mr. John's Paintings at the Chenil Gallery', *The Star*, 6 December 1910.

11. 'Art Exhibitions. Mr. Augustus John', *The Times*, 5 December 1910.

12. *Queen*, 10 December 1910.

13. See Holroyd 1996, p. 348.

14. For the full text of the letter from John to John Quinn, 11 January 1911, see Holroyd 1996, p. 342.

CÉZANNE AND GAUGUIN

1. *The Morning Post*, 17 November 1910.

2. See typescript of Michael Sadler's diary entry, 27 September 1911, Tate Gallery Archive, 8221.5.23.

3. Letter from E. Druet to Michael Sadler, 21 October 1911, Tate Gallery Archives, 8221.1.6.82.

4. The Sadlers also planned to include Van Gogh but the plan came to nothing.

5. Hind, *The Post Impressionists*, 1911, p. 14.

6. M.T.H. Sadleir, 'L'Esprit Veille', *Rhythm*, 1911.

7. *Ibidem*.

8. J.B. M[anson], 'The paintings of Cézanne and Gauguin', *The Outlook*, 2 December 1911; in Bullen 1988, pp. 245–46.

9. *Ibidem*; in Bullen 1988, p. 247.

10. P.G. Konody, 'Cézanne and Gauguin', *The Observer*, 3 December 1911; in Bullen 1988, p. 249.

11. M.T.H. Sadleir, 'After Gauguin', *Rhythm*, Spring 1912; in Bullen 1988, p. 285.

12. *Ibidem*; in Bullen 1988, p. 286.

13. *Ibidem*; in Bullen 1988, p. 287.

THE FUTURIST EXHIBITION

1. F.T. Marinetti, 'Futurist Venice', *The Tramp*, 1 August 1910, pp. 487–88. Valerio Gioè, 'Futurism in England: A Bibliography (1910–1915), in *Vorticism. ICSA Cahier 8/9*, Brussels 1988, gives a full list of the futurist publications that appeared in English periodicals. I am much indebted to his research.

2. 'Manifesto of the Futurist Painters', *Art News*, 15 August 1910, pp. 83–84.

3. For details of the opening see Rossella Caruso, 'La Mostra dei futuristi a Londra nel 1912: ricensioni e commenti's in *Futurism in USA, Ricerche di storia dell'arte*, 1991, pp. 57–63.

4. See Anne Coffin Hanson, 'The Futurist Exhibitions, 1912–1917', in New Haven, Yale University Art Gallery, *Severini futurista: 1912–1917*, exhibition catalogue, 1995.

5. This catalogue is included in Piero Pacini's boxed set of facsimile catalogues, *Esposizioni futuriste*, Florence 1977.

6. Frank Rutter, 'Round the Galleries: The Futurist Painters', *The Sunday Times*, 10 March 1912; in Bullen 1988, p. 301.

7. Roger Fry, 'Art: The Futurists', *The Nation*, 9 March 1912; in Bullen 1988, p. 300.

8. P.G. Konody, 'The Futurists and their Leader', *The Pall Mall Gazette*, 14 March 1912, p. 8.

9. 'The Italian Futurists: Nightmare Exhibition at the Sackville Gallery', *The Pall Mall Gazette*, 1 March 1912; in Bullen 1988, p. 292.

10. *The Sunday Times*, 10 March 1912; in Bullen 1988, p. 303.

11. C. Lewis Hind, 'Futurist Painters. Manifestos and Works of an Italian School,' *The Daily Chronicle*, 4 March 1912.

12. 'The Futurist "Devil-among-the-Tailors"', *The English Review*, April 1912, p. 309.

13. *The Sunday Times*, 10 March 1912; in Bullen 1988, p. 304.

14. *The Nation*, 9 March 1912; in Bullen 1988, p. 300.

15. *The English Review*, April 1912; in Bullen 1988, p. 310.

16. See Giovanni Cianci, 'Futurism and its Impact on Vorticism', *Vorticism. ICSA Cahier 8/9*, Brussels 1988.

THE SECOND POST-IMPRESSIONIST EXHIBITION

1. Roger Fry had originally intended to capitalize on the impact of *Manet and the Post-Impressionists* in 1910 with a show consisting solely of old and new guard British art. But this plan fell through. See Frances Spalding, *Roger Fry: Art and Life*, London 1980, p. 154.

2. These are reprinted in Bullen 1988, pp. 348–56.

3. See Judith Collins, *The Omega Workshops*, London 1983, p. 27.

4. Roger Fry, 'The Exhibition of Modern Art at Cologne', *The Nation*, 31 August 1912, p. 798.

5. Susan Drees, *Urban Enlightenment? Northern Collectors and a Loan Exhibition of Post-Impressionism, Leeds 1913*, unpublished B.A. dissertation, University of Leeds, 1995, shows that *Poèmes barbares* was exhibited as cat. 16 in *Post-Impressionist Pictures and Drawings*, Leeds, 1913.

6. Roger Fry, 'The Salons and van Dougen [*sic*], *The Nation*, 24 June 1911; in Bullen 1988, p. 232.

7. *The Nation*, 31 August 1912, p. 798.

8. *Ibidem*.

9. Spalding 1980, p. 133.

10. C. Lewis Hind, 'Ideals of Post Impressionism,' *The Daily Chronicle*, 5 October 1912; in Bullen 1988, p. 366.

11. Claude Phillips, 'Second Post-Impressionist Exhibition', *The Daily Telegraph*, 5 October 1912.

12. 'Post-Impressionism. A Thought-Provoking Exhibition', *The Glasgow Herald*, 5 October 1912.

13. 'A Post-Impressionist Exhibition: Matisse and Picasso', *The Times*, 4 October 1912; in Bullen 1988, p. 361.

14. Roger Fry, 'Art: The Grafton Gallery: an Apologia', *The Nation*, 9 November 1912; in Bullen 1988, pp. 390–91.

15. P.G. Konody, 'Art and Artists: More Post-Impressionists', *The Observer*, 19 January 1913, in Bullen 1988, p. 414.

16. 'Cézanne and the Post-Impressionists', *The Times*, 8 January 1913; in Bullen 1988, pp. 410–11.

17. George Moore, *Reminiscences of the Impressionist Painters*, Dublin 1906, pp. 34–35.

18. Clive Bell, *Art*, London 1914, p. 52.

19. Daniel Kahnweiler, *André Derain*, Leipzig 1920, p. 7; quoted William Rubin, 'Cézannisme and the Beginnings of Cubism', in New York, Museum of Modern Art, *Cézanne: The Late Work*, exhibition catalogue, ed. William Rubin, 1977, p. 156.

20. See Theodore Reff, 'The Reaction against Fauvism: The Case of Braque', in *Picasso and Braque. A symposium*, ed. Lynn Zelevansky, New York and London, 1992, pp. 17–43.

21. See Elizabeth Cowling on this aspect of Derain's work in London, Tate Gallery, *On Classic Ground: Picasso, Léger, de Chirico and the New Classicism 1910–1930*, exhib. cat., 1990, p. 92.

22. P.G. Konody, 'Art and Artists – more Post-Impressionism at the Grafton,' *The Observer*, 6 October 1912; in Bullen 1988, p. 372.

23. The Post Impressionists: Some French and English Work', *The Times*, 21 October 1912; in Bullen 1988, p. 379.

24. Roger Fry, 'The Autumn Salon', *The Nation*, 11 November 1911, p. 237.

25. *Ibidem*.

26. *Ibidem*.

27. See James Beechey, 'In Memoriam', *The Charleston Magazine*, no. 12, autumn/winter 1995, pp. 47–51, for a discussion of Fry's Marchand.

28. *The Nation*, 24 June 1911; in Bullen 1988, p. 230.

29. Clive Bell, *Pot-Boilers*, London 1918, p. 200.

30. Daniel Kahnweiler, *My Galleries and Painters* [1961], trans. Helen Weaver, New York 1972, p. 32.

31. *Ibidem*.

32. See Werner Spies, 'Vendre des tableaux – donner à lire', in *Daniel-Henry Kahnweiler*, ed. Isabelle Monod-Fontaine, Paris 1984, p. 28. Spies reprints the account of a visit made by a journalist in 1912 drawing attention to the chronological ordering of these scrapbooks.

33. Kahnweiler's only other British venture before the Great War was in 1913, when he lent one Vlaminck to the Society of Scottish Artists, Edinburgh.

34. Roskill, *Picasso and Braque*, 1992, p. 223 and n. 15, p. 237.

35. See William Rubin, 'Picasso and Braque: An introduction', in New York, Museum of Modern Art, *Picasso and Braque: Pioneering Cubism*, 1989, p. 27.

36. P.G. Konody, 'Art and Artists – More Post-Impressionism at the Grafton', *The Observer*, 6 October 1912; in Bullen 1988, p. 370.

37. Claude Phillips, 'Second Post-Impressionist Exhibition', *The Daily Telegraph*, 5 October 1912.

38. *The Nation*, 9 November 1912; in Bullen 1988, p. 394.

39. *Ibidem*.

40. For an overview of the effect of this interpretation see Patricia Leighton's excellent 'Revising Cubism', *The Art Journal*, winter 1988, p. 269–76.

41. Frank Rutter, *Revolution in Art*, London 1910, p. 23.

42. See Edward Fry, 'Picasso, Cubism and Reflexivity', *The Art Journal*, winter 1988, p. 297.

43. 'Post Impressionists at the Grafton Galleries', *The Architect*, 8 November 1912.

44. *The Observer*, 6 October 1912; in Bullen 1988, p. 370.

45. *The Glasgow Herald*, 5 October 1912.

46. C. Lewis Hind, 'Ideals of Post Impressionism', *The Daily Chronicle*, 5 October 1912; in Bullen 1988, p. 366.

47. *The Observer*, 6 October 1912; in Bullen 1988, p. 370.

48. E.S.G. 'Beauty in Ugliness. Impressions of the Post-Impressionist Show. Remarkable Exhibition. A Plea for Impartial Views on the Cubists', *The Daily Graphic*, 4 October 1912, p. 6.

49. Fry to Simon Bussy, 22 May 1911; in Sutton 1972, p. 348.

50. Clive Bell, *Old Friends*, London 1956, p. 173, refers to Michael and Sarah Stein's "superb collection of early Matisse" which enabled him to follow and appreciate the master's art.

51. Roger Fry, 'The French Group', preface to *Second Post Impressionist Exhibition* catalogue; in Bullen 1988, pp. 352–55.

52. For an excellent discussion of Matisse's exhibition strategies and his relationship with the Bernheim-Jeune Galleries see Jack Flam, *Matisse. The Man and his Art*, London 1986.

53. *The Glasgow Herald*, 5 October 1912.

54. Flam 1986, p. 232.

55. See Richard Shone, *Bloomsbury Portraits: Vanessa Bell, Duncan Grant and their circle*, revised edn., London 1993, p. 255, n. 10.

56. Fry, *The Nation*, 24 June 1911.

57. Fry, *The Nation*; in Bullen 1988, p. 392.

58. *Ibidem*.

59. *Ibidem*.

60. *The Times*, 4 October 1912; in Bullen 1988, p. 362.

61. *The Daily Telegraph*, 5 October 1912.

62. *The Daily Chronicle*, 5 October 1912; in Bullen 1988, p. 368.

63. *The Times*, 4 October 1912; in Bullen 1988, p. 362.

64. Fry, 'The Autumn Salon', *The Nation*, 29 October 1910, p. 194.

65. Rutter, 'The Autumn Salon, *The Sunday Times*, 2 October 1910.

66. *The Times*, 4 October 1912; in Bullen 1988, p. 362.

67. *The Spectator*, 5 October 1912.

68. *The Observer*, 4 October 1912; in Bullen 1988, p. 372.

69. In Bullen 1988, p. 361.

70. Fry, *The Nation*, 9 November 1912; in Bullen 1988, pp. 390–95.

71. Quoted in Frances Spalding, *Vanessa Bell*, London 1983, p. 113.

72. Bell to Grant, 25 March 1914, in Regina Marler, ed., with an introduction by Quentin Bell, *Selected Letters of Vanessa Bell*, London 1994, p. 161.

73. Clive Bell, 'The English Group'; in Bullen 1988, p. 350.

74. Duncan Grant to Virginia Woolf, 23 September 1912, University of Sussex Library, quoted Simon Watney, *The Art of Duncan Grant*, London 1990, p. 33.

75. Shone 1993, p. 255, n. 10.

76. See Richard Shiff, 'Imitation of Matisse', in *Matisse*, ed. Caroline Turner and Roger Benjamin, Queensland 1995, p. 42.

77. I am grateful to Frances Spalding for sharing the research for her forthcoming biography on Duncan Grant with me.

78. See Shone 1993, p. 57. Shone suggests that Grant saw *Dance II* lying in the studio; however, this would have been impossible, because it was sent to Shchukin in Moscow in December 1910. Grant must have been referring to *Nasturtiums with Dance I*.

79. Rupert Brooke, *The Cambridge Magazine*, 23 November 1912; in Bullen 1988, p. 403.

80. See Lisa Tickner, 'A lost Lewis: the Mother and Child of 1912', *Wyndham Lewis Annual*, 1995, pp. 2–11.

81. P.G. Konody, 'Art and Artists: English Post-Impressionists', *The Observer*, 27 October 1912; in Bullen 1988, p. 387.

82. Rupert Brooke, *The Cambridge Magazine*, 30 November 1912; in Bullen 1988, p. 407.

83. *The Daily News and Leader*, 7 April 1914, quoted Tom Normand, *Wyndham Lewis the Artist*, Cambridge 1992, p. 44.

84. See Tickner 1995, p. 8 for an excellent discussion of this point.

85. Keith Clements, *Henry Lamb*, Bristol 1985, p. 134.

86. Vanessa Bell to Margery Snowdon, 15 October 1912, quoted Shone 1993 p. 77.

87. *Ibidem.*

88. *The Nation*, 24 June 1911; in Bullen 1988, p. 230.

89. Spalding 1980, p. 00.

90. Clive Bell, *The Athenaeum*, 27 July 1912.

91. Spencer Gore, 'Cézanne, Gauguin, Van Gogh at the Grafton Galleries', *Art News*, 15 December 1910; in Bullen 1988, p. 141.

92. *The Observer*, 27 October 1912; in Bullen 1988, p. 388.

93. *The Westminster Gazette*, 7 October 1912.

94. *The Sheffield Daily Telegraph*, November 1912.

95. Charles Marriott, *The Evening Standard*, 7 October 1912.

96. For a discussion of Neo-Primitivism see John E. Bowlt, 'Neo-primitivism and Russian Painting', *The Burlington Magazine*, CXVI, March 1974, pp. 133–40.

EXHIBITION OF PICTURES BY J.D. FERGUSSON, A.E. RICE AND OTHERS (THE RHYTHM GROUP).

1. C. Lewis Hind, 'Two Visions of Art. The Straightforward and the Eerie', *The Daily Chronicle*, 16 October 1912.

2. Roger Fry, 'The Autumn Salon', *The Nation*, 11 November 1911.

3. Walter Sickert, 'Introduction', *Exhibition by S.J. Peploe, Leslie Hunter, F.C.B. Cadell and J.D. Fergusson*, London, Leicester Galleries, 1925.

4. For a discussion of the group and its connection with *Rhythm* see Sheila McGregor, 'J.D. Fergusson and the Periodical *Rhythm*', in Edinburgh, Scottish Arts Council, *Colour Rhythm and Dance. Paintings and Drawings by J.D. Fergusson and his Circle*, 1985, pp. 13–17, and Mark Antliff, *Inventing Bergson. Cultural Politics and the Parisian Avant-Garde*, Princeton NJ 1993, pp. 67–105.

5. P.G. Konody, 'Art and Artists: English Post-Impressionists', *The Observer*, 27 October 1912; in Bullen 1988, p. 386.

6. Frank Rutter, 'Round the Galleries. The Stafford Gallery', *The Sunday Times*, 18 October 1912.

7. Antliff 1993, p. 69.

8. Frank Rutter, 'The Portrait Paintings of John Duncan Fergusson', *The Studio*, December 1911, pp. 203–07.

9. Frank Rutter, 'The Autumn Salon', *The Sunday Times*, 2 October 1910.

10. Michael Sadleir, 'Fauvism and a Fauve', *Rhythm*, summer 1911; in Bullen 1988, pp. 233–36.

11. Antliff 1993, p. 86.

12. *Rhythm*, summer 1911

13. Frank Rutter, 'The Autumn Salon', *The Sunday Times*, 1 October 1911.

14. *The Sunday Times*, 18 October 1912.

15. *Ibidem.*

16. *The Daily Chronicle*, 16 October 1912.

POST-IMPRESSIONISTS AND FUTURISTS

1. Rutter 1910, p. 48.

2. Bullen, 1988, suggests that Rutter's journal, *Art News*, carried an advertisement on 15 October 1910 (p. 5) which used the phrase for the first time. However, as we have seen, Rutter was using the phrase in his art criticism at the beginning of October.

3. Rutter, 'An Art Causerie', *The Sunday Times*, 10 November 1912; in Bullen 1988, p. 398.

4. See Drees 1995 for an account of the Leeds exhibition.

5. Frank Rutter, *Art in My Time*, London 1933, p. 149.

6. W.R., 'Post-Impressionism at the Doré Galleries', *The Sunday Times*, 26 October 1913.

7. See Drees, 1995, pp. 11–13.

8. The visit took place on 11 October 1922. Sadler papers, Tate Gallery Archive, 8221.5.38.

9. Rutter to Lucien Pissarro, 6 September 1913, Library of Western Art, Ashmolean Museum, Oxford.

10. W.R. Sickert, introduction to *Camille Pissarro*, Stafford Gallery, London 1911.

11. Rutter, *Art News*, 1911.

12. Rutter, introduction to *Post-Impressionist and Futurist Exhibition*, Doré Galleries, London 1913.

13. Sickert, 'Post-Impressionists, *The Fortnightly Review*, January 1911; in Bullen 1988, p. 165.

14. See Belinda Thomson, *Vuillard*, Oxford 1988, p. 76.

15. Walter Sickert, 'New Wine', *The New Age*, 21 April 1910.

16. Rutter, introduction, Doré Galleries, 1913.

17. *Ibidem*.

18. Clive Bell, 'The New Post-Impressionist Show', *The Nation*, 25 October 1913, p. 172.

19. This is almost certainly the *Self-portrait* in the McNay Art Museum, San Antonio.

20. Alfred Sutro, *Celebrities and Simple Souls*, London 1933, p. 27.

21. The Van Gogh colortypes were: *French Peasant, Sower, Portrait of the Artist, The Orchard, Way to the Churchyard, Portrait of Pere Tranquit* [*sic*], *Chestnut Tree, Pot of Flowers* and *Young Girl*. I have not been able to identify these 'colortypes'. They were not *Van Gogh: Mappe*, Munich 1912, which was another set of early reproductions.

22. Rutter, introduction, Doré Galleries, 1913.

23. W.R. Sickert, 'The International Society', *The English Review*, May 1912, p. 321.

24. Charles Ginner, 'Harold Gilman: An Appreciation', *Arts and Letters*, spring 1919, reprinted as preface to *Harold Gilman Memorial Exhibition*, London, Leicester Galleries, 1919.

25. Frank Rutter, 'The Work of Harold Gilman and Spencer Gore. A Definitive Survey', *The Studio*, March 1931, p. 207.

26. Anthony Ludovici, ed., *The Letters of a Post-Impressionist: Being the Familiar Correspondence of Vincent Van Gogh*, London 1912.

27. Ginner and Gilman were overlooked in the long list of artists who responded to Van Gogh discussed in Kodera Tsukasa and Yvette Rosenberg, edd., *The Mythology of Van Gogh*, Amsterdam 1993.

28. *The Nation*, 25 October 1913, p. 172.

29. See Rutter 1926, p. 81.

30. *Ibidem*.

31. Rutter, introduction, Doré Galleries, 1913.

32. *Ibidem*.

33. Rutter 1926, p. 83.

34. See Patricia Leighton, 'Revising Cubism', *The Art Journal*, winter 1988, p. 270.

35. John Cournos, 'The Battle of the Cubes', *The New Freewoman*, 15 November 1913, p. 214.

36. Rutter, Doré Galleries, 1913.

37. For a detailed scholarly discussion see Virginia Spate, *Orphism*, Oxford 1979.

38. Claude Phillips, 'Post-Impressionists', *The Daily Telegraph*, 21 October 1913.

39. J.B., 'Doré and the Post-Impressionists', *The Manchester Guardian*, 29 October 1913.

40. 'The Confetti School of Painting', *The Daily Sketch*, 17 October 1913, p. 6.

41. Gino Severini, *The Life of a Painter. The Autobiography of Gino Severini*, trans. Jennifer Franchina, Princeton NJ 1995, p. 119.

42. 'Get Inside the Picture', *The Daily Express*, 11 April 1913.

43. *Ibidem*.

44. *Ibidem*.

45. P.G. Konody, 'A Futurist at the Marlborough Gallery', *The Pall Mall Gazette*, 10 April 1913.

46. C. Lewis Hind, 'A Futurist in St. James', *The Daily Chronicle*, 12 April 1913.

47. S.F. Gore, 'The Third London Salon of the Allied Artists Association', *Art News*, 4 August 1910.

48. Wilfrid H. Myers, *The Onlooker*, 22 July 1910.

49. Michael Sadler, catalogue notes, *Post-Impressionist Pictures and Drawings*, Leeds 1913.

50. Sadler papers, postcard from Kandinsky to Rutter, 11 August 1911, Tate Gallery Archive. Soon after Sadleir and Kandinsky were engaged in a lengthy correspondence. I am grateful to Adrian Glew for drawing my attention to these papers.

51. Michael Sadleir, 'Kandinsky's Book on Art', *Art News*, 9 March 1912.

52. In a letter from Nolde to Sadler, 24 August 1912, Nolde says that he is glad that Sadler has seen some of his works and he gives him the price of some of his woodcuts. Tate Gallery Archive.

53. Sadler to Kandinsky, Tate Gallery Archives.

54. Sadleir, Leeds 1913.

55. Roger Fry, 'The Allied Artists', *The Nation*, 2 August 1913; in Reed 1996, pp. 150–53.

56. *The Nation*, 2 August 1913; Reed 1996, p. 152.

57. Frank Rutter, 'Round the Galleries. Twentieth Century Art', *The Sunday Times*, 24 May 1914.

58. Roger Fry, 'The Allied Artists at the Albert Hall', *The Nation*, 20 July 1912.

59. Clive Bell, 'The London Salon at the Albert Hall', *The Nation*, 27 July 1912.

60. J.B. Manson, *Outlook*, 3 August 1912.

61. PG Konody, 'Sculpture at the London Salon', *The Observer*, 21 July 1912.

62. 'Everything acceptable', *Tatler*, 24 July 1912.

63. PG Konody, 'Art and Artists. The London Salon', *The Observer*, 13 July 1913.

64. *Ibidem*.

65. *The Nation*, 2 August, 1913; in Reed 1996, p. 151.

66. Konody, *The Observer*, 13 July 1913.

67. C. Lewis Hind, '"Anyhow Art". London Salon at the Albert Hall', *The Daily Chronicle*, 15 July 1913.

68. Konody, *The Observer*, 13 July 1913.

69. *Ibidem.* For a discussion of Cubism and British sculpture see Jane Beckett, 'Cubism and Sculpture in England before the First World War', in London, Whitechapel Art Gallery, *British Sculpture in the Twentieth Century*, 1981, exhibition catalogue, pp. 49–62.

70. *The Manchester Guardian*, 29 October 1913.

71. *The Daily Sketch*, 17 October 1913.

72. 'Post-Impressionism at the Doré Galleries', *The Observer*, 26 October 1913.

73. *The Nation*, 25 October 1913.

74. *The Daily Telegraph*, 21 October 1913.

75. *The Observer*, 26 October 1913.

76. Ramiro de Maeztu, 'Expressionism', *The New Age*, 27 November 1913.

77. *The Nation*, 25 October 1913.

TWENTIETH-CENTURY ART: A REVIEW OF MODERN MOVEMENTS

1. For a discussion of the Whitechapel Art Gallery see Juliet Steyn, 'The Complexities of Asimilation in the 1906 Whitechapel Art Gallery Exhibition "Jewish Art and Antiquities"', *Oxford Art Journal*, vol. 13, no. 2, 1990, pp. 44–50, and Juliet Steyn, 'Inside-out: Assumptions of "English" Modernism in the Whitechapel Art Gallery, London 1914,' in Marcia Pointon, ed., *Art Apart*, Manchester 1994, pp. 212–30.

2. 'Post-Impressionists for Whitechapel', *The Manchester Guardian*, 8 April 1914.

3. 'East End Critics. Futurist Art in Whitechapel', *The Observer*, 10 May 1914.

4. P.G. Konody, 'Side-Splitting Art. Humour Conscious and Unconscious. "Isms" in East End', *The Daily Express*, 8 May 1914.

5. Steyn 1994, p. 221.

6. See Judith Collins, *The Omega Workshops*, London 1983, p. 00.

7. Frank Rutter, 'Round the Galleries', *The Sunday Times*, 24 May 1914.

8. Introduction, *Twentieth-Century Art: A Review of Modern Movements*, p. 3.

9. Lisa Tickner examined the significance of these groups in the 1996 Paul Mellon Lectures, *Modern Life and Modern Subjects*, at the National Gallery, London, in November 1996.

10. Introduction, *Twentieth-Century Art*.

11. *Ibidem.*

12. 'Art Exhibitions. Whitechapel Gallery', *The Morning Post*, 11 May 1914.

13. Introduction, *Twentieth-Century Art*.

14. See Steyn 1994.

15. 'Jewish Art at Whitechapel. Twentieth Century Exhibition', *The Jewish Chronicle*, 15 May 1914.

16. *Ibidem.*

17. 'Art exhibitions. Cubists in East End. Picture-puzzles to be seen in Whitechapel', *The Standard*, 14 May 1914.

18. 'Twentieth Century Art', *The Westminster Gazette*, 21 May 1914.

19. 'Art and Reality. Challenge of Whitechapel to Piccadilly', *The Times*, 8 May 1914.

20. *Ibidem.*

21. *The Sunday Times*, 24 May 1914.

22. *The Observer*, 17 May 1914.

23. *The Morning Post*, 11 May 1914.

24. Wyndham Lewis, 'The Cubist Room', later republished in *The Egoist*, 1 January 1914; in Bullen 1988, pp. 467–68.

25. Walter Sickert, 'On Swiftness', *The New Age*, 20 March 1914.

26. P.G. Konody, *The Observer*, 8 March 1914, quoted Richard Cork, *David Bomberg*, New Haven and London 1987, p. 61.

27. Walter Sickert, 'Whitechapel', *The New Age*, 28 May 1914.

28. Wyndham Lewis, 'Frederick Spencer Gore', *Blast No. 1*, p. 150.

29. *The New Age*, 28 May 1914.

30. *Ibidem.*

31. See Cork 1987, p. 56.

32. Cork 1987, p. 87.

33. Quoted in Cork 1987, p. 78. Cork takes a different view of this statement.

34. 'A Jewish Futurist. Chat with Mr. David Bomberg', *The Jewish Chronicle*, 8 May 1914.

35. *Blast No. 1*, pp. 139–40.

36. Wyndam Lewis, 'The Melodrama of Modernity', *Blast No. 1*, 1914, p. 143.

37. Roger Fry, 'Two Views of the London Group: Part 1', *The Nation*, 14 March 1914, p. 999, in Reed 1996.

MATISSE AND MAILLOL AT THE LEICESTER GALLERIES, 1919

1. See Oliver Brown, *Exhibition: The Memoirs of Oliver Brown*, London 1968, p. 63.

2. *Ibidem*, p. 65.

3. Quoted in David Scrase, *Maynard Keynes: Collector of Pictures, Books and Manuscripts*, exhibition catalogue, Fitzwilliam Museum, Cambridge, 1983, cat. 40. I am grateful to David Scrase for drawing my attention to this picture. For the Keynes collection see also Richard Shone with Duncan Grant, 'The Picture Collector', in Milo Keynes, ed., *Essays on John Maynard Keynes*, London 1975, pp. 282–84.

4. Minutes of Contemporary Art Society, 5 December 1912, Tate Gallery Archives; quoted in John House, 'Modern French Art for the Nation: Samuel Courtauld's Collection and Patronage in Context,' in London, Courtauld Institute Galleries, *Impressionism for England. Samuel Courtauld as Patron and Collector*, 1994, p. 10.

5. See Michael C. Fitzgerald, *Making Modernism. Picasso and the Creation of the Market for Twentieth Century Art*, New York 1995, p. 32.

6. Letter of 13 March 1926, Matisse to St. John Hutchinson, quoted Alley 1981, p. 498.

7. For a discussion of Samuel Courtauld as a collector and the rôle of the Courtauld Fund, see House in London 1994, pp. 9–33, and Madeline Korn, 'Courtauld's List', *The Burlington Magazine*, May 1996.

ACKNOWLEDGEMENTS

BARBICAN ART GALLERY

would like to thank its Corporate Members

Barclays Bank of Ghana Limited,
Zambia Limited and Zimbabwe Limited

The Bethlem Maudsley NHS Trust

British Petroleum Company plc

British Telecommunications plc

Chemical Bank

Robert Fleming & Co. Limited

The Observer

Save & Prosper plc

Sun Alliance Group

TSB Group plc

Unilever plc

AUTHOR'S ACKNOWLEDGEMENTS

My colleague Professor Barrie Bullen has been generous to the extreme in sharing his knowledge of Post-Impressionist criticism with me. Caroline Cuthbert, Dr Frances Spalding and Dr Richard Cork have offered their expert advice. I have benefited from conversations about the project with Professor Christopher Green. Susan Drees was a valuable research assistant. Sophie Cook, Alison Hart, John Hoole and Tomoko Sato of the Barbican Art Gallery have contributed their expert knowledge about exhibition organization.

In addition I would like to thank the following: Dr Robert Anderson, Christiane Berndes, William Bradford, Ian Buruma, Richard Calvocoressi, Angela Coles, Elizabeth Cowling, Fenella Crichton, Hilary Diaper, Dr Mark Evans, Harriet Frazer, Simon Frazer, Susan Gethin, Teresa Gleadowe, Adrien Glew, Michael Holroyd, Professor John House, Hans Janssen, Peter Jenkinson, Rebecca John, Philip Harley, Nancy Hobbs, Christine Hopper, Jonathon Horwich, Professor Geoffrey Jones, Madeline Korn, Jeremy Laurance, Dr Simon Lee, Philip Long, Jane Munro, Felicity Owen, Deborah Parsons, Professor Alex Potts, Dr Elizabeth Prettejohn, David Scrase, Nicholas Serota, Michael Simpson, Dr Christine Stevenson, Quentin Stevenson, the staff of the Tate Gallery Library, Professor Lisa Tickner, Louis van Tilborgh, Belinda Thomson, Professor Richard Thomson, John Whiteley, Linda Whiteley, Abigail Willis, Laura Woolley.

I am indebted forever to my family – to Nancy Gruetzner and to Sara, Martha, Ted, Alisa and John Gruetzner for giving Daniel and Sophie a good time. Daniel and Sophie Robins have had to put up with far too much from me. David Robins has been a perfect partner and my 'in-house' editor. I dedicate this catalogue to him.

ANNA GRUETZNER ROBINS

LIST
OF LENDERS

Barbican Art Gallery would like to thank all those lenders listed below, and those who wish to remain anonymous.

CANADA
Art Gallery of Ontario, Toronto

FINLAND
The Finnish National Gallery (Collection Antell Ateneum), Helsinki

FRANCE
Musée des Beaux-Arts, Bordeaux
Musée d'Orsay, Paris

HUNGARY
Szépmüvészeti Múzeum, Budapest

THE NETHERLANDS
Van Gogh Museum (Vincent van Gogh Foundation), Amsterdam
Haags Gemeentemuseum, The Hague
Stedelijk Van Abbemuseum, Eindhoven

RUSSIAN FEDERATION
State Russian Museum, St Petersburg

SPAIN
Fundación Colección Thyssen-Bornemisza, Madrid

UNITED KINGDOM
John Adams
Arts Council Collection, Hayward Gallery, London
Ashmolean Library, Oxford
The Visitors of the Ashmolean Museum, Oxford
Barclays Bank Collection
Bristol Museums and Art Gallery
The British Council
Trustees of the British Museum, London
Richard Burrows
Courtauld Institute Galleries, London
Mrs David Drey
Edinburgh City Art Centre
Eric and Salome Estorick Foundation, London
Ferens Art Gallery, Kingston-upon-Hull City Museums and Art Galleries
The Fergusson Gallery, Perth and Kinross Council
Bryan Ferry
Syndics of the Fitzwilliam Museum, Cambridge
Michael Holroyd
University of Hull Art Collection
Kettle's Yard, University of Cambridge

Provost and Fellows of King's College, Cambridge
Leeds Museums and Galleries (City Art Gallery)
The University of Leeds Art Collection
Manchester City Art Galleries
Miss K. McCreery
National Gallery of Scotland, Edinburgh
National Museum of Wales, Cardiff
National Portrait Gallery, London
National Railway Museum, York
Pallant House, Chichester
The Museum of Reading
Royal Albert Memorial Museum, Exeter
Rye Art Gallery Trust
City of Salford Art Gallery
Scottish National Gallery of Modern Art, Edinburgh
Scottish National Portrait Gallery, Edinburgh
Sheffield City Art Galleries (Graves Art Gallery)
Southampton City Art Gallery
University of Stirling, J.D.Fergusson Collection
Swindon Museum and Art Gallery
Trustees of the Tate Gallery, London
Belinda and Richard Thomson
The Board of Trustees of the Victoria and Albert Museum, London
Walker Art Gallery, Liverpool (National Museums and Galleries on Merseyside)
Walsall Museum and Art Gallery
The Whitworth Art Gallery, University of Manchester
Worthing Museum and Art Gallery
York City Art Gallery

UNITED STATES OF AMERICA
Albright-Knox Art Gallery, Buffalo
Harvard University Art Museums, Cambridge, Massachusetts
Hirshhorn Museum and Sculpture Garden, Smithsonian Institution, Washington, DC
The Metropolitan Museum of Art, New York
The Museum of Modern Art, New York
Philadelphia Museum of Art
Harry Ransom Humanities Research Center, The University of Texas at Austin
Yale Center for British Art, New Haven, Connecticut

INDEX

Anrep, Boris 64, 105
Apollinaire, Guillaume 26, 44, 128
Asselin, Maurice 120

Bell, Clive 16, 40, 48, 64, 68, 72–73, 92, 96, 100, 104, 120, 137, 140, 149, 152–53, 158
Bell, Vanessa 10, 44, 64, 73, 80–81, 88–89, 93, 100–01, 104, 140, 153, 159
Bevan, Robert 140, 144
Blaker, Hugh 16, 25, 41
Blanche, Jacques-Emile 109, 120
Blunt, Wilfrid Scawen 29, 37
Boccioni, Umberto 56–57
Bomberg, David 8, 60, 89, 129, 140, 151–53
Bonnard, Pierre 10, 120
Borenius, Tancred 24, 28
Brancusi, Constantin 7, 134, 136
Braques, Georges 44, 68–69, 72–73, 96
Brown, Oliver 16, 53, 159

Carra, Enrico 9, 56–57
Cézanne, Paul 8–10, 17–18, 20–26, 28, 35, 40, 48, 53–54, 65, 68, 72, 92, 117, 120, 149, 153
Chadbourne, Mrs Emily 17, 41
Čiurlionis, Mikalojus Konstantinas 105
Courtauld, Samuel 12, 160
Cross, Henry Edmond 12, 17, 20, 35
Cursiter, Stanley 60

Delaunay, Robert 128–29
Dell, Robert 8, 17, 52
Denis, Maurice 17, 22, 26, 28, 101
Derain, André 8–9, 17, 44, 55, 65, 68–69, 73, 104, 109
Dismorr, Jessica 46, 108–09, 112–13
van Dongen, Kees 72–73
Drummond, Malcolm 121
Duchamp, Marcel 128

Epstein, Jacob 17, 46, 96, 134, 136, 140
Etchells, Frederick 64, 89, 92, 144, 148

Fénéon, Félix 17–18
Fergusson, John Duncan 7, 10, 108–09, 112–13, 144
Friesz, Othon 9, 17, 68, 104, 109
Fry, Roger 7, 9–10, 12, 15, 17–21, 23–26, 28–29, 36, 40–41, 44–45, 57, 64–65, 68–69, 72–73, 76–77, 80–82, 84, 88–89, 92, 104, 108, 120, 125, 128, 130, 133, 140, 150–53, 158

Gaudier-Brzeska, Henri 60, 129, 134, 136
Gauguin, Paul 8–10, 17–18, 22–23, 26, 28–29, 32, 35, 40, 48, 53–55, 65, 104, 117, 125, 134, 152
Gertler, Mark 53, 140, 150–51
Gill, Eric 84, 89, 96, 129
Gilman, Harold 121, 124, 144
Ginner, Charles 96, 121, 124, 144
van Gogh, Vincent 8–10, 17–18, 28, 35–37, 40, 48, 65, 72, 117, 120–21, 124
van Gogh Bonger, Johanna 16–17, 35–37
Gontcharova, Natalia 105, 109
Gore, Spencer 9, 29, 53, 89, 96, 104, 121, 130, 144, 149–50, 152
Gosse, Sylvia 144
Grant, Duncan 9, 64, 88–89, 92–93, 96, 129, 140, 144, 150–53, 158–59

Hind, C. Lewis 10, 12, 35, 40–41, 45–46, 57, 84, 108, 130

Innes, James Dickson 140

John, Augustus 7–8, 46, 48–49, 53, 89, 105

Kahnweiler, Daniel 17, 44–45, 68, 72–73, 77, 109, 153
Kandinsky, Vassily 7–8, 12, 55, 117, 130, 132–34
Konody, Paul G. 10, 12, 35–36, 41, 45, 57, 68, 76–77, 84, 88, 96, 108, 130, 137
Kramer, Jacob 140

Lamb, Henry 89, 96
Larionov, Mikhail 105
Léger, Fernand 128
Lewis, Wyndham 10, 60, 76, 89, 96, 137, 140, 148–49, 151, 158
Lhote, André 72

MacCarthy, Desmond 15–17, 25, 32, 35–37, 124
MacColl, D.S. 19–20
Maillol, Aristide 17, 26, 159
Manet, Edouard 8–9, 17–21
Manson, J.B. 53–54
Marchand, Jean 69, 72
Marinetti, Filippo Tommaso 9, 56–57, 129–30, 153
Marquet, Pierre-Albert 17, 104, 150
Marriott, Charles 105
Matisse, Henri 8–10, 12, 17, 28, 40–41, 45, 49, 64–65, 68, 78, 80–82, 84, 88–89, 92, 96, 117, 125, 134, 152, 158–59
Meier-Graefe, Julius 8
Meyer-See, R.R. 57

Middleton Murry, John 108
Modigliani, Amedeo 140
Monet, Claude 20–21
Moore, George 19–20, 68
Morrell, Lady Ottoline 17, 96
Muirhead, David 46

Neville, John 53, 108
Nevinson, Christopher 60, 76, 129–30, 137, 144, 148
Nicholson, William 46
Nolde, Emil 9, 130

Peploe, Samuel John 108, 113, 144
Petrov-Vodkine, Kouzma 105
Picabia, Francis 12, 128
Picasso, Pablo 8–10, 17, 40, 44, 64, 69, 72–73, 76–78, 92, 96, 109, 121, 125, 128, 153, 158
Pissarro, Camille 10, 28, 117, 144
Pissarro, Lucien 104, 117, 140, 144

Rice, Anne Estelle 7, 10, 108-09, 112–13, 140
Ross, Robert 21, 29
Russolo, Luigi 56
Rutter, Frank Vane 8, 10, 12, 21, 32, 35, 40, 48, 56–57, 60, 77, 84, 109, 112, 116–17, 120–21, 125, 128–29, 132, 134, 137, 151

Sadleir, Michael T.H. 8–9, 12, 52–55, 108–09, 125, 132–33, 159
Sadler, Michael 8–9, 12, 32, 36, 52–55, 117, 120
Sagot, Clovis 17, 44–45
Saunders, Helen 140
de Segonzac, Dunoyer 109, 112, 129
Sérusier, Paul 55
Seurat, Georges 17–18, 20, 35
Severini, Gino 9–10, 56, 60, 129–30, 137
Sickert, Walter 19, 22, 24, 28, 32, 41, 60, 120–21, 124, 140, 148–50
Signac, Paul 17, 20, 35
Stein, Gertrude 17, 44, 92, 96
Stein, Leo 17, 23, 44, 92, 96
Stein, Michael and Sarah (Sally) 40, 78

Turner, Percy Moore 12, 17

Vallotton, Félix 17
Vlaminck, Maurice de 9, 17, 44, 69, 73
Vollard, Ambroise 17, 44–45, 48
Vuillard, Edouard 10, 93, 120
Wadsworth, Edward 137, 144, 148

Zadkine, Ossip 134, 136

Exhibition selected by
Anna Gruetzner Robins

Exhibition organized by
Tomoko Sato and John Hoole

Exhibition assistant
Alison Hart

Exhibition consultants
Caroline Cuthbert, Frances Spalding, Richard Cork

Catalogue edited by
Anna Gruetzner Robins
Tomoko Sato
John Hoole

PHOTOGRAPHIC ACKNOWLEDGEMENTS

Barbican Art Gallery would like to thank all the lenders of works from both private and public collections and the following individuals and organizations who have kindly supplied photographic material for the catalogue, or who have given permission for its use.

Agence photographique de la réunion des Musées Nationaux, Paris

Beeldrecht, Amstelveen

Boston Museum of Fine Arts

The Bridgeman Art Library, London

The British Library

Cartwright Hall, Bradford

Christie's, London

Peter Cox

M.K. Čiurlionis State Museum of Art, Kaunas

Elke Walford, Hamburg

Mike Fear for White Bros. (Printers Ltd.)

Hamburger Kunsthalle

David Nicolls

Antonia Reeve Photography, Edinburgh

Science & Society Picture Library, Science Museum, London

San Francisco Museum of Modern Art

Quentin Stevenson

Tate Gallery Library and Archive
John Webb

Special thanks must also be extended to Jonathan Morris-Ebbs, who undertook considerable photographic work for the catalogue.

Copyright for the work of J.D. Fergusson is held by Perth and Kinross Council ©1997

The following artists' works are DACS ©1997:

Maurice Asselin, Pierre Bonnard, Maurice Denis, André Derain, Othon Friesz, Natalia Gontcharova, Vassily Kandinsky, André Lhote, Albert Marquet, Henri Matisse, Pablo Picasso, Gino Severini, Walter Sickert, Maurice de Vlaminck, Edouard Vuillard, Edward Wadsworth.

First published in 1997 by Merrell Holberton Publishers Ltd
in association with the Barbican Art Gallery, London,
on the occasion of the exhibition,
Modern Art in Britain 1910–1914, 20 February – 26 May 1997

ISBN 1 85894 039 7 (paperback)

ISBN 1 85894 032 X (hardback)

Produced by Merrell Holberton Publishers

Designed by Roger Davies

Printed and bound in Italy